MW00964036

WOMEN'S STUDIES QUARTERLY
VOLUME 36 NUMBERS 1 & 2 SPRING/SUMMER 2008

An Educational Project of The Feminist Press at The City University of New York
and the Center for the Study of Women and Society at The Graduate Center,
City University of New York

EXECUTIVE DIRECTOR
Gloria Jacobs, *The Feminist Press at The City University of New York*

EDITORS
Cindi Katz, *The Graduate Center, City University of New York*
Nancy K. Miller, *The Graduate Center, City University of New York*

GUEST EDITORS
Kathryn Abrams, *University of California, Berkeley*
Irene Kacandes, *Dartmouth College*

MANAGING EDITOR
Anjoli Roy

ADMINISTRATIVE ASSOCIATES
Jess Bier
Stacie McCormick

DESIGN & PRODUCTION
Lisa Force

EDITORS EMERITAE
Diane Hope, *Rochester Institute of Technology* 2000–2005
Janet Zandy, *Rochester Institute of Technology* 1995–2000
Nancy Porter 1982–1992
Florence Howe 1972–1982; 1993–1994

WSQ: Women's Studies Quarterly, a peer-reviewed, theme-based journal, is published in the summer and winter by The Feminist Press at The City University of New York, The Graduate Center, 365 Fifth Avenue, Suite 5406, New York, NY 10016; 212-817-7926.

WEB SITE

http://www.feministpress.org/wsq

EDITORIAL CORRESPONDENCE

WSQ: Women's Studies Quarterly, The Feminist Press at The City University of New York, The Graduate Center, 365 Fifth Avenue, Suite 5406, New York, NY 10016; wsqeditorial@gmail.com.

PRINT SUBSCRIPTIONS

Subscribers in the United States: Individuals—$40.00 for 1 year; $90.00 for 3 years. Students—$28.00 for 1 year. (Student subscribers must provide a photocopy of current student identification.) Institution—$60.00 for 1 year; $144.00 for 3 years. *Subscribers outside the United States:* Add $15 per year for surface delivery; add $45 per year for airmail delivery. To subscribe or change an address, contact Customer Service, *WSQ: Women's Studies Quarterly,* The Feminist Press at The City University of New York, The Graduate Center, 365 Fifth Avenue, Suite 5406, New York, NY 10016; 212-817-7920; amanghnani@gc.cuny.edu.

FORTHCOMING ISSUES

Trans, Pailsey Currah, *Brooklyn College, City University of New York*, and Lisa-Jean Moore, *The Graduate Center, City University of New York*, and Susan Stryker, *Stanford University* *Technologies*, Karen Throsby, *University of Warwick*, and Sarah Hodges, *University of Warwick*

RIGHTS & PERMISSIONS

Fred Courtright, The Permissions Company, 570-839-7477; permdude@eclipse.net.

SUBMISSION INFORMATION

For the most up-to-date guidelines, calls for papers, and information concerning forthcoming issues, write to *WSQ: Women's Studies Quarterly* at The Feminist Press at The City University of New York, wsqeditorial@gmail.com or visit our web site, www.feminist press.org/wsq.

NEWSLETTER

Subscribe to the *WSQ* newsletter to receive calls for papers, related conference and publication information, and notifications of our Tables of Contents for forthcoming issues. Visit www.feministpress.org/wsq and select "Newsletter Sign-Up."

ADVERTISING

For information on display-ad sizes, rates, exchanges, and schedules, please write to *WSQ Marketing,* The Feminist Press at The City University of New York, The Graduate Center, 365 Fifth Avenue, Suite 5406, New York, NY 10016; 212-817-7920; amanghnani@gc.cuny.edu.

ELECTRONIC ACCESS AND SUBSCRIPTIONS

Access to electronic databases containing backlist issues of *WSQ* may be purchased through JSTOR at www.jstor.org. Access to electronic databases containing current issues of *WSQ* may be purchased through Project Muse at muse.jhu.edu, muse@muse.jhu.edu; and ProQuest at www.il.proquest.com, info@il.proquest.com. Individual electronic subscriptions for *WSQ* may also be purchased through Project MUSE.

Printed in the United States of America by Sheridan Press.

ISSN: 0732-1562 ISBN: 978-1-55861-577-9 $22.00

CONTENTS

OBJECT LESSONS

ACTS OF WITNESS

PART II—ART

PART III—FEMINIST CLASSICS: JUDITH HERMAN'S *TRAUMA AND RECOVERY*

PART IV—REVIEWS

EDITORS' NOTE

"One becomes a witness to one's own experience by finding a testimonial form; in other words, a language and a listener." In her analysis of Judith Herman's groundbreaking study *Trauma and Recovery*, the feminist classic we honor in this issue of *WSQ*, autobiography theorist Leigh Gilmore underlines the survivor's vital need to identify and address an interlocutor capable of receiving her story. This need becomes particularly acute when the traumatic events belong to the domain of women's lives, to violations like rape (to this day not everywhere recognized as a crime to be prosecuted by law), as well as the brutal scenes of domestic violence. History changes when women break the silence and bear public witness to the trauma so often marked by gender. This impulse is at the heart of Kara Walker's stunning reappropriation of racialized and gender stereotypes. In her film *Testimony: Narrative of a Negress Burdened by Good Intentions* (which was on display at the Whitney Museum, New York City, October 11, 2007–February 3, 2008) the artist, playing the role of puppeteer, brings the black woman's erased words into the world. Through Walker's creative practice, testimony acts as an agent for social change.

In their Introduction to *Witness*, our guest editors Kathy Abrams and Irene Kacandes have highlighted the importance of bearing witness as a key challenge to interdisciplinary feminist scholarship in the twenty-first century. Throughout the pages of the journal in which they, a law professor and a literary critic, combine their impassioned knowledge and expertise, the intense focus on matters of "women's witnessing" and "the configuring of gendered narratives of witness" guides the complex organization of the issue. At the same time, the editors ask a key question to which there is no simple response: "If we, as feminists, aim to create a space for women's witnessing," to put forward "a broader political project . . . what *kinds* of witness do we want to enable, and how might we propose to do it?" The complexity of their answer as editors lies in part in the unexpected juxtapositions produced by the diversity of the contributions chosen for the issue. In bringing together, for example, Mamie

[*WSQ: Women's Studies Quarterly* 36: 1 & 2 (Spring/Summer 2008)]

Till's decision to show the world the horror of the harm to her son from the violence of 1950s racism, with Yale Law School Professor Judith Resnik's chilling exposure of U.S. governmental complicity in contemporary practices of torture where victims often are denied the right to bear witness, and essays on the recent creation of women's graphic narratives as a subversive political form, Abrams and Kacandes have demonstrated the always intersecting domains of the everyday and the extreme, the domestic and the national, the global and the intimate, the historic and the contemporary in matters of trauma and witnessing. The editors have gathered an extraordinary collection of materials that demonstrate not only the power of witnessing, but the ways it calls forth and insists upon women's subjectivity and selfhood.

With *Witness* the two of us leave our tenure as coeditors of *WSQ*. We leave this position with a certain degree of sadness, but also with the knowledge that the work we've done since the fall of 2004 when we began to grapple with the reconfiguration of *Women's Studies Quarterly* has become secure enough to pass on. We are delighted to announce here that the successful transformation of the journal has been recognized by a prize from the Council of Editors of Learned Journals (CELJ). *WSQ* has received the 2007 Phoenix Award for Editorial Achievement, which is announced at the annual convention of the Modern Language Association (MLA). This has been a collaborative effort between the two of us and the staff at The Feminist Press, notably the Executive Director, Gloria Jacobs, the Managing Editor, Anjoli Roy, and The Feminist Press designer, Lisa Force. The transformation of the journal also testifies to its long feminist history, and the early vision of its founding editor Florence Howe. During our tenure as general coeditors, we have been extraordinarily fortunate in having Kamy Wicoff as our fiction/nonfiction editor, and Kathleen Ossip as our poetry editor. They have helped us extend the presence of cultural forms that for us have been essential to the expanded focus of the journal, and our effort to reach new readers and contributors. The artists Lorie Novak, Ellen Rothenberg, and Mira Schor, members of our fabulous Editorial Board, also served as informal consultants on the redesign and all matters visual. Naturally, we are grateful to our generous and spirited Editorial Board, our distinguished Advisory Board, and all of the extraordinary guest editors with whom we have worked these past four years. We would also like to thank here the graduate students who have worked as Administrative and Editorial

Associates, Marta Bladek and Jennifer Gieseking, without whose devotion and talent the enterprise would have been lost from the start. We leave the journal in the hands of a new pair of editors and a new pair of student assistants. With the December 2008 issue, the general coeditors will be Victoria Pitts-Taylor and Talia Schaffer, both of Queens College and The Graduate Center, CUNY. Jess Bier and Stacie McCormick, who have begun to work for the journal during this period of transition, will continue to play a crucial role in supporting the editorial project. Kathleen Ossip will remain as poetry editor and distinguished author Susan Daitch, who teaches at CUNY's Hunter College, will take on the position of fiction/nonfiction editor.

It seems fair to say that in the years that we have worked together reconceiving the journal for its new place in feminist scholarship we have borne witness to the always surprising productivity of collaboration across the conventional boundaries of academic discourse and, at the same time, across the borders that typically separate academic forms from the cultural arenas of the arts—literary and visual, archival and experimental. Bridging these gaps and juxtaposing different modes of discourse have been the most exhilarating part of our work. We do not know exactly which generic and disciplinary boundaries will be crossed in future issues or what new practices our endeavor to maintain the mix of genres will produce, but as we exit from our editorial tenure and join the Advisory Board, we do so with the conviction that *WSQ* will thrive.

Cindi Katz
Professor of Geography and Environmental Psychology
The Graduate Center, City University of New York

Nancy K. Miller
Distinguished Professor of English and Comparative Literature
The Graduate Center, City University of New York

INTRODUCTION: WITNESS

KATHRYN ABRAMS & IRENE KACANDES

Two young women sat in a café. Two who had met each other and inter-acted in a mainly social way years earlier as undergraduates now had their heads bent over a very different task: an analysis. An analysis of a complicated literary text that was supposed to constitute a dissertation chapter. But the argument wasn't clear yet, and the legal scholar, a fledgling academic with interests beyond her disciplinary ken, was help-ing the literary-scholar-still-in-training clarify what she was trying to say. Several hours passed. The legal scholar succeeded not only in assist-ing her friend articulate the most compelling aspects of her thinking on the text, but also in reviving her hope that one day, maybe even soon, she could complete the chapter draft, and another and another could follow.

There are at least three aspects of this otherwise mundane event that merit our attention. In an age of "postfeminism" it seems worth remembering that women completing advanced degrees and leading academic careers were not common occurrences until recently. When the two had first met at Harvard, there were only 13 tenured women on a faculty of 640. It also merits recalling that a mere twenty years ago intellectual exchange across disciplines was rare. The two women felt this: the one requested aid timidly; the other offered feedback gingerly. The third aspect is one that neither woman could have even fantasized at the time: that they were practicing for the future. One day they would be working together on an even more sustained intellectual project, and that project would take up some of the very themes at stake in the dis-cussion in the café that day. For what the literary scholar eventually realized, with the help of the legal scholar, was that her interpretation of the structure of the text in question was the most interesting contri-bution she could make with her chapter. At the heart of that structure were acts of accusation, defense, witnessing, and what that scholar would eventually term *literary cowitnessing*, acts that shaped the relation-ships within the text, but also that implicated the reader of the text in its

[*WSQ: Women's Studies Quarterly* 36: 1 & 2 (Spring/Summer 2008)]

moral dilemmas. The work of literature in question was Günter Grass's novella *Cat and Mouse* (*Katz und Maus*); the rhetorical device was apostrophe; and as you may have guessed by now, the two women were Kathy Abrams and Irene Kacandes.

When we exchanged e-mail two decades later about whether we would guest coedit an issue of *WSQ* on the topic witness, we did not wonder whether the other person was up to the task, or whether our disciplinary differences would be fruitful. We knew the answers to those questions. In fact, we took them for granted. No, what we debated was whether an intellectually coherent issue could be crafted if we cast our net for submissions very broadly. Fairly quickly, we came to the decision that our call for papers would raise as many issues as we could fit on the page, and that we would take the temperature of current interest in this huge topic by seeing what would come back to us in the content of the abstracts. Those proposals would witness to us things that we maybe did not know about the state of current feminist scholarship on witness.

We were delighted, in the fundamental sense of the word, by what we received: the diversity of topics, especially in terms of geography and history, seemed promising, if not as wide as we'd dreamed of. Reflecting this breadth seemed in and of itself a worthwhile contribution that we could make, and we quickly determined to ask for shorter-than-standard-length essays, so that we could include as many voices as possible. In a similar vein, we decided to use all parts of the issue, including the memoir, fiction, poetry, and book review sections, to illuminate our theme from various angles.

As diverse as the topics seemed, we were a bit surprised to discover the aspects of our call for papers to which prospective authors responded and, by the same token, the parts to which no one did. To take the most dramatic example, despite the fact that Holocaust studies has led the way in recent discussions of the concept of witness, we did not originally receive a single proposal on the Shoah. Similarly unexpected was the absence of interest in parsing the diversity of terms that the overlapping fields of memory and trauma studies have developed and circulated in the past fifteen years. When we looked at the abstracts as a group, it became clear that the invitation that the largest number of would-be submitters accepted was to share examples of feminists—past or present—bearing witness. In a sense, every contribution to this issue (and many more we could not include) constitutes a response to that call. It makes sense, we

realized in retrospect, for we are living in a society that, as Brecht lamented through his protagonist Galileo, has need of heroes: ("Unglücklich das Land, das Helden nötig hat" [Brecht 1955/1972, part 13, 114]).

We decided to foreground the prominence of the act of bearing witness in this issue by selecting a cover photo that did the same. In Renata Stih and Frieder Schnock's art project *The City as Text: Jewish Munich*, the city is viewed through an unusual cultural perspective, that is to say, through the prism of its Jewish past. To view the city thus, however, the viewer must play an active role. The photo itself shows one of several ways the artists challenge viewers to do so: a visitor to the museum must physically carry a (large and relatively heavy) marker through the special carpet-map of the city the artists installed in the Jewish museum—a map on which no street names are listed—to learn about the particular point of interest a place may have had at a specific time in the city's history. Through a special brochure-map they can take with them, individuals are invited to carry out a similar act by walking through the city itself. Stih and Schnock's previous installations, such as their project on the Nuremberg Laws installed in Berlin's Bavarian Quarter, have similarly foregrounded active viewing. Their demonstrated interest in incorporating into their installations the complex interactions of gender, religion, race, class, and ethnicity for individuals and societies make our choice of them a particularly appropriate one, we believe, for this issue and this journal.

Some other discernable patterns of interest among the abstracts included a number of submissions on "graphic narrative," and specifically multiple proposals to analyze Alison Bechdel's *Fun Home*. We were also intrigued by a cluster of pieces on how material objects can function as catalysts of witness. Numerous proposals on rape testified to our continued need to understand and combat the ubiquitous problem of violence against women.

The various elements we ultimately decided to include in this issue do not function as pieces in a single puzzle that we can present to you as a coherent whole. Nevertheless, we perceive several compelling topics running through these essays, which we would like to explore with readers of *WSQ*, and around which we structure the comments that follow. The pieces speak so well for themselves, and we count this opportunity to explore these issues with feminist readers as so precious that—much as

we consciously determined to include particularly diverse types of writing in this issue—we have decided, in this Introduction, to eschew the traditional task of enumerating the contents of this volume in favor of a more topical organization. To make more apparent what we find urgent about the issues highlighted by the selected essays, we turn first to some background on the concept of "witness" that is not explicitly provided by any of our contributors.

While religious and legal discourse has inflected notions of testifying for millennia, the role of witness today in societies as different as those of North America, Europe, Argentina, South Africa, and Rwanda has been shaped by the personal and professional processing of the Holocaust. It is difficult to assess exactly why this should be so; however, the scale and ignominy of the way these state-sponsored crimes were perpetrated begin to point to one explanation. Early eyewitnesses from among the targeted victims of the Nazis tried to tell and were not believed; it seemed impossible to many contemporaries that large groups of people were being murdered just because they were Jews. Meanwhile, those who were doing the murdering were told they were performing glorious work about which they must remain silent precisely because the world could not (yet) understand its importance ([Himmler speech to the SS at Posen, October 4, 1943 [see Dawidowicz 1976, 132–33]). Despite these barriers to dissemination, the perpetration of Judeocide became more widely known when it was testified to by the eventual victors, the conquering Allied armies that came upon the extermination and concentration camps as they proceeded East and West toward Germany. Although the large number of victim-eyewitnesses to the atrocities became increasingly apparent and signs of the crimes were documented through photography and film, the ability to take in what had happened was short lived on all sides. It persisted just long enough for the war to reach its conclusion and some major criminals to be prosecuted at Nuremberg. The overwhelming desire to leave the war behind, and talk of its victims and perpetrators with it, made itself manifest through rebuilding efforts, new political alliances, and countless admonishments to survivors to forget and move on.

While we do not have the space here to present all the major stages of witnessing to the Holocaust, we have highlighted the impediments at these early stages to make clear why it is that when eyewitness testimony was solicited—most dramatically in the Eichmann trial in Israel in 1961,

but also in the series of trials known as the Frankfurt trials in Germany several years later—it had such a powerful effect. Annette Wieviorka surveys the transformation from ignoring to interviewing to celebrating victims of the Shoah over the past half century in her slender but provocative and helpful volume, published in French as *L'Ere du témoin* in 1998, translated into English by Jared Stark (*The Era of the Witness*, 2006), and insightfully reviewed in this issue by Judith Greenberg. Recording eyewitnesses to the Holocaust by (originally) local projects such as that in the New Haven, Connecticut area (archived at Yale University and now referred to as the Fortunoff Archive for Holocaust Video Testimony) or that in Israel at Yad Vashem seems to have precipitated or at least coincided with a powerful new interest in trauma theory and witnessing to trauma that has resulted in numerous studies cited repeatedly by this issue's contributors (those of Caruth on trauma and memory, Felman and Laub on testimony, Hirsch on postmemory, and La Capra on writing trauma). Recent developments in concepts of witnessing that have come through Holocaust studies are discussed more explicitly in several reviews of important new studies. (In addition to Greenberg on Wieviorka, see Carrard on Suleiman's *Crises of Memory and the Second World War*; Kligerman on Kaplan's *Unwanted Beauty*; and Bladek's review of the more personal document, Mendelsohn's *The Lost*.)

Given the primacy of the belated processing of the Holocaust for new types of thinking about witness, we want to draw attention to the fact that the Holocaust, trauma, and gender relate in complex ways. On the one hand, violence against European Jews was anticipated by its soon-to-be targets, and indeed was often perpetrated, in gendered fashion. To cite just two of many possible examples: in early forced-labor details the Nazis humiliated Orthodox Jewish men by, among other actions, cutting off their beards; later in the war, at death camps the Nazis sent pregnant women and women with young children immediately to the gas chambers. On the other hand, Nazi race ideology trumped most aspects of the program (including winning the war); that is to say, Jews were killed foremost because they were Jews. Accordingly, many Holocaust survivors and scholars have been uncomfortable with, or have outright rejected, the very idea of Holocaust gender studies. Scholars committed to gender analysis have nonetheless managed to make some critical contributions, both to uncovering the salience of gender during the perpetration of the Judeocide and to witnessing to it. For

instance, one of the ways in which victims tried to leave a trace of what was happening to them was in the creation or refashioning of material objects. The milk cans into which Emmanuel Ringelblum and his Oneg Shabbat organization placed documentation about what was happening in the Warsaw Ghetto and that they then buried are a well-known example. To what exactly other found objects testify may not be immediately apparent, especially without taking into consideration the gender of the fashioners and the receivers. Marianne Hirsch and Leo Spitzer (2006) have explored a cookbook compiled in Terezin (Theresienstadt) and a tiny picture book created in Varpniarka, a concentration camp in Transnistria. They have proposed theories about how these "testimonial objects" came into being in places of extreme deprivation, what they may tell us about their creators' sense of identity both in their prewar lives and in their circumscribed lives in the camps, and how projected and actual acts of transfer of such objects may themselves be gendered and can engender feminist readings. Although none of the essays takes up the topic of the Shoah directly, we are gratified to be able to include some contributions about objects, gender, and memory from a small con-ference Hirsch organized at Columbia University in spring 2007. We have grouped these essays under the rubric Object Lessons, a phrase coined by Sonali Thakkar for her closing remarks at the colloquium. These short pieces take up objects as diverse as an armoire (Kate Stanley), a car transmission (Patricia Dailey), and a knitting manual (Thakkar). They take their readers to places as different as early twentieth-century Russia (Nancy Miller), mid-twentieth-century Mississippi and Chicago (Valerie Smith), and early twenty-first-century Chernivtsi, Ukraine (Hirsch and Spitzer). Each of these essayists tries to discern what objects might tell us about the complexly gendered ways in which individuals, families, communities, and cultures interact across time and space.

For Irene, coming mainly from the field of Holocaust studies, one of the attractions of editing this issue, then, was precisely to pursue a gen-dered examination of witness. For Kathy, working in the field of femi-nist legal theory, witnessing has been more consistently intertwined with considerations of gender. Yet from this disciplinary lens, too, there is ample room for interrogation. For example, feminist scholars and activists have sometimes participated in the orientalizing assumption that witness is the native tongue of women, that testifying to the truth of our experience flows naturally from our mouths. Our experience in edit-

ing this issue has persuaded us, to the contrary, that witnessing involves reflection, mediation, and much conscious effort. It is, as another of our section titles suggests, an "act," not an emanation from women's essence. The essay by Mikhal Dekel demonstrates both the familiar assumption about women's witnessing and the more effortful experience we have observed in the articles that make up this issue. Narrating her assault at Kishinev, Rivka Schiff labored very hard at trying to communicate her experience: her detailed, colloquial account traces the movements of the perpetrators' hands, the terse exchanges through which one "honest goy" tried to persuade the assailants to spare the victims, the locations of those in the attic who witnessed the multiple rapes. Yet the prominent Hebrew poet Hayyim Nahman Bialik, who journeyed to Kishinev to take the testimony of the survivors, could not repeat this testimony without orientalizing Schiff (prefacing her narrative with the reifying heading "From the Mouth of the Raped Woman Rivka Schiff") or heroicizing the survivors (with his epic, faintly pornographic poem "On the Slaughter"). Dekel acknowledges these issues, recognizing as well her own place in the complicated act of making them apparent.

The work involved in witnessing is also illuminated in several other pieces in this issue: for example, the contributions of Rachel Kranz (on the slave trader Creswell), of Nancy Miller (on trying to understand an unusual object found among her father's possessions), of Amy Hungerford (reviewing Susan Gubar's *Rooms of Our Own),* and of Susan Brison. This last witness not only shares the account of her brutal rape and attempted murder; she also reflects on the many reasons that she has, over time, born witness to violence against women. Moreover, Brison's essay illustrates the subtle changes in the iteration of her experiential narrative that have emerged—changes in emphasis, tone, and the ways in which she contextualizes the account of her attack—as she has moved from devastating trauma to healing.

Our experience as editors, moreover, replicates the labor of witnessing we see in these essays: as we put together this issue we found that our project, compared with other editing jobs we had undertaken, required unusually intensive collaborations between ourselves and many of the authors to achieve pieces that "spoke" to the subject of witness. Sometimes we even needed to negotiate between ourselves over the use of particular terms—such as the word "narrative"—that have different resonances in our distinct disciplinary communities.

If, in fact, witnessing does not come effortlessly to women's lips, a second question arises: what configures narratives of witness? What we can witness is affected by a complex circuit between what the witness feels that she can tell; what (she believes) others can hear; and what, once others have heard, they can apprehend and repeat. Many factors help to construct this circuit. Cultural taboos may, in the first instance, shape the things to which women can witness. Women who have sought to speak of their sexualized coercion initially had to overcome social conventions—strongly enforced by a sense of shame—about the public discussion, or even acknowledgment, of women's sexuality. Tamar Hess communicates one such instance in the efforts of Henya Pekelman to witness to her own life, and rape, in the context of the Palestine Mandate, and the ability of her memoir to bear witness for her in contemporary Israel. Christine Cynn evokes a similar set of constraints, these from late twentieth-century Haiti: when Rosiane Profil, a survivor of the Raboteau massacre, lifted her skirts above her waist to show where her legs had been pock-marked by her assailants' bullets, jurors and spectators became agitated, and the presiding judge had to ring his bell repeatedly to call the proceedings to order. What listeners can hear, and witnesses can say, may also be powerfully configured by circulating political discourses. In reporting the deep reluctance of abortion clinic workers in the contemporary United States to acknowledge the ordinary reasons that women seek abortions, Jeannie Ludlow describes a political terrain in which pro-choice forces emphasize dramatic circumstances of rape, incest, or (to a lesser degree) contraceptive failure, while more commonplace factors of financial constraint or doubts about one's ability to parent appear only in the condemnations of abortion issued by the political Right. Even when witnesses are able to relate a crucial dimension of their experience—often at great cost—those to whom they have reported it may be unable to hear it. Susan Brison notes that when she emerged from the ravine to tell passersby of her rape and attempted murder, they insisted that she must have been hit by a car.

Institutional structures and their rhetorical scripts also play a potent role in configuring narratives of witnesses. Allison Tait explains how the possibility of women's citizenship in the early modern constitutionalism that preceded the resumption of absolute monarchy in seventeenth-century France produced powerful effects on women's capacity to witness. The fact that "aristocratic and judicial privilege [enabled] female

political engagement" transformed the way that women's witness was able to function, both on the stage—where the politically potent female witnessing of Madeleine de Scudéry's *Les Femmes illustres* replaced the tragic neoclassical female witnesses of Corneille's *Le Cid* and *Rodogune*—and in the Fronde, where noble women joined with officials of the judiciary to resist the challenge of absolute monarchy. Yet the opportunity to bear witness within the formal institutional structures of the state has not always been enabling for women witnesses. In her essay, Christine Cynn describes how the political agency of women, fostered through engagement in the collective, nongendered mobilizations of the Raboteau Victims' Association and the September 30th Foundation, was constrained and domesticated in the course of the very trial for which the activists had fought, in order to meet the prosecution's rhetorical need for innocent, gendered victims of the Raboteau Massacre. (Richard Mollica's review of Eric Stover's *The Witnesses* explores another context, the International Criminal Tribunal for the former Yugoslavia, in which witnesses did not always fare well in institutions designed for legal redress.)

Finally, the forms of witness themselves can configure the narratives that women and other witnesses are able to offer. The experiential narrative, whose quotidian details challenge listeners to glimpse the political in what might be seen as the ordinary dramas of personal life, was a form of women's witnessing pioneered through consciousness-raising. Feminist scholars have introduced such narratives in a range of academic contexts, sometimes unsettling deeply held assumptions that privilege objective rationality over engaged, affective, perspectival argumentation. (Reviewing a recent conference, "Law and the Emotions," Tucker Culbertson explores one trajectory of this critique of objectivity. As for the quotidian details of daily life, see Kamy Wicoff's *I Do But I Don't*, reviewed by Irene Kacandes.) Over time, and in response to the varied challenges of witnessing, new forms of witness have emerged. Most scholars agree that, in *Maus*, Art Spiegelman invented a form that allowed postmemorial witnessing to occur: the artist son is able to represent not only the story of his parents' survival in the Holocaust, but also and simultaneously his own struggle with the monumentality of that past in his more ordinary life. We discovered, through the works that we received on "graphic narrative," that women artists have built upon Spiegelman's accomplishment to extend this form as a container for

witnessing to other kinds of traumas, including those relating to gender or queer sexualities. The graphic narrative's juxtaposition of visual images, with written dialogue and a retrospective narrative, create layers of meaning, interpretation, or ambiguity, which feminist witnesses deploying a single narrative line often struggle to convey. The contrast and confluence of these multiple narrative lines can underscore the fault lines between past and present, public and private, epic and ordinary, hidden and revealed that figure prominently in works such as Marjane Satrapi's *Persepolis* (see Chute's essay) and Alison Bechdel's *Fun Home* (discussed by Cvetkovich and Lemberg). These contrasting narrative forms may be further enriched by pluralization within each narrative line, for example, the "documentary archive" of quasi-photographic images within Bechdel's larger visual narrative or by forms of representation that provocatively merge word and image, such as Bechdel's "curvy circumflex" (see Cvetkovich). The three essays in this issue devoted to the graphic narrative—and by including three we editors mean to witness to the remarkable development of the genre—attest to the reasons that this form has become a rich and supple resource for contemporary witnessing by women artists. (This question of forms of expression taken up by women artists is extended through a report on recent interest in feminist art; see the contribution by Siona Wilson.)

This backdrop ultimately leads us full circle to reflect on our own implication as feminist scholars in the configuring of gendered narratives of witness. If we, as feminists, aim to create a space for women's witnessing—to enact as a broader political project what we have attempted, on a small scale, to achieve in this issue—what *kinds* of witness do we want to enable, and how might we propose to do it? Although this is a large question that must, in many cases, be answered contextually, the essays in this issue gesture toward several points of departure.

First, we see value in making room for witnessing that attests to ordinariness, both in the constraints, injuries, and possibilities that witnesses relate and in the manner of reporting them. Speaking of abortion rhetoric, Jeannie Ludlow attests powerfully to the tendency to construct women seeking abortions as victims who struggle heroically with the consequences of rape or incest, when far more often they come to clinics because they lack the financial means to raise a(nother) child, doubt their abilities to function as parents, or seek to make a new start in their lives. The "trauma-tization" of women seeking abortion—perpetuated by

pro-choice activists' own discourse—touches all women, engendering shame and self-doubt in those who seek abortion for more ordinary, and far more prevalent, reasons. Further, Dekel's essay reveals the effects of the heroic lens through which women's testimony is often refracted. Dekel permits us, as readers, to witness the power of Rivka Schiff's richly textured yet quotidian discourse—a form of address that almost assumes that we know who the "Zichec daughter" is, or where the stairs are located in the attic where the assault occurred—as compared with the momentous, yet somehow generic, rendering of the event in Bialik's poem. As feminists' earliest experiences with narratives have taught us, the power of many forms of witness lies in that texture, those details: they help us relate the jarring injury to our own lives, help us see the way that we too could move in an instant from the familiar details of our lives to an unimagined horror, or to be confronted with the kind of searing choice that we would like to deny. Reclaiming that ordinariness in relation to both the subjects of gendered testimony and the styles in which women render it seems to us a worthy object of feminist efforts. Activist Byllye Avery's account of the founding of a birthing clinic in Gainesville, Florida, offers in straightforward narrative language not only a success story that we are happy to share here, but also a claiming of joy in the fundamental, ordinary event of birth when it can happen in a safe, clean, welcoming, and life-affirming environment.

Second, we believe that feminists should make a space for witnessing to recovery from victimization. Susan Brison's account is not simply a narrative of a sense of self lost or obliterated through traumatic injury; it is also a narrative of the regaining of self, often at a seemingly glacial pace and with incalculable shifts between forward movement and painful regression. The role that bearing witness to sexual violence plays in that recovery is one of the most important lessons that we draw from her essay. Yet another lesson, which can be glimpsed in the interstices, is what it might mean to have a more mature, or more realistic, notion of recovery itself. Brison's effortful, incremental rediscovery of her "old" self, in part through the surprising vehicle of jazz and the blues, is illuminating in the trajectory that it holds out as uncertain yet possible and in the texture and detail of that trajectory. Moreover, it is not the only rendering of what a mature vision of recovery might mean that we find in these pages. We see, too, at least a bit of what recovery meant in the lives of the women of Raboteau, who were also galvanized by music, in their

case protest songs; in the lives of specific "lost generation" daughters who found cowitnesses in their innovative and resourceful lawyers (see Rosanne Kennedy's essay); in the dignified yet subversive witnessing of Mamie Till, who demanded that the nation see what had been done to her child (discussed by Smith).

The tragic journey of Mamie Till came to one kind of end in fall 2007, when the county of Tallahatchie (encompassing the town of Sumner, Mississippi), where an all-white jury had previously acquitted two men of the murder of Emmett Till, offered an apology to the few surviving members of the Till family. This apology, offered long after most of those family members who might have heard it had passed away, takes us from the realm of individual to collective recovery. As Irene has suggested in her work on cowitnessing, following leads by scholars as diverse as Martha Minow, Judith Herman, and Cathy Caruth, "transcultural and transhistorical cowitnessing"—even if it does not aid the original victims—can benefit the health and healing of the society in which those victims suffered and we continue to live. When a trauma has yet to be cowitnessed to, on a collective level, it still exists. When we acknowledge that certain kinds of acts were wrong, that we no longer condone their perpetration, and that we wish the outcome of the original event for the victim(s) and the perpetrators had been different, we become, in a sense, a different society (Kacandes 2001, 138–40).

Part of this individual and collective movement toward recovery may be a willingness to loosen our hold on victimization and the work that victimization has done for us. The pioneering research and writing of Judith Herman, to which we return in this issue, makes clear how witnessing to victimization has contributed to feminist claim-making and social transformation—and can form a crucial step in the recovery of individual victims. Yet in her response to Herman, Susan Suleiman sounds a note of caution, citing the possibility of a clinical, and a broader social, investment in victimization, which makes ongoing care and vigilance about how we hear and engender narratives of trauma essential. A similar debate has echoed in the realms of law and political theory, where Wendy Brown (1995), among others, has argued that the dominance of feminism's focus on sexual violence as the paradigmatic form of gendered (and gendering) injury may foster a kind of *ressentiment*, a continued moral and political investment in one's victimization, which not only distorts remediation when it is embraced on a social scale, but also

can make the relinquishment of the victimized self difficult. This critique has not been easy for feminist lawyers and legal scholars to hear; recognizing women's victimization through law has not only been critical for fostering social understanding of gender inequality, it has also been the predicate for forms of legal recovery that call perpetrators to account. Yet slowly, and often painfully, feminist lawyers are beginning to reconsider the law's relationship to victimization. One step, which Kathy has sought to initiate in her own work, has been to rethink the way that we characterize women as victims (Abrams 1995). (For another view of how feminism might be reenergized by more plural or fluid understandings of those who are its subjects, see Angela Harris's review of two books on the transgender movement.) Feminist legal scholars such as Elizabeth Schneider (2000) and Martha Mahoney (1991) have argued that advocates must help courts to see the partial agency (and the struggle for power and control) in the lives of battered women, rather than seeing these women as wholly compromised victims. And the U.S. Supreme Court, at best an ambivalent advocate of women's rights, held in 1993 that women did not have to prove "serious psychological injury" to prevail in a claim of sexual harassment, a decision that helped to foster a new image of what it might mean to be a victim of sexualized injury. Another part of this effort has been to develop forms of lawyering that support the self-direction, and in subtle ways contribute to the healing, of the clients themselves. In her essay in this issue, Rosanne Kennedy is not wholly sanguine about the law, noting how courts have frequently denied remedies to "stolen generation" children in Australia; yet she eloquently documents how lawyers have served as cowitnesses for clients seeking redress for the state-authorized destruction of their Indigenous families. Similarly, lawyers assisting Thai and Mexican workers in the sweatshops of El Monte, California, have pioneered an innovative form of representation that uses the lawsuit as a vehicle to create sustaining solidarity among these women and fosters their sense of capacity by supporting their ability to bear witness—both inside and outside the courtroom—to coercion in the garment industry (see Su 1998). These efforts remain far from typical; yet, echoing the forceful and trenchant witnessing of many authors in this issue, they may suggest that we are at the threshold of a change. Feminists may be willing to take the lead in fashioning a more complete and nuanced account of the movement through victimization and forward.

These points about eschewing the orientalizing of women as natural witnesses, embracing narratives of ordinariness or healing, and transforming and supplementing claims of victimhood with more agentic accounts of women's lives are not, we think, ones with which every reader of or even contributor to this issue of *WSQ* agrees. However, as we two women sat at yet another café, this time in Berkeley, California, in October 2007, they were ones that we believed were ripe for debate. We wanted to risk putting them out into the feminist public sphere through this discussion. For, as so many of the acts of witnessing recounted and performed in this issue make clear, to witness is to risk.

KATHY ABRAMS is the Herma Hill Kay Distinguished Professor of Law at UC-Berkeley School of Law. She is a graduate of Harvard-Radcliffe College and Yale Law School. Before coming to UC-Berkeley, she was on the faculty at Cornell University, where she taught in the Law School and directed the women's studies program. Her widely anthologized articles have focused on feminist jurisprudence and its intersection with the law of gender discrimination; she has also written on voting rights law, the jurisprudence of race, and the regulation of sexuality. Her current interests include the law's engagement with the emotions; she is working on a book on the relationship between law and the emotion of hope.

IRENE KACANDES is on associate professor of comparative literature and German studies at Dartmouth College, where she also teaches women's and gender studies and war and peace studies. Author of *Talk Fiction: Literature and the Talk Explosion* (University of Nebraska Press, 2001) and coeditor of *A User's Guide to German Cultural Studies* (University of Michigan Press, 1997) and *Teaching the Representation of the Holocaust* (Modern Language Association of America, 2004), Kacandes has a book manuscript called *Daddy's War* about family remembrance of World War II that is forthcoming from University of Nebraska Press.

WORKS CITED

Abrams, Kathryn. 1995. "Sex Wars Redux: Agency and Coercion in Feminist Legal Theory." *Columbia Law Review* 95(2):304–76.

Brecht, Bertolt. 1955/1972. *Leben des Galilei*. Edited by Victor Lange. Edition Suhrkamp in American text editions. New York: Harcourt Brace Jovanovich.

Brown, Wendy. 1995. "Wounded Attachments." In *States of Injury: Power and Freedom in Late Modernity*. Princeton: Princeton University Press.

Caruth, Cathy, ed. 1995. *Trauma: Explorations in Memory*. Baltimore: Johns Hopkins University Press.

Dawidowicz, Lucy S. 1976. *A Holocaust Reader*. West Orange, New Jersey: Behrman House.

Felman, Shoshana, and Dori Laub. 1992. *Testimony: Crises of Witnessing in Literature, Psychoanalysis, and History*. New York: Routledge.

Hirsch, Marianne. 1997. *Family Frames: Photography, Narrative, and Postmemory*. Cambridge: Harvard University Press.

Hirsch, Marianne, and Leo Spitzer. 2006. "Testimonial Objects: Memory, Gender, and Transmission." In *Diaspora and Memory: Figures of Displacement in Contemporary Literature, Arts and Politics*, edited by Marie-Aude Baronian, Stephan Besser, and Yolande Jansen. Amsterdam: Rodopi.

Kacandes, Irene. 2001. "Testimony: Talk as Witnessing." In *Talk Fiction: Literature and the Talk Explosion*. Lincoln: University of Nebraska Press.

La Capra, Dominick. 2001. *Writing History, Writing Trauma*. Baltimore: Johns Hopkins University Press.

Mahoney, Martha. 1991. "Legal Images of Battered Women: Redefining the Issue of Separation." *Michigan Law Review* 90(1):1–94.

Schneider, Elizabeth. 2000. "Beyond Victimization and Agency." In *Battered Women and Feminist Lawmaking*. New Haven: Yale University Press.

Su, Julie. 1998. "Making the Invisible Visible: The Garment Industry's Dirty Laundry." *Journal of Gender, Race, and Justice* 1:405–17.

Wieviorka, Annette. 1998/2006. *The Era of the Witness*. Translated by Jared Stark. Ithaca: Cornell University Press.

THE THINGS WE CANNOT SAY: WITNESSING THE TRAUMA-TIZATION OF ABORTION IN THE UNITED STATES

JEANNIE LUDLOW

What would happen if one woman told the truth about her life?
The world would split open.—Muriel Rukeyser, "Käthe Kollwitz"

"Can you tell me what *really* happens at an abortion clinic?" My interviewer shifts forward, careful not to jar the camera she has leveled at me. It's a question I've been asked many times. I began working part time at an abortion clinic in 1996. In 2000, I began speaking to small groups—classes, student organizations, feminist organizations—about clinic work, and in 2003 I began researching U.S. abortion politics. Yes, I probably could tell her what really happens at a clinic, but I don't. Although a part of me wants to tell her that the patients at the clinic are women like her, like her mother, like me, that they come to us for help with mundane situations more often than with horror stories, I don't, because I am being recorded, and I am afraid. Instead, I ask her to be more specific. "Tell me about the really tough cases," she urges. She's already confessed that someone she is close to was conceived during rape, so I suspect that she wants to hear about women who live with violence and undergo abortion. This is a politically necessary narrative about abortion in the United States; often, pro-choice activists argue correctly that laws that limit (or ban) abortion revictimize women impregnated during rape, incest, and domestic violence. Careful not to violate patient confidentiality, I tell her about my relatively infrequent experiences with rape victims at the clinic.

Why am I reluctant to talk about the majority of my clinic experiences? It would be disingenuous to deny that I fear that the common stories would disappoint my interlocutor. Each week I do intake medical history screenings and peer counseling sessions for two to four patients at the clinic. For approximately twelve to forty patients a week, I act as surgical advocate, standing next to the women as they have their abor-

[*WSQ: Women's Studies Quarterly* 36: 1 & 2 (Spring/Summer 2008)]

tions, coaching them through the procedure ("Now you may feel another dilation cramp; take a deep breath and blow it out") or distracting them with small talk if they prefer, proffering cool washcloths for their foreheads, basins in which to vomit, or my hand to be squeezed. Each of these women has shared a decision-making narrative during our screening process, and many retell those narratives to me while waiting to see the doctor or during their surgeries. Most of these narratives center around women's struggles with the ordinary—and, simultaneously, monumental—details of life: managing family economics, negotiating work and child care, setting priorities, and planning for the future. Not long ago, a coworker estimated that I have acted as a surgical advocate in more than seven hundred abortions. Usually the patients and their narratives stay with me for a few weeks at most and then begin to blend into a kind of abortion chorus in my memory. Often a patient will say to me, "You were here for my last abortion, too," and I smile, nod, and say, "I hope I was helpful to you," because I don't remember her abortion.

The patient narratives that stay with me longer are the rarer or more traumatic situations. The stories of aborting fetuses conceived during rape or because of fetal anomaly and the narratives of forty-two-year-old cancer sufferers and frightened thirteen-year-olds do not merge into that chorus in the same way. These stories are easier to remember, and auditors tend to respond to them with sympathy and support, another reason for my reluctance to share the more common situations. From my experiences talking about my clinic work, I have determined that there is a hierarchy of abortion narratives from a pro-choice political perspective. There are abortion narratives that are considered politically necessary to tell (rape/incest/domestic violence victims' difficulty in obtaining abortion services, clinic personnel's struggles with antiabortion protesters, the risks of illegal abortion to women's health and welfare). These narratives are considered central to maintaining public support for abortion rights and access. When I was asked to represent Ohio abortion clinics in a federal hearing to determine the constitutionality of a restrictive abortion law, these are the stories I told. I talked about how the law would hurt most those who are already hurting: women living in violent relationships and pregnant teens living in abusive or neglectful families. There are also abortion narratives that are considered politically acceptable to tell (contraceptive failure rates, a young mother's inability financially to support

another child, fetal anomaly cases). Although these narratives raise potentially difficult questions about personal choice and responsibility, they do represent situations with which most Americans can empathize, thereby posing no threat to continued public support for abortion rights and access. At my talks on abortion, I regularly hear these narratives from audience members and other activists, and often I relate them myself. When I do, I recognize that I am saying the "expected things" rather than speaking openly about what I've learned through my work at the clinic. I have spoken with my coworkers about this realization, and we have agreed that there is another category of abortion narratives. One of my coworkers refers to this kind as "the things we cannot say." These are narratives of abortion experiences that, while often exploited in antiabortion discourse, are generally not considered part of pro-choice public discourse in the United States; they are narratives of multiple abortions; of failure or refusal to use contraceptives (correctly, consistently, or at all); of grief after abortion; and of the economics of abortion provision.[1] These are the recitals that are the most familiar to clinic personnel and, although we talk about them among ourselves, we seldom move these discussions into public spaces, even explicitly pro-choice ones. The irony of our silence is that "the things we cannot say" describe the majority of our clinic experiences.

In other words, there is a politically and socially constructed gap between what we experience at our clinics and how we talk about those experiences in public. When I began to notice this gap in my own speaking about abortion, I realized that it had been constructed in part out of political necessity. I was reluctant to close this gap for fear that I might, as one academic colleague accusingly put it, "provide fodder for the other side." Abortion rights advocates have long found ourselves in defensive positions vis-à-vis antiabortion discourse, from accusations of indulgence implied by antiabortion phrases such as "abortion on demand" to those of callousness implied in recent examinations of "post-abortion syndrome" (Bazelon 2007). This defensive stance has circumscribed our own discourse. At the same time, the gap between what I see at the clinic and what I feel I can say in public has been constructed discursively from what Lane, in her 2005 documentary, *The Abortion Diaries*, calls the "silence and stigma" around abortion, even among pro-choice people. In MariAnna's words, abortion is "a topic that many people—even some who support legal abortion—find distasteful or offensive"

(2002, ix). "Distasteful" and "offensive" are socially constructed responses that cannot be separated neatly from antiabortion discourse; the adoption of these responses by self-defined pro-choice people reveals the power of cultural narratives to "structur[e] meaning in our lives and, consequently, facilitat[e] particular understandings of truth" (MariAnna 2002, 121).

Recently, I have begun to think about the relationship between cultural narratives of abortion as distasteful or stigmatized and the experiences patients have at our clinic. Sometimes, the relationship seems obvious and direct to me, such as when a college-aged patient writes on her chart that she is "a bad person" and says to me in a cheerful voice, "I expect I will feel terrible [after the abortion]. I'm sure I'll think about it a lot and always wonder about the baby, what it would have been. But I just can't have a baby right now, when I'm about to start school." At other times, the relationship is oblique; once, a woman having a late-second-trimester abortion leaned close to me at the end of her medical history screening and whispered, "Is this legal?" While I was stunned by the courage it took to show up for a surgery that she suspected might not be legal, I was also aware that the discourse around the "partial-birth abortion ban" had inspired her confusion. Because I see these relationships at work in women's abortion experiences, I have decided that I will no longer allow my fears to delimit the stories I tell.

This essay is located in the gap between witness and testimony, "between the seen and the told" (Bernard-Donels and Glejzer 2000, 5), at the site of the "things we cannot say," a location from which I hope to propose a more complex and more honest reading of abortion experiences.[2] I believe that the gap between what I have witnessed at the clinic and what I have been willing to testify about in relation to my clinic experiences indicates that abortion in the United States has been constructed as traumatic. I would like to refer to abortion in this essay as "trauma-tized"—trauma-tized in part by the fears and silence of people like me who work for women's reproductive rights. By speaking from this gap to illustrate how this trauma-tization affects my patients at the clinic, I hope to mitigate my role in its construction and replication. To that end, I situate myself as "witness" and my readers—particularly those who identify as pro-choice—as what Kacandes calls "cowitnesses" or "enablers" to/for the story of trauma, individuals who can themselves be "transformed" by the act of hearing or reading another's testimony

(2001, 95, 107). The transformations I hope for begin when I and other abortion rights activists become more comfortable telling the most common stories and adjust our public discourse to claim the rightness of women's mundane reasons for terminating pregnancies. As we articulate "the things we cannot say," perhaps we can normalize ordinary abortion experiences, thus reducing the effects of silence and stigma, in turn transforming patients' experiences, enabling them to approach their abortion decisions, whether mundane or extraordinary, as free as possible from socially constructed guilt. Although I am not fully optimistic about this outcome, I admit that I also long for an overtly feminist sociopolitical context in which ordinary abortion narratives become the politically necessary narratives, the ones we rehearse in order to defend abortion access.

THE THINGS WE CANNOT SAY

The sedative is working; the patient is woozy and relaxed yet awake and aware. As usual, I stand at her left shoulder where I can speak with her and maintain eye contact and still see enough of the doctor's actions to anticipate and explain them. The nurse and the clinic director, who performs our ultrasounds, are the only other people in the room. The vital-signs monitor beeps the rhythm of the patient's heart. The patient is nervous and clutches my left hand tightly; she does not want to know what the doctor is doing, so we chat. As a strong cramp grips her abdomen, she pulls my arm and says softly, "I have a really good reason for doing this, but abortion shouldn't be used as birth control." I know better than to try to reason with sedated patients; often they don't know what they're saying. But in the spirit of keeping her mind off the doctor, I say that most women have really good reasons for having abortions. "No," she says, gritting her teeth through another cramp. "People should not just have sex and do this for an easy way out."

I could dismiss this patient's statement as a combination of drug-induced rambling and difficulty with her own decision, but I know that many self-described pro-choice people, including activists, politicians, and academics, agree with it. What is meant by the statement, "Abortion should not be used as birth control," as Senator Hillary Clinton articulated in a 2005 speech, is that abortion should be an exception, not a normal aspect of women's reproductive lives. It should not "ever have to be exercised or only in very rare circumstances" (Clinton 2005). Correlative

activist phrases include "safe, legal, and rare," and the assertion "To decrease abortion, we must increase comprehensive sex education." This is, to my thinking, the least risky pro-choice narrative that exists in the contemporary neoconservative United States, which is doubtless why politically liberal people such as Clinton have adopted it. This narrative is effective; it is hard to argue against reducing unintended pregnancies and increasing individual responsibility for sexuality.

As my experience with this patient indicates, however, this narrative tends to trivialize most abortions; she calls abortion an "easy way out" of an unwanted pregnancy. This construct compels us to focus on "exceptional" circumstances—situations in which the woman had very little choice in the matter—to justify abortion's continued legality and accessibility; reduced choice means reduced culpability. As noted above, many pro-choice activists respond to legal challenges to abortion by invoking politically necessary and politically acceptable circumstances. Because they are presented so frequently, these circumstances have become reinscribed as the "appropriate reasons" to have an abortion, and they render all other reasons for aborting questionable at best and frivolous at worst. Statistically, however, these "appropriate abortions" are rare. Only 1 percent of abortions in the United States are of fetuses conceived via rape or incest and fewer than 1 percent are of fetuses with severe anomalies; fewer than 20 percent of abortion patients are aged nineteen or younger. Much more common are abortions performed for economic reasons or to correct mistakes that people have made. Among women having abortions in the United States, the two most frequently given reasons for choosing abortion are financial (57 percent of women having abortions are poor or low income and 21 percent report that financial hardship has influenced their decision to abort) and lack of readiness for responsibility (21 percent of abortion patients) (Alan Guttmacher Institute [AGI] 2005).

These are the women I see in the clinic; our demographics correlate with the national statistics. Because our patients complete an intake screening form that asks, "How do you define abortion?" and "How do you feel about your decision?" I know that many patients "used to think abortion was wrong" but now believe that "it is a woman's choice," a way not to have to change one's life because of a mistake. Many tell me during screening that they feel guilty because they did not use contraceptives consistently and correctly. Nationally, 43 percent of women with

unintended pregnancies were using no contraceptive method at all during the month they conceived, and those who were using contraception did not use it correctly every time they had sex. Both my experiences and data from the Alan Guttmacher Institute suggest that contraceptive failure is not much more common than failure to use contraceptives. When pro-choice activists insist on the legitimacy of abortion by invoking the former and do not mention the latter, we reinscribe the gap between the pro-choice narrative of "appropriate abortions" and women's lived experiences.

A coworker indicates that the patient in the next procedure room is "difficult." She's been uncooperative since her ultrasound appointment, complaining about having to speak with a physician before setting up her abortion appointment (this extra step is the outcome of the hearing at which I testified). "She said she's done this before, and she doesn't need to talk to anybody before her abortion," my coworker explains. I look at the patient's chart. She's a thirty-nine-year-old mother of four. Although she has written on the front of the chart that she has "been here before," her gestation history inside is incomplete. She lists her childbirths but no previous abortions. I ask if we are certain that the woman is a "sister" (repeat patient) and am assured that she has had several abortions with us. I enter the procedure room. The patient is lying on the gynecological table and does not sit up. I introduce myself and compliment her hairstyle, which is very short. She smiles and compliments mine (also very short). Something inspires me to ask, "Did I tell you that last time?" She nods and we laugh. As her procedure begins, the patient says to me, "Just as soon as I can, I'm getting myself to the doctor to get my tubes tied." During the procedure, we talk about her children and the difficulties of working a swing shift. She says her boyfriend asked her to marry him, and that she will do so after she gets her tubal ligation. When her abortion is finished, she says softly, "Thank you, again." Then, more loudly, she says to all of us, "I love you guys, but I hope I never see you again!"

According to the Alan Guttmacher Institute, among women having abortions, 12 percent have had one or more previous abortions, 25 percent have had one or more previous births, and 36 percent have had both previous abortion(s) and previous birth(s) (2005). This means that 48 percent of U.S. abortion patients have more than one abortion, and 61 percent are mothers when they abort. These previous situations can shape a woman's

abortion experience. If I had done the medical screening and peer counseling for the woman mentioned above, the missing abortion history would have compelled me to ask how she was feeling about having multiple abortions. I suspect that her "difficult" behavior grew out of her frustration with having another unplanned pregnancy and, in turn, led to her advocate's unwillingness to question her about those feelings. Because her medical screening was incomplete, I do not actually know why this patient had multiple abortions. I do know that asking why does not help her in her present situation as a single mom of four who does not want more children and does want to build a life with the man who has asked her to marry him.

When I am screening women who have had multiple abortions, I do ask directly about the repetition. These women tell me most frequently that they feel shame "for getting myself into this situation again" and fear "that I won't be able to get pregnant again if I want to." In these women's responses, I hear echoes of antiabortion rhetoric. I trace such women's fear that abortion will render them sterile to claims made by "crisis pregnancy centers." More important, to me, I hear the result of the refusal of pro-choice advocates to address repeat-abortion situations. The silence and stigma surrounding ordinary abortion experiences seems to be aggravated by multiple abortions. Yet when I consider the obstacles that prevent women from using contraceptives consistently and correctly (economics, heteronormative relationship dynamics, the vagaries of daily life), the incidence of three, four, or five abortions over the course of the thirty-plus years that a woman is fertile and sexually active seems neither shameful nor unreasonable. It is time we publicly address the needs of repeat-abortion patients.

When I am silent about "the things we cannot say" and focus on exceptional circumstances, I reinscribe a discourse of "appropriate abortion" that in turn feeds a cultural climate in which abortion patients feel "guilty" or "like bad people" for exercising their right to decide whether and when to become parents. Thus, I delegitimate the most common reasons women decide to abort. As witness to the effects of this delegitimation on my patients, I invite my reader-cowitnesses to join me in challenging the notion of "appropriate abortions," that is, to join me in articulating "the things we cannot say." When someone states, "Abortion shouldn't be used as birth control," I will reply, "But that's exactly what it is—a way for women to control when we give birth." And when,

during a conversation about why abortion must remain safe, legal, and accessible, someone invokes exceptional circumstances, I will inject a dose of normalization into the discussion; I will define the gap by drawing attention to it. I will say, "Yes, of course abortion must remain legal for victims *and* for those of us who forget our pills or diaphragms and who do not want babies right now." I believe that when witnesses are willing to testify to "the things we cannot say," including to some phenomena that may be read as politically ambiguous, the continuous process of narrative structuring, to use MariAnna's terms, will shift, making way for more diverse, and perhaps even for contradictory, "understandings of truth" about abortion (2002, 121).

WITNESSING AND TRAUMA-TIZATION

> *Witnessing . . . entails responsibility. And it's not without its own risks.* Se paga por ver *(one pays for looking).*—Diana Taylor, *Disappearing Acts: Spectacles of Gender and Nationalism in Argentina's "Dirty War"*

It feels risky to write about abortion in the context of witnessing for four reasons. First, I never want my witnessing to compromise a patient's confidence or dignity. However, if I name my work "witnessing to abortion," readers may expect my testimony to reveal confidences, including "horror stories" about patients' experiences as I recounted above. Often revealing anything at all runs a risk of violating trust. Let me try to explain. My position of relative power over my patients has been created in part by their confidence in me—their confidence that they can tell me things they cannot tell other people, and their confidence that I know what to do and say. When I care appropriately for patients, I use this power to ease their way through some aspects of their experience: decision making, surgery, recovery, and communication with loved ones about these stages. However, my role as liaison/witness is often complicated if not thwarted by feelings of shame on both ends of any communication. Many abortion patients are unwilling to share their abortion experiences with others, even when I assure them that doing so would be profoundly helpful. Numerous patients tell me that they never knew anyone who had an abortion; this is statistically unlikely. In fact, many a young patient's mom has confided in me that she too had had an abortion years earlier. Often, these apparently loving and supportive mothers will

say, "I wish I could tell her, so she would know she wasn't alone," but they seldom do, despite my urging. One mother said, "I just can't. She would be so disappointed in me." I recognize that in writing about these mothers' shame or embarrassment I risk seeming judgmental of them. I do not intend to blame but, rather, to testify to the tragedy of their socially inflicted shame and how it overpowers their desire to support their daughters. I do so to point out how these loving mothers' social silencing ultimately reinforces the shame and secrecy that surround abortion in the United States.

The second reason I am nervous about witnessing to abortion is also related to the issue of the confidence my patients put in me. As Moor explains, caregiving surrogate witnesses might "extend [the] socio-medical gaze (and ear) onto the patients' broader lives" (2003, 226). A caregiver's testimony, Nettleton worries, might unintentionally further subject patients to the vast "web of medical power and surveillance" (qtd. in Moor 2003, 226). For abortion patients, whose experiences are circumscribed by concerns about privacy and political discord, this sur-veilling gaze would be particularly problematic. Tal's view concurs and extends Moor's and Nettleton's. Tal argues that "it is a short step from empathy to appropriation, and health professionals should monitor themselves carefully for signs that they are replacing survivors' stories and testimonies with their own narratives" (1996, 220).

The third reason it feels risky to me to write about abortion in the context of witnessing is that I do not want to imply that abortion is an atrocity. Although the trope of witnessing is imbricated with experi-ences of trauma, abortion is not trauma, in and of itself. My experiences as both abortion patient and provider demonstrate that abortion does not, by definition, victimize women, although of course there are women whose abortion experiences are traumatic, and their stories must be heard and respected. In the public domain, pro-choice abortion narra-tives are particularly rare; an online search reveals hundreds of abortion "horror stories" and poems attributed to women who regret their abor-tions and only a few sites dedicated to pro-choice narratives.[3] In spite of this dearth, abortion providers have not typically responded by becom-ing surrogate witnesses, perhaps because many of us use our activist time fighting reduced access and providing abortion services. Still, perhaps we need to run the risk and witness to the ubiquity of nontraumatic abor-tion. This is part of why I am writing this essay.

The fourth reason it feels risky to testify to "the things we cannot say" is that my testimony might be appropriated by antiabortion interests. What if opponents of abortion took my words and used them against my patients? What if they read my admission that many women have multiple abortions or fail to use contraceptives as evidence that women use abortion cavalierly, thereby concluding that it should be illegal? I acknowledge that these responses are possible, and I am prepared to take responsibility for them. The risk feels minimal because these arguments are already deployed to justify antiabortion laws and regulations. For example, the law about which I testified in federal court imposed on women aborting in Ohio a twenty-four-hour waiting period with informed consent given in a face-to-face visit with a physician. On the surface, this law seems perfectly reasonable: certainly I should consult with a physician before undergoing surgery. What most observers did not realize is that Ohio already had a twenty-four-hour informed-consent law, a law which allowed women to obtain the required information via videotape or audiotape, thus providing women who were several hours from the closest clinic with a way to obtain abortions without incurring additional expenses for travel or child care and without drawing attention to their decision. The passage of a second law regulating that the consultation be in person implies that women approach abortion decisions casually and must be forced to think them through. I am willing to testify to the full reality of abortion practices in the Unites States, thereby running the risk of potential appropriation by antiabortion forces, because "to *not* put the experience in words will not make it go away" (Kacandes 2001, 140). Rather than continue to allow "horror stories" to shape the discourse of abortion advocacy, I want to remember—and testify—that, as poet Judith Arcana writes, "Abortion is, in the ordinary motherhood-type way, the concern of women who are taking responsibility for the lives of their children" (1994, 160).

CONCLUSION: HEALING DISCOURSES

Next to the words "reason for having an abortion," the patient has written, "I'm not responsible enough for a baby." I ask how she came to her decision. She launches into a story, which I paraphrase:

> After my first abortion when I was eighteen, I felt like a total
> failure. My parents were supportive, but I knew I had let them

down. My boyfriend turned out to be a real loser—not dad material, you know?—so after I told everybody and dropped out of school to be a mother (giving up an athletic scholarship), I ended up getting an abortion anyway. This time, no one knows except my fiancé. It was his idea, really. He's starting grad school in the fall, and he says we need to live our own lives before we try to support another one. But then I got to thinking: I'm only twenty. I could go back to school. I was a good student, loved science. I'd like to be a nurse. So I've decided to make this abortion the next step in getting myself back on track. I'm in a good relationship; I'm not disappointing anybody. I'm going to feel good about this and move forward with my life. This probably sounds weird, but I'm almost glad I got pregnant.

This patient's reported reason for choosing to abort her pregnancy is one of the two most common reasons given by women in the United States: "not ready for responsibility" (AGI 2005). Clearly, though, this women views her second abortion as a step toward responsibility to and for herself. MariAnna explains that women's abortion stories "function in two seemingly conflicting ways: first, to reaffirm certain cultural narratives; second, as a commentary on our social environment and the cultural scripts into which women are cast" (2002, 121). In this patient's story I hear the tension between self-determination (*I'm going to feel good about this and move forward*) and the cultural scripts that define a woman's proper place in a heteronormative relationship (*his idea, really . . . he says we need to live our own lives*). Although this young woman is telling me her individual story, the situation to which I am witness is a social one, defined and reified by cultural narratives of "heterosexuality, romance, motherhood, reproduction, family, and acceptable norms of female identity and behavior" (MariAnna 2002, x). That this patient's empowerment is enabled by the silence surrounding her abortion (*no one knows. . . . I'm not disappointing anybody*) indicates that individual empowerment does not guarantee freedom from cultural narratives that work to define and shame her. That kind of freedom comes only through social change.

Kacandes, following Judith Herman, Martha Minow, and others, notes that witnessing and cowitnessing to social violations can be valuable, even in the absence of "any personal psychotherapeutic healing" because the process of analysis that accompanies cowitnessing compels us

to recognize a trauma(-tization) that, "precisely because it has yet to be fully witnessed . . . still exist[s]" (Kacandes 2001, 135). I understand this to mean that even if my witnessing to this patient's turn toward self-determination does nothing to help her honor her abortion experience and her life goals in (spite of) a patriarchal social system, I will still be a successful witness if my reader-cowitnesses receive my narratives and, in turn, witness to others about "the things we cannot say" (paraphrasing Kacandes 2001, 140). Thus, together, we all may "broaden the scope of the possible . . . and allow for a wider range of responses" (Taylor 1997, 265) to contemporary abortion politics. I am hopeful that my resolution to testify to the most common reasons women decide to abort will inspire others to recognize and counter the ongoing trauma-tization of abortion in the United States. Can I get a witness?

ACKNOWLEDGMENTS

Sincere thanks is owed to Irene Kacandes and Kathryn Abrams for their support and editorial suggestions and to two anonymous *WSQ* readers, whose responses both encouraged and challenged me to make this essay better.

JEANNIE LUDLOW is a lecturer and an undergraduate coordinator in women's studies at Bowling Green State University and a patient advocate at the Center for Choice in Toledo, Ohio.

NOTES

1. For an examination of grief after abortion and its relationship to the fetal body, see my "Sometimes It's a Child *and* a Choice" (2008).

2. I do not intend to analyze the impacts of antiabortion discourse on patients; there are many feminist/progressive analyses that accomplish this, including Solinger 2001; Mason 2002; Saletan 2004; Feldt and Fraser 2004; and Jacob 2006.

3. See www.imnotsorry.net, which invites "positive abortion experiences"; www.4exhale.org, which offers pro-choice postabortion counseling and e-cards; and the recently closed www.heartssite.com, which invited people to speak "from the heart" about their abortions.

WORKS CITED

Alan Guttmacher Institute (AGI). 2005. "An Overview of Abortion in the United States." http://www.agi-usa.org/presentations/ab_slides.html (accessed May 9, 2007).

Arcana, Judith. 1994. "Abortion Is a Motherhood Issue." In *Mother Journeys: Feminists Write About Mothering*, edited by Maureen T. Reddy, Martha Roth, and Amy Sheldon. Minneapolis, Minn.: Spinsters Ink, 159–65.

Bazelon, Emily. 2007. "Is There a Post-abortion Syndrome?" *New York Times Magazine*, January 21. http://www.nytimes.com/2007/01/21/magazine/21abortion.t.html (accessed January 26, 2007).

Bernard-Donels, Michael, and Richard Glejzer. 2000. "Between Witness and Testimony: Survivor Narratives and the Shoah." *College Literature* 27(2):1–20.

Clinton, Hillary. 2005. Remarks by Senator Hillary Rodham Clinton to the New York State Family Planning Providers, 24 January. http://clinton.senate.gov/~clinton/speeches/2005125A05.html (accessed May 9, 2007).

Feldt, Gloria, with Laura Fraser. 2004. *The War on Choice: The Right-Wing Attack on Women's Rights and How to Fight Back*. New York: Bantam Books/Random House.

Jacob, Krista, ed. 2006. *Abortion Under Attack: Women on the Challenges Facing Choice*. Emeryville, Calif.: Seal Press/Avalon.

Kacandes, Irene. 2001. "Testimony: Talk as Witnessing." In *Talk Fiction: Literature and the Talk Explosion*. Lincoln: University of Nebraska Press, 89–140.

Lane, Penny. 2005. *The Abortion Diaries*. Self-produced documentary short. www.theabortiondiaries.com.

Ludlow, Jeannie. 2008. "Sometimes It's a Child *and* a Choice: Toward an Embodied Abortion Praxis." *NWSA Journal* 20(1)26–50.

MariAnna, Cara. 2002. *Abortion: A Collective Story*. Westport, Conn.: Praeger/Greenwood.

Mason, Carol. 2002. *Killing for Life: The Apocalyptic Narrative of Pro-life Politics*. Ithaca: Cornell University Press.

Moor, Katrien De. 2003. "The Doctor's Role of Witness and Companion: Medical and Literary Ethics of Care in AIDS Physicians' Memoirs." *Literature and Medicine* 22(2):208–29.

Rukeyser, Muriel. 1968. "Käthe Kollwitz." In *The Speed of Darkness*. New York: Random House, 99–105.

Saletan, William. 2004. *Bearing Right: How Conservatives Won the Abortion War*. Berkeley and Los Angeles: University of California Press.

Solinger, Ricki. 2001. *Beggars and Choosers: How the Politics of Choice Shapes Adoption, Abortion, and Welfare in the United States*. New York: Hill and Wang/Farrar, Straus and Giroux.

Tal, Kali. 1996. "Comment: The Physician as Witness: A Response." *Literature and Medicine* 15(2):217–20.

Taylor, Diana. 1997. *Disappearing Acts: Spectacles of Gender and Nationalism in Argentina's "Dirty War."* Durham: Duke University Press.

NOU MANDE JISTIS! (WE DEMAND JUSTICE!): RECONSTITUTING COMMUNITY AND VICTIMHOOD IN RABOTEAU, HAITI

CHRISTINE CYNN

On November 9, 2000, sixteen of twenty-two defendants were convicted in Gonaïves, Haiti, for their participation in an April 1994 massacre at Raboteau, a poor seaside community in Gonaïves. A week later, thirty-seven more defendants were convicted in absentia, including the leaders of the 1991–94 military dictatorship, which followed a military coup, and the heads of the paramilitary group FRAPH (Revolutionary Front for Haitian Advancement and Progress, later renamed the Revolutionary Armed Front for the Progress of Haiti). The United Nations lauded the Raboteau trial as a "landmark," the "longest and most complex [trial] in Haiti's history," and "a huge step forward" for the Haitian justice system (United Nations Commission on Human Rights 2000). Scholars have also described the Raboteau trial as the most important human rights trial in Haiti (Farmer 2005, 80) and "the single successful attempt to partially cleanse the country of the terror of the 1991 coup d'état" (Fatton 2002, 155).

During the trial, two massacre survivors, Rosiane Profil and Deborah Charles, provided some of the most spectacular testimony for the prosecution, their eyewitness descriptions of the events on the day of the massacre and the display of their dramatically visible scars compelling counterevidence against defendants' accounts of the massacre. Their testimony also buttressed the prosecution's contention that the junta violently attacked the entire community as part of their campaign of systematic political repression. Drawing from research for a documentary on the trial that I coproduced, in this essay I examine the women's court testimony alongside alternative, communal testimony, especially in protest songs circulating in less authorized sites: demonstrations, sit-ins, and commemoration marches (Cynn and Hirshorn 2003). I argue that

[*WSQ: Women's Studies Quarterly* 36: 1 & 2 (Spring/Summer 2008)]

failing to supplement Charles and Profil's gendered representation as "political innocents" in the official record with this alternative testimony risks reinforcing the gendering of the women as passive and helpless individual victims, ignoring the radical dimensions of their claims, and reproducing the violent erasures that the women sought to resist.

Haitian women had participated in the revolution and occasionally had been targets of state violence, but prior to the Duvaliers' regime (1957–86) they were regarded, like children and the elderly, as dependents—political innocents subject to special protection (Trouillot 1989, 166–67). Not permitted to vote until 1950 and classified as legal minors until 1979, women contributed to the nation as reproducers of male national subjects, as mothers and wives, with legal marriage and economic dependence on husbands operating as markers of class and social status that were closely linked with national identity (Schiller and Fouron 2001, 134–35). Violence instituted by François Duvalier during his 1957–71 dictatorship transformed social and family relations and redefined conceptions of women as "political innocents." Women were no longer protected *qua* women from state repression, but subjected to indiscriminate gendered violence—rape and sexualized torture—in retribution for their own political activism, as well as that of their male relatives and acquaintances (Trouillot 1989, 166–67; Charles 1995, 139). The system of violent repression and terror implemented by Duvalier and his paramilitary force, the Tonton Makout, has become emblematic; in the context of Africa, Achille Mbembe uses the term "tonton makoutization" to index the excesses of corruption and coercion of "new institutions charged with administering violence" to found or shore up authoritarian regimes (2001, 83).

However, as Carolle Charles argues, Duvalierist violence directed against women had the paradoxical effect of politicizing women. Duvalierism effectively suppressed any independent women's movement, but Haitian women who were exiled in the diaspora formed organizations influenced by anti-imperialist struggles and the North American women's movement (1995, 140, 146–47). Radicalized poor women led food riots in 1985 and linked with Catholic priest Jean-Bertrand Aristide's Ti Kominotés Légliz (TKL, base ecclesial communities derived from Latin American liberation theology) in a growing opposition movement that eventually forced self-proclaimed "President for Life" Jean-Claude Duvalier into exile in 1986. After Duvalier's departure,

women returning from exile organized with rural and urban women for participatory democracy. Most of these groups united in the Lavalas (the name of Aristide's political party, meaning "flood") movement that elected Aristide president with 67 percent of the vote in 1990, in Haiti's first free and fair elections (Charles 1995, 139–40; Fuller 1999, 42–43; Gammage 2005, 763).

On September 30, 1991, barely eight months after Aristide's inauguration, a military coup headed by General Raoul Cédras overthrew Aristide. Coup leaders Cédras and Philippe Biamby and many of their associates were former Duvalierists, and they reproduced the repressive tactics from the Duvalier period, including the creation of the paramilitary group FRAPH, which puns on the verb "to hit" in Creole. The Armed Forces of Haiti (Forces Armées d'Haïti, or FAD'H) and FRAPH repeatedly directed attacks against Aristide supporters, in both Port-au-Prince and outlying provinces. In this essay I focus on just one site of repression: Raboteau.

In 1995, after his return to Haiti, Aristide established a new legal structure to investigate the most notorious murder cases, including the Raboteau massacre (Stotzky 1997, 138). Four different examining judges (*juges d'instruction*), with the support of an international team, took four years to finally issue an ordinance (*ordonnance*) detailing charges for the Raboteau massacre, and the trial did not open until a year later, on September 29, 2000, and when it did, it took place in a tent outside the courthouse, since the courtroom was too small. For the Haitian government, the Raboteau trial represented a trial of the entire coup leadership and judgment of the crimes committed during its rule and was widely publicized as such.[1] By conducting a national trial rather than deferring to an international prosecution, the state further sought to demonstrate its commitment to judiciary reform and to ending the long history of impunity in Haiti (Concannon 2001, 341; 2000, 11).

In the ordinance for the Raboteau massacre, the examining judge challenged the military coup dictatorship's narrative of what had taken place on April 18 and April 22, 1994, in Raboteau. In an April 26, 1994, press release, the FAD'H had contended that on April 22, 1994, a group of Raboteau activists and Aristide supporters, led by Amio Métayer, had mounted an armed terrorist attack on a military post. According to the press release, the military had shot at Métayer and his followers as they tried to flee in a boat across the water (République d'Haïti 1999, 37).

Contradicting this account, the ordinance asserted that the military and paramilitary had conducted "a military action directed against a civilian, unarmed population" on both April 18 and April 22, 1994, collectively referred to as the Raboteau massacre. During the two attacks, the FAD'H and FRAPH beat, tortured, and shot local residents and burned down their homes. To destroy evidence of the massacre, they hid the bodies of nine people killed during the attack by burying them in a shallow common grave (République d'Haïti 1999, 39–40). According to the ordinance, the army and paramilitary were not responding to a terrorist attack but seeking "to destroy all popular resistance [*résistance de la population*] to the September 30, 1991, military coup d'état and force supporters of President Jean Bertrand Aristide [*contraindre cette population liée au Président*] to abandon their struggle for a return to constitutional order" (my translation, République d'Haïti 1999, 91, 99). By showing that the massacre was part of a nationwide campaign of political repression directed against unarmed civilians, the prosecution sought to hold both individual military and FRAPH members, as well as the military high command, accountable for the massacre (République d'Haïti 1999, 37, 52, 60).

During the trial, a contradiction emerged between depictions of Raboteau as a community of heroic pro-Aristide activists and a community of political innocents whom the army and paramilitary had targeted in violent retribution for the actions of a few of its residents. Prosecution attempts to hold the junta accountable for its Duvalierist repressive tactics reinforced the gendered category of "political innocent" to mediate the contradiction between the community characterized simultaneously as heroically politically resistant and as innocent/passive. According to the examining judge, Raboteau was known for its political activism and its radicalism (*réputation révolutionaire*); it instigated the mass protests against Jean-Claude Duvalier in November 1985 that spread to the rest of the country and led to Duvalier's exile in February 1986. Of the popular neighborhoods that made up the base of Aristide's support, Raboteau in particular "played a primary [*primordial*] role" in Aristide's election and was the "stronghold par excellence" resisting the de facto regime installed after the 1991 coup (République d'Haïti 1999, 60). As former executive director of the International Civilian Mission in Haiti (MICIVIH) Colin Granderson testified, during a period in 1993, Gonaïves, where Raboteau is situated, continued to organize for Aristide's return despite constant violent reprisals: "Gonaïves was the only

place where the people and popular organizations had the courage to demonstrate publicly."

Veena Das has pointed out how violence against women and the discursive formations of that violence in the former Yugoslavia and the 1947 Partition of India underscored the extent to which the nation is imagined as masculine (Das 2000, 205). Similarly, trial representations of fearless resistance to the coup synecdochally figured Métayer and other male activists, such as Charles-Eddy Joseph, who also testified during the trial, as "Raboteau," itself a synecdoche for Gonaïves, effectively figuring pro-Aristide political activism in Raboteau, and Raboteau itself, as male. Women, the elderly, and children were thus marginalized from this masculine community of radical resistance and instead embodied Raboteau as politically innocent, literally asleep when the massacre began.

Male witnesses also testified to having been beaten and tortured during the massacre, but two female eyewitnesses and massacre victims, Rosiane Profil and Deborah Charles, were particularly important in establishing a narrative of the massacre, in buttressing charges of attempted murder, and in corroborating that the military and paramilitary had shot unarmed civilians. When questioned by a juror whether he had any proof documenting that "blood had been spilled in Raboteau," former MICIVIH executive director Granderson responded that bodies found afterward were "tangible proof," as were the surviving victims Charles and Profil. As Charles bluntly stated in an interview, as the only survivors with visible scars from bullet wounds, she and Profil "were the only proof to appear as people who were shot. The other people are dead" (interview with the author, February 22, 2001).

Aged twenty-one and nineteen, respectively, at the time of the massacre, Charles and Profil were referred to as "girls" (*jeunes filles* or *filles*) by the examining judge and by other members of the community (République d'Haïti 1999, 69, 74, 75, 77, 120). As such, they were by definition "unarmed civilians," the visible scars on their bodies directly contradicting the FADH's claims that military and FRAPH had shot at armed terrorists who had attacked a military post (République d'Haïti 1999, 85). As the embodiment of "the community" of unarmed civilians, differentiated from the community of political activists gendered as masculine, Charles and Profil further dramatically attested to the junta's campaigns of systematic violent repression against entire communities as retaliation against political opponents.

Such representations do not take into account that while women in Raboteau served mainly in supporting roles for male pro-Aristide activists, they did participate in the struggle to restore Aristide: Profil, for example, described taking part in pro-Aristide demonstrations and bringing food to the men who were *en mawanaj* (in marronage, or hiding) during the coup years (interview with the author February 22, 2001). They also occlude how the women had become politicized by their participation in organizing following the massacre—activism that had led to the trial itself. In her testimony, Profil in particular contests her figuring as political innocent and therefore excluded from the community of Raboteau, constituted as heroically resistant and male.

In her court testimony, Charles described how gunfire startled her and Profil awake. Through a window, she saw someone being beaten by a soldier and convinced Profil that they should run to the sea for safety. However, when she and Profil reached the shore, they encountered many more soldiers beating and shooting at residents. Charles boosted herself on the back of a chair to demonstrate how she was shot as she tried to lift herself into a boat: "I saw bullets here, bullets here, bullets here. Lots of soldiers. I was so shocked by the bullets that I let go of the boat like this. . . . April 22, 1994, I got shot three times as I was climbing into the boat." After her testimony, Charles lifted her skirt to her thighs to display the pocks where the three bullets had struck her legs.

Profil, in her testimony, similarly described how she awoke to the sound of gunfire and then fled with Charles to the sea, where she, too, was shot as she tried to climb into a boat: "I was hit by bullets. I will show you." Lifting her skirt above her underpants, Profil pointed at the deep scars from four bullet wounds on her upper thigh and ankles and displayed them to the judge and defendants seated in front of her and to her right. With her skirt still hoisted above her waist, she then walked to the jurors on her left, gave them copies of photographs she had had taken of her injuries, and turned to provide them a closer look. The display provoked intense response—the trial audience erupted, a juror uneasily gestured at her to lower her skirt, and the judge repeatedly rang his bell calling the courtroom, and Profil herself, to order.

Enjoined by the prosecution to embody "visible proof" of the massacre and of FAD'H's and FRAPH's Duvalierist techniques of mass reprisal, Profil refigured the vulnerability of the display of her gendered body. Her testimony upended her prior relationship to the military and

FRAPH as she displaced the shame and humiliation of her injuries and of their exposure onto the men who attacked her: "As soon as I entered the courtroom, they were looking at me, and they were very surprised to see me. That's when I looked at them and said: Yeah, it's me, Rosiane. After they saw that it was me, they couldn't even look up at me, and they all bent their heads over their knees. As you could see, after my testimony, I lifted up my skirt and showed them my scars, first to the *Makout*, then to the judge. [Former captain and commander of the Military District of Gonaïves] Castera [Cénafils] put his head down like this; he was ashamed to look at me" (interview with the author, February 22, 2001).

Serving as legal witness required Profil to exhibit her wounds as evidence; her body and its wounds graphically attested to the violence and suffering that the language, "I was hit by bullets" could not adequately convey. But the display of her scars as visible evidence of her victimization also subjected her body to the evaluative eyes of the courtroom and of her attackers, a process that potentially replicates the structures of violence that the trial was initiated to condemn.

During the coup years, as under Duvalierism, techniques of domination entailed surveillance and the military and paramilitary's exclusive claiming of the gaze. In her testimony, Profil both conformed to and exceeded the constraints of legal protocol to repudiate military authority. She exposed her wounds, but as a gesture of defiance compelling her attackers to look at and acknowledge what they had sought to deny. While previously Profil had been too terrified even to look at the symbols of military power, in the courtroom, her solidarity with political allies emboldened her to confront her attackers: "I just wanted to remind them of what they had done to me. . . . Back then, I couldn't dare look at Castera. . . . During military rule, whenever you passed by the army headquarters, the best thing to do was not to look, or run for your life. In the courtroom, I knew that I was with my people, so I took full advantage of the opportunity to express my feelings. I was with my people. I was with my friends, Lavalas people, not with the *Makout*. So I let it all out. We were together and strong as Lavalas" (interview with the author, February 22, 2001). As Profil declared, her affiliation with Lavalas, her belonging in a community constituted by its political solidarity and mobilization, enabled her testimony. Her confrontation with her attackers clearly indicated that if during the massacre she had been as politically innocent as the prosecution's case implied, she certainly was

no longer. However, Profil's intervention did not register in trial transcripts and did not transmit via radio, the principal mode of communication in Haiti. Significantly, Profil expressed her anger and defiance primarily through gestures, not through her verbal testimony, which further obscured the politicization that had made her testimony possible.

After the massacre, Charles and Profil became involved in the movement for justice and, along with other survivors, formed what they eventually called the Raboteau Victims' Association. Loosely organized with a shifting informal leadership, the association collaborated with a range of governmental and nongovernmental organizations, including the September 30th Foundation, an umbrella organization in Port-au-Prince that coordinated efforts to demand justice for coup violence. Profil underscored the importance of working with other organizations: "When it is the September 30th Foundation that is getting together, they send for us, and we go in force to support them, and when it is us who are organizing ourselves, we also send for them, and they come down to support us as well" (interview with the author, February 22, 2001). The foundation's protest tactics, which in turn influenced the association's, were inspired by the highly publicized Mothers of the Plaza de Mayo in Argentina, and the association used performative tactics similar to those of the Mothers: songs, marches, and a traveling photographic exhibit commemorating victims of the 1991–94 coup violence.

However, in contrast to the Mothers, the association did not organize around gender-based claims. During the coup years, humanitarian organizations in Haiti had identified violence against women as a human rights issue and focused on the junta's use of rape as a political weapon (Human Rights Watch/National Coalition of Haitian Refugees 1994; United Nations Commission on Human Rights 1994; Mission Civile Internationale en Haïti 1996; Fuller 1999, 44). After Aristide's return, the government was slow to implement its own recommendations for redress for victims of sexual violence, and women's groups such as Women Victims Mobilize (Fanm Viktim Leve Kanpe) and Coordination of Women Victims in Haiti (Coordination des Femmes Victimes d'Haïti) formed to demand response (République d'Haïti 1995, chap. 5; Fuller 1999, 45; Merlet 2001, 163–64). Whether women were sexually assaulted during the Raboteau massacre remains unknown; no woman reported such crimes after the massacre, but the difficulties attending reporting rape are widely acknowledged (United Nations Commission on Human

Rights 1994). In any event, as the examining judge noted in the ordinance, while the initial complaint listing all possible charges included rape, he decided to drop this charge, since it could not be substantiated (République d'Haïti 1999, 36, 80).

Women targeted during the Raboteau massacre who had not been subjected to rape as a political weapon (or who were unable to acknowledge that they had been) did not conform to the dominant paradigm of "women victims" constituted by humanitarian interventions and women victims' advocacy groups. The Raboteau Victims' Association provided an alternative forum in which they could participate in a political community constituted by shared victimhood inseparable from collective action. Prior to the 1991–94 coup years, activists identified as *militants* (activists); only later did they adopt the term *viktim* (victim) in their organizing efforts (James 2004, 131; 2003, 13). Although the shift in terminology might seem to signal a corresponding shift away from more radical politics, mobilizing under this category in Haiti must be read as deeply inflected by liberation theology and the Ti Kominotés Légliz. In the pro-democracy and social justice movements under and after Duvalierism, the historic marginalization and victimization of the poor in Haiti came to imply and entail not individual suffering and passivity but collective resistance that privileges the poor as the primary agents in the creation of a new social and economic order (Dupuy 2007, 80–81). Through their protest songs, association members affirmed this conception of victimhood as propelling political mobilization. In songs commemorating the dead, they asserted a communal identity that effaced gender differences among victims and declined to recognize a separate category of "women victims."

In one song, Raboteau victims identify themselves as such:

Call: I am already a victim! [*Mwen deja viktim deja!*]
Response: I am dying horribly, worthlessly! [*M'ap mouri mal o san valè!*]

The repeated call-and-response inserts the first-person singular into a responsive structure—a relation that affirms victimhood as shared. Paradoxically, the identification as victim, with its attending isolation and despair, enables its negation, as the assertion of communal victimhood becomes grounds to claim communal identity. The song was

chanted during commemorations for massacre victims that were also demonstrations for redress, and the lyrics convey this double valence. The singers resurrect the piteous voices of those killed during coup violence in the present perfect, but the "I" is doubled and then redoubled, referring also to individuals who form the collective marching, mourning the dead and remembering their own injuries to demand justice in all their names.

Another song sung in weekly protests identifies Raboteau activists as part of a genealogy of activism:

> We demand justice, help!
> The bunch of criminals, thugs, evildoers should be judged.
> They killed Ti Claude—we demand, we demand justice!
> They killed Jamè Dodo—we demand, we demand justice!
> They killed Diékivlé—we demand, we demand justice!
> We strongly demand justice! Help!
> The bunch of killers, thugs, evildoers, should be judged.
> Where is Guy Malary? We demand, we demand justice!
> Where is Antoine Izmery? We demand, we demand justice!
> Where is Jean Marie Vincent? We demand, we demand justice!

> *Nou mande jistis! Anmwe!*
> *Bann kriminèl, san manman yo, malfektè yo, fòk yo jije!*
> *Yo touye Ti Claude! Nou mande, nou mande jistis!*
> *Yo touye Jamè Dodo! Nou mande, nou mande jistis o!*
> *Yo touye Diékivlé! Nou mande, nou mande jistis!*
> *Nou fout mande jistis! Anmwe!*
> *Bann asasen, san manman yo, malfektè yo, fòk yo jije!*
> *Kote Guy Malary? Nou mande, nou mande jistis o!*
> *Kote Antoine Izméry? Nou mande, nou mande jistis o!*
> *Kote Jean-Marie Vincent? Nou mande nou mande jistis o!*

Before demanding justice for the murders of such internationally known supporters of Aristide as Minister of Justice Guy Malary, businessman Antoine Izméry, and peasant rights activist and priest Jean-Marie Vincent, the song refers by nickname to the Raboteau activists killed during the massacre, Claude Joseph (Ti Claude), Pierre Michel (Jamè Dodo), and Frédéric Léxéus (Diékivlé). By inserting these names, Raboteau

victims counter assertions, for example, by the administration of George Herbert Walker Bush in 1992, that only prominent Aristide supporters were targeted during the coup years (United States Department of State 1992, 421–27).

The improvised song also includes a verse linking the association with other victims of coup violence: "Where are the victims of Carrefour-Feuilles? . . . of Raboteau? . . . of Cité Soleil?" These verses identify the *san non*, those without a name—or the poor majority—alongside nationally and internationally publicized victims to challenge their erasure from history and establish continuities not only between the well-known Aristide supporters and Raboteau activists but also between victims of coup violence across the country. Through the song, association members lament the dead but respond to their own question, "Where are the victims of Raboteau?" They march and sing, claiming victimhood that also lodges protest, compelling responses from their auditors through the appeal that is also an imperative: "Help!"

Another song recording and disseminating the community's narrative of the massacre reiterates the conception of community as articulating resistance through their victimization:

> April 22nd: we can't forget it.
> The people of Raboteau were fast asleep.
> The sound of gunfire woke them up.
> Lots of people ran to the sea.
> Military and FRAPH looted and smashed the neighborhood.
> They turned our butt skin into drums!
> Many people went into marronage.
> April 22nd is a day we can't forget.

> *22 avril nou pap sa bliye-l.*
> *Moun Raboto te nan dòmi.*
> *Lè koud zam te vin reveye n.*
> *Anpil moun te pran lanmè.*
> *Militè ak Frap tap kraze brize.*
> *Po dada nou te tounnen tanbou!*
> *Anpil moun te nan mawon.*
> *22 avril nou pap sa bliye-l.*

The song narrates and commemorates the massacre from the perspective of the community, refusing distinctions between male activists and female innocents or the conflation of victimhood with passivity as it figures the community as "the people" both "fast asleep" and resistant. The song, like the trial, offers a revisionist account of the military's account after violence inflicted during the massacre, humorously, irreverently refusing victimhood even as it claims it.

The line about the butts transformed to drums could be read in the context of what Elizabeth McCalister identifies as *betiz*, vulgarity or obscenity, that she argues borrows from Papa Gede, a Voudou figure who links sex with satire. As she argues, in *rara* music *betiz* is the only forum for the *ti nèg* (literally the "small black person," someone outside the circuits of social, political, and economic power, explicitly racialized as black) publicly to express political commentary and critique; further, *betiz* "opens a philosophical space for opposition and rejection of the suffering of the world through laughter" (McAlister 2002, 61). As an example of *betiz*, the reference to butts transformed into drums highlights the suffering of Raboteau massacre victims but, often accompanied with a laughing gesture, simultaneously minimizes and rejects it. The line also transforms that suffering into a coded affirmation of political allegiance.

After Aristide announced his unexpected candidacy in the 1990 presidential elections, the American ambassador to Haiti, Alvin Adams, in a speech assured Haitians that the United States would support whichever candidate was elected but concluded his remarks with a proverb (or *pwen*) emphasizing the problems that would remain after the elections: "After the dance, the drum is heavy [*Apre bal, tanbou lou*]" (Richman 1990, 120–21). Aristide responded with another proverb, which became Lavalas's unofficial campaign slogan: "With many hands, the burden isn't heavy" (*Men anpil, chay pa lou*), which also alluded to a Boukman Eksperyan song that critiques, without ever explicitly referring to, Prospère Avril's government: "They gave me a burden to carry / I'm not going to carry it. . . . The burden is too heavy! [*Yo ban m chay la pote/ M pa sa pote l. . . . Chay-la lou wo!*]" (Averill 1997, 180–81). As Gage Averill observes, some Haitians began to call Aristide by the nickname "Ambassador Heavy Drum [*Ambasadè Tanbou Lou*]" (1997, 188). The reference to butt skin being turned into drums, then, might be read as a coded expression or *pwen* of political support and of defiance that like marronage (*mawonaj*) is enabled by the very violence that sought to repress it.

The term "marronage" initially referred to slaves who had escaped their bondage individually or collectively by hiding in the mountains or other remote areas or in urban centers (Fick 1990, 51). As Averill notes, the term continues to be used in a wide variety of contexts "to refer to the unspectacular, but very patient and often-successful, tactics used by the politically and economically powerless in Haiti to carve out a space for autonomous existence and to undermine the strategies of those with power and money" (1997, 8). Flight or hiding from the military and FRAPH attack, then, is characterized as a tactic simultaneously undermining or resisting violent repression, to go into marronage. The song defines the community through shared memory and trauma, its performance simultaneously narrating and itself enacting the transformation of the violence of the massacre, the drumming of beatings, into the song sung in demonstrations and marches demanding justice for the Raboteau massacre and reaffirming support for Aristide. Put another way, the song could be read as an expression and example of *mawonaj* constituting the Raboteau community through its coding of protest.

Although the association did not assert explicitly gendered claims, it articulated demands of central concern to its women members. It called for justice in the form of a trial of the men who attacked Raboteau, but also in the form of food, homes, jobs, money for medical expenses, and schooling for children. The group demanded a transformation of the prebendary or predatory state, from an instrument of the elite that historically facilitated extraction of surplus from the poor to a vehicle of economic redistribution (Dupuy 1997, 21–22; 2007, 25–26; Fatton 2002, 51). The association vigorously engaged with the contradictions inherent in its position. The victims demanded justice from a state that had never served their interests. Yet the protests, which began after Aristide's return, were directed at Aristide's Lavalas government and at his successor, René Préval. The association therefore demanded justice from the same government that, during the coup years, its members had been victimized for upholding. It was, then, at the same time demonstrating against the coup dictatorship and against any attempt to overthrow Aristide and his government. The protests for justice implicitly articulated support for Aristide and for Lavalas and, more explicitly, a refusal to accept the systematic economic and political disenfranchisement of the poor, even as they reminded Aristide of the sacrifices his supporters had made to enable his return. The association's appeal to a weak, impoverished state relied

on the future promise of a state that would be capable of response.

In the prosecution's case at the Raboteau trial, Charles and Profil embodied female unarmed civilians, political innocents attacked during the massacre in reprisal for the militant activism of male leaders. These gendered representations obscured the political organizing work that had made Charles's and Profil's testimonies and the trial itself possible. Delinking from the category of "women victims" as it circulates in humanitarian interventions and women victims' groups, women in the association asserted an alternative conception of community through shared victimhood that, while not immediately legible as feminist, served as the foundation for women's involvement in political organizing. As Profil said in an interview: "When I say justice, I mean justice for all, not just for me, because I could never ask justice just for myself, since there were many other victims besides me" (interview with the author, February 22, 2001).

I close by reiterating the importance of attending to sites of knowledge and history that do not register in the official record. That demonstrations in Gonaïves led to Aristide's exile in 2004, that the men imprisoned for their crimes during the massacre escaped from prison shortly thereafter, and that the Raboteau verdict has since been vacated do not negate the force of association efforts (Amnesty International 2005; Institute for Justice and Democracy in Haiti 2005). I would argue that these events only emphasize the importance of thinking through the effects of how forms of gendering are strategically deployed or elided in attempts to obtain justice both in and outside the courtroom.

ACKNOWLEDGMENTS
I am grateful to the editors of this volume, Jacqueline Bhabha, and anonymous reviewers for their productive comments. Susan Caskie, Brian Concannon, and Lisa Estreich contributed invaluable editing assistance. Special thanks to Deborah Charles and Rosiane Profil.

CHRISTINE CYNN is an Andrew W. Mellon Postdoctoral Fellow in women's studies at Barnard College. She was the coproducer of the documentary *Pote mak sonje: The Raboteau Trial* (2003) and coproducer, director, and editor of the short video *Al teste! Sida pa diskrimine* (2005). She is currently working on a documentary with women living with HIV in Côte D'Ivoire, where she was a Fulbright lecturer/researcher from 2005 to 2006.

NOTE

1. According to Michelle Karshan, a spokesperson for President René Préval, "This trial is not only that of major human rights offenders. It is the trial of the coup d'etat [*sic*] itself and of its atrocities" (qtd. in Norton 2000). According to former justice minister Camille Leblanc, the trial "revealed the role of the army high command in the massacre. In this sense, it was the trial of the coup d'etat [*sic*]" (qtd. in Auguste 2000). Cédras was among those convicted in absentia for his role in overseeing the Raboteau massacre, as were the head of the High Command Biambi; former chief of police and third in command Michel François; and FRAPH founder and leader Emmanuel (Toto) Constant.

WORKS CITED

Amnesty International. 2005. "Haiti: Obliterating Justice, Overturning of Sentences for Raboteau Massacre by Supreme Court Is a Huge Step Backward." May 26. http://web.amnesty.org/library/Index/ENGAMR360062005.

Auguste, Marie-Andre. 2000. "Coup Leader, Army Officers Given Life in Prison for 1994 Haitian Massacre." Associated Press. November 16.

Averill, Gage. 1997. *A Day for the Hunter, a Day for the Prey: Popular Music and Power in Haiti*. Chicago: University of Chicago Press.

Charles, Carolle. 1995. "Gender and Politics in Contemporary Haiti: The Duvalierist State, Transnationalism, and the Emergence of a New Feminism (1980–1990)." *Feminist Studies* 21(1):135–65.

Concannon, Brian, Jr. 2000. "Justice in Haiti." *Human Rights Tribune* 7(4):11–15.

———. 2001. "Justice for Haiti: The Raboteau Trial." *International Lawyer* 35:641–47.

Cynn, Christine, and Harriet Hirshorn, prods. 2003. *Pote mak sonje: The Raboteau Trial.* Independently distributed video.

Das, Veena. 2000. "The Act of Witnessing: Violence, Poisonous Knowledge, and Subjectivity." In *Violence and Subjectivity*, edited by Veena Das et al. Berkeley and Los Angeles: University of California Press, 205–25.

Dupuy, Alex. 1997. *Haiti in the New World Order: The Limits of the Democratic Revolution*. Boulder: Westview Press.

———. 2007. *The Prophet and Power: Jean-Bertrand Aristide, the International Community and Haiti*. Rowman and Littlefield.

Farmer, Paul. 2005. *Pathologies of Power: Health, Human Rights, and the New War on the Poor*. Berkeley and Los Angeles: University of California Press.

Fatton, Robert. 2002. *Haiti's Predatory Republic: The Unending Transition to Democracy*. Boulder: Lynne Reinner.

Fick, Carolyn E. 1990. *The Making of Haiti: The Saint Domingue Revolution from Below*. Knoxville: University of Tennessee Press.

Fuller, Anne. 1999. "Challenging Violence: Haitian Women Unite Women's Rights and Human Rights." *Association of Concerned African Scholars Bulletin: Women and War* 55/56:39–48.

Gammage, Sarah. 2005. "Exercising Exit, Voice, and Loyalty: A Gender Perspective on Transnationalism in Haiti." *Development and Change* 35(4):743–71.

Human Rights Watch-National Coalition of Haitian Refugees. 1994. "Rape in Haiti: A Weapon of Terror." (6):8. http.www.nchr.org/reports/rape_in_haiti_ 1994.pdf.

Institute for Justice and Democracy in Haiti. 2005. "Legal Analysis of Raboteau Trial Reversal." June 6. http://www.idjh.org/articles/article_recent_news_6-06-05-c.htm.

James, Erica. 2003. *The Violence of Misery: "Insecurity" in Haiti in the "Democratic" Era.* Ph.D. diss., Harvard University.

———. 2004. "The Political Economy of 'Trauma' in Haiti in the Democratic Era of Insecurity." *Culture, Medicine and Psychiatry* 28(2):127–49.

Mbembe, Achille. 2001. *On the Postrolony.* Berkeley: University of California Press.

Merlet, Myriam. 2001. "Beyond Love, Anger and Madness: Building Peace in Haiti." In *The Aftermath: Women in Post-Conflict Transformation*, edited by Sheila Meintjes, Anu Pillay, and Meredith Turshen. London: Zed Books, 159–71.

McAlister, Elizabeth. 2002. *Rara! Vodou, Power, and Performance in Haiti and Its Diaspora.* Berkeley and Los Angeles: University of California Press.

Mission Civile Internationale en Haïti. 1996. *Haïti: Droits de l'homme et rehabilitation des victims.* http://www.un.org/rights/micivih/rapports/victime1.htm.

Norton, Michael. 2000. "Coup Leader, Former Soldiers Face Murder Charges in Haiti." Associated Press, September 30.

République d'Haïti. 1995. "Rapport de la Commission Nationale de Vérité et de Justice: Si m Pa Rele, 29 septembre 1991–octobre 1994." http://www.haiti.org/truth/chapit1.htm#Top.

———. 1999. "Ordonnance." August 27. www.ijdh.org/article/article_raboteau.htm.

Richman, Karen. 1990. "'With Many Hands, the Burden Isn't Heavy': Creole Proverbs and Political Rhetoric in Haiti's Presidential Elections." *Folklore Forum* 23(1–2):115–23.

Schiller, Nina Glick, and Georges Eugene Fouron. 2001. *Georges Woke Up Laughing.* Durham: Duke University Press.

Stotzky, Irwin. 1997. *Silencing the Guns in Haiti: The Promise of Deliberative Democracy.* Chicago: University of Chicago Press.

Trouillot, Michel-Rolph. 1989. *Haiti: State Against Nation: The Origins and Legacy of Duvalierism.* New York: Monthly Review Press.

United Nations Commission on Human Rights. 1994. "Situation of Human Rights in Haiti." A/49/513. http://www.unhchr.ch/Huridocda/Huridoca.nsf/0/b3358a1 b8c77b21e802566fa0050ac7a?Opendocument.

———. 2000. "Raboteau Verdict in Haiti." November 20. http://www.unhchr.ch/huricane/hurricane.nsf/NewsRoom? OpenFrameSet.

United States Department of State. 1992. *Country Reports on Human Rights Practices.* Washington, D.C.: U.S. Government Printing Office.

SUBVERSIVE WITNESSING: MEDIATING INDIGENOUS TESTIMONY IN AUSTRALIAN CULTURAL AND LEGAL INSTITUTIONS

ROSANNE KENNEDY

Like many other nations, Australia has been engaged in a painful reckoning with a shameful past. In the past fifteen years, questions concerning the removal of Indigenous children from their families, known as the "stolen generations," the extent of frontier violence, and whether genocide occurred in Australia have been central to the public controversy over how the story of "settlement" or "invasion" should be narrated. Testimony has played a crucial role in this confrontation with the past, as Indigenous Australians have been called upon to testify to past injustices and their continuing legacies in the present. In the 1980s and 1990s Aboriginal women pioneered the use of personal testimony in memoirs, bringing into visibility "forgotten" practices of child removal.[1] Aboriginal organizations such as Link-Up, which helps separated individuals locate family members, also published collections of "stolen generations" testimony (see, for instance, Edwards and Read 1989; Link-Up and Wilson 1997). It was not, however, until 1996, when the Human Rights and Equal Opportunity Commission (HREOC) conducted a National Inquiry into the policies, practices, and effects of removing children of mixed descent from their mothers and communities, to be forcibly assimilated into white Australian culture, that testimony achieved national prominence. In 1997, HREOC published its moving report, *Bringing Them Home* (Wilson 1997), which exposed the brutality, loneliness, and loss of family, identity, culture, and language that was experienced by children who had been removed. Although the report drew on international human rights law to argue, controversially, that child removal constituted cultural genocide, in foregrounding victim testimony, it participated in a global trend in which claims of historical injustice are articulated through personal stories of suffering.[2]

[*WSQ: Women's Studies Quarterly* 36: 1 & 2 (Spring/Summer 2008)]

In court, testimony is subjected to an adversarial process of cross-examination, which is meant to reveal whether the witness is reliable, and whether there are significant gaps or contradictions in the testimony, which may invalidate it. By contrast, semijudicial processes such as truth commissions and national inquiries tend to take a dialogic approach, in which to testify is "to *address* another, to impress upon a listener, to appeal to a community" (Felman and Laub 1992, 204). In this conception, "witness" refers both to the person who gives testimony and to the secondary witness who receives it. Listening and acknowledging the other's suffering and loss are crucial aspects of the testimonial exchange. In asking Australians to "listen . . . with an open heart and mind" to stories of Indigenous suffering and trauma, the *Bringing Them Home* report presented testimony as a dialogic process with social, political, historical, and ethical significance, rather than simply a matter of fact-finding (Wilson 1997, 3). Predictably, some conservative critics and journalists challenged the legitimacy of the testimonies on the grounds that witnesses were not subject to a judicial process of cross-examination.[3] The Australian public, however, responded to the call to bear witness, turning out in large numbers to express their regret by signing Sorry Day books, participating in reconciliation walks, and offering other symbolic gestures. As historian Robert Manne has noted, "No inquiry in recent Australian history has had a more overwhelming reception or . . . a more culturally transforming impact. . . . It soon seemed to many Australians that no historical question was of greater importance than the stolen generations" (2001, 5–6).

The National Inquiry held out considerable promise for the power of witnessing to heal Aboriginal individuals and communities, to unify the nation in confronting the past, and to contribute to the ongoing process of reconciliation. It also played a powerful role in legitimating Indigenous testimony as a significant historical and cultural form.[4] For instance, it recommended that the federal government provide funding to collect oral histories from members of the "stolen generations," their adoptive parents and carers, and patrol officers and missionaries. The resulting Bringing Them Home Oral History Project, housed at the National Library of Australia, constitutes an archive of more than three hundred testimonies and is drawn on by other cultural institutions. Today, "stolen generations" testimony circulates widely in museums and art exhibitions; in memoirs and autobiographies; on radio; in narrative and documentary

films; in song and theater; and in ephemeral but moving performances, when survivors tell their stories at events such as commemorations, book launches, and memorial openings. Memoirs such as Sally Morgan's *My Place* (1987), and Doris Pilkington's *Follow the Rabbit-Proof Fence* (1996), which appeared prior to *Bringing Them Home*, have been published in children's editions for use in schools. Philip Noyce's 2002 film, *Rabbit-Proof Fence*, brought the "stolen generations" into international circulation.

Although Indigenous testimony has been accorded visibility and legitimacy in the cultural sphere, it has not fared well in courts. The treatment of Lorna Cubillo's testimony in *Cubillo v. Commonwealth* (2000), a landmark test case litigated in the wake of the National Inquiry, provides insight into how testimony and memory are evaluated in law. Lorna Cubillo and Peter Gunner, who had been removed in the 1940s and 1950s respectively, sought compensation for wrongful imprisonment from the Commonwealth government. In a meticulous judgment, Justice Maurice O'Loughlin found that in Cubillo's case, there were "great gaps" in the evidence concerning the circumstances of her removal, and that in Gunner's case, the thumbprint of his mother on a form constituted "consent." He accepted some parts of Cubillo's testimony, but rejected others, commenting that she had engaged, however unwittingly, in "subconscious reconstruction"—that her memories of events were shaped by a narrative of child removal that had been developed long after the events. Although he advocated a "clinical" approach to testimony, "devoid of emotion," his judgment was inevitably shaped by subjective perceptions. For instance, he states that during the trial Cubillo became "progressively defensive, evasive and argumentative" (O"Loughlin 2000, paragraph 728). He speculates that she was unloved at the Retta Dixon Home, where she was placed as a child, not through any deficiency in the missionaries, but because of her difficult personality (paragraph 729).

Of course, the opposition between the cultural and legal sphere in Australia is gendered. Men and women work in both domains, but women dominate in cultural institutions, particularly as exhibition curators, whereas senior positions in the legal profession are still predominantly held by men. Moreover, the treatment of testimony in each sphere is governed by a gendered logic: whereas cultural institutions value personal stories and symbolic artifacts, which can be used to engage visitors, law favors an adversarial, impersonal approach to testimony. As the Cubillo case suggests, the law assumes that testimony can and should be

evaluated "objectively," and that an emotional response would compromise the process of judgment. Yet, as I argue, the limits and possibilities of witnessing in cultural and legal institutions may not be as predictable as this gendered opposition suggests. In cultural institutions, "unspeakability" may function as a limit that precludes certain stories from being told; in the legal sphere, however, litigants and their lawyers may find unexpected opportunities for witnessing to racism and other oppressions. To explore the framing, mediation, and reception of testimony, I compare nonlegal and legal texts and contexts, which may enable a clearer understanding of the diverse and sometimes contradictory roles cultural institutions and courts play in shaping and mediating testimony and in legitimating or discrediting it. This comparison may provide a more nuanced understanding of how the mediation of testimony in different contexts empowers or disempowers the witness. In the following section, I consider the framing and mediation of testimony in cultural institutions.

LEGITIMATING INDIGENOUS TESTIMONY: CULTURAL INSTITUTIONS

The dialogic approach to testimony that the National Inquiry promoted has, in the aftermath of *Bringing Them Home,* been adopted by many national and state cultural institutions.[5] For example, the Australian Museum in Sydney, which has a permanent exhibit dedicated to Indigenous culture and heritage, articulates and practices the principles that underlie a dialogic approach: working collaboratively with Indigenous people; having them tell and interpret their own stories; and positioning the visitor as a secondary witness. These principles are stated explicitly and performed throughout the exhibit. For instance, on the wall above a case displaying baskets woven by different Aboriginal groups, a plaque informs visitors that the museum works in collaboration with Indigenous communities to protect and promote Aboriginal cultural heritage. Another plaque, at the beginning of the exhibit on the "stolen generations," articulates the philosophy of the Aboriginal organization Link-Up: "Empowerment is the basis of our work. Empowerment means that as workers we acknowledge the person's experience and we respect their ability to make decisions about their needs and their healing process. They are the experts of their own experience."

Link Up's commitment to empowering the witness finds a strong parallel in Linda Alcoff and Laura Gray's feminist analysis of the dis-

course of sexual abuse survivors. They argue that this discourse could challenge dominant social and power structures by naming unthinkable categories such as "husband rapist" and "father rapist." When an expert mediator is called in, however, survivors' narratives are often "recuperated" to reinforce dominant social relations and power structures (1993, 282). To enable "subversive speaking," the role of the expert mediator must be eliminated or reconfigured, and the split between experience and interpretation must be abolished. Like Link-Up, they advocate the need to create speaking situations in which "survivors are authorized to be both witnesses and experts, both reporters . . . and theorists of experience" (282). When survivors interpret their own experiences, testimony and memory become "tools of intervention" rather than "instruments for recuperation," and may "alter existing subjectivities as well as structures of domination and relations of power" (282). The affinity between Link-Up and feminism's approach to empowering the witness to interpret his or her own experiences is evidence of the implicitly feminist and postcolonial frameworks that are operative in the Indigenous exhibit in the Australian Museum.

Link-Up's philosophy of empowerment is exemplified in the Australian Museum's "stolen generations" exhibit, which positions Indigenous people as interpreters of their own experience. The exhibit features the artwork of Indigenous artist Kevin Butler, who offers an interpretation of the child's experience of removal. In one of his paintings, Butler uses the metaphor of a maze, with many blind alleys and dead ends, to represent the feelings of confusion and disorientation that the removed child experienced. To simulate these feelings in the viewer, Butler's paintings are hung on the walls of a narrow maze through which visitors walk. In this exhibit, Butler testifies through the visual language of art, and museum visitors are positioned as secondary witnesses who receive the stories. Just under the Link-Up plaque, at the entrance to the maze, is a documentary video, in which Lola McNaughton, a case worker for Link-Up, and herself a member of the "stolen generations," explains that Butler's painting is a metaphor for the experience of removal. Her explanation is illustrated by the testimony of an elderly man, Alex Kruger, who describes being removed from his mother as an infant and not seeing her again until just before she died. Kruger's testimony is intercut with that of an elderly Indigenous woman, Wadjularbinna, who recalls going by train with her grandmother to deliver her older sister to

boarding school, as required by the authorities. She describes her grand-mother's distress when the authorities unexpectedly demanded that she, although only four years old, stay at the school as well as her older sister, and how grief stricken she was not to be able to say good-bye to her mother. In the video testimony, the Indigenous witnesses narrate and interpret their own experiences, and Butler's paintings constitute another frame of interpretation and mediation.

The interviews in the Bringing Them Home Oral History Project also exemplify a dialogic approach to testimony, in which the inter-viewer, who acts as an empathic listener rather than an interrogator, plays a crucial role in receiving, legitimating, and mediating the testi-mony. As Susannah Radstone points out, memory in oral history inter-views, as in other contexts, is mediated. Memory is shaped by the pur-pose and circumstances of the interview, the relationship between the interviewee and the interviewer, the questions the interviewer asks, and the interviewee's sense of the audience. The memories that emerge from the interview are typically "replete with absences, silences, condensa-tions and displacements that were related, in complex ways, to the dia-logic moment of their telling" (2000, 11). In the Bringing Them Home Oral History Project, interviews are shaped by the participants' under-standings of the historic significance of the project as an archival record of a previously untold history and of the ongoing realities of racism in Australia. Gaps and silences in the interviews reveal the difficulty of giv-ing voice to painful and intimate memories. Indigenous artist Pamela Croft's interview illustrates how testimony is shaped and mediated by the interviewer and interviewee at the moment of its telling.

Croft's story is unusual, in that she grew up with "two mothers"—her Aboriginal mother and her white adoptive mother. She was born in 1955 to an Aboriginal woman and a white man, who, respectively, were seventeen and twenty-two years old. Her father, a musician, did not want children. Her mother, inexperienced and poor, moved to Brisbane, where she often left Pamela in the care of an older fundamentalist Chris-tian white couple. Eventually, when her mother moved to Sydney and married a white man who did not want Pamela, the older couple adopted her, at the age of five. Her father reluctantly signed the papers; her mother signed in return for yearly visiting rights. Croft recalls that she and her Aboriginal mother "cherished" their visits and wrote to each other, "but it was very hard, very hard growing up having two mothers,

having to love them equally" (2000, 10). Croft, like many Aboriginal children adopted by white families, did not learn of her Aboriginal heritage until she was an adolescent. She was sufficiently "different" that she did not fit in at school, where she was the only Aboriginal child. As she narrates the story of her adoption, she sometimes cries quietly, and the tape is paused. This embodied, affective dimension—hearing Croft's voice and registering her emotions—is unsettling and makes the listener aware of the painful intensity of these memories.[6]

During the interview, Croft articulates the process of "working-through" that has enabled her to give her testimony. For example, on the second day, the interviewer asks her, "Is there anything that yesterday's discussion brought to mind that you would add to the tape?" She responds: "The things that I said and just how revealing I was in the last two tapes was very frightening to me. . . . I really do want to continue . . . but it's important to me too, that anyone who is listening to my story know . . . that there was a process that I had to go through to actually get to [record] those two taped sessions" (2000, 41). In this self-reflexive statement, Croft mediates her testimony by drawing attention to her long and painful struggle with issues of self-identity and cultural identity, and to the counseling process that eventually gave her the confidence to tell her story. Through such moments, she actively participates in shaping how her testimony will be received: she wants it to be heard not simply as a completed and narratable "story," but as an ongoing process that involves a struggle to recall, process, and voice painful memories.[7] Throughout the interview, Croft positions herself as an interpreter of her experiences, placing her life narrative in a historical context. She explains, for instance, how confusing it was when "the people who ended up bringing you up, you love them and it's very hard to believe that they were part of that stealing process" (69).

The Oral History Archive, which includes more than three hundred testimonies, offers a diversity of narratives of removal, none of which is positioned as representative. In the museum, where only a handful of testimonies can be presented, the issue of which story to transmit is politically and culturally significant, as museums contribute to the construction of a dominant and visible cultural memory of the "stolen generations." In cultural institutions, certain stories may be "unspeakable" because they do not conform to the dominant "stolen generations" narrative of traumatic separation, which typically features iconic scenes,

such as the violent or callous separation of mother and child, and the abuse, loneliness, and neglect the child suffered in alien and alienating institutions. There are good reasons to be wary. When Aboriginal leader Lowitja 'O Donoghue stated that her white father took his five children from their Aboriginal mother and gave them to Colebrook Home to be raised and educated by sisters, her revelation was immediately reinterpreted by conservative journalist Andrew Bolt, who claimed that she was not "stolen," but "rescued," and that her Western education had served her well.[8] Given this political context, in which stories may be recuperated for conservative political ends, curators face the problem of how to include testimony that does not conform to the dominant trauma narrative.

Jay Arthur, curator of a new exhibit on the "stolen generations" in the Gallery of First Australians at the National Museum of Australia, aims to introduce complexity into the dominant narrative. She has chosen, for instance, to present testimonies and objects that reveal how even those removed children who had relatively "good" childhoods in loving adoptive families nonetheless suffered an irreparable loss of culture, identity, and language. To this end, she has selected Pamela Croft's autobiographical artwork *Matters of the Heart* as a centerpiece of the exhibit. In this installation, Croft reveals fragments of her life story, one in which she is torn between two mothers and two cultures, through such documents as her adoption papers, her original birth certificate, her altered birth certificate, family photos, personal letters, wedding photos showing her marriage to a white man, and her divorce papers. To collect additional oral histories and material objects for the exhibition, Arthur traveled to the now abandoned site of a notorious home for Aboriginal boys with four men who had been raised there. Three of the men detailed the suffering, deprivation, and abuse they experienced at the home, but the fourth man, who asked to speak to her in private, told a different story. His experience at the home, he recalled, was "not so bad" in comparison with that of his prior life. Arthur explains the ethical and political dilemma she faced in deciding how to present his testimony without betraying the trust of the other men, who gave their testimony with the expectation that it would be used to convey the message that the home, and child removal, produced terrible suffering and had devastating consequences.[9]

While cultural institutions have played a significant role in legiti-

mating and circulating Indigenous testimony, legal courts have been cir-
cumspect toward such testimony. In the following section, I consider a
case for unfair dismissal brought by two Indigenous women who had
served as cultural heritage inspectors against Gavin Jennings, the Minis-
ter for Aboriginal Affairs for the state of Victoria. I analyze practices of
testifying and witnessing in the legal process, including in interactions
between the litigants and their lawyers.[10] This analysis suggests how wit-
nessing may occur in the legal process, even in instances in which the case
is ultimately lost.

SUBVERSIVE TESTIMONY: THE CULTURAL HERITAGE INSPECTORS CONTROVERSY

Vicki Nicholson-Brown and Ella Anselmi's cases against Gavin Jennings
originated from a controversy over the use of public space in Melbourne
during the high-profile Commonwealth Games in March 2006 (*Anselmi v.
Minister for Aboriginal Affairs* 2007, hereafter "Anselmi's case"). Aiming to
use international media coverage of the games to promote their protest,
a group of local Aborigines set up a temporary camp in Kings Domain
Park in central Melbourne. Adopting the acronym GST, for "genocide,"
"stolen children," and "treaty," the protestors lit a "sacred fire," engaged
in Aboriginal storytelling and dances, and encouraged visitors to learn
about Aboriginal cultures. Although the then Prime Minister John
Howard called "Camp Sovereignty" "the ugly face of reconciliation,"
locals and international tourists visited the site, and a number of letters to
the *Melbourne Age* expressed sympathy toward the camp.[11] After some of
the protestors refused to dismantle the camp at the end of the games, an
officer from Melbourne City Council served a "Notice to Comply,"
which required the protestors to remove the camp and extinguish the fire
by 4:00 PM on April 10, 2006. If they did not comply, the camp would be
removed and the fire extinguished. The protestors called on Nicholson-
Brown, a cultural heritage inspector whose area of expertise included
Melbourne, to protect the site.[12]

Appointed under Commonwealth legislation, Indigenous cultural
heritage inspectors had the authority to make "emergency declarations"
if a significant Indigenous cultural site was at risk of immediate destruc-
tion or desecration. On April 10, Nicholson-Brown issued an emergency
declaration to protect Camp Sovereignty, declaring, "The site of the
camp is of cultural significance to Aboriginal people from all parts of

Victoria as it is the burial site for ancestral human remains which originated from different parts of Victoria and were recovered from the Museum of Victoria and interred at the site in approximately 1985. A sacred fire was lit at Camp Sovereignty, which was of cultural and ceremonial significance in association with the burial site" (Nicholson-Brown 2006, 4–5). A sacred fire must be extinguished in accordance with Aboriginal customary rituals. By the time the emergency declaration expired one month later, a mutual agreement had been reached between the protestors and Melbourne City Council, and the fire was extinguished. Nicholson-Brown's declaration, however, precipitated a political storm.

The Melbourne City Council, the *Sun-Herald*, and speakers on talkback radio expressed outrage at Nicholson-Brown's decision. The federal (Liberal) Environment and Heritage Minister, Senator Ian Campbell, lambasted the Victorian government's handling of the case: "Your State Labor Government . . . has appointed an inspector who's not only a member of the Wurundjeri tribe, but as I understand it has actively been involved down at the site. . . . It's . . . absurd . . . to appoint an inspector who is . . . so close to the action" (Mitchell 2006). Apparently, Campbell did not realize that Nicholson-Brown, who had served since 1991, was appointed precisely because she was "close to the action"—that is, a member of a tribe with knowledge of local cultural heritage issues. As an Aboriginal woman who exercised her statutory authority to make a politically unpopular decision, Nicholson-Brown behaved in a way that several government officials apparently found challenging and disruptive. Despite representing opposing political parties, Jennings, the Minister for Indigenous Affairs for the state of Victoria, shared Campbell's view that Nicholson-Brown's emergency declaration was an inappropriate use of her authority. Shortly after her declaration, he suspended the appointment of the forty-eight cultural heritage inspectors and declared that the power to make emergency declarations would rest with him "until the new arrangements [were] in place" (Nicholson-Brown 2006, 5). The "new arrangements" referred to a new state law that was being drafted, which would require that cultural heritage inspectors be employed as public servants. He wrote to all the inspectors, asking them to show cause of why they should not be dismissed under the new law.

Ella Anselmi, a volunteer cultural heritage inspector for fifteen years, who had not been involved in the Camp Sovereignty controversy,

responded to Jennings. In writing directly to him, instead of going through a lawyer, she positioned herself as an "expert" on Indigenous cultural heritage matters. Yet whereas Jennings's letter, typed on ministerial letterhead, was backed by the authority of the state, Anselmi's handwritten letter positioned her as an "ordinary" person. Anselmi and Jennings had met many times, and Anselmi refused to allow Jennings to hide behind the mask of bureaucracy. In response to his impersonal address, Anselmi wrote a letter to Jennings in which she addressed him by his first name, adopting the tone of an elder scolding a child: "Gavin I am very disappointed that you ask me to prove why I should still be an inspector" (Anselmi n.d.). In signing her letter "Ella Anselmi, Woongie from the Yorta Yorta Nation," she positioned herself as a respected elder among her people. At the same time, her use of vernacular English bore witness to her status "outside" the government bureaucracy and contrasts sharply with the minister's instrumental voice. In telling him, "[I work] from my heart" and from "[my] hard life living in the bush running from welfare with my mother, brother and sisters," she rejected the masculine logic of government rationality and, instead, asserted an emotional, embodied connection to her role as a cultural heritage inspector. Drawing attention to his dismissive attitude toward her cultural knowledge and experience, she rhetorically asked whether he would treat a returned soldier—an iconic figure of white male Australian identity—in the disrespectful way in which he had treated her, an Indigenous female elder: "If I was in the army and got a medal would you come and ask for it back after 15 or 16 years?" In response, Jennings sent a form letter stating that he had decided to remove all inspectors who did not meet the new requirements. He stated that his decision was underpinned by a "change in policy," but added that the "community reaction" to the Camp Sovereignty controversy had "reinforced the need for inspectors to have . . . [the] oversight, training and support" that is available to public servants (Jennings 2006b).

In response to Jennings's second letter, Anselmi, speaking on behalf of her people, the Yorta Yorta Nation, explicitly took up the position of the witness, using testimony to bear witness to past and continuing racism in Australia. Refusing to accept Jennings's administrative justification for the changes, she introduced the history of racial inequality, government persecution, and disregard for Aboriginal knowledge and experience that have prevailed in settler colonial Australia. She asserted,

"I have never been a raciest [*sic*] person in my life and I don't like what happened to my ancestors. The Government people then did not want Aboriginal people at Cummergunja to get education, only allowed our people to get a grade three education" (Anselmi 2006b).[13] She contended that rather than respect Aboriginal knowledge, the government of today, like past governments, regarded Aborigines as a "problem" to be "managed": "Gavin I believe you are like the old Government years ago, because you are doing the same thing to us Aboriginal people today by trying to stop us looking after our own burial grounds and culture." Asserting the self-determination and expertise of her people, she challenged him: "All of us Yorta Yorta people can look after our own culture and you should be supporting and embracing this." She suggested that the government should collaborate with Indigenous people, as cultural institutions have done, rather than subject them to government rules and policies, into which they have had little input.

SUBVERSIVE WITNESSING: CRACKS IN THE LEGAL PROCESS

Not surprisingly, after Jennings's disappointing failure to respond personally to her letters, and his decision to dismiss all the inspectors, Anselmi sought redress through the legal system. She approached Holding Redlich, the Melbourne firm that represented Lorna Cubillo in her case against the Commonwealth. Nicholson-Brown, who felt that the media publicity surrounding her issuing of an emergency declaration, and the minister's decision to suspend all the Aboriginal cultural heritage inspectors, had damaged her reputation, also approached Holding Redlich. Both women wanted the court to recognize their Indigenous knowledge and skills and their good performance as heritage officers, which they felt had been devalued by their dismissal. In addition, Anselmi wanted the court to hear the story of her difficult childhood. Four of her siblings had died at young ages. After her father died, and two of her brothers were removed from the mission, she lived rough in the bush with her impoverished mother and remaining siblings, in an attempt to avoid capture by welfare. Anselmi's wish to have her testimony heard in court should be understood in the post-Inquiry context, in which expectations of "discursive justice" have been generated (Whitlock 2006, 25). The case, an administrative law case, was tried on narrow technical grounds concerning whether due process had been followed in dismissing the cultural inspectors. What makes it of broader interest,

however, is the insight it provides into the limits and possibilities of witnessing in the legal process.

Carmen Currie, a feminist lawyer with a commitment to Aboriginal rights, considered it not only a matter of justice, but also of her ethical responsibility to ensure that Anselmi was heard. As she knew from her legal practice and from research she had done on "stolen generations" litigation, Aboriginal people have significant interaction with the courts, and most of it leaves them feeling disempowered. In preparing Anselmi's affidavit, Currie and her colleague David Shaw gave Anselmi the opportunity to tell her story. In listening to her testimony, they took upon themselves the role of secondary witnesses, validating her experiences. They were deeply moved by her testimony and by the letters she had written to the minister. Through their legal practice, they exemplified what Dominick LaCapra has described as "empathic unsettlement," a concept he uses to characterize how a historian or critic may be deeply affected by listening to testimonies of trauma (2001, 78). He contends that allowing oneself to be open to an affective response may result in a suspension of traditional subject-object relations, in which the historian is positioned as the "subject" of knowledge, and the witness as the "object." Clearly, the concept of empathic unsettlement may also apply to the experience of lawyers who are working on cases in which personal testimonies of abuse, trauma, and discrimination feature, and in which the lawyers themselves may feel shame or the need to atone for past injustices. In responding empathically, the lawyer, at least temporarily, abandons the role of "expert" mediator and recognizes the litigant's humanity and life experience.

Shaw and Currie acted as witnesses, receiving and transmitting Anselmi's testimony to the court. At the same time, however, they were aware that the judge and the opposing counsel were likely to take a dim view of any "personal" material that was considered "irrelevant" to the immediate technical issues before the court and "wasting" the court's time. Enabling Anselmi to tell her story might in fact damage, rather than enhance, her case. As Currie explains: "There were two parallel processes involved in the case: on the one hand, trying to get the best legal outcome for the litigants, which was to have them reinstated in their positions as Cultural Heritage Officers, and on the other, ensuring that the women felt that they had been heard and treated fairly by the non-Indigenous legal system" (interview with the author, July 20, 2007).

Currie described feeling that she and Shaw occupied a "boundary" position. They had to conform to the narrow expectations of the legal process; at the same time, they wished to ensure that their clients had a positive experience. Drawing on their knowledge of legal protocol and relevance, they mediated Anselmi's testimony in line with the conventions of the legal affidavit. They included as much of her testimony as they felt they could, without having the evidence dismissed for irrelevance. In the end, a single long paragraph about her traumatic childhood remained in the affidavit, a trace of the witnessing that had taken place outside the courtroom (2006a). Other opportunities for "subversive witnessing" in the legal process would include, for instance, the use of an expert witness, who could introduce testimony that could not be introduced by the claimant. For instance, in the *Cubillo* case, Cubillo's counsel called in historians who could testify to the historical conditions in which child removals took place, thereby providing contextualizing information about how to view issues such as "consent" and fill in the gaps where evidence was lacking.

The opportunities for "subversive witnessing" in the legal process are, however, severely constrained by norms of legal practice. In the pre-trial exchange of "considerations of fact and law," Jennings's lawyer questioned the relevance of most of Anselmi's affidavit. Perhaps he wished to put Holding Redlich's lawyers on notice that they were in danger of breaching legal protocol. As the representative of the Minister for Aboriginal Affairs, however, he did not challenge the relevance of Anselmi's testimony in court, an act that might have seemed disrespectful to an Aboriginal elder. Further, he noted that Anselmi had written directly to the minister, rather than have her lawyers write on her behalf, questioning her positioning of herself as an "expert." Predictably, Nicholson-Brown and Anselmi lost their cases. What Anselmi's case demonstrates, however, is that even where the testimony is rejected, witnessing can occur in the legal process itself.

CONCLUSION

In transnational work on testimony and witness, there has been relatively little gender analysis. As Marianne Hirsch points out, gender analysis is often limited to investigating the gendered particularities of women's testimonies (2003, 23). As I have shown, gendered logics shape the production, mediation, and reception of Indigenous testimony in cultural

and legal institutions in Australia. Australian cultural institutions, however unwittingly, share a feminist commitment to the politics of the personal in their use of testimony. Yet despite a commitment to bearing witness to the suffering caused by misguided policies, and to empowering witnesses, curators are constrained by political and material imperatives. These imperatives constitute another frame that shapes and mediates the stories they can tell. In particular, the divisive politics of the present, which were illustrated in the Camp Sovereignty controversy, may make it difficult for curators to transmit complex stories and may lead to implicit censorship. Moreover, severe space constraints, and the need to communicate to an easily distracted audience, limits the curator's ability to convey the complexity and diversity of experiences of removal. In contrast to cultural institutions, the law in Australia is, more often than not, suspicious of and hostile to Indigenous testimony. Yet, despite the law's masculinist skepticism toward the personal, with its challenging emotions, there are cracks in the legal system that make it possible for the activist lawyer to take on the role of witness and to receive and transmit Indigenous testimony. Annette Wieviorka has compellingly argued that to understand how testimony functions and how it is legitimated or discredited, it is necessary to examine the "circumstances surrounding the act of bearing witness" and the "larger story" of which it is part (2006, xiv–xv). My exploration of some of the circumstances surrounding testimony and witnessing in contemporary Australia demonstrates that gender is an important, if often neglected, part of the story.

ROSANNE KENNEDY is head of the discipline of gender, sexuality, and culture at the Australian National University. She has published on trauma, testimony, and witnessing in journals such as *Biography*, *Studies in the Novel*, *Life Writing*, *Aboriginal History*, and has edited (with Jill Bennett) a volume on cross-cultural approaches to trauma and memory titled *World Memory: Personal Trajectories in Global Time* (Palgrave, 2003). She is currently working on a book on witnessing in settler colonial societies.

NOTES

1. Margaret Tucker's memoir, *If Everyone Cared*, published in 1977, was the first to describe an Indigenous person's experience of forcible removal.

2. The report focused national attention on the continuing devastating effects of

child removal and colonization in the present, which is manifested in high rates of suicide, substance abuse, health problems, criminality, and social dysfunction in some Indigenous communities.

3. For a compelling history and analysis of the conservative attack on the *Bringing Them Home* report, see Manne 2001.

4. Limited by funding, time, lack of adequate counseling services, and the practicalities of traveling to urban centers and remote communities, the National Inquiry nonetheless collected testimony from more than 535 individuals who had been separated as children.

5. These institutions include the National Library of Australia, the National Archives, the National Museum of Australia, the Australian Museum, ABC (Australian Broadcasting Corporation Television and Radio), and state cultural institutions such as the state libraries and museums.

6. *Many Voices*, an edited volume that introduces the Oral History project, was issued with a CD that contains the voices of people giving testimony. See Mellor and Haebich 2002.

7. In Kennedy 2004, I analyze Croft's use of her artwork to engage with issues of reception and address across racial difference.

8. For an account of this incident, see Manne 2001.

9. Jay Arthur discussed this issue in a lecture she gave in my course Trauma, Memory and Culture, at Australian National University on May 24, 2007.

10. Typically, what happens in the legal process remains inaccessible to public view, and practicing lawyers rarely write about their experiences of working on cases. Instead, critics tend to analyze the judicial decision, which does not reveal the context or the interpersonal relationships that developed through the legal process. My analysis is based on a reading of the materials submitted in evidence to the court, as well as the judgment, and on several conversations and e-mail exchanges in June and July 2007 with Carmen Currie, a lawyer with the Melbourne firm Holding Redlich, who worked on the case. I would like to thank Currie for discussions of this case.

11. The camp had parallels to the long-standing Aboriginal Tent Embassy in Canberra, which has existed since the 1970s, despite the Howard government's desire to remove it. For information about Camp Sovereignty, see http://campsovereignty .wordpress.com/. Letters to the editor of the *Age*, April 10, 2006, "We Should All Embrace Camp Sovereignty," "A Perfect Opportunity," and "Converted to the Cause," can be viewed at http://www.theage.com.au/news/letters/we-should-all-embrace-camp-sovereignty/2006/04/09/1144521206233.html.

12. Nicholson-Brown was one of forty-eight individuals in the Australian state of Victoria who had been appointed as Indigenous "cultural heritage inspectors" under the Aboriginal and Torres Strait Islander Heritage Protection Act 1984. These positions, although voluntary, both recognized and conferred cultural authority on the inspectors, who were consulted on issues such as the appropriateness of development or archaeological excavations. Inspectors also give talks to university, school, and tourist groups and perform a range of other functions, including consulting with museums and organizations.

13. I have retained the original spelling and grammar in this document, as it evidences the vernacular nature of Anselmi's language.

WORKS CITED

Alcoff, Linda, and Laura Gray. 1993. "Survivor Discourse: Transgression or Recuperation?" *Signs* 18(2):260–90.

Anselmi, Ella. 2006a. Affidavit. Affirmed August 18, 2006. Melbourne.

———. 2006b. "Letter to Gavin Jennings." June 30. Exhibit to Anselmi's affidavit of August 18, 2006.

———. n.d. "Letter to Gavin Jennings." Exhibit attached to Anselmi's affidavit of August 18, 2006.

Anselmi v. Jennings. 2007. Federal Court of Australia, May 3, unreported. Per Middleton J. Judgment available at http://www.austlii.edu.au/cgi-bin/sinodisp/au/cases/cth/FCA/2007/634.html.

Croft, Pamela. 2000. "Oral History Interview." Transcript of Interview. Bringing Them Home Oral History Project. National Library of Australia. Interviewer: Deborah Anne Somersall. Date of Interview: February 24–25, 2000. National Library, Canbern, Tape Recording Collection #5000/099.

Cubillo v. Commonwealth of Australia. 2000. Federal Court of Australia, August 11. Per O'Laughlin J. Judgement available at http://www.austlii.edu.au/cgi-bin/sinodisp/au/ cases/cth/FCA/2000/1084.html.

Edwards, Coral, and Peter Read, eds. 1989. *The Lost Children: Thirteen Australians Taken from Their Aboriginal Families Tell of the Struggle to Find Their Natural Parents.* Sydney: Doubleday.

Felman, Shoshana, and Dori Laub. 1992. *Testimony: Crises of Witnessing in Literature, Psychoanalysis, and History.* New York: Routledge.

Hirsch, Marianne. 2003. "Nazi Photographs in Post-Holocaust Art: Gender as an Idiom of Memorialization." In *Phototextualities: Intersections of Photography and Narrative,* edited by Alex Hughes and Andrea Noble. Albuquerque, NM: University of New Mexico Press.

Jennings, Gavin. 2006a. "Letter to Ella Anselmi: Review of Inspectorship." April 21. Exhibit attached to Anselmi's affidavit of August 18, 2006.

———. 2006b. "Letter to Ella Anselmi: Review of Inspectorship." June 23. Exhibit attached to Anselmi's affidavit of August 18, 2006.

Kennedy, Rosanne. 2004. "The Affective Work of Stolen Generations Testimony: From the Archives to the Classroom." *Biography* 27(1):48–77.

LaCapra, Dominick. 2001. *Writing History, Writing Trauma.* Baltimore: Johns Hopkins University Press.

Link-Up (NSW) Aboriginal Corporation and Tikka Jan Wilson. 1997. *In the Best Interest of the Child? Stolen Children: Aboriginal Pain/White Shame.* Canberra, A.C.T.: Aboriginal History.

Manne, Robert. 2001. *In Denial: The Stolen Generations and the Right.* Melbourne: Black.

Mellor, Doreen, and Anna Haebich, eds. 2002. *Many Voices: Reflections on Experiences of Indigenous Child Separation.* Canberra: National Library.

Mitchell, Neil. 2006. *Morning Programme*. Radio Station 3AW. April 18.

Morgan, Sally. 1987. *My Place*. New York: Seaver Books.

Nicholson-Brown, Vicki. 2006. Affidavit. Affirmed 20 July. Melbourne.

Nicholson-Brown v. Jennings. 2007. Federal Court of Australia. May 3, unreported. Per Middleton J. Judgment available at http://www.austlii.edu.au/cgi-bin/sinodisp/au/ cases/cth/FCA/2007/634.html.

Noyce, Philip, dir. 2002. *Rabbit-Proof Fence*. Australian Film Finance Corp.

Pilkington, Doris. 1996. *Follow the Rabbit-Proof Fence*. St. Lucia, Qld.: University of Queensland Press.

Radstone, Susannah. 2000. "Working with Memory: An Introduction." In *Memory and Methodology*, edited by S. Radstone. Oxford: Berg.

Tucker, Margaret. 1977. *If Everyone Cared*. Sydney: U. Smith.

Whitlock, Gillian. 2006. "Active Remembrance: Testimony, Memoir, and the Work of Reconciliation." In *Rethinking Settler Colonialism*, edited by A. E. Coombes. Manchester: Manchester University Press.

Wieviorka, Annette. 2006. *The Era of the Witness*. Ithaca: Cornell University Press.

Wilson, Sir Ronald. 1997. *Bringing Them Home: Report of the National Inquiry into the Separation of Aboriginal and Torres Strait Islander Children from Their Families*. Sydney: Human Rights and Equal Opportunity Commission.

FAMILY MODEL AND MYSTICAL BODY: WITNESSING GENDER THROUGH POLITICAL METAPHOR IN THE EARLY MODERN NATION-STATE

ALLISON ANNA TAIT

FRANCE BEFORE SUNRISE: TWO POLITICAL THEORIES MEET

The sixteenth century in France was a "constitutional moment"—a time when political theorists and jurists articulated a full and rich iteration of the value of constitutionalism and legal-parliamentary authority in relation to the monarch. It was also a moment to "witness" in many senses. It was a time to witness history—Henri II died in a jousting match, only to be followed by three degenerate sons who died in short succession; Catherine de Medici incited the hatred of rival factions; and thousands of Huguenots were massacred in Paris on St. Bartholomew's Day in 1572. It was also a time of witnessing in a religious sense, as the Wars of Religion tore France apart and the powerful Catholic Ligue targeted the French Calvinists; and it was an instance when witnessing gained new associations related to a striking growth in France's judicial infrastructure caused by the sale of new offices. By the end of the century, this tremendous political and social instability resulted in the development of a different perspective on political organization and absolutist theory came into circulation, bringing with it a significantly different sense of witnessing. During the first half of the seventeenth century these two political theories vied for the right to define the terms of engagement. For women, this battle between political perspectives was especially important. Each theory, constitutionalism and absolutism, represented a distinct vision of sovereignty—the former emphasized the need for strong judicial governance and the latter the need for a strong monarch—and affected whether women witnessed in a religious sense or in a legal one, as rightsholders and members of the political community.

Framing the theoretical conversation about sovereignty were two distinct political positions regarding the nature of kingship and what—if

[*WSQ: Women's Studies Quarterly* 36: 1 & 2 (Spring/Summer 2008)]

any—checks should exist in relation to sovereign power. Jurists such as Claude Seyssel developed a theory of early modern constitutionalism that incorporated checks and balances on royal power and located substantive authority in legal precedent and social custom. Seyssel and his fellow constitutionalist jurists advocated readings of French history that often traced its origins to a model of kingship that was elective and based on the idea of the ruler being *primus inter pares* (first among equals) instead of an individual *apart*.[1] The second strand of theory, the absolutist position, was initially staked out by Jean Bodin in his well-known *Six livres de la République*, published in 1576. Bodin—in contrast to his constitutionalist contemporaries and in reaction to the violent chaos produced by the Wars of Religion—issued a call for a strong central sovereign who could neutralize warring factions and bring order to the developing nation-state. This call for sovereign command would be further developed in the seventeenth century as Louis XIII and Louis XIV became increasingly interested in asserting absolute power in response to overabundant noble privilege. However, in the almost hundred years that came between Bodin's articulation of absolute power and Louis XIV's real ascension to absolute power in the mid 1660s, political debate flourished and there was great give and take between the two schools of thought. By 1661, when Mazarin died and Louis XIV assumed total personal control of ruling the state, it was clear which philosophy would dominate. Until that moment, the coming of absolutism was still up for debate, as was the capacity of women. Women would witness either as political outsiders with no governmental agency or as members of a political collective, adept at leveraging the governmental apparatuses of justice.

As the seventeenth century opened, ideas that political theorists initially articulated in the sixteenth century came into play as the stakes of power increased and issues implicated in the theoretical dispute played out on the historical stage, where political battles between noble families and the monarch took place. While scholars discussed the evidence for and merit of the two philosophies, the debate also moved out of the library corridors and past the city streets, onto the stage and into the salon. Much of the debate transpired within the cultural arena—which was itself a contentious domain—and while more conservative rhetoric could be found on the theatrical stage, new modes of social and literary expression were being engineered in the female-centered salons. Within the cultural arena and the multiple sites it encompassed, one of the sup-

plest ways in which the contrast between constitutionalism and abso-
lutism was articulated was in the use of political metaphor. The evoca-
tive frameworks of two distinct metaphors found their way not only
into political treatises but also into literary production, where each did
the work of weaving cultural archetypes into political theoretical foun-
dations.

The preferred political metaphor in the constitutionalist context
was the *mystical political body*, a concept that defined a system in which
power was shared and the well-being of the community was linked to the
well-being of the individual. Within the mystical political body, the the-
oretical possibility exists for women not only to occupy a civic space
through organic (and organological) (Kantorowicz 1957, 270) association
but also to articulate their perspective and its consequences for the polit-
ical community in a civically approved way. In the mystical body,
women approach a citizenship status impossible within the traditional
family framework and their witnessing is closely associated with the
expansive juridicalism of the sixteenth century. Women witness—they
perceive with great clarity the political agenda driving sociocultural
events—and they also have the ability to attest to their perceptions in an
official capacity connected to "legal" witnessing. In the absolutist con-
text, the family unit (in its most conventional makeup) is the primary
expression of political organization. Within the family system, women
can witness in that they have a firsthand account of something seen,
heard, or experienced. Their witnessing, however, is confined to a quasi-
"religious" sense of the word—they witness the strength of their beliefs
and testify to these beliefs by affirming them as a moral duty, sometimes
in the face of dispossession and death.

In both contexts women have the capacity to witness, in that they
observe historical events, transgressive acts, and the consequences of a
patriarchal agenda. In both contexts women also have some capacity to
testify—or to act on the strength of what they have seen. In the mystical
body paradigm, however, women are able to make the connection
between witnessing and testifying. They articulate their knowledge in
the public sphere, where they replicate judicial forums and highlight
female inclusion in and value to the state by using and maximizing their
rights as cultural and political agents. In the family model, by contrast,
when witnessing does lead to action (testimony), the action almost
invariably contravenes state interest, positive legislation, and political

sensibility. Women are not understood to have the kind of citizenship that permits them hearing as political speakers or legal witnesses.

SITUATING THE METAPHOR: THE NEOCLASSIC FAMILY TAKES THE STAGE

As the curtain rose on the seventeenth century, one of the earliest and most important dramatists to put these conflicts into verse was Pierre Corneille. As Jacqueline Lichtenstein notes, "Corneille is a political thinker, no doubt the most important political thinker of the seventeenth century. He is constantly raising questions about the nature of power [and] the foundations of its legitimacy" (1996, 81). Corneille's theater marked an important new phase of interrelation between theater and politics and his plays define the parameters as well as the complications of the family model. For Corneille, the family is a fundamental political unit, and in this he is of one mind with Bodin. For both Corneille and Bodin, the metaphor of the family does significant work in incising the deep grooves of political interrelation. Drawing on Aristotle's foundational political imagery, Bodin frames governmental structure in terms of the family: "The family [is] not only the true source and origin of the commonwealth, but also its principal constituent" (1967, 6). The family metaphor fits neatly into the hierarchical outline of absolute monarchy, and analogous models position man as sovereign and at the center of numerous relationships. The father possesses "a natural authority, subject neither to question nor to rejection" (Saxonhouse 1980, 15) and a mutually reinforcing equivalency exists between king and father. As Jonathan Dewald notes: "From Bodin in the sixteenth century through Montesquieu in the eighteenth, theorists argued that the authority of the polity rested on properly functioning families, and above all on proper respect for fathers. Order in the small, familial polity would lead to order in the polity at large and to respect for its father, the king" (1993, 78). According to this concept, biology is destiny, and power is reducible to the strongest pre-political unit, which is then amplified and reified in other contexts.

The problem inherent in this metaphor is that the construct supports a perpetual conflict between pre-political and political, between domestic and governmental. While the *family father* rules within his own sphere of influence, once he enters the public sphere he must abdicate his ultimate authority in favor of royal right and become one of the family members, a compliant member of a lower order. This is a problem for

men at certain political junctures, especially when family interest is in contention with the state, and often the problem is circumvented by allowing men the privileged status of warrior, one who functions at the bidding of the king and yet holds the power of life and death. This is, however, always a problem for women because they have no recognized identity outside a domestic one and are never able to escape the fate of hierarchy. Instead, they are called upon to remain "domestic" and become subordinate not only to the warrior-father but also to the monarch-father. The family model sets up a binarism between warrior and woman that Jean Bethke Elshtain has named the "Just Warrior/Beautiful Soul" dichotomy; as Elshtain points out, this model influences both domestic and political models. In this model, while the male is construed as an actor on the battlefield, contributing to the credit of the state, the woman must fill the necessary role of the beautiful soul, representing the home and hearth, which must be protected. Whether she needs protection is irrelevant; what matters is that the warrior must have a moral and emotive reason to wage war (Elshtain 1987). There are exceptional dissenters, but they often confirm the rule. As Linda Kerber states, "Antigone and Cassandra are both outsiders . . . [but] both roles maintain the classic dichotomy in which men are the defenders of the state and women are the protected" (1993, 104). Female behavior is forced into one of two categories: passive acceptance of the role of "hearth-tender" or criminal dissent. Witnessing results in silent assessment or unspoken outrage, and testimony, if it exists, is usually a tragic affair, a transgressive act that speaks to individual moral belief and state error—and results in death.

These classic female models, shaped during a formative time for the nascent field of political theory, set standards for women's witnessing and created archetypes that were transhistorical in their ability to communicate deeply ingrained notions of family roles and female nature. As Corneille began writing, neoclassicism dominated the stage and dramatists engaged vigorously with classical sources in an attempt not only to lend a certain gravitas to their enterprise and but also to claim their own particular versions of these universal narratives. Additionally, the political context in the early seventeenth century was such that there were many perceived similarities between France and the classic political societies. The early seventeenth century was a time that bore witness to the new and evolving idea of the nation-state, and classic narratives

addressed many of the same issues that compelled and inspired Corneille and his colleagues. Using classic sources, then, neoclassic dramatists sought to understand the location and limits of the family while advocating a "generous" and "glorious" loyalty to the *patria*.

If Antigone is Kerber's example of a classic prototype—a political outsider and domestic loyalist who is forced to act against the state because the family and the polity are mutually exclusive spheres of influence—she had many kindred female spirits on the stage, especially in the theater of Corneille. Corneille's heroines are often like Antigone in their dedication to family honor—a duty that trumps both romantic love and state concern. *Le Cid*, which was a popular sensation when it was produced and published in 1636, struck an emotive chord with audiences, who were enthralled by the noble dilemma of family duty opposed to sentimental attachment. In the play, the noble heroine Chimène is caught in a conflict between her father and her beloved—her father insults her suitor, Rodrigue, who is in turn drawn into a duel in which he kills the father. Chimène, a powerless witness to the wages of the duel, cannot marry Rodrigue, the man who caused her father's death. To satisfy family duty, she seeks revenge by asking the king for Rodrigue's head. Rodrigue, however, leaves for battle, triumphs over the Moors, and is able to return to the community to ask for Chimène's hand in marriage. When the king approves the match, Chimène has doubts about its appropriateness, asking the king, "And when you ask this measure from my feeling of duty, / is it entirely in accord with your sense of justice?" (5.4.1808–9; translation mine). The king, however, exerts his prerogative as the ultimate father and sets law aside: "Time has often rendered lawful / that which at first seemed impossible without being a crime" (5.4.1813–14; translation mine). Chimène witnesses the breakdown of both domestic and then public law, and what began as family protest, premised on the law of one father, must be transformed into acceptance of the political law of another, higher-placed, father. Witnessing—Chimène's own emotional response and consequent intuitive analysis of the situation—does not connect to action, in that she cannot act on her perception of what is right without crossing royal opinion. What she must witness—without comment if she is to preserve the glorious continuation of the nation-state—is the fundamentally changeable and arbitrary nature of paternal law where women are concerned. Exceptions are made in the name of the state, for those who serve the state, and this ensures that exceptions will never be made for women.

In tragic works such as *Horace* (1640), the drama of daughterly duty and heroic exceptionalism is even more forceful and demonstrates the risks of not complying with paternal law. In *Horace*, the dispute between family and state is polarized within the family unit itself and, as Dewald notes, is gendered as well: "*Horace* presents public and private realms [that] oppose and threaten each other, in gendered terms: the public presented as male, the private as female. Father and son in the play insist on the superiority of public obligations, whereas sisters and daughters call for the primacy of private affections" (1993, 78). Camille, sister to Horace, protests the senseless violence of warfare that is occurring around her and insists on undermining the glory attached to bloodshed through her speech, so much so that her brother must kill her to silence her opposition. Camille, unlike Chimène, is a noncompliant witness to brutality in the name of the state and ultimately dies on the altar of state interest. Camille's death lays bare the charade of "rule of law" when sovereign interest is at stake; like Chimène, Camille is a cipher when confronted with the irrefutable logic of the victorious warrior. As Tulle says to Horace, the hero of the battle, pardoning him after he has killed his sister:

> Such servants are the very lifeblood of kings,
> And such servants are held above the law.
> Let law be silent then . . . (5.3.1753–55; translation mine)

Women witness the failure of the rule of law—the idea that government is a body of law, not a congregation of men—in the face of exceptions made on behalf of those who serve the state and the arrogant sovereignty of an unchecked monarch. Female witnessing is a powerlessness to act; women can choose to either accept the will, voice, and authority of the state or risk punishment and death. Their testimony, the active voice, is nothing more than Camille's dying cry.

If the figure of Antigone provides one universal model that is particularized by Corneille, there is another figure of witnessing and non-cooperation—one that Elshtain briefly references and one that Kerber does not include in her statement about classic female response to male brutality. This is Clytemnestra, Aeschylus's murderous queen in the *Oresteia*, who provides an alternate model for the neoclassic dramatists

as her character loosely defines the foundational image of a woman who
vigorously refuses to accept patriarchal status quo. This is a female pro-
totype that refuses to witness patriarchal bias and will neither accept
paternal law without protest, like Chimène, nor become an unwitting
victim, like Camille. This form of incandescent female rage is strongly
present in the neoclassic imagination, and dramatists used it to reinforce
the normative model of powerful, political women as tyrannical and
homicidal. Corneille's first tragedy, *Medea* (1635), underscores the pri-
macy of this model, and *Rodogune* (1644) provides an in-depth explo-
ration of the evil that comes when women possess political agency and
power. In *Rodogune*, Cleopatra, the evil queen, is an unnatural wife who
has killed her husband, an unnatural mother who plays her twin sons
against each other and ultimately kills one of them, and an unnatural
ruler who brings tyranny. Cleopatra has usurped her husband's throne,
murdering him when he reappears after the war and tries to repossess it,
and as the play opens the kingdom is in political turmoil, having
descended into a brutal oppression. Cleopatra refuses to allow trans-
parency into the political process, leading her sons as well as her sub-
jects through a maze of manipulated information. She plots surrepti-
tious revenge against Rodogune, the onetime mistress of her husband,
the beloved of both her sons, and a symbol of femininity validated by
masculine desire. Ultimately, Cleopatra's scheming results in the death
of one son as well as her own demise; her legacy to the other twin son
and Rodogune is a family history of shame and crime. Cleopatra's sin
encompasses deviant maternal behavior; however, her greater trans-
gression is grabbing political power from the male patrimony and lin-
eage. Cleopatra's role, like that of Clytemnestra, is to demonstrate the
dangers of power-hungry women and what can happen when "the
mother" becomes the dominant organizing principle. A mother, unlike
a father, is not born to rule, and Cleopatra underscores the tragic and
destructive outcomes of female sovereignty, confirming that women
have no business within the polity. While Chimène and Camille remain
constant to the ideal of family—to their possible and actual detri-
ment—Cleopatra demolishes the sanctuary of the household, just as she
destroys the health of the state. Determined to transition from witness-
ing to acting, Cleopatra imitates male justice and chooses to testify
through violent action, leaving devastation in her wake. Unfortunately
for the ruinous queen, female violence, unlike male violence, has no

official role and no governmental blessing and in the end, Cleopatra must die.

(RE)SITUATING THE METAPHOR: SALON WOMEN TAKE THE STAND

While the Comédie-Française was staging epic masterpieces, and Corneille and his colleagues were producing plays that would define national and family politics, salon women such as Madeline de Scudéry were formulating another version of women's witnessing: one that was premised on the constitutional idea of full participation for all "citizens." This more equitable vision of political organization and a woman's capacity to contribute to the community aligned with the constitutionalist model and presented the possibility of a political corporation that was protodemocratic, based on political representation. This alternate metaphor—the image of mystical political body—was one that resonated strongly with noble women of the early seventeenth century and found cultural application in their literary production. Its political roots, however, went back to medieval theology, and constitutionalism's vigor and depth were located in far-reaching, explicit comparisons made between the church and the state. These comparisons had two direct results that biased political theory toward the juridical and the inclusive. First, theologians asserted that the church and the state were to be constructed along parallel lines, noting that the church's "highest governing authority lies with the General Council as the representative assembly of the faithful, and that the Pope's apparent plenitude of power is in effect conceded to him as a matter of administrative convenience" (Skinner 1978, 116). The implications for the secular state were radical and the idea that the head of the secular community was in fact a servant of the people proved a weighty counterpoint to the idea of executive privilege. Second, through the application of the religious model, the political community gained a sense of stability and transcendence as the weight and significance attached to the religious *corpus mysticum* transferred to the mystical political body.[2] Members of the secular state, like the ecclesiastical state, cohered and related "mystically" by belonging to a group defined not just by location or tradition but by a governing, intellectual principle. Like the religious faithful, "citizens" were citizens in one sense because of their shared belief in a transcendent operating principle—in this context it was, however, the political corporation and the ideas of just power and mutual aid. A concept of a synergistic political organization was born

and French jurists of the sixteenth century exploited the mystical body metaphor to maximum effect. From the outset, this metaphor of "mystical" cohesion in the political corporation indicated a more progressive idea of limited executive power, highlighting the notion that every part has a symbiotic relationship with the whole and that political power is a shared possession as well as a collaborative process that depends on the optimal functioning of all members.

The primary consequences of this metaphor is that the possibility of being external to the political body is not theoretically supported and the condition of women, although not specifically targeted, shifts. At no point in this political discussion is gender equity mentioned explicitly. This metaphor, however, signals a more equitable social design by locating agency in the individual rather than the ruler; privileging justice, rather than obedience; and detailing the rights of the subject rather than the responsibilities. As Charlotte C. Wells notes in her discussion of early modern citizenship, a constitutionalist system could be represented as a "web of connections among citizens" while the absolutist construct meant that the "republic as a whole was held together by the vertical bond of allegiance between prince and subject" (1995, 97).[3] Within the constitutionalist "web of connections," women were able to identify as "citizens" in a way that was denied to them within the family model, in which the power current ran uniquely from the top down. Elite women, who had the resources to take advantage of "citizenship" amenities, were functionally able to prosper under this model. Aristocratic women possessed public voice to give testimony and the space within which to give testimony—the salon. The salon not only authorized and narrativized female witnessing, it also functioned as a site of exemplary female engagement, and salon gatherings of like-minded individuals (individuals of "spirit" and "distinction") were themselves moments of witnessing defined by reflexivity and a collective sense of self-awareness. The salon was a female-controlled environment that, although still technically a space within the home, was far removed from the family model. And, as such scholars as Carolyn Lougee and Joan DeJean have shown, salon women, though often married, did not prioritize their roles as wives and mothers and were opposed to the forcible association of womanhood with conjugal and maternal duty. Within this female-centric space, there was a new goal—to celebrate exemplary women and create a new model of female discourse.

Leveraging the same classical models and engaging in the same discourses as their male counterparts, Scudéry and her circle renegotiated the classic narratives and inserted a female perspective. Published just six years after Corneille's *Le Cid*, Madeleine de Scudéry's *Les Femmes illustres* is a fine example of reconstructed female discourse, in that Scudéry revisits the stories of mythic and historic women to give voice to the female perspective. In her prefatory letter to the second volume, Scudéry tells her readers that "the Glory of [our] Sex" is the object of her endeavor and that the entire work is nothing less than the pleading of the female cause. She lets Hecuba speak, pens Helen's speech to Paris, and creates Cleopatra's oration to Mark Antony. In each "harangue," Scudéry briefly constructs a "case" for her heroine that is designed in the form of testimony given before a jury. Each story has both an opening "argument" and a final judgment on the effect and success of the speech. While Scudéry often focuses on traditional female virtues such as constancy and selfless love, each argument is nonetheless an attempt to vindicate female action and is clearly designed to both manipulate sympathy and generate goodwill toward women who have been wronged by their lovers and by subsequent historical retellings. Women control the narrative, in a way that they do not elsewhere, and therefore control the framing of the story—what the reader sees and how the reader perceives what she sees—as well as the final verdict. Through Scudéry's work, women gain representation in the cultural-historical imagination (as well as the literary canon) and, as her heroines testify in the court of aristocratic public opinion, their stories support the idea that women possess agency as well as value to the state, while the conjured image of a courtroom jury underscores the importance of legal review as an alternative to royal decree. Salon women thereby enter the civic system through the thin end of the wedge, taking control of the terms of the debate and making the connection between witnessing and testifying in a procedural sense that implicates both the court of public opinion and Scudéry's explicit case for the virtues of women's participation. Women fully actualize the space of the salon, appropriate the concrete space of the published page, and evoke the important space of the courtroom.

Apart from these heroines who redeem themselves through voice and intellectual agency, there is another important model of female leadership and civic participation in the salon imaginary—one that reconfigures women's relationship to physical as well as political power and

reclaims the violence symbolized by a figure such as Clytemnestra. Scudéry and her circle celebrated "illustrious" amazon warriors who embodied the twin concepts of noble spirit and action. The amazon was appealing to salon women in that she represented another model by which to refute the institution of marriage. In addition, the amazon was considered to be a just warrior who fought primarily for the greater social good. Even outside of the salon, however, the amazon and her spiritual sisters were much discussed: "the early 1640s saw a veritable outpouring of portrait books of women referred to as 'illustrious,' 'generous,' 'heroic,' or 'strong,'" *Les Femmes illustres* among them (DeJean 1991, 28). Strong women, in this context, use violence in service of the state and the state reciprocates by valuing female military engagement. Strong women are again able to make the connection between witnessing and action, but this time the action is not rhetorical; it is martial. Echoing heroic sentiments that would traditionally come from the mouths of men, Scudéry's Zenobia speaks about constancy, even after being captured by enemy forces: "It is truly at such times that it is necessary to have a heroic soul, and never let it be said to me that in such encounters despair is a virtue and constancy a weakness. . . . Let no one tell me that this sort of constancy is more appropriate to philosophers than to kings. . . . There is no difference between philosophers and kings, except that the one teaches true wisdom and the others should practice it" (Scudéry 2004, 81).

What is remarkable about Scudéry's presentation of the virtue of courage is that she problematizes it in an adjoining argument, underscoring the idea that there are always multiple points of access and interpretation in narratives and that there is not one, monolithic frame of reference. In the another argument, Sophonisba, queen of Carthage, faces captivity as well, but reacts differently to the idea of constancy, saying, "Such sentiments are suitable for philosophers but not for kings, whose every action should be a heroic example of courage" (Scudéry 2004, 73–74). The multiple perspectives represented by the individual women produce a rich collection of portraits that interact to produce something that is layered, inclusive, and representative of the complexity of civil society.[4] While these noble responses to situations of military conflict bring to mind male operating models, the differential lies in an ability to see two sides to an issue, two definitions of a virtue. This differential is what takes women's military participation out of the family model and

places it squarely within the lines of a mystical political body, where all member perspectives contribute to the greater good. In this framework, women observe and participate in historical events *and* testify to their beliefs through strong speech and action. Through Scudéry's subversion of the family model, their strong acts of testimony do not contravene state interest, and female voice is given both volume and amplitude to express what stage counterparts cannot.

ECLIPSED BY THE SUN: FROM THE BARRICADES TO VERSAILLES

What emerges from the exploration of these two political metaphors is that they trace the sometimes subtle and sometimes unsettling points of connection between political organization, women's agency, and a capacity to witness in this early modern context. When the law of the father stands—unchallenged and often arbitrary—women can only witness from the perspective of an outsider, witnessing a truth that may or may not be seen, understood, or accepted by the community. It is a witnessing that concentrates on the moral authority of the wronged, and given the pervasive divide between home and public square, it is significant that the wrong done is not a legal wrong with the potential for constructive outcome or political efficacy. The rule of law—a system of government that approximates evenhanded, impersonal treatment of all citizens—fractures when a woman's cause is at stake; consequently, any female action that occurs is dissent, counter to the official political agenda and without any avenue of either legal or political recourse. However, when unchecked paternal rule cedes to a governance process that incorporates the perspectives of diverse institutions and parties, precedent and judicial influence, women are able to conjure the courtroom, reclaim voice outside the home, and actualize the potentiality of witnessing. Women articulate their own political perspective and value to the state and formulate their arguments to win support and a positive verdict from a jury of peers. The mystical political body, the mysterious and synergistic social corporation, encompasses female speech and action—witnessing as well as testimony.

What also emerges from the comparison is that women benefit from the promise of judicial influence, bringing as it does the model of a more balanced and process-oriented community that does not encourage or tolerate exceptionalism. This does not mean that women gained full access to the political and social rights that men possessed at the time, but

the first part of the seventeenth century—when aristocratic and judicial privilege favored female political engagement and before the certainty of absolutism set in—is nonetheless exceptional in the strong women who were leaders in both political and social circles. The women of the salons, who called themselves the "new amazons," were important thought-leaders who pioneered new ways for women to influence and participate in cultural and political life. During these years, France saw the regencies of two queens—Marie de Medici and Anne of Austria—and thereby spent more than a decade under the official rule of women. In studying the female iconography of the period, DeJean remarks, "New portrayals of female power were developed, as if to document women's capacity to govern" (1991, 26). In addition, there were a number of strong noble women from some of the most important families, such as the duchesse de Longueville or the princesse de Condé, who—although generally at great odds with the royal administration—exhibited the same interest in gaining political influence and were widely acknowledged to be extremely powerful.

The crowning example of this conjunction, one that underscores the connection between female cause and the interest of the jurists, was the Fronde, an ultimately unsuccessful civil war started in 1648. The first part of the Fronde—the parliamentarian Fronde—was a strike by Parisian judges against the overwhelming tax burden that Mazarin imposed. In the second part, nobles joined the fight to preserve the aristocratic privilege of local feudal jurisdiction and protest undue taxation as an indicator of an overreaching centralized government. Although the failure of the Fronde is often attributed to a lack of organization between various contingents who held conflicting motives and goals, it is of great note that the magistrates and noble women saw their interests as aligned against the challenge of exceptional sovereignty. During the Fronde, noble women exemplified new models of female action: "More than any other conflict in French history, the Fronde can be seen as a woman's war. For once women had taken command, the resistance to absolutism remained" (DeJean 1991, 37). Women witnessed history from the barricades, and the Fronde was one of the great "moments of resistance" in response to the absolutist drive of progress. It was, however, ultimately only momentary and in little over a decade after the Fronde, all power—political, social, and cultural—moved to a new, centralized location, Versailles. By the early 1660s, Louis XIV, having come of age and gained

political facility, took control of the state and built a court society that became its own isolated culture, a model solar system contained within the walls and grounds of a prosperous palace. Versailles became the ultimate household—the ultimate family model—and the mystical political body fell into ill health and negligent care, signaling an end to engaged female witnessing.

ALLISON TAIT has a Ph.D. in French from Yale University. Her interests are women in the seventeenth century, salon culture, and political theory. She is currently working on Madeleine de Scudéry and the *Carte de Tendre*.

NOTES

1. Outside of Seyssel, the best example of this tradition is Francois Hotman and his primary work, *Franco Gallia*. Others include Guillaume Budé and Justus Lipsius. Seyssel and Budé were writing in the early half of the sixteenth century, while Lipsius and Hotman wrote in the second half of the century, contemporary with Bodin.

2. As Kantorowicz notes, "In short, the expression 'mystical body,' which originally had a liturgical or sacramental meaning, took on a connotation of sociological content." The term was first applied to the church (by Boniface VIII) and then to the political community in the late Middle Ages and Renaissance (1957, 196).

3. Wells notes that generally citizenship rights were more expansive in the sixteenth century, as measured by property rights and in cases concerning the *droit d'aubain* (the right of the king to claim the estate of any unnaturalized foreigner who died on French soil without legal heirs).

4. The editors and translators of this Scudéry volume note that they included both of these speeches regarding the courage of suicide when faced with captivity "because they form a paired set in the tradition of the sophistic and humanist rhetorical exercise of arguing on both sides of a question" (Donawerth and Strongson 2004, 22–23).

WORKS CITED

Bodin, Jean. 1967. *Six Books of the Commonwealth*. Translated by M. J. Tooley. Oxford: Basil Blackwell.

Corneille, Pierre. 1980. *Théâtre II*. Paris: Garnier-Flammarion.

DeJean, Joan. 1991. *Tender Geographies: Women and the Origins of the Novel in France*. New York: Columbia University Press.

Dewald, Jonathan. 1993. *Aristocratic Experience and the Origins of Modern Culture*. Berkeley and Los Angeles: University of California Press.

Donawerth, Jane, and Strongson, Julie. 2004. "Volume Editors' Introduction." In

Selected Letters, Orations, and Rhetorical Dialogues, edited and translated by Jane Donawerth and Julie Strongson. Chicago: University of Chicago Press.

Elshtain, Jean Bethke. 1987. *Women and War*. New York: Basic Books.

Kantorowicz, Ernst H. 1957. *The King's Two Bodies: A Study in Mediaeval Political Theology*. Princeton: Princeton University Press.

Kerber, Linda. 1993. "'A Constitutional Right to Be Treated Like . . . Ladies': Women, Civic Obligation and Military Service." In *University of Chicago Roundtable*. Vol. 1. Chicago: University of Chicago.

Lichtenstein, Jacqueline. 1996. "The Representation of Power and the Power of Representation." *SubStance* 80(25):81–92.

Saxonhouse, Arlene W. 1980. "Men, Women, War, and Politics: Family and Polis in Aristophanes and Euripides." *Political Theory* 8(1):65–81.

Scudéry, Madeleine de. 2004. *Selected Letters, Orations, and Rhetorical Dialogues*. Edited and translated by Jane Donawerth and Julie Strongson. Chicago: University of Chicago Press.

Skinner, Quentin. 1978. *The Foundations of Modern Political Thought*. Vol. 2. Cambridge: Cambridge University Press.

Wells, Charlotte C. 1995. *Law and Citizenship in Early Modern France*. Baltimore: Johns Hopkins University Press.

THE TEXTURE OF RETRACING IN MARJANE SATRAPI'S *PERSEPOLIS*

HILLARY CHUTE

In July 2004, the *New York Times Magazine* ran a cover story on graphic novels, speaking of them as a "new literary form" and asserting that comics are enjoying a "newfound respectability right now" because "comic books are what novels used to be—an accessible, vernacular form with mass appeal." However, this lengthy *Times* article virtually ignores graphic narrative work by women: the piece excerpts the work of four authors, all male; depicts seven authors in photographs, all male; and mentions women writers only in passing: "The graphic novel is a man's world, by and large" (McGrath 2004, 24, 30). This is not true. Some of today's most riveting feminist cultural production is in the form of accessible yet edgy graphic narratives.[1] While this work has been largely ignored by feminist critics in the academy, interest is now growing from outside the field of comics, as we can see in recent essays in journals such as *Life Writing*, *MELUS*, *Modern Fiction Studies*, and *PMLA*.[2] Feminist graphic narratives, experimental and accessible, will play an important role in defining feminisms that "could provide a model for a politically conscious yet post-avant-garde theory and practice" (Felski 2000, 187).

I use "graphic narrative," instead of the more common term "graphic novel," because the most gripping works coming out now, from men and women alike, claim their own historicity—even as they work to destabilize standard narratives of history.[3] Particularly, there is a significant yet diverse body of nonfiction graphic work that engages with the subject either *in extremis* or facing brutal experience. In much American women's work, autobiographical investigations of childhood, the body, and (traumatic) sex—speciously understood as private, all-too-individual topoi—are a central focus. Yet whether or not the exploration of extremity takes place on a world-historical stage (as in, say, the work of Joe Sacco and Art Spiegelman), or on a stage understood as the private sphere (as in, say, the

[*WSQ: Women's Studies Quarterly* 36: 1 & 2 (Spring/Summer 2008)]

work of Alison Bechdel or Phoebe Gloeckner) should not affect how we understand these graphic narratives as political: the representation of memory and testimony, for example, key issues here, function in similar ways across a range of nonfiction work through the expansivity of the graphic narrative form, which makes the snaking lines of history forcefully legible. I am interested in bringing the medium of comics—its conventions, its violation of its conventions, *what it does differently*—to the forefront of conversations about the political, aesthetic, and ethical work of narrative. The field of graphic narrative brings certain constellations to the table: hybridity and autobiography, theorizing trauma in connection to the visual, textuality that takes the body seriously. I claim graphic narratives, as they exhibit these interests, "feminist," even if they appear discrete from an explicitly feminist context.

Further, I argue that the complex visualizations that many graphic narrative works undertake require a rethinking of the dominant tropes of unspeakability, invisibility, and inaudibility that have tended to characterize recent trauma theory—as well as a censorship-driven culture at large. Unquestionably attuned to the political, these works fundamentally turn on issues of the ethical, in Lynn Huffer's important sense of the ethical question as "how can the other reappear at the site of her inscriptional effacement?" (2001, 3). I am interested in this notion of ethics as it applies to autobiographical graphic narrative: what does it mean for an author to *literally* reappear—in the form of a legible, drawn body on the page—at the site of her inscriptional effacement? Graphic narratives that bear witness to authors' own traumas and those of others materially retrace inscriptional effacement; they reconstruct and repeat in order to counteract. It is useful to understand the retracing work of graphic narratives as ethical repetitions (of censored scenarios). In *Sexuality and the Field of Vision* Jacqueline Rose writes that the encounter between psychoanalysis and artistic practice draws its strength from "repetition as insistence, that is, the constant pressure of something hidden but not forgotten—something that can come into focus now by blurring the fields of representation where our normal forms of self-recognition take place" (1986, 228). This repetition is manifested with particular force in the hybrid, verbal-visual form of graphic narrative, where the work of (self) interpretation is literally visualized; the authors show us interpretation as a process of visualization.[4] The medium of comics can perform the enabling political and aesthetic work of bearing witness powerfully

because of its rich narrative texture: its flexible page architecture; its sometimes consonant, sometimes dissonant visual and verbal narratives; and its structural threading of absence and presence.

Here, I focus on *Persepolis*, an account of Marjane Satrapi's childhood in Iran, in which she endured the Islamic Revolution and the Iran-Iraq War. (We may understand the book as bridging the wartime-focused testimonies of Sacco and Spiegelman, and the child-oriented testimonies of many American women authors.[5]) Satrapi currently lives in France and writes in French. *Persepolis* was encouraged into existence, as she has explained, by French cartoonists in the L'Association comics publishing collective (particularly David B. of the autobiographical *Epileptic*), with whom she happened to share the Atelier des Vosges studio; their support, as well as her discovery of work such as Spiegelman's *Maus*, led her to compose her story in the form of comics. (It is important to understand Satrapi in the context of Europe, where her book was not only a surprise bestseller but also what L'Association publisher Jean-Christophe Menu correctly terms a "phenomenon" [2006, 169].)[6] While *Persepolis* has been translated into many languages, because of the political situation in Iran it is unable to be officially translated into Farsi or published there—although Satrapi recently mentioned that there is a Persian version, which she has not seen or authorized, circulating on the black market.

PORTRAIT OF THE ARTIST AS A CHILD

Satrapi, an Iranian born in 1969 whose work was first published in an explicitly feminist, antiracist context in the United States in *Ms.* magazine (2003b), presents in *Persepolis: The Story of a Childhood* (first available in the United States in 2003) a visual chronicle of childhood rooted in and articulated through momentous—and traumatic—historical events.[7] *Persepolis* is about the ethical verbal and visual practice of "not forgetting" and about the political confluence of the everyday and the historical: through its visual and verbal witnessing, it contests dominant images and narratives of history, debunking those that are incomplete and those that do the work of elision. And while its content is keenly feminist, I will argue that we may understand the text as modeling a feminist methodology *in its form*, in the complex visual dimension of its author's narrating herself on the page as a multiple subject.

Throughout Satrapi's narrative, the protagonist is a child (the young Marjane, called "Marji"). The issue of veiling opens the book (Fig. 1).

Satrapi begins *Persepolis* with a row of only two frames. In the first panel, the narrator offers exposition. In a box above a drawing of an unsmiling, veiled girl, sitting with her arms crossed in the center of the frame, she situates the reader with the following information: "This is me when I was 10 years old. This was in 1980." The following panel depicts a line of four similarly composed girls, unsmiling and with crossed arms, and a sliver of a fifth on the reader's left: we are only able to infer a hand, a bent elbow, and a chest-length veil. The narrator writes, "And this is a class photo. I'm sitting on the far left so you don't see me. From left to right: Golnaz, Mahshid, Narine, Minna" (2003a, 3).

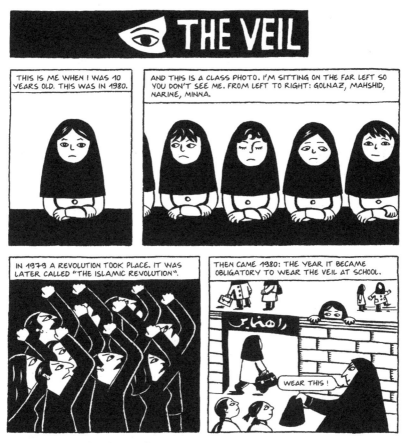

Fig. 1. From *Persepolis: The Story of a Childhood* by Marjane Satrapi, translated by Mattias Ripa and Blake Ferris, copyright © 2003 by L'Association, Paris, France. Used by permission of Pantheon Books, a division of Random House, Inc.

Here Satrapi uses spacing within the pictorial frame as the disruption of her own characterological presence. We do in fact, clearly, "see" her—just not all of her—but her self-presentation as fragmented, cut, disembodied, and divided between frames indicates the psychological condition suggested by the chapter's title, "The Veil." An icon of a single eye, directly engaging the reader, dangles over the book's very first gutter, reminding readers at the outset that we are aligned with Satrapi's penetrating vision and enabling retracing of that vision: "I give myself this duty of witnessing," Satrapi explains about the book (2004a). Satrapi defines *Persepolis* as a text of witness; the two-volume series concludes decisively in 1994 because that was when she left Iran for good. She will not write a third volume based on "second-hand information" (Leith 2004, 12). Here, her self-establishing ("this is me") and the immediate deestablishment of her person in the following frame ("you don't see me") not only creates disjuncture between narration and image (we do see her, even as she notes we do not; we know we are seeing a drawing, even as she announces the panel as a photograph) but also indicates how the visual form of the graphic narrative, in harnessing the possibilities of pictorial space, can create a complex autobiographical fabric. The comics form calls attention to what we as readers "see" and do not see of the subject: the legibility of the subject as a literal—that is to say, readable—issue to encounter.

The first page also zooms from the ostensibly prosaic—a drawing of a class photo and list of the names of classmates pictured—to the explicitly political; the panel subsequent to the row of ten-year-olds throws us back a year: "In 1979 a revolution took place. It was later called the 'Islamic Revolution,'" reads text above the frame, which pictures an anonymous crowd of people throwing their fists into the air in front of a stark black background. And then quickly enough, we are back at school and 1980: "Then came 1980: the year it became obligatory to wear the veil at school." *Persepolis* literally moves back and forth across a momentous event. In the first four frames alone, we have criss-crossed from 1980 to 1979 and back to 1980; the chapter will then backtrack to 1975. Divided into nineteen chapters, *Persepolis* narrates the trials and tribulations of precocious Marji and her upper-class leftist parents: their protests against the Shah, and later against the Islamic regime; Marji's growing class consciousness; the torture and killing of family and friends; the havoc wreaked by the Iran-Iraq war; and Marji's fierce and danger-

ous outspokenness, which eventually leads her fearful parents to send her out of the country at age fourteen. The book's last page shows her mother fainting at the airport as Marji leaves Iran.

Satrapi's text is framed diegetically, and externally in her introduction, by injunctions to "never forget": it is the defining project of the text. Arguably the most moving narrative thread in the book is Marji's relationship with her charismatic uncle Anoosh, a Marxist. He is allowed only one visitor in prison before his execution, and he requests Marji. Anoosh tells her: "Our family memory must not be lost. Even if it's not easy for you, even if you don't understand it all." Marji replies, "Don't worry, I'll never forget" (2003a, 60). The phrases—"don't forget," "never forget"—recur again at significant moments in the text. In the brief prose introduction to *Persepolis*, Satrapi affirms that her book, visually and verbally, is indeed itself the product and act of "not forgetting" upon which Anoosh insisted.

Persepolis not only does not forget, but also, more significant, shows us the process of "never forgetting" through its layers of verbal and visual narration: it presents the procedure, in addition to the object, of memory. *Persepolis* proliferates selves on the page. The graphic narrative form allows for a dialectical conversation of different voices to compose the position from which Satrapi writes, verbally and visually inscribing multiple autobiographical "I"s. Satrapi's older, recollective voice is most often registered in overarching narrative text, and her younger, directly experiencing voice is most often registered in dialogue, and in the discursive presentation of pictorial space—the "visual voice" of the book is one of its many narrative levels. (To allow these levels their distinct weight, I refer to *Persepolis*'s author as "Satrapi," to the narrator in the text as "Marjane," and to the child protagonist as "Marji.") Satrapi's embrace of the perspective of youth for her narrative is a way for the author to return to and present the historical events of her childhood with a matter-of-factness that is neither "innocent" nor "cynical," but in constant negotiation of these as the character Marji's knowledge and experience increases, and as the author, reaching back, engages the work of memory that requires a conversation between versions of self. Satrapi shows us the *state of being* of memory (as opposed to a singular act of recall) by triangulating between the different versions of herself represented on the page.[8] She shows us, then, the visual and discursive process of "never forgetting."

While one way that Satrapi unfolds the procedure of memory is through the spatializing form of comics, which visualizes and enmeshes an overlap of selves and their locations, the other crucial aspect is her style. As I have asserted, *Persepolis*'s presentation of pictorial space is discursive: Satrapi displays the political horror producing and marking her "ordinary" childhood by offering what seems to a reader to be a visual disjuncture in her child's-eye rendition of trauma. This expressionism weaves the process of memory into the book's technique of visualization. Satrapi's stark style is monochromatic—there is no evident shading technique; she offers flat black and white. The condition of remembering, Kate Flint points out, "may be elicited by the depiction of deliberately empty spaces, inviting the projection of that which can only be seen in the mind's eye on to an inviting vacancy" (2003, 530). In *Persepolis*, while many of the backgrounds of panels are spare, a significant number of them are also entirely black. The visual emptiness of the simple, ungraded blackness in the frames shows not the scarcity of memory, but rather its thickness, its depth; the "vacancy" represents the practice of memory, for the author and possibly for the reader.

STYLE AND TRAUMA: THE CHILD

Satrapi's technique also specifically references ancient Persian miniatures, murals, and friezes, especially in the frequent scenes in which public skirmishes appear as stylized and even symmetrical formations of bodies. Her style locates itself along a continuum of Persian art: Satrapi notes that in Persian miniatures, as in her own text, "the drawing itself is very simple," eschewing perspective—and she describes this aspect of her style as "the Iranian side [that] will always be with me" (2004a). Sheila Canby observes that Persian painting offers a "flat surface to form a rhythmic whole"—a quality we note throughout *Persepolis* that Canby asserts necessarily marks Persian paintings as exceeding mere mimetic representation (1993, 7). But while we may recognize traditions of Persian art in *Persepolis*, Satrapi's use of black and white specifically, as with the political underpinnings of her overall visual syntax, must also be understood as consonant with traditions of the historical avant-garde. The minimalist play of black and white is part of Satrapi's stated aim, as with avant-garde tradition, to present events with a pointed degree of abstraction in order to call attention to the horror of history, by re-representing endemic images, either imagined or reproduced, of vio-

lence. While Luc Sante (2004) suggests the expressionist Matisse as an inspiration, *Persepolis*'s sure, stronger stylistic inspiration is avant-garde, black-and-white cinema—especially expressionistic films such as Murnau's vampire fantasy *Nosferatu* (1922), whose "games" with black and white Satrapi has claimed as an influence (2004a).

Theorizing her particular use of black and white—which is not related to the color-rich classic tradition of Persian miniatures—Satrapi explains, "I write a lot about the Middle East, so I write about violence. Violence today has become something so normal, so banal—that is to say everybody thinks it's normal. But it's not normal. To draw it and put it in color—the color of flesh and the red of the blood, and so forth—reduces it by making it realistic" (Hajdu 2004, 35). Throughout, *Persepolis* is devastatingly truthful and yet stylized. The fact of style as a narrative choice—and not simply a default expression—is fundamental to understanding graphic narrative (as it is, of course, to understanding, say, prose, poetry, and painting).[9] Satrapi's choice of pared-down techniques of line and perspective—as with modernist painting such as Cezanne's; as with German Expressionism; and as with abstract expressionism, which justifies a flatness of composition to intensify affective content—is hardly a shortcoming of ability (as some critics have alleged) but rather a sophisticated, and historically cognizant, means of doing the work of seeing.[10]

Satrapi's autobiography is a "story of a childhood," and *Persepolis*'s style reflects this perspective: the narrative's force and bite come from the radical disjuncture between the often-gorgeous minimalism of Satrapi's drawings and the infinitely complicated traumatic events they depict: harassment, torture, execution, bombings, mass murder. *Persepolis* is about imagining and witnessing violence; more than half its chapters—which each commence with a black bar framing a white title drawn in block letters and preceded by a single, shifting icon—contain images of dead bodies and serious, mostly fatal, violence. A prominent example of what I have named its child's-eye rendition of trauma occurs early, in the book's second chapter, "The Bicycle."

Here, in the text's first startling image of violence, Satrapi depicts a massacre that Marji first hears about by eavesdropping on a discussion between her parents. The corresponding image we see represents the death of four hundred moviegoers deliberately trapped inside the burning Rex Cinema (whom the police willfully decline to rescue): it is a

large, almost full-page-sized panel in which the anonymous, stylized dead, their faces shown as hollow skulls, fly burning up from their seats as sizzling, screaming ghosts (2003a, 15). This is clearly a child's image of fiery death, but it is also one that haunts the text because of its incommensurability—and yet its expressionistic consonance—with what we are provoked to imagine is the visual reality of this brutal murder. While Satrapi defines her text as one of witness—"I was born in a country in a certain time, and I was witness to many things. I was a witness to a revolution. I was a witness to war. I was witness to a huge emigration"—we see in *Persepolis* that witnessing is, in part, an inclusive, collective ethos: the author draws a scene of death not as a child perceives it empirically, but as she *imagines* it in a culture pervaded by fear of violence and retribution (Leith 2004, 12). In this sense, *Persepolis*—ostensibly a text about growing up and the private sphere—blurs the line between private and public speech.[11] In a form keyed to structural gaps through the frame-gutter sequence, Satrapi further stresses the gap between our knowledge (or our own imagination) of what brute suffering looks like and that possessed by a child. The tension that is structural to pictorially depicting trauma in a visual idiom shaped by the discursive scaffolding of a child is one of *Persepolis*'s most moving and effective tactics supplied by the graphic narrative form.

The following chapters reflect Marji's growing awareness of turmoil, in that they offer further images of massacre. They both present mass death in a highly stylized fashion: indeed, they show her attempts to understand violence and death through attempts to visualize these occurrences and circumstances. As befits a child's understanding, the style is simple, expressionistic, even lovely in its visual symmetry: in the penultimate panel of "The Letter," Satrapi draws ten bodies—five on each side of the panel (2003a, 39) (Fig. 2). They are horizontally stretched out, abstractly stacked, configured to meet one another, as if linked in dying (the man in the foreground of the frame reaches his arm across its length, almost as if embracing the man who faces him). The bodies are stylized against a black background, filling up the frame, some open mouthed in horror, some appearing grimly asleep. In that mass death in Satrapi's work looks almost architectural, her representations both suggest a child's too-tidy conceptualization of "mass" death and tacitly suggest the disturbing, anonymous profusion of bodies in the Iranian landscape.

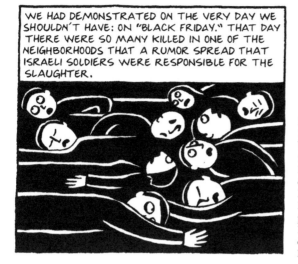

Fig. 2. From *Persepolis: The Story of a Childhood* by Marjane Satrapi, translated by Mattias Ripa and Blake Ferris, copyright © 2003 by L'Association, Paris, France. Used by permission of Pantheon Books, a division of Random House, Inc.

Forcefully underlining the work that style performs in *Persepolis*, the chapter "The Heroes" is one of the most pivotal in the book. Here, two political prisoners recently released from prison after the shah's upending, and who are friends of the Satrapi family, visit their home and describe their experiences of torture to the Satrapis. Significantly, Siamak Jari also describes how a guerilla friend *did not* survive his time in prison. A panel, large and unbordered—its unboundedness evoking both the uncontainability of trauma and also the fleeting, uncategorizable images running through Marji's imagination as she listens to Siamak recount the fate of a guerilla friend who "suffered the worst torture"— accompanies the narration (2003a, 51).

A torturer urinates into open wounds on the man's back; brutally whips the man bound face down to a table; thrusts an iron into the center of the man's back, searing his flesh. While we are supposed to understand these depictions as the child Marji's envisionings, they are plausible visualizations, consonant with the "real world" depicted in the text. The page's last tier is one single panel—connoting stillness in eliminating the passage of time between frames—in which Marji contemplates the household iron: "I never imagined that you could use that appliance for torture" (51). While these images unsettle the reader, on the following page, Marji's imagining of Ahmadi's final, fatal torture is one of the text's most potent moments, suggesting the political point of Satrapi's expressionism.

We learn from Siamak of Ahmadi that "in the end he was cut to pieces" (52). The accompanying, page-wide panel shows the limit—what Marji *cannot* yet realistically imagine (Fig. 3). The frame depicts a man in seven neat pieces, laid out horizontally as a dismembered doll on an operating table would appear (indeed, he appears hollow). His head is separated cleanly from the torso, precisely severed at the waist, shoulders, and above the knees. Referring to this panel in an interview, Satrapi theorizes her visual-verbal methodology in *Persepolis*, calling attention to the pitfalls of other, ostensibly transparent representational modes: "I cannot take the idea of a man cut into pieces and just write it. It would not be anything but cynical. That's why I drew it" (Bahrampour 2003, E1). By drawing this image from a child's (realistically erroneous but emotionally, expressionistically informed) perspective, Satrapi shows us that certain modes of representation depict historical trauma more effectively, and more horrifically, than does realism (in part because they are able to do justice to the self-consciousness that traumatic representation demands).

The visual, *Persepolis* shows, can represent crucially important stories from a child's putatively "simple" perspective, because no perspective, however informed, can fully represent trauma.[12] The horror of "the idea of a man cut into pieces" cannot be adequately illustrated by words—or by pictures—from the perspective of either children or adults: it is in "excess of our frames of reference," as is testimony itself (Felman 1992, 5). Here, the patently artificial containment of testimony, the act of

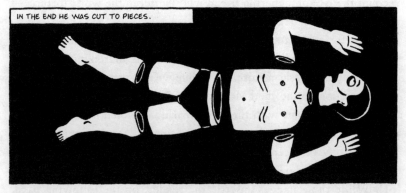

Fig. 3. From *Persepolis: The Story of a Childhood* by Marjane Satrapi, translated by Mattias Ripa and Blake Ferris, copyright © 2003 by L'Association, Paris, France. Used by permission of Pantheon Books, a division of Random House, Inc.

bearing witness, in comics frames signals, but not despairingly, the text's awareness of this condition of representation. In *Persepolis*, Marji's visualizing of a man cut into neat, hollow pieces provides what I have been calling a productive disjuncture. It is a moment of defamiliarization (a child's imaging of torture) in which one recognizes not only the inadequacy of any representation to such traumatic history, but also, more significant, the simultaneous power of the radically inadequate (the child's naive confusion).[13] *Persepolis* at once comments on the insufficiency of any representation to "fully" represent trauma and also harnesses the power of the visual to represent an important emotional landscape (the child's), which is moving paradoxically because of its distance from and proximity to the realities it references. In the panel's emotional impact and its spareness, offering a disarticulated, white body floating on an all-black background, *Persepolis*'s style shows that the retracing work of historical graphic narrative—even when retracing trauma—does not have to be visually traumatic. The minimalist, two-tone, simplified schema of *Persepolis* at once speaks to the question of representation and also, in its accessible syntax, its visual ease, suggests the horrifying normalcy of violence in Iran.

VIOLENCE AND THE ORDINARY

Persepolis does not shy away from representing trauma, even as it stylizes it. Dead bodies litter the text, appearing consistently—and significantly—in pages that also casually situate readers in the everyday details of Marji's life. Throughout, *Persepolis* demonstrates the imbrication of the personal and the historical. We see this clearly in the chapter "The Cigarette." Its last page is composed in three tiers: the top tier is located in the family basement, the middle tier at an execution site, and the bottom tier back in the basement. Satrapi shows us—as if it is par for the course—a panel depicting five blindfolded prisoners about to be executed against a wall, directly above and below frames in which we view Marji in that prosaic, timeless rite of initiation: smoking her first cigarette (2003a, 117) (Fig. 4). Here, Satrapi presents her experience as literally, graphically divided by historical trauma. This episode acquires further significance by breaking out of the book's established schema of narrative levels. Marji faces readers head-on, as if directly addressing us, and delivers frank summaries of historical and personal events. This retrospective mode of narratorial address to the audience from *within* the

pictorial space of the frame and the child body of Marji is unusual in the text; the blurring of voices and registers here works with the blurring of the historical and "everyday" registers that is also part of the narrative suggestion of the page.

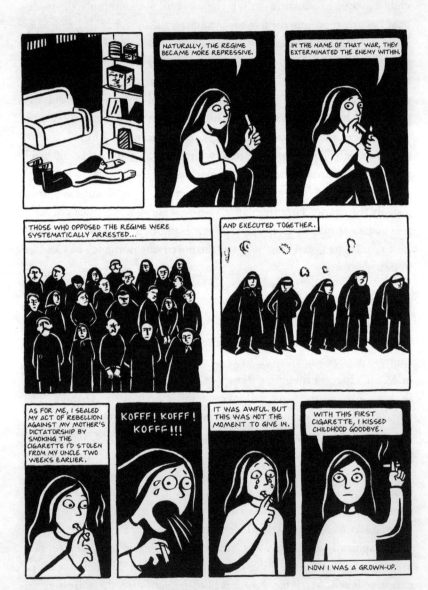

Fig. 4. From *Persepolis: The Story of a Childhood* by Marjane Satrapi, translated by Mattias Ripa and Blake Ferris, copyright © 2003 by L'Association, Paris, France. Used by permission of Pantheon Books, a division of Random House, Inc.

Through techniques such as combining on a page—with only apparent casualness—what constitutes the historical "routine" (execution) and the personal "routine" (sneaking cigarettes), Satrapi uses her understated graphic idiom to convey the horror of her "story of a childhood." *Persepolis* shows trauma as ordinary, both in the text's *form*—the understated, spatial correspondences *Persepolis* employs to narrative effect through comics panelization—and in *style*: the understated quality of Satrapi's line that rejects the visually laborious in order to departicularize the singular witnessing of the author, as well as open out the text to readers. In its simple style, *Persepolis* powerfully alludes to the ordinariness of trauma: one does not need, and in fact should reject, the virtuosic to tell this tale, it suggests. The book's division into chapters with plain titles, most of which commence with the definite article "the" and are followed by a commonplace noun, denotes the ordinariness Satrapi is intent on underlining, even when the events depicted appear extraordinary.[14] And while *Persepolis* may show trauma as (unfortunately) ordinary, it rejects the idea that it is (or should ever be) normal, suggesting everywhere that the ethical, verbal, and visual practice of "not forgetting" is not merely about exposing and challenging the virulent machinations of "official histories," but is more specifically about examining and bearing witness to the intertwining of the everyday and the historical. Its polemical resonance lies in its rejection of the very idea that the visually virtuosic is required to represent the political trauma that plagues Marji's childhood.

Its only apparent visual simplicity coupled with emotional and political complexity—and insisting on the connectivity of aesthetics and politics—*Persepolis* has earned the most international attention of any graphic narrative in the past ten years (it has been translated into more than twenty languages). And yet, right now, *Persepolis* is poised to garner an even larger readership. On May 27, 2007, the film version—which was written and directed by Satrapi, and to which she retains all creative rights—won the Jury Prize at the Cannes Film Festival.[15] *Persepolis* the film presents several intriguing aspects relevant to this essay's discussion of witnessing. That Satrapi, a first-time director with no film experience, confidently declined to sell the rights (even when Hollywood money came calling), and demanded full creative control, demonstrates how one woman brought the auteur-driven model of the literary graphic narrative—and life narrative—to a different medium (one that happens to be the dominant representational idiom of our time).

Satrapi translates the conceptual, epistemological concerns of her graphic narrative into the medium of film through its process of creation. She insisted on an artisanal mode of production, so her team hand-traced images on paper—an art that has long been obsolete in animation, replaced by computer technology. She also insisted—as for the graphic narrative—on black and white, a rarity for contemporary animated films. But most strikingly, *Persepolis* the film, as with the book, insists in its mode of production on what I call the texture of retracing, and underlines the power and risk of reproducing and making visible the site of one's inscriptional effacement (as critique, as a narrative of development, as a positing of the collectivity of self). As with American author Alison Bechdel—who posed, for her own visual reference, for every person in every frame of her brilliant graphic memoir *Fun Home*—Satrapi acted out the physical gestures for each scene of the film to give her animators a physical reference ("I play all the roles. Even the dog," she told the *New York Times* [Hohenadel 2007, 18]). *Persepolis* is a work of reimagination and literal reconstruction that retraces the growing child body in space, reinscribing that body by hand to generate a framework in which to put versions of self—some stripped of agency, some possessing it—in productive conversation. *Persepolis* the film is, in a sense, a repetition of this primary act of repetition. Satrapi, in the expanded field of production afforded by film, yet inserts her literal, physical body into each frame of the film through her own physical act of repetition.

Making the hidden visible is a powerful if familiar feminist trope. Yet for Satrapi, as with other authors of feminist graphic narrative, making the hidden visible is not simply rhetorical; *Persepolis* offers not simply a "visibility politics," but an ethical and troubling visual aesthetics, presenting the censored and the censured through the urgent "process of re-representation and re-symbolization," to draw on a crucial formulation of Drucilla Cornell's (1995, 106). Iran, which, as noted earlier, has not allowed the graphic narrative to be published there, decried the film version of *Persepolis*; the day after it won the Jury Prize, Medhi Kalhor, cultural advisor to President Mahmoud Ahmadinejad, released a statement to the Iranian press calling the film "anti-Iranian" and accusing it of trying to "sabotage Iranian culture" (Satrapi, accepting her Cannes prize, dedicated her award "to all Iranians," despite explaining at a press conference that "I no longer go to Iran, because the rule of law does not exist there") (iafrica.com 2007; "Persepolis" 2007). Kalhor further alleged,

"The Cannes Film Festival, in an unconventional and unsuitable act, has chosen a movie about Iran that has presented an unrealistic picture of the achievements and results of the glorious Islamic Revolution in some of its parts" (PressTV 2007). Protesting the prize, the culture bureau demonstrates both the enormous impact and the risk of representation that Satrapi forces us to confront, offering us texts that suggest the importance of cultural invention and visual-verbal mapping in the ongoing project of grasping history.

ACKNOWLEDGMENTS

Thank you to Marianne DeKoven, Nancy K. Miller, Art Spiegelman, and Amy Squires for stimulating conversations about Satrapi. I'm grateful to Joe Ponce, Ana Merino, and two anonymous *WSQ* readers for their specific suggestions.

HILLARY CHUTE is a Junior Fellow in Literature in the Harvard Society of Fellows. Coeditor with Marianne DeKoven of the "Graphic Narrative" issue of *Modern Fiction Studies*, she has essays published or forthcoming in *American Periodicals*, *Literature and Medicine*, *Modern Fiction Studies*, *PMLA*, and *Twentieth-Century Literature*. She is working with Art Spiegelman on his project *MetaMaus* (forthcoming, Pantheon, 2009) in addition to a book on feminist graphic narratives.

NOTES

1. I agree, for example, with journalist Peggy Orenstein, who asserts in a lengthy profile of cartoonist Phoebe Gloeckner—which, ironically, ran in the *New York Times Magazine* in 2001—that "a small cadre" of women cartoonists "is creating some of the edgiest work about young women's lives in any medium." Orenstein makes an important point: "Perversely, even their marginalization—as cartoonists, as literary cartoonists, as female literary cartoonists—works in their favor. Free from the pressures of the marketplace, they can explore taboo aspects of girls' lives with the illusion of safety" (28). In a forthcoming book project, I examine work by Gloeckner as well as by Marjane Satrapi, Lynda Barry, Alison Bechdel, and Aline Kominsky-Crumb.

2. Female cartoonists themselves have long been vocal proponents and theorists of the value of their work in a male-dominated medium. The noncommercial American "underground comix revolution" of the late 1960s and 1970s—which established the mode of serious, artistic work for adults that we now recognize in the term "graphic novel"—saw numerous and heterogeneous feminist comic books. One of these, *Twisted Sisters*, went on to engender two important book collections of original work

(1991 and 1995), many of whose contributors are discussed in the *Comics Journal* issue "Comics Gal-ore" (2001).

3. For further explanation of comics terminology, see Chute 2006.

4. If James Olney writes that the autobiographical practice he calls "the autobiography of memory" is composed "simultaneously of narration and commentary; past experience and present vision, and a fusion of the two in the double 'I' of the book," graphic narratives meet and *exceed* Olney's criteria in displaying the autobiographer's shaping "vision" (1980, 248).

5. There are two volumes of *Persepolis*. All page references here are to the first volume, *Persepolis: The Story of a Childhood* (Satrapi 2003a).

6. For more on the European comics field, see Beaty 2007. *Persepolis* was originally published in France in two volumes as *Persepolis 1* and *Persepolis 2* by L'Association in 2000 and 2001, respectively.

7. *Ms.* excerpted *Persepolis* previous to the book's release in a section titled "Writing of War and Its Consequences." In *Ms.*, the title of the work—*Persepolis: Tales from an Ordinary Iranian Girlhood*—differs from that of the final book version issued by Pantheon, which carries the subtitle *The Story of a Childhood* (2003a); the inclusion of "ordinary" in the original title underlines one of the central claims of this essay. *Persepolis*'s sequel, *Persepolis 2: The Story of a Return* (2004b); a memoir-style story about sex and intergenerationality, *Embroideries* (2005); and an account of the suicide of Satrapi's musician great-uncle, *Chicken with Plums* (2006) have also been published in English; I focus here solely, as noted, on the first volume of *Persepolis*.

8. In "Painting Memory," Kate Flint tracks the shifting perceptions of Victorian artists in the process of representing the invisible operations of memory; she points out that "memory, in part because of the way in which it is bound in with the operation of the senses, had come to be seen as something different from simple recall" (2003, 530).

9. Critics have misread graphic narrative: Patricia Storace, for example, comments that *Persepolis* is "a book in which it is almost impossible to find an image distinguished enough to consider an important piece of visual art" (2005, 40). As I hope to make clear, authors of graphic narrative are not interested in creating images to be independent artworks, but rather in what Spiegelman calls picture writing, and Satrapi calls narrative drawing.

10. The merit of *Persepolis*'s style has been a subject of debate in the United States, and also in Europe (see Beaty 2007, 246–48). One common strain of criticism identifies the book's political topicality as its reason for success but devalues its aesthetics.

11. I use "speech" in the manner of Leigh Gilmore's assertions about the "nexus of trauma and gender as the terrain of political speech, even when that speech explicitly draws on a rhetoric of private life and elaborates a space of privacy" (2003, 715).

12. However, in keeping with my focus on what I think of as the "risk of representation" of trauma in visual-verbal texts, there is significant critical attention to the role of the visual in the presentation of traumatic experience. See, for example, Saltzman and Rosenberg 2006 and Bennett 2005.

13. I use "imaging" in de Lauretis's sense as that which binds affect and meaning

to images by establishing the terms of identification, orienting the movement of desire, and positioning the spectator in relation to them (1984, 135).

14. The two exceptions are a place-name—"Moscow"—and a proper name, that of a popular American singer, "Kim Wilde."

15. Satrapi codirected the film with Vincent Paronnaud, a fellow comic-book author who also had no feature-length film experience (the film is in French). The two shared the Jury Prize, a tie, with *Silent Light*'s Carlos Reygadas.

WORKS CITED

Bahrampour, Tara. 2003. "Tempering Rage by Drawing Comics," *New York Times*, May 21.

Beaty, Bart. 2007. *Unpopular Culture: Transforming the European Comic Book in the 1990s*. Toronto: University of Toronto Press.

Bennett, Jill. 2005. *Empathic Vision: Affect, Trauma, and Contemporary Art*. Stanford: Stanford University Press.

Canby, Sheila R. 1993. *Persian Painting*. London: Thames and Hudson.

Chute, Hillary. 2006. "Decoding Comics." *Modern Fiction Studies* 52(4):1014–27.

Cornell, Drucilla. 1995. *The Imaginary Domain: Abortion, Pornography, and Sexual Harassment*. New York: Routledge.

de Lauretis, Teresa. 1984. *Alice Doesn't: Feminism, Semiotics, Cinema*. Bloomington: University of Indiana Press.

Felman, Shoshana. 1992. "Education and Crisis, or, the Vicissitudes of Teaching." In *Testimony: Crisis of Witnessing in Literature, Psychoanalysis, and History*, by Shoshana Felman and Dori Laub. New York: Routledge.

Felski, Rita. 2000. *Doing Time: Feminist Theory and Postmodern Culture*. New York: New York University Press.

Flint, Kate. 2003. "Painting Memory." *Textual Practice* 17(3):527–42.

Gilmore, Leigh. 2003. "Jurisdictions: *I, Rigoberta Menchú*, *The Kiss*, and Scandalous Self-Representation in the Age of Memoir and Trauma." *Signs: Journal of Women and Culture in Society* 28(2):695–718.

Hajdu, David. 2004. "Persian Miniatures." *BookForum*, October/November, 32–35.

Hohenadel, Kristin. 2007. "An Animated Adventure, Drawn from Life." *New York Times*, January 21.

Huffer, Lynn. 2001. "'There Is No Gomorrah'": Narrative Ethics in Feminist and Queer Theory." In *differences: A Journal of Feminist Cultural Studies* 12(3):1–32.

iafrica.com. 2007. "Iran Blasts 'Islamophobic' Film." May 29. http://entertainment.iafrica.com/news/912582.htm.

Leith, Sam. 2004. "A Writer's Life: Marjane Satrapi." *Daily Telegraph*, November 27.

McGrath, Charles. 2004. "Not Funnies." *New York Times Magazine*, July 11.

Menu, Jean-Christophe. 2006. "Interview by Matthias Wivel." *Comics Journal* 277:144–74.

Olney, James. 1980. "Some Versions of Memory/Some Versions of *Bios*: The Ontology of Autobiography." In *Autobiography: Essays Theoretical and Critical*, edited by James Olney. Princeton: Princeton University Press.

Orenstein, Peggy. 2001. "Phoebe Gloekner is Creating Stories about the Dark Side of Growing Up Female." *New York Times Magazine*, August 5.

"Persepolis." 2007. Cannes Film Festival profile. http://www.festival-cannes.com/index.php/en/archives/film/4434938.

PressTV. 2007. "Persepolis Another Scenario Against Iran." May 28. www.presstv.ir.

Rose, Jacqueline. 1986. *Sexuality in the Field of Vision*. London: Verso.

Saltzman, Lisa, and Eric Rosenberg, eds. 2006. *Trauma and Visuality in Modernity*. Hanover: Dartmouth College Press.

Sante, Luc. 2004. "She Can't Go Home Again." *New York Times*, August 22.

Satrapi, Marjane. 2003a. *Persepolis: The Story of a Childhood*. New York: Pantheon.

———. 2003b. "Tales From an Ordinary Iranian Girlhood." *Ms.*, Spring.

———. 2004a. "*Address on Persepolis*." Barnes & Noble, New York City, September 8.

———. 2004b. *Persepolis 2: The Story of a Return*. New York: Pantheon.

———. 2005. *Embroideries*. New York: Pantheon.

———. 2006. *Chicken with Plums*. New York: Pantheon.

Storace, Patricia. 2005. "A Double Life in Black and White." *New York Review of Books*, April 7.

DRAWING THE ARCHIVE IN ALISON BECHDEL'S
FUN HOME

ANN CVETKOVICH

Placing Alison Bechdel's *Fun Home* alongside other graphic narratives, most notably Art Spiegelman's *Maus* (1993) and Marjane Satrapi's *Persepolis* (2003), that explore intergenerational trauma and the role of the child as witness, seems both obvious and potentially inappropriate, even presumptuous.[1] In writing about the Holocaust and the Islamic Revolution in Iran, respectively, Spiegelman and Satrapi take on histories that have been formative for global politics in the past century. In *Fun Home*, by contrast, there is no mass genocide or the same obvious connection to political debate, and the single death, that of Bechdel's father, someone who might be categorized (however problematically) as a pedophile, suicide, or closet homosexual, raises the possibility that there are some lives that are not "grievable," certainly not in a public context (Butler 2004, 20).

But a queer, even perverse, sensibility not unlike Bechdel's draws me to idiosyncratic or shameful family stories and their incommensurate relation to global politics and historical trauma. I want to risk inappropriate claims for the significance of Bechdel's story, to read it in the context not just of *Maus* and *Persepolis* but also efforts to redefine the connections between memory and history, private experience and public life, and individual loss and collective trauma. *Fun Home* confirms my commitment (in *An Archive of Feelings* [2003]) to queer perspectives on trauma that challenge the relation between the catastrophic and the everyday and that make public space for lives whose very ordinariness makes them historically meaningful. And although *Fun Home*'s critical and popular success obviously provides many entry points for readers (and warrants its sustained attention in this issue of *WSQ*), Bechdel's narrative of family life with a father who is attracted to adolescent boys has particular meaning for me because it provides a welcome alternative to public discourses about LGBTQ politics that are increasingly homonormative and dedicated to family values.

[*WSQ: Women's Studies Quarterly* 36: 1 & 2 (Spring/Summer 2008)]

I write more as a specialist in queer studies than as one in graphic narrative, but I hope nonetheless to articulate how Bechdel uses this insurgent genre to provide a queer perspective that is missing from public discourse about both historical trauma and sexual politics. The recent success of graphic narrative, a hybrid or mixed-media genre, and also a relatively new and experimental one, within mainstream literary public spheres suggests that providing witness to intimate life puts pressure on standard genres and modes of public discourse. I seek to juxtapose *Fun Home* with other prominent graphic memoirs such as *Maus* and *Persepolis* to show how its queer sensibility extends their treatment of the relation between individual and historical experience, so central to second-generation witness, especially through a more pronounced focus on sexuality. But I also want to situate *Fun Home* as part of other insurgent genres of queer culture, such as memoir, solo performance, women's music, and autoethnographic documentary film and video, including the traditions of lesbian feminist culture within which Bechdel's long-running *Dykes to Watch Out For* comic strip circulates. Standing at the intersections of both contemporary LGBTQ culture and public discussions of historical trauma, *Fun Home* dares to claim historical significance and public space not only for a lesbian coming-out story but also for one that is tied to what some might see as shameful sexual histories.

WITNESSING SEXUALITY

Dori Laub's claim, in the context of Holocaust testimony, that trauma is an "event without a witness" (in part because the epistemic crisis of trauma is such that even the survivor is not fully present for the event) takes on a different resonance in Bechdel's story about her father, who was run over by a truck while crossing the highway outside the house he was restoring (Felman and Laub 1991, 80).[2] In a literal sense, his death is an event without a witness (other than the truck driver, who thinks that her father might have jumped back into the road); and Bechdel and her mother's hunch that it is a suicide, or somehow connected to his complex sexual history, is ultimately only speculation. While the moment of her father's death is arguably the "unrepresentable" trauma to which the text insistently returns, it is also the point of departure for the more diffuse narrative of his sexuality, which encompasses not only his attraction to young men but also his devotion to literature and home restoration, his emotionally volatile relation to his wife and children, and his artistic

ambitions. Like Satrapi and Spiegelman, Bechdel serves as an intergenerational witness who explores the ongoing impact of traumatic histories on successive generations and into the present; each of their texts in its own way is haunted by questions about the effects of growing up in the vicinity of powerful combinations of violence and secrecy, including forms of secrecy that in the interest of protecting children's innocence seem only to harm them. But Alison's experiences growing up with an eccentric family and an emotionally erratic father in a funeral home in rural Pennsylvania may seem of a different order from Marji's direct witnessing of war and revolution in Iran in *Persepolis*. Bechdel's case might seem more comparable to that of Spiegelman, who has been shaped by a story that precedes him and the withholding of which produces forms of what Marianne Hirsch has called "postmemory" (1997). But *Maus* emerges from Spiegelman's interviews with his father (the basis for its written text), whereas Bechdel has no such overt connection of witness to her father, since he emphatically did not tell her about his sexual life. (Even their brief explicit acknowledgment of a shared homosexuality just before his death is something of a missed encounter.) While not on the order of the literal horror of Spiegelman's father's life in Poland and Auschwitz, Bechdel's father's story is arguably "unspeakable" in its own way, a reminder that "the love that dare not speak its name" is an applicable term even in the era after Stonewall, since men who desire other men but who are married and living in small towns, or men who desire young boys, rarely talk about their sexual desires, particularly not to their young daughters. (I hesitate about language, since the term "pedophilia" carries connotations that presume its criminality or immorality, although I sometimes use it here in order to challenge such presumptions.)

I'd like to underscore, then, that Bechdel's focus on sexualities, and especially illicit or secret sexualities, gives a decidedly queer twist to the second-generation witnessing exemplified by *Maus* and *Persepolis*. The secrecy and shame attached to Bechdel's father's sexual life make it function like occluded trauma and suggest the relevance of witness to a range of seemingly ordinary contexts. Bechdel explores the story of her father's death out of a desire to understand her own history and the genesis of her gender and sexual identity, seeking to be the sympathetic witness who can make available the rich and contradictory story of his life so that he is something more than a pedophile, suicide, or tragic homosexual. Her

witnessing is complex, like a version of Nachträglichkeit, in that she goes back to the past and revisits it for the signs of queerness that she didn't quite see at the time.

Sexuality also complicates the graphic narrative's dynamic combination of the visual and textual and its important use of the visual to both enhance and trouble acts of witness. While it can carry with it the presumption of the evidentiary truth of seeing so attached to the visual, graphic narrative's hand-crafted drawing distinguishes it from contemporary realist forms such as photography and film and reminds us that we are not gaining access to an unmediated form of vision. For example, Spiegelman's famous cats and mice and Satrapi's stylized black-and-white forms reconfigure the relation between the visual and the truthful, demonstrating in visual form testimony's power to provide forms of truth that are emotional rather than factual.[3]

One of the biggest representational challenges for Bechdel is not so much the mystery of her father's suicide as the secret of his sexual attraction to young boys and the messy question of his sexual identity. To become a "witness" (either literally or more indirectly) to anyone's sexuality is a difficult documentary task, given its frequent privacy or intimacy, and this general secrecy can be further heightened when that sexuality is constructed as immoral or criminal or perverse. Moreover, for a child to explore a parent's sexuality is potentially to transgress social boundaries. Yet while Bechdel has no way of directly knowing all the details of her father's sexuality (and perhaps because of that), she is an avid observer and collector of evidence both as a child and as an adult artist, and one of *Fun Home*'s distinctive features is her reproduction of paper documents that have provided crucial access to her father's story in the absence of more direct forms of information. It is this archival mode of witness that I want to explore in further detail.

DRAWING THE EVIDENCE

One of the most striking examples of archival documentation in *Fun Home*, with respect to both its visual qualities and its narrative significance, is an image that Bechdel has called the book's "centerfold"—a two-page spread, the only one of its kind in the book, that features a careful reproduction of a snapshot of the family's male babysitter.

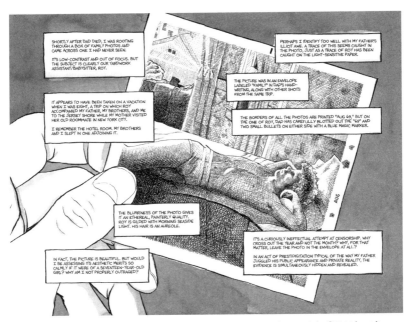

Fig. 1.: Alison Bechdel, *Fun Home: A Family Tragicomic*, 100–101. (Copyright ©2006 by Alison Bechdel. Reprinted by permission of Houghton Mifflin Company. All rights reserved.)

Taken by her father during a family vacation, the photograph of Roy lying supine on a motel bed, wearing only jockey shorts, his arms raised to expose his bare chest and his torso turned to face the camera, combines the conventions of pornography and the high-culture nude. In an interview, Bechdel describes coming across the photograph after her father's death and being startled by this disturbing visual and material evidence of his parallel life taking place in the room next to where she and her brothers were sleeping and in the midst of their childhood fun on the beach (Chute 2006, 1006). As much as the event of her father's death itself, this unsettling image, which resituates what she thinks she knows about her own experience and her family's history, serves as the initial inspiration for *Fun Home* and becomes the visual and emotional kernel out of which the story emerges.

The "centerfold's" visual elements—its style, composition, layout, and sequencing—underscore its emotional significance. The frame also includes Alison's hand holding the photograph (tilted at an angle) as a reminder that there is a witness here, for whom this photograph leaps out of the past in an odd version of Benjamin's notion of history as that which

"flashes up at a moment of danger" (Benjamin 1940/1969, 255). The details that give it the historical qualities of a 1970s snapshot are painstakingly reproduced—the square shape, the white border, the printed date (mysteriously blotted out by her father).[4] Accentuating its capacity to disrupt the family history, on the following page (2006, 102) Bechdel draws the strip of negatives (like a miniature graphic narrative) that includes images of her and her brothers playing on the beach right next to the image of Roy (all of them bordered, ironically, by the familiar "Kodak Safety" logo). But the proximity of these ostensibly disparate images (both enabled by the technology of the home camera) offers evidence of her father's capacity to inhabit different worlds simultaneously and shows how the putatively innocent family vacation is closely shadowed by sexual desires that it excludes or renders invisible. Adding a further layer of complexity to the image of the snapshot is the superimposed text that offers Alison's adult comments and reflections. Using the powers of the graphic form to combine word and text, Bechdel both reproduces the visual evidence and engages in a discussion of what it means.

Indeed, along with Alison, we might ask what kind of visual evidence the photograph offers. What, in other words, is wrong with this picture? Is it in itself incriminating because it represents an erotic gaze that is inappropriate? Does it gesture toward a sexual act that remains unwitnessed in the photo, providing circumstantial evidence of some possibly criminal form of behavior? Is the problem homosexuality? Or intergenerational sexuality? Or just the fact of secrecy? And, if the last, is her father responsible for the secrecy, or is it the product of his times? Offering no easy answers to these questions, the photograph's status as evidence is indeterminate. Its real significance lies in what it means to

A PERUSAL OF THE NEGATIVES REVEALS THREE BRIGHT SHOTS OF MY BROTHERS AND ME ON THE BEACH FOLLOWED BY THE DARK, MURKY ONE OF ROY ON THE BED.

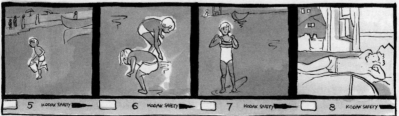

Fig. 2.: Alison Bechdel, *Fun Home: A Family Tragicomic*, 102. (Copyright ©2006 by Alison Bechdel. Reprinted by permission of Houghton Mifflin Company. All rights reserved.)

Bechdel looking at it from adulthood. As such, the photograph becomes a key document in what I have elsewhere called the "archive of feelings," serving as a touchstone for both her father's feelings and her own, as well as for the complexities of their relationship. Following in her father's path, Alison reads the photo not in realist terms but in aesthetic and erotic ones: "The blurriness of the photo gives it an ethereal and painterly quality. Roy is gilded with morning seaside light. His hair is an aureole" (Bechdel 2006, 100). Part of her shock comes from viewing the photograph as framed through her father's sexual desire. She acknowledges that "the picture is beautiful" and wonders why she is not "outraged" as she might be if it were a photograph of a young girl (100). "Perhaps I identify too well with my father's illicit awe" (101). Alison moves away from moral condemnation of the image, letting it sit uncomfortably within ambiguous distinctions between the erotic and the aesthetic, the past and the present, the father's sexuality and his daughter's.

This image is of particular interest to those reading intertextually with *Maus*, in which Spiegelman strategically places three archival family photographs—a snapshot of the future artist, Artie, with his mother (who committed suicide); a photograph of the dead brother, Richieu, whom Artie never knew; and a studio portrait of his father in a concentration camp outfit taken shortly after his release from Auschwitz. In an important reading of these images, Marianne Hirsch suggests that, precisely because they are reproduced as copies rather than drawn, the photographs rupture the surrounding graphic text and hence become a sign of unassimilable memory (1997, 29). It's interesting that photographs have a similar emotional and visual power within Bechdel's text despite their being drawn images rather than copies. Bechdel has suggested that she draws actual photographs to remind the reader that her story is connected to actual lives, echoing Hirsch's emphasis on the photograph's access to the shock of the unassimilable real and its ability to hover between life and death by bringing the absent dead into the realm of the living. That Bechdel's drawings could have the disruptive force of photographs owes something to the labor she devotes to reproducing them. Her detailed and, by her own admission, even obsessional act of reproduction becomes a form of witness, made possible by a sustained attention to the object that reinforces her attachment to it. The style, however, is not photorealism. The cross-hatching and shading that she uses to render the photograph's qualities are those of the drawing, or even the print; in fact, by drawing

her father's photographic portrait of Roy, she returns it to the genre from which it borrows and becomes the artist her father aspired to be. Despite their differences—the photograph instantaneous, the drawing laborious; the photograph apparently truthful, the drawing achieving other kinds of verisimilitude—both serve as technologies of memory. And it is not just as images but as material objects connected to lost pasts that they serve as the site of dense and often unprocessed feeling.

Moreover, unlike the photographs of dead family members that interrupt Spiegelman's text, Bechdel's photograph points toward disturbing sexual desires, which might better remain lost or forgotten. Noting the effort at "censorship" in her father's blotting out of the date on the photo, Alison concludes that the photograph's "evidence is simultaneously hidden and revealed," like the relation between "public appearance and private reality" in her father's life (Bechdel 2006, 101). Whereas Spiegelman's photographs might safely (albeit painfully) inhabit the family living room or album (while also, as Hirsch argues, constituting public history), Bechdel's photograph has an uneasy relation to publicity—although her father sealed the image and its negative with the other vacation photos in an envelope marked "family" and saved the box, it is not necessarily for public or even private consumption. For Bechdel as a public and political lesbian, there might be something disturbing about her own inability to recognize her father's hidden life, even if she wouldn't be expected to as a child. She carries the responsibility of not continuing to closet him, even if revealing his questionable sexual behavior casts doubt not only on her own sexuality but also that of gay people more generally. Rather than taking on the potentially heroic task of exposing the persecution of the Jews or the Iranian people, as do Spiegelman and Satrapi, Bechdel has to grapple with the more ambiguous morality of her father's status as a perpetrator of sorts. (Although, ultimately, Spiegelman and Satrapi also trouble easy moral categories: Spiegelman by being willing to explore his father's bad behavior and even the painful repercussions of his mother's suicide, and Satrapi by exploring the mixed results of the Islamic revolution, especially for women.) Central to *Fun Home*'s moral and political complexity is its willingness to engage with sexual desire as a messy and unpredictable force that can't be relegated to scapegoated perverts. Mimicking her father as witness to the image, Alison is brought closer to him only at the risk of replicating his illicit sexual desires.

Placed in the larger context of the chapter in which it appears, whose title, "In the Shadow of Young Girls in Flower," and whose literary references come from Proust, Alison's discovery of the photograph leads to a complex sense of the connection between her and her father. She explores their shared identity as "inverts" as well as her own "inverted" relation to her father—where he is sissy, she is butch; where he is aesthetically fussy and baroque, she is spare and minimalist; while he wants her to wear a dress, she wants to wear his suits. Immediately before the image of the photograph of Roy, she describes their shared interest in the image of a young man posing in an *Esquire* magazine fashion spread—she wants the suit, while her father wants the boy, and in anticipation of the image to follow, there is another layered set of gazes as she holds the magazine and her father watches the image over her shoulder (Bechdel 2006, 99). The image of Roy's photo inverts this structure as Bechdel draws herself holding the photograph that provides access to what her father saw, as though *she* is looking over *his* shoulder. In either case, she can't separate herself from her father's sexuality or his aesthetics, a point that she underscores by noting Proust's ability to convert the one into the other. Graphically representing this relationship through more drawn photographs that appear at the chapter's end, where father and daughter mirror each other as gender-crossing homosexuals, they are intertwined in a way that doesn't allow easy distinctions between perverse and normal sexuality, obsession and art, or pre-liberation closeted queers and out and proud lesbians and gays.

BECHDEL'S ARCHIVE OF FEELINGS

In addition to photographs, *Fun Home* is structured around many other paper documents, including diaries, maps, and books, especially literary ones, that Bechdel also painstakingly reproduces to obtain access to history. Describing herself as a compulsive collector, she imports this archive into her text, rendering each document with such care that her drawings carry some of the same magical qualities of the photograph's verisimilitude. Indeed, photography is an integral part of her laborious process, since many of her drawings are based on actual photographs, some of them acquired through research and others made by posing herself in settings that she then draws. As adept with print sources as visual ones, Bechdel also lovingly reproduces pages of print text from both literary and handwritten sources, often blowing them up beyond their

MY DIARY ENTRIES FOR THAT WEEKEND ARE ALMOST COMPLETELY OBSCURED.

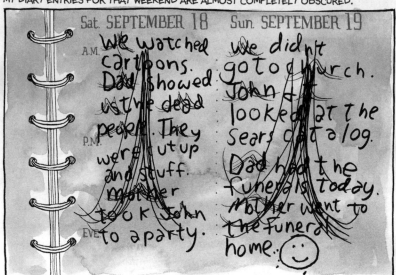

Fig. 3.: Alison Bechdel, *Fun Home: A Family Tragicomic*, 148. (Copyright ©2006 by Alison Bechdel. Reprinted by permission of Houghton Mifflin Company. All rights reserved.)

usual size so as to emphasize their material qualities and emotional meanings. Bechdel thus creates an "archive of feelings," using the intensive labor of her drawing to become an archivist whose documents are important not merely for the information they contain but because they are memorial talismans that carry the affective weight of the past. The act of drawing itself thus becomes an act of witness, while also giving rise to a collection of emotionally charged documents and objects.

Offering the promise of direct witness, Bechdel's childhood diaries are an especially poignant document in her archive because they also show early signs of her "obsessive compulsive" impulse to document or witness and its relation to creative autobiography. Introduced to the genre by her father, who initially gives her an advertising calendar to write in, the diaries connect her to the high-culture literary world of Joyce, Proust, and other writers to which her father, the high school English teacher and frustrated artist, aspires, but they are also part of the culture of young girls in the 1960s and 1970s who did not necessarily think they were making art. The ordinary life that the diaries document— school, TV, vacations—takes an ominous turn though, as Alison's efforts to witness in a world of silences, secrets, and repressions lead to various

forms of writer's block, censorship, and unrepresentability. Sentences are disrupted by the insertion of a hesitant "I think," which later turns into a blot and then morphs into a "curvy circumflex" mark that eventually strikes out entire sections of text.

The act of witnessing appears to break down as Alison is unable even to document the everyday events that are so frequently the subject of adolescent journals. The graphic act of striking out words with a mark that is a cross between word and image (and which in turn makes the drawings of the text of the diary become as much image as word) provides its own eloquent testimony to the impossibility of documenting truthfully what she is seeing or experiencing. It suggests the potential ordinariness of the unrepresentability that is the hallmark of some theories of trauma.[5] Even though she has no direct knowledge of her father's sexual desires or activities, the diaries provide witness to the secrecy and uncertainty that pervade the house, testifying to her inchoate reaction to that which cannot be narrated. There's something deeply poignant about the form of witness provided by that odd graphic symbol, especially since what it effaces (and announces) is nothing so dramatic as the violence of war or genocide but simply the all-too-ordinary life of an adolescent girl growing up with silences around emotion and sexuality.

In a subsequent chapter, Bechdel plays with denial as both personal and political, linking her own censorship of sexual issues—masturbation and menstruation—with the Watergate scandal and its lies and omissions, as well as with her father's arrest for giving a beer to a minor. Perhaps her inability to testify to her own sexuality explains her father's failure to make his own transparent. Alison describes as "Wildean" her use of the phrase "How Horrid!" to represent sexuality because "it appears to embrace the actual horror—puberty, public disgrace—then at the last second nimbly sidesteps it, laughing" (a comment that she illustrates with a television image of a Roadrunner cartoon in which the bird narrowly misses being hit with a falling object) (Bechdel 2006, 174). Indeed, Alison often circles around her feelings or speculates about them at a distance. Like her father, whose lack of feeling for the corpses in his undertaking business leads him to show the young Alison a body in what she imagines to be an effort at vicarious feeling, she often turns to the activity of documentation in the absence of feeling. Although it might seem that drawing replaces words, compensating for narrative's lapses, Alison's "compulsive propensity to autobiography" (140) sug-

gests that witnessing can be the sign of emotional distress as much as its cure. She frequently links the creative and the compulsive in describing both her own and her parents' artistic talents, as well as connecting the expressive energies of creativity to those of sexualities that might be seen as perverse.

Perhaps creative obsession and a desire to have access to feelings that remain elusive explain Bechdel's elaborate and varied renditions of archival documents. Especially notable is her use of maps, inspired by the *Wind in the Willows* map that she loved as child, to locate from a cartographic distance her father's circumscribed trajectory in the small town of Beech Creek in the hills of western Pennsylvania as though she might be able to map the history that she can't comprehend as a direct witness. Equally important are the drawings of literary texts that become the vehicle for a dazzling array of intertextual references that pervade *Fun Home* and, by orienting it towards high culture, have led to its critical and crossover success. Although space limitations prevent me from exploring this archive in detail, were I to do so I would want to link the high culture references to the equally dense proliferation of lesbian and feminist texts. In addition to Joyce and Camus and Proust and Fitzgerald, there are not only other versions of modernism represented by Colette, Sylvia Beach, Virginia Woolf, and Radclyffe Hall, but also a feminist canon that includes *Our Bodies, Our Selves*, Olga Broumas, Adrienne Rich, Kate Millett, Jill Johnston, Rita Mae Brown, and Jane Rule (but also, adding a queer touch, Cecil Beaton!).[6] Bechdel includes drawings of stacks of books that serve as a kind of bibliography for the narrative (2006, 76, 205, 207). Alongside such literary icons as Joyce and Proust, *Fun Home* also finds its foundation in Bechdel's long-running serial comic strip *Dykes to Watch Out For*. Bechdel's ability to move seamlessly between lesbian culture and high culture, combining, for example, in one hilarious series of frames cunnilingus and the *Odyssey*, is crucial to *Fun Home*'s power to craft new archives of history and memory.

QUEER TIME

One effect of Bechdel's archival documents is the insertion of her family story within a larger public history and one that is significantly queer. For example, Alison refers to having been in New York as a young girl not long before the Stonewall riots (but having no awareness of them until much later), suggesting that she is both part of that history and out-

side it. (It's notable that she makes contact with history when she leaves Beech Creek for a larger world, particularly that of New York City.) In representing the Bicentennial of 1976, during which she and her family made one of the periodic trips to New York that appear to have given her father access to an overtly gay culture, she links the tall ships on the Hudson to another version of U.S. culture, a moment of gay ascendancy and sexual expression in the West Village and a time before AIDS. She reminds us of other temporalities and histories that pervade the national public even as they remain largely invisible within it—her father's queerness and her own incipient lesbianism. In asking about the relation between two generations of queerness, her own and that of her father, Bechdel also raises larger questions about histories of sexuality and their relation to national histories.

Alison's references to histories of sexual liberation and sexual community suggests that her life might be significantly different from her father's not only for personal reasons but also for historical ones—she comes out in a culture of 1970s lesbian feminism that is part of her college experience; her father, despite fleeting contacts with a world beyond rural Pennsylvania, in Paris and New York (and also perhaps even more significantly through literature), does not have access to the social world that might allow him to assume a more overtly gay identity. Would this also prevent him from being a lover of young boys or a suicide? Is the book calling for the social or structural changes that might make history work itself out differently? Bechdel offers no simple answers to these questions, thus avoiding the pieties that can sometimes accompany a cultural politics of witnessing that would encourage us to sympathize with her father as a victim of history whose problems could be solved by our retrospective enlightenment. Although Alison certainly gestures toward this version of historical contextualization, she also refuses to settle for it definitively—"Maybe I'm trying to render my senseless loss meaningful by linking it, however posthumously, to a more coherent narrative. A narrative of injustice, sexual shame and fear, of life considered expendable. There's a certain emotional expedience to claiming him as a tragic victim of homophobia, but that's a problematic line of thought. For one thing, it makes it harder for me to blame him" (Bechdel 2006, 196). Pursuing this more selfish investment in her father's fate, Alison also notes that this altered version of history would erase her own—had her father assumed a gay identity he might never have married and had children.

Moreover, he might have avoided suicide only to become a member of the generation of gay men affected by the AIDS crisis that emerges in the years immediately following his death.

By playing out the alternative histories in negative as well as positive ways, Bechdel reminds us that there can be no self-congratulatory separation of past and present, as though her father's life would never happen now and her lesbian identity is safely cordoned off from his. By constructing a more complex intergenerational connection between herself and her father, she doesn't disavow the relation between his homosexuality and her lesbianism, between his femme tastes and her butch style, between his fussy home decorating and her compulsive drawing. She is willing to claim her father for herself and hence for history, insisting that his story be incorporated into a more fully historicized present but also that its unassimilability be acknowledged in order to problematize the present. In doing so, she embraces a queer temporality, one that refuses narratives of progress.

Indeed, *Fun Home* can be productively read alongside recent critical interest in queer temporalities, particularly Elizabeth Freeman's call for rethinking queer generations in order to feel the "temporal drag" of putatively anachronistic categories such as "lesbian" and feminist" (2000).[7] In fact, one of *Fun Home*'s charms is that it claims a relatively unapologetic relation to the lesbian feminist culture within which Alison came out, although it maintains the sense of self-deprecating humor that is the hallmark of *Dykes to Watch Out For* (and gives the lie to the idea that the culture of lesbian political correctness is unremittingly sincere or serious). In this case, the anachronistic identity is her father's closeted homosexuality, which persists even in the post-Stonewall period of gay liberation, thus serving as another reminder of uneven temporalities. Bechdel makes the interesting move of claiming a paternal lineage for a generation of lesbian feminism more commonly known for its embrace of a matriarchy and also connects it to a version of homosexuality that might seem the anathema of her generation. She joins a cluster of lesbian artists who have claimed their father's stories, sometimes in order to explore butch identities but also in ways that go well beyond this obvious connection in order to rewrite queer generational histories.[8]

In doing so, Bechdel also adds a queer dimension to the witness narratives of other graphic narrative writers such as Satrapi and Spiegelman, extending their consideration of the messy complicities of past and

present through her more overt treatment of sexuality. As second-generation narratives that explore the legacy of catastrophic events across time, all three narratives understand how (as Hillary Chute also points out) history makes itself manifest in ordinary life, in the endlessly petty complaints of a Holocaust survivor father, in the dress codes of young Iranian schoolgirls, in the restoration of a rural Pennsylvania home. By representing not only her own lesbian identity (as part of a generation that is repeatedly erased or misrepresented in the public sphere) but also her father's stigmatized identity, she enlarges the scope of historical witness. It is important to understand these graphic narratives not just as efforts to explore the personal effects of history; they also use ordinary experience as an opening onto revisionist histories that avoid the emotional simplifications that can sometimes accompany representations of even the most unassimilable historical traumas. Thus, one of Spiegelman's most important contributions to Holocaust representations is not the history of the camps themselves but his exploration of his ambivalent relation to his father. Satrapi's text is most trenchant when exploring the contradictions of the Iranian Revolution and its relation to previous histories of colonialism. Like these authors, Bechdel refuses easy distinctions between heroes and perpetrators, but doing so via a figure who represents a highly stigmatized sexuality is a bold move. I find her willingness to represent her father with compassion and complexity particularly poignant in the current moment when not only a general public but LGBTQ cultures are quite willing to disavow stigmatized identities that might disrupt the clean wholesome image of gay people who just want to get married and have families. Those of us who resist this direction for LGBTQ politics have had a hard time making ourselves seen or heard in a public sphere that has been dominated by calls for and against gay marriage, but Bechdel sidesteps this debate in favor of a different form of visibility.[9]

In the two final images on the last page of *Fun Home*, Bechdel returns to the relationship between Icarus and Daedalus that opened the narrative, in the wake of having linked it to the complex relation between Bloom and Stephen Dedalus in Joyce's *Ulysses*. She follows a close-up of the truck that killed her father (linking him to the falling Icarus) with one of her father, in the position now of Daedalus, catching her in the pool as a child. Reversing time and inverting roles in a fantasy that makes him the paternal protector, Bechdel ends with the possibility

of rewriting history, including the canon of male literary heroes that her text continually invokes. With this messy story of a father who is neither hero nor victim, crafted from an aesthetic power that is also linked to compulsions both psychic and sexual, Bechdel keeps history indeterminate. *Fun Home*'s queer witnessing deserves to be part of its highly successful and well-deserved reception, since it provides such a compelling challenge to celebratory queer histories that threaten to erase more disturbing and unassimilable inheritances. Perhaps we can look to graphic narrative and other new genres of public feeling that shape personal witness into historical commentary to renew both queer politics and public cultures.

ACKNOWLEDGMENTS

I'd like to thank Lisa Duggan, Lisa Moore, and Ann Reynolds for helpful readings and discussion, as well as the journal's anonymous reviewers.

ANN CVETKOVICH is professor of English and women's and gender studies at the University of Texas at Austin. She is the author of *Mixed Feelings: Feminism, Mass Culture, and Victorian Sensationalism* (Rutgers University Press, 1992) and *An Archive of Feelings: Trauma, Sexuality, and Lesbian Public Cultures* (Duke University Press, 2003). She is coeditor (with Annamarie Jagose) of *GLQ: A Journal of Lesbian and Gay Studies*.

NOTES

1. The category of graphic narratives in which *Fun Home* could be classified is huge, but I compare it with these two because they have had such significant mainstream visibility and because they all bring the graphic narrative to "serious" subjects that allow it to compete alongside the novel. The crossover success of Bechdel's book is all the more notable, given her long-standing work on the weekly comic strip *Dykes to Watch Out For*, which, while very successful with a lesbian audience, has not necessarily been widely read by others. For a good selection of reviews of *Fun Home* and information about its many reviews, see Alison Bechdel's web site at www.alisonbechdel.com.

Following a practice that has become conventional in discussions of memoir, I use "Bechdel" to refer to the author outside the text, and "Alison" to refer to her presence inside the text. I use the term "graphic narrative" for reasons that Hillary Chute suggests in her essay in this volume, especially since these three texts are closer to memoir or creative nonfiction than to the novel. For more on graphic narrative, see the special issue of *Modern Fiction Studies* edited by Chute and Marianne DeKoven (2006).

2. Cathy Caruth's notion of "unclaimed experience" has also widely disseminated the association of trauma with unrepresentability and epistemic crisis. See *Trauma* (1995) and *Unclaimed Experience* (1996).

3. See Hillary Chute's essay in this volume for more on Satrapi's graphics.

4. Bechdel's reproduction of the photographic archive as a form of access to history is reminiscent of Zoe Leonard's work in *The Fae Richards Photo Archive*, a series of fictional photographs created for Cheryl Dunye's film *The Watermelon Woman* (Dunye and Leonard 1996). See *An Archive of Feelings* for a discussion of this work and the use of invented archives by lesbian cultural producers (Cvetkovich 2003). Bechdel's use of the graphic narrative to combine text and image can be compared to the blurring of fiction and documentary in other visual genres such as photography, film, and video to document history.

5. I'm thinking here of Cathy Caruth's work but would argue that the ordinariness of unrepresentability reframes her emphasis on its extreme nature.

6. For a rich discussion of the literary references in *Fun Home*, see Michael Moon's review (2006), especially his argument that Colette is ultimately more important to the narrative than Joyce or Proust.

I would also compare Bechdel to visual artist Nicole Eisenman, who combines references to Picasso and many other canonical artists with lesbian popular culture, often using a cartoonish style.

7. In addition to Freeman's article in *New Literary History* (2000), see the special issue of *GLQ* that she edited (2007). For other important work on queer temporalities, and especially the reclamation of failed or perverse histories, see Dinshaw (forthcoming, 2008), Love (2007), and Nealon (2001).

8. Examples include Marga Gomez, *A Line Around the Block*; Peggy Shaw, *You're Just Like My Father*; and Lisa Kron, *2.5 Minute Ride* (2001) (which is also a second-generation Holocaust story). These are all in the genre of solo performance, which I would link to the graphic narrative as another insurgent form of memoir that makes personal experience historical. See Holly Hughes and David Roman on queer solo performance as a form of historical witness in *O Solo Homo* (1998).

9. See, for example, the "Beyond Same-Sex Marriage" statement (2006), Duggan 2003, and Warner 1999.

WORKS CITED

Bechdel, Alison. 2006. *Fun Home: A Family Tragicomic*. New York: Dutton.

———. n.d. www.alisonbechdel.com.

Benjamin, Walter. 1940/1969. "Theses on the Philosophy of History." In *Illuminations*. Translated by Harry Zohn. New York: Schocken.

"Beyond Same-Sex Marriage: A New Strategic Vision for All Our Families and Relationships." 2006. www.beyondmarriage.org.

Butler, Judith. 2004. *Precarious Life: The Power of Mourning and Violence*. New York: Verso.

Caruth, Cathy, ed. 1995. *Trauma: Explorations in Memory*. Baltimore: Johns Hopkins University Press.

———. 1996. *Unclaimed Experience: Trauma, Narrative, and History*. Baltimore: Johns Hopkins University Press.

Chute, Hillary. 2006. "An Interview with Alison Bechdel." *Modern Fiction Studies* 52(4):1004–15.

Chute, Hillary, and Marianne DeKoven, eds. 2006. "Graphic Narrative." Special issue, *Modern Fiction Studies* 52(4).

Cvetkovich, Ann. 2003. *An Archive of Feelings: Trauma, Sexuality, and Lesbian Public Cultures*. Durham: Duke University Press.

Dinshaw, Carolyn. Forthcoming, 2008. "Born Too Soon, Born Too Late: The Female Hunter of Long Eddy, Circa 1855."

Duggan, Lisa. 2003. *The Twilight of Equality*. Boston: Beacon.

Dunye, Cheryl, and Zoe Leonard. 1996. *The Fae Richards Photo Archive*. San Francisco: Artspace Books.

Felman, Shoshana, and Dori Laub. 1991. *Testimony: Crises in Witnessing in Literature, Psychoanalysis, and History*. New York: Routledge.

Freeman, Elizabeth. 2000. "Packing History, Count(er)ing Generations." *New Literary History* 31:727–44.

———, ed. 2007. "Queer Temporalities." Special issue, *GLQ: A Journal of Lesbian and Gay Studies* 13(2–3).

Hirsch, Marianne. 1997. *Family Frames: Photography, Narrative, and Postmemory*. Cambridge: Harvard University Press.

Hughes, Holly, and David Roman. 1998. *O Solo Homo: The New Queer Performance*. New York: Grove Press.

Kron, Lisa. 2001. *2.5 Minute Ride and 101 Humiliating Stories*. New York: Theatre Communications Group.

Love, Heather. 2007. *Feeling Backward: Loss and the Politics of History*. Cambridge: Harvard University Press.

Moon, Michael. 2006. Review of *Fun Home*. *Gutter Geek*. September http://guttergeek.com/funhome.html.

Nealon. Chris. 2001. *Foundlings: Lesbian and Gay Emotion Before Stonewall*. Durham: Duke University Press.

Satrapi, Marjane. 2003. *Persepolis: The Story of a Childhood*. New York: Pantheon.

Spiegelman, Art. 1993. *Maus: A Survivor's Tale: My Father Bleeds History/Here My Troubles Began*. New York: Pantheon.

Warner, Michael. 1999. *The Trouble with Normal: Sex, Politics, and the Ethics of Queer Life*. Cambridge: Harvard University Press.

CLOSING THE GAP IN ALISON BECHDEL'S *FUN HOME*

JENNIFER LEMBERG

Alison Bechdel's 2006 memoir, *Fun Home: A Family Tragicomic*, makes a strong and explicit claim for the power of graphic narrative as witness. Employing the straightforward visual style developed over more than twenty years as creator of the comic strip *Dykes to Watch Out For*, in *Fun Home* Bechdel explores her relationship with her father, Bruce, who died when she was in college. Although his death was declared an accident— he was hit by a truck while working outdoors near their family's home in rural Pennsylvania—Bechdel is convinced it was a suicide, a sign of his deep unhappiness. The event occurs shortly after she comes out to her parents as a lesbian, an announcement that is followed by the revelation that her father, too, has struggled with his sexuality. In the memoir, Bechdel seeks to understand the connections between her father's life and her own and to work through the trauma that can accompany queer identity. Created in the shadow of a father who "used his skillful artifice not to make things, but to make things appear to be what they were not" (2006a, 16), however, *Fun Home* bears witness not only to Bruce Bechdel's trauma and its effect on his family, but also to the artist's effort to claim the authority to represent their story.[1]

Bechdel's comic style may at first seem almost "invisible" behind her exploration of other mediums, particularly photography and literature.[2] Photographs and texts are critical to her effort to uncover her family's history, and she relies on them extensively in structuring *Fun Home*. Hillary Chute notes that a family photograph drawn by Bechdel appears at the beginning of every chapter (Bechdel 2006b, 1009), and these are carefully paired with phrases from works of literature relevant to this story of two English-teacher parents and their well-read daughter. In this context, what Bechdel has called the "usual cartoony style" she uses to draw most of the book seems to exist in service to the "real" documents and images it is used to explore (1009). Yet, as Ann Cvetkovich observes in her essay for this issue, the contribution of literature and

[*WSQ: Women's Studies Quarterly* 36: 1 & 2 (Spring/Summer 2008)]

photographs to understanding the story of a life are interrogated within the memoir, their usefulness as documentary evidence or narrative models held up to careful scrutiny (see pages 116 and 122, this volume). Photographs prove difficult to decipher, while overidentification with literature by and about other people threatens to throw lives off course. By framing each of her chapters with words and images that bear a complex relationship to each other, Bechdel reminds us that it is in the space between existing visual images and familiar storylines where we make meaning of our individual lives. Here, that is precisely the space described by comics. And while *Fun Home* casts doubt on our ability to interpret the visual and textual worlds around us, it also invests a particular faith in its author's chosen medium.

Cvetkovich rightly identifies *Fun Home* as a work of what Marianne Hirsch has called postmemory (see page 113, this volume), a term for how the memory of trauma belonging to one generation can shape the memories of the next (Hirsch 1997, 22). In her ongoing study of postmemorial visual art, Hirsch has stressed the importance of "forms of identification that are nonappropriative," through which artists may communicate the memory of transmitted trauma without claiming to know it fully (2002, 88). This is accomplished most successfully, Hirsch maintains, by work that "allows for a historical *withholding* that does not absorb the other" but is also able to "expand the circle of postmemory in multiple, inviting, and open-ended ways" (88).[3] Consistent with these ideas, Cvetkovich shows how Bechdel admits to being unable to truly know her father's trauma and thereby preserves the specificity of his story. Additionally, however, Bechdel relies upon the visual element of comics to bring the reader into her complex family history. As Hirsch has argued in *Family Frames*, "The individual subject is constituted in the space of the family through looking" (1997, 9), and throughout *Fun Home*, Bechdel highlights moments of perception that offer illuminating forms of knowledge crucial to her development as a woman, a lesbian, and an artist both within and outside the visual field proscribed by her father's watchfulness.

Intent on telling her family's story, Bechdel must get beyond her parents' deceptions and denials, even as her commitment to the truth prevents her from speculating too widely. Despite her father's seemingly overwhelming influence in the memoir, however, after his suicide, Bechdel writes, "his absence resonated retroactively, echoing back through all the time I knew him," so that she experienced something that

was the "converse of the way amputees feel pain in a missing limb. He really was there all those years. . . . But I ached as if he were already gone" (2006a, 23).[4] She is anxious to bear witness to her father's presence in her family and seeks to counter this "absence" through her art. One of the ways in which she responds to this challenge is to present her father in his many different aspects—as a "lowering, malevolent presence"; an aspiring "country squire"; a college student wearing a woman's bathing suit; and even, finally, as a corpse—in order to convey the depth and variety of his character.

To further thematize the difficulty of recovering her father's presence, Bechdel depicts her childhood encounters with the visible world, part of the memoirist's attempt to represent that which would otherwise remain unseen.[5] Crucial to her exploration is the Bechdel family home, a nineteenth-century Gothic Revival house that, like her father, is complex and multifaceted. "Fun home" is a nickname for the funeral home her father inherits (an event that brings Bechdel's parents back to his hometown to live), but it also suggests, in its similarity to "funhouse" or "funny farm," the distortions of Bechdel's childhood and the way the house her father slavishly restores serves as a screen for his unhappiness. Proving that her father "really was there" requires the author to render not only the rare moments of connection between father and daughter, but also his effort to hide. Nowhere is this more apparent than in his continuing struggle to perfect the house, which therefore becomes the most visible feature of his presence.

The family's house and her father's internal conflicts are directly linked in the narration as well as the composition of the memoir. "His shame inhabited our house as pervasively and invisibly as the aromatic musk of aging mahogany," Bechdel writes. "In fact, the meticulous, period interiors were expressly designed to conceal it. Mirrors, distracting bronzes, multiple doorways. Visitors often got lost upstairs" (2006a, 20). On this single page, Bechdel employs an arrangement used only rarely in the book, with four rectangular panels of the same size evenly laid out.[6] In their symmetry, the panels convey the sense of order her father strives to achieve in his obsessive attention to his surroundings. Looking more closely, however, we find images of an upstairs interior that is perfectly arranged but also unsettling, just as Bechdel describes.

In the panels, the vertical stripes of the hallway wallpaper are interrupted by a series of doorways, behind which we glimpse young Alison

slipping into her room or spy her father safely tucked away in bed.[7] We are unable to see their faces, so that the physical space overpowers our perception of the people inside. The more visible human figures in the upper-left and lower-right panels include Bechdel as a child and a representative visitor to the house who stands, confused, before a large (funhouse) mirror that seems deceptively like yet another doorway. Both figures are simply drawn, so that the daughter who lives there and the unnamed guest seem similarly lost. With the equally sized panels promising order that we do not find, the confusing vertical lines of the doorways, stairwells, and wallpaper, and figures that are barely visible or are unknown to us, we experience the house's interior as a series of refusals, and like its occupants, we have difficulty making sense of what we see.

Bechdel points to the challenge as well as the importance of seeing past her father's constructions in her depiction of the house. But as she makes very clear, the order of the house belies the chaos of the life lived within it, not just her father's shame but also the messiness of everyday family interactions. "It's tempting to suggest, in retrospect, that our family was a sham," Bechdel reflects. "That our house was not a real home, but the simulacrum of one, a museum" (2006a, 17). However, she affirms that despite the lies, just as her father "really was there," "we really were a family, and we really did live in those period rooms" (17). With these words we find a long horizontal panel depicting a great deal of activity: a cat strolls across the room; the children race toy cars around a track, play

Fig. 1. Excerpted from *Fun Home: A Family Tragicomic* by Alison Bechdel. Copyright © 2006 by Alison Bechdel. Reprinted by permission of Houghton Mifflin Company. All rights reserved.

with Tinkertoys, or dig through open drawers whose contents are in disarray; while Helen Bechdel reclines on a settee, her husband sitting on the floor watching television, drinking wine, and eating straight from a giant bucket of Kentucky Fried Chicken.

This image, which invites the reader to linger over its length and assorted details, stands to counter several others preceding it, where the family presents a more perfect appearance. Just opposite, another long horizontal panel shows them composed and still, posing for a photograph taken by Bruce Bechdel, looking, as the narrative says, "impeccable." This is followed by another image of the family in church, and yet another pose for a photograph, this time taken by Alison and accompanied by the reflection that it would be easy to view her family as a "sham." When we finally see the family in disorder back at home, it reminds us of the ability of comics to depict the life behind the formal pictures. The panel demonstrates the artist's interest in "going beyond the surfaces, telling the stories surrounding the images, attempting to open the curtains" (Hirsch 1997, 107), which Hirsch defines as part of many contemporary artists' effort to get beyond the "familial gaze" that "imposes and perpetuates certain conventional images of the familial" (11), and which, typified by the two poses for a camera held first by the father and then by the daughter, exists in tension in the Bechdel household.[8]

From an early age, Bechdel maintains a suspicion toward appearances in response to her father's behaviors, and this has an impact on her ability to represent the world around her. As an adolescent diarist, she experiences an "epistemological crisis" when she is paralyzed by a growing awareness of the "troubling gap between word and meaning" (2006a, 143). The problem persists until her mother intervenes to help her record her daily activities, in an instance of the older woman's caretaking or of her introducing Alison to a language of denial. As Cvetkovich remarks, the crisis is caused in large part by Alison's growing awareness of the silences in her family's life and the sexual secrets they imply (page 121, this volume).[9] Even as Bechdel demonstrates how writing becomes almost impossible for her, however, she offers several examples of the way in which drawing seems capable of filling the "gap" between language and its subject. What remains unspeakable in her family and unrepresented in her diary can be at least partially represented through images. While she does not articulate precisely how or why this is so, she consistently privileges drawing as a more direct mode of representation.

Without elaborating on her thoughts about the workings of the comic form, Bechdel nonetheless tells us that before she was stricken by the inability to write, as a child she was captivated by the images in her *Wind in the Willows* coloring book, in particular by the pictures on the map of "the Wild Wood." In addition to the pleasure of recognition offered by the resemblance of the map's topography to that of her hometown, Beech Creek, the pictures accompanying the place-names provided a special fascination: they offered, Bechdel recalls, a "mystical bridging of the symbolic and the real, of the label and the thing itself" (2006a, 147).[10] Unlike the dissonance of writing, these simplified images seem to exist in harmony with their subjects, and Bechdel carries this early understanding of drawing into her adolescence. It is precisely when she is unable to write that Bechdel locates drawing as an outlet for queer desires that, under her father's vigilant maintenance of her femininity and oppressive social norms, are continually held at bay.

Drawing seems both to produce strong feelings and to provide a medium capable of expressing them, and Bechdel's discovery of the power of creating visual art is rendered as a climactic experience. At one point, a series of images reveals Alison alone at her desk as she sketches a lithe young male basketball player and experiences "an omnipotence that was in itself erotic. In the flat chests and slim hips of my surrogates, I found release from my own increasing burden of flesh" (2006a, 170). Over several panels, we see first Alison's hands drawing the young man; then the lower part of her body as she rocks in her chair to achieve orgasm; then her hands again, now clutching the desk surrounding the picture she's made as she experiences an "implosive spasm so staggeringly complete and perfect that for a few brief moments I could not question its inherent moral validity" (171). While drawing the picture has not itself caused her to orgasm, the caption makes it so that the reader encounters these two acts almost simultaneously, their connection made explicit.

Special significance attaches to the picture Alison draws in this scene, emphasizing the ability of visual art to express ideas that her writing cannot support. In an earlier set of panels, we see Alison firmly rooted on the ground, watching her male cousins' bodies arc through the air as they play a game of basketball (Bechdel 2006a, 96–97). These scenes are interspersed with others depicting a struggle between Alison and her father over her unwillingness to wear a barrette in her hair, a symbolic

battle in which she resists his efforts to make her more obviously feminine. "It keeps the hair out of your eyes," he tells her. "So would a crewcut," she responds, and they continue to argue for two pages, her father insisting she wear the barrette before she goes out and replacing it after she removes it during the game (96). Alison's resistance to wearing this feminine accessory is premised upon desires that she cannot yet fully articulate, much as her father's determination is related to unspoken needs of his own. Functioning as a "surrogate" that embodies aspects of her queer identity, the basketball player she draws signifies feelings she cannot put into words. These are related to desire, pleasure, and self-knowledge and have already been marked as illicit.

Until she finds the words that will eventually allow her to type, simply, "I am a lesbian," in a letter she mails home from college, the drawing Alison creates serves as evidence of her ability to know herself, proof of an internal state that external appearances tend to obscure. As part of her effort to bear witness, then, Bechdel uses her art to foreground instances of seeing during which she achieves clarity about her own needs and fantasies. She balances an awareness of the limits of her own perception with faith in her vision as a source of knowledge. Further, at these moments she self-consciously draws attention to the visual dimension of the narrative, slowing down time and posing her subjects almost as if to reinforce the idea that it is her controlling vision that determines what we see on the page.

Although Bechdel has said that the family photographs she drew for the book remind readers that the story is "real" (2006b, 1009), Scott McCloud contends in *Understanding Comics* that more "realistic" drawings of people convey a sense of absolute "otherness" (1994, 44), while cartoons, in their simplicity, seem more readily accessible (36). Bechdel's "cartoony" drawings of people may therefore allow us to feel that we know them more fully, their simplicity implying a direct link between the subject and its representation, like the images on the map that fascinated her as a child.[11] In this way, the world outside the photographs, the comic world Bechdel creates for us from her own vision, may seem most real. As an example, we may look at the image of the "truck-driving bulldyke" Bechdel sees when she is a girl. This woman is described as one whom Bechdel "recognized . . . with a surge of joy," as if she were seeing "someone from home" (2006a, 118) a feeling that stems from the sudden knowledge that "there were women who wore men's clothes and had

Fig. 2. Excerpted from *Fun Home: A Family Tragicomic* by Alison Bechdel. Copyright © 2006 by Alison Bechdel. Reprinted by permission of Houghton Mifflin Company. All rights reserved.

men's haircuts" (118) and that helps to precipitate Bechdel's dawning consciousness of her queer identity.[12]

The bulldyke is drawn as a cartoon, her face and body presented to us for our perusal, as opposed to the more "realistically" drawn photographs, as Bechdel describes them (2006b, 1009) that refuse our identification and by extension our understanding. Further, in successive panels Alison is shown first behind the woman, inviting us to compare their faces, and then staring backward toward her, returning our gaze to her image. While we learn that Alison's father "recognized her too" and that his sneering question, "Is *that* what you want to look like?" discourages Alison from admitting the strong feelings of affinity by which she is possessed (2006a, 118), as readers we are compelled by the woman's image. The emphasis on looking in these panels suggests the overwhelming visibility Bechdel assigns to this figure and engages us in see-

ing the connection between Alison and the bulldyke that her father is anxious to erase.

Bechdel will use a similar approach in her ongoing exploration of her relationship with her father, relying on acts of looking to convey what her narration cannot easily describe. She is vigilant about reigning in her impulse to identify too strongly with him, and cautiously tries to avoid his tendency to overidentify with the biographies and stories of authors he admired. Yet careful as she is, an important part of her project is also to find a way to bear witness to the strength of their attachment, and she achieves this partly through repeatedly negotiating their relationship on the visual as well as the narrative plane. For example, except for chapter 5, "The Canary-Colored Caravan of Death," which focuses mostly on Bechdel's mother, Helen, all the chapters in *Fun Home* end by depicting Bechdel and her father in a single panel. Often showing the pair occupying the same space yet engaged in separate pursuits, these panels reveal separation as much as togetherness. By consistently yoking father and daughter together in images that the narration does not directly address, however, they visually reinforce the strength of the connection to which Bechdel wishes to attest.

Near the end of the memoir, Bechdel intensifies her use of this technique, specifically employing images to heighten our sense of her bond with her father. Toward the beginning of the last chapter, we find an image of the pair together in New York during the 1976 Bicentennial. Bruce and Alison face the reader, in a static pose that allows us to examine their faces, while Bechdel tells us that on this visit to New York, her first since becoming a teenager, she saw Greenwich Village "in a new light" (2006a, 189). Alison is "seeing" Greenwich Village, but we see her, side by side with her father, and for us the "new light" she describes illuminates the striking resemblance the two family members bear toward each other. The dark background of the night sky makes the image unusually stark, creating relief against which their faces and bodies stand out. Bruce is drawn in greater detail (again, emphasizing his "otherness"), but father and daughter are undeniably alike, their ambiguously gendered appearances allowing great similarity between them. And while a skyscraper in the background divides the figures in the foreground, drawing our eye upward and away from them, this only strengthens our desire to piece the two halves of the picture together. Despite Bechdel's ambivalence about laying too strong a claim to her

father's story, this image asserts a direct link through an ineffable same-
ness, its visibility an important part of the story she is trying to tell.

This does not mean that Bechdel claims absolute authority for her
artistic vision. Crucial events remain beyond our sight, such as the
instants just before and after Bruce's death: no matter how many times
we revisit the empty stretch of highway where he died, we cannot see her
father's death, cannot be certain of why or how it happened. Even seeing
his dead body and visiting his grave cannot make Bechdel believe that he
is gone; like his life, his death remains "incomprehensible" (2006a, 50). Yet
ultimately Bechdel insists upon the validity of her art as a form of witness.
This is emphasized by the choice she makes at the end of the book, when
she closes the final chapter with a panel depicting herself with her father.
At the top of the last page, the grille of a truck bears down upon us. Below
it, in another panel, young Alison leaps off a diving board into her father's
arms, an image that in its construction reprises the panel that began the
memoir, when he held her aloft during a game of airplane. The image
reverses the "photograph" that begins the last chapter, which shows
father and daughter from the opposite direction. In the photograph, taken
from a distance, we see Alison's face, while in the drawing, larger and
close up, we see her father's. It is as if Bechdel has flipped the picture to
peer through the other side, impossible, of course, except through an act
of imagination. Although nearly every chapter ends with an image of
Bechdel with her father, this is the only case where she deliberately
reconstructs and reverses the photograph with which it begins.

These final panels suggest the power that Bechdel attributes to her
vision and her art, even as they testify to her awareness of its limitations.
The image of the truck is arrested by a text box that continues Bechdel's
closing thoughts, in which she reflects on the myth of Icarus with which
she opens the book; the words seem to push back at the oncoming vehicle,
as if to stop it, but we know this cannot happen. The narrative cannot be
altered, if the truth is to be told. And though she may admire an artistic
commitment to what she calls "erotic truth," Bechdel admits that it is "a
rather sweeping concept" and that her father's truth is beyond her knowl-
edge (2006a, 230). Despite all that remains hidden from her, however,
Bechdel maintains that "in the tricky reverse narration that impels our
entwined stories, he was there to catch me when I leapt" (232), suggest-
ing, perhaps, her metaphoric leap into life as an adult queer artist. In bear-
ing witness to their lives, the picture of her family can be reframed, the

perspective shifted, her father's importance to her no longer obscured, but made visible through her art: when she leaps, he is "really there."

Ultimately, *Fun Home* asserts the value of comics as a medium for bearing witness and insists on the validity of Bechdel's perspective in refiguring the image of her family. Whether or not we are convinced, along with young Alison, that images provide a "mystical bridging of the symbolic and the real," or succeed in closing the "gap between word and meaning," we are powerfully engaged by Bechdel's controlling vision. In recruiting us to attend to the trauma that shaped her father's life as well as her own, Bechdel brings us into the "circle of postmemory" Hirsch describes. By pushing us to recognize our role as viewers of the images she creates, she reminds us of just how much our relations with the world around us depend on how, and what, we see.

JENNIFER LEMBERG is an instructor at the Gallatin School of Individualized Study, New York University. She also serves as project coordinator for the Holocaust Educators Network, a professional development organization housed at Lehman College, City University of New York.

NOTES

1. In her essay for this volume, Ann Cvetkovich demonstrates the importance of recognizing the "everyday" trauma Bechdel describes.

2. By referring to Bechdel's comics as "invisible" I am invoking Scott McCloud's denoting of comics as "the invisible art" in *Understanding Comics*. McCloud plays on the notion that comics can "represent the invisible" (1994, 129), but as Douglas Wolk notes, his title also reflects "the medium's tradition of effortlessness" (2007, 124).

3. In her discussion of "historical withholding," Hirsch draws from Gayatri Spivak's analysis of the transmission of trauma between mother and daughter in Toni Morrison's *Beloved* (Spivak 1995).

4. The language Bechdel employs here resonates with discourse sometimes used to describe the experience of children of Holocaust survivors. For example, in her frequently quoted essay "Remembering the Unknown," Nadine Fresco writes of second-generation survivors who "are like people who have had a hand amputated that they never had. It is a phantom pain, in which amnesia takes the place of memory" (1984, 421). Bechdel's formulation differs in establishing her father's presence before his death.

5. For a fuller consideration of this idea, see Ann Cvetkovich, in this issue, on the treatment of family documents in the book.

6. I follow Scott McCloud in referring to an image contained within a single frame a "panel" (1994).

7. Nancy K. Miller (2007), in her recent essay "The Entangled Self: Genre Bondage in the Age of the Memoir," refers to "Alison" when describing Bechdel's younger self as she appears as a character within her own story. My own references are meant to be consistent with Miller's example.

8. The curtains mentioned here recall the frontispiece to Roland Barthes's *Camera Lucida*, an image by Daniel Baudinet, which, Hirsch writes, "serves as a figure for the impenetrable façade of the domestic picture" (1997, 2).

9. For an illuminating discussion of this episode, see Ann Cvetkovich's essay, this issue.

10. Further, a scene from *The Wind in the Willows* is referred to in the chapter title and plays a role in Bechdel's early struggle for artistic independence from her father. The pictures therefore resonate doubly—as evidence of the pleasure Bechdel describes and as a reflection of the world she has created for us as readers.

11. Ann Cvetkovich's analysis, in this issue, of the "centerfold" image in *Fun Home* illustrates how Bechdel acknowledges the difficulty of reading the drawn "photographs" in the book.

12. Bechdel articulates her response to seeing the bulldyke, a figure who, according to Judith Halberstam, "has made lesbianism visible and legible as some kind of confluence of gender disturbance and sexual orientation" (1998, 119), in a way that resembles what she will later say about first putting on men's clothes. Dressing up in her father's suits, Bechdel writes, is "like finding myself fluent in a language I'd never been taught" (2006a, 182); similar to the experience depicted in the earlier scene, it produces a feeling of being at home.

WORKS CITED

Bechdel, Alison. 2006a. *Fun Home: A Family Tragicomic*. New York: Houghton Mifflin.

———. 2006b. "An Interview with Alison Bechdel." Interview by Hillary Chute. *Modern Fiction Studies* 52(4):1004–13.

Fresco, Nadine. 1984. "Remembering the Unknown." *International Review of Psychoanalysis* 11:417–27.

Halberstam, Judith. 1998. *Female Masculinity*. Durham: Duke University Press.

Hirsch, Marianne. 1997. *Family Frames: Photography, Narrative, and Postmemory*. Cambridge: Harvard University Press.

———. 2002. "Marked by Memory: Feminist Reflections on Trauma and Transmission." In *Extremities: Trauma, Testimony, and Community*, edited by Nancy K. Miller and Jason Tougaw. Urbana: University of Illinois Press, 71–91.

McCloud, Scott. 1994. *Understanding Comics: The Invisible Art*. New York: HarperPerennial/HarperCollins.

Miller, Nancy K. 2007. "The Entangled Self: Genre Bondage in the Age of the Memoir." *PMLA* 122(2):537–48.

Spivak, Gayatri Chakravorty. 1995. "Acting Bits/Identity Talk." In *Identities*, edited by Anthony Appiah and Henry Louis Gates, Jr. Chicago: University of Chicago Press, 147–80.

Wolk, Douglas. 2007. *Reading Comics: How Graphic Novels Work and What They Mean*. Cambridge: Da Capo Press/Perseus Books.

THE TILE STOVE

MARIANNE HIRSCH & LEO SPITZER

My emotions peaked when I approached the tile stove, next to which my divan once stood. It was a kind of upright floor-to-ceiling ceramic tile stove, the same one where Papa used to warm the eiderdown to cover me on cold winter nights.

 I opened the creaky door. To my astonishment inside was a gas burner instead of the coal or wooden logs we used in my time. Still caressing the cold tile stove, as if merely by touching it I could reproduce the feelings of a pampered and sheltered infancy, I collapsed into a nearby chair. The river of tears would not stop flowing for several minutes, overwhelmed as I was by this physical contact with my past.

 I stared lovingly at the French crystal-paned doors and the parquet floors we used to walk on. I could almost see Mama meticulously polishing it with the two brushes mounted on her shoes. I got goose bumps as I touched . . . the horizontal iron bar on which everyone used to beat the dust out of the rugs and on which we children exercised our athletic prowess.
—Ruth Glasberg Gold, *Ruth's Journey: A Survivor's Memoir*

Chernivtsi, Ukraine, 1998:
When we accompanied our parents/parents-in-law, Lotte and Carl Hirsch, on their walk through the city of their youth in 1998, we realized how predominant critical and traumatic memories had become for them in the long period of their exile and emigration. Our visits to the public squares and central streets of the former Austrian Czernowitz enabled broad historical narratives to emerge. Walking, we heard accounts of the Romanian takeover of the city and province from the Austrians after World War I; of the process of Romanianization in the 1920s; of the Soviet annexation of the province in 1940, followed by the war and return of fascist Romanians with their Nazi allies; of the establishment of a Jewish ghetto in the city and deportations of Jews in 1941 and 1942. At relevant spots, we also listened to the stories of Carl and Lotte's marriage in the Jewish ghetto, their avoidance of deportation, their survival dur-

[*WSQ: Women's Studies Quarterly* 36: 1 & 2 (Spring/Summer 2008)]

ing wartime, and the many dangers they succeeded in evading. Even
though they had come on this return trip with powerful attachments and
nostalgic reminiscences of the city in which they had spent their child-
hood and youth, in the place itself, they were time and again drawn to
the sites where the Jewish community suffered humiliation and persecu-
tion. And we encouraged the visits to these sites as well, eager to deepen
our own historical knowledge of the war period in Czernowitz/
Cernnǎuti with on-site reminiscences and evocations.

But when we walked along the city's streets toward the houses in
which they had spent their childhood and youth—when we entered the
building where Lotte had lived the first twenty-seven years of her life
and where, except for a brief period in the ghetto, she and Carl had sur-
vived the war—the two of us also expected to hear their more unam-
biguously positive recollections of home, friendship, and community that
had provoked their return trip in the first place. Lotte had described this
apartment in detail over many years and had made it clear that many lov-
ing memories of home and family life were associated with its spaces and
the objects it had contained. We envisioned the visit there as one of the
highlights of our journey. We were as eager to see the apartment itself as
to observe Lotte and Carl's reactions to their ability to view, touch, and
smell the sites from their youth once again. For us, such participatory
witnessing—offering some potential insight into a private lifeworld
preceding (or resisting) the persecutions and deportations that came to
eviscerate the city's Jewish community—was what a visit to our parents'
former home had promised to convey.

The present occupant of the second-floor apartment on the former
Dreifaltigkeitsgasse 41 (now Bogdana Khmelnitskogo ulitza, 63), a tall,
arresting Ukrainian woman in her mid-forties, introduced herself to us
as Nadja; she was slightly taken aback when we rang the doorbell, but
was welcoming when, in halting Russian, Lotte explained her desire to
revisit her childhood home. "Somehow it was much more beautiful,"
Lotte whispered to us in her native German as she walked through the
rooms, finding familiar spaces, pointing out differences. Under her
breath, she recalled some of the objects she remembered vividly and
pointed to where they used to be—the large, blue Smyrna carpet, the
brown leather couch and chairs in the sitting room, the walnut dining
table. We learned from Nadja that the apartment had been subdivided
for two families during the Soviet period after the war. The old dining

room had been split up into two rooms and an extra wall had been built there—a disorienting change for Lotte. Recently, Nadja and her husband, Yuri, and their two sons had been able to reunite the two units.

Two large tile heating stoves—*Kachelöfen*—a white one in the bedroom and a green one in the former dining room, stood out amid the unfamiliar furnishings. "They're the same." Lotte smiled as she bent down to open the two small hinged doors of the white one to peek inside its dark interior. "When the bad times came," she told us, ignoring the change to gas burners that were clearly visible behind the open door, "this stove was heated with wood, and when the fire was going out, cakes were baked here." She was eager to translate this story for Nadja and called her into the room to show her where this had taken place.

When refugees and exiles return to a past "home"—to the interior spaces where they went about their daily lives—they attempt to make contact with and to recover the qualities of that dailiness. "Habit," Paul Connerton writes, "is a knowledge and a remembering in the hands and in the body, and in the cultivation of habit it is our body which 'understands'" (1989, 95). And when the displaced revisit old homes and reencounter the material objects associated with them, they can indeed recover habits and embodied practices along with incorporated knowledge and memory. In bourgeois, turn-of-the-century apartment houses in East and Central Europe, such as the one in which Lotte grew up, several spaces and objects can provide striking continuities across the space of decades. When Lotte put her finger on the old doorbell, turned the external doorknob, ran her hands over the indentations of the wooden banister and the cast-iron decorations of the staircase; when she touched the iron rod in the backyard where carpets were beaten and children used to swing and play; when she walked up the well-trodden stone stairs; and when she opened the doors of the two *Kachelöfen*, she reanimated body memories—deeply absorbed habits of long ago.

But unlike many other such objects of habitual use, the white tile stove in which "when the bad times came . . . cakes were baked" is overdetermined. It possesses historical, as well as memorial and post-memorial, dimensions. And it carries powerful symbolic associations. Historically, energy-efficient *Kachelöfen* can be traced back to the fourteenth century in the Germanic world (see "A History of Traditional Tile Stoves" n.d.). They became popular in Czernowitz in the nineteenth

century, during the city's long, prosperous stint under Hapsburg rule, when it had been the capital of the imperial province of the Bukowina. Heated with wood or coal and, later, with gas, the stoves' richly colored exterior tile—the *Kachel*—generally reflected the fashion of the period of their creation. They could be Gothic, rococo, Biedermeier, art nouveau, or modernist in style. They were almost always custom built, and their aesthetic appearance and size were indicative of class background and affluence. Their built-in permanence, moreover, enabled them to endure through historical continuities and radical discontinuities: changes in family life, furniture fashion, and decor, to be sure, but also, more significant, the political shifts that led to the persecution, deportation, and displacement of German-Jewish and Romanian populations in the 1940s and their replacement with Soviet and Ukrainian populations after the war. The stoves' endurance even to this day testifies to the minimal modernization undertaken during Soviet and now Ukrainian rule in such cities as Chernivtsi.

If the *Kachelöfen* mediate the memory of returnees, they not only do so through the particular embodied practices that they reelicit. They also act as a medium of remembrance by invoking primal associations with home, comfort, and security—with a childhood world of familial warmth and safety, of privacy and interiority. These associations persist, or perhaps even increase, when war and deprivation interrupt normal familial life and break incorporated practices. Lack of heating materials during wartime did change the habitual functionality of the stoves: in Lotte's case the dying embers in the bedroom stove had to be used for cooking and baking. But as her apartment visit and reverie shows, returnee journeys can recover and convey the duality of nostalgic and negative associations through the imbrication of deeply ingrained habits with the fractures of extraordinary circumstances. In telling her story, Lotte used the German impersonal pronoun "man" to describe what took place in the room—"*Man hat Feuer gemacht*"; "*Man hat Kuchen gebacken*" (translating into the passive voice in English: "Fire *was* made"; "Cake *was* baked")—eschewing agency, and thus allowing the ghosts from the past to drift into the present room like gentle spirits. Conjuring up the smell of cake and the fading fire in a wartime of want also enabled her to overlay conflicting memories unto an alienating present, without resolving the contradictions between them. As she walked through the apartment searching for the remnant traces of past lives and for cues to remem-

brance, she recovered body memories both of comfort and warmth and of extreme scarcity and threat. And amid these contradictions, she found resilience, adaptability, and small pleasures—ingredient elements that enabled survival. She found these things, and was able to transmit them to us, by means of a testimonial object, the tile stove in which "cakes were baked." The stove both bears witness to events and elicits the testimonial encounter between generations.

Chernivtsi, summer 2000:
A question arises: We have been arguing that the contact made by first-generation returnees with objects and spaces from their own past reflects an attempt by returnees to work through multiple and discordant layers of lives interrupted by war, genocidal threat, displacement, and emigration. But what rewards do journeys and narratives of "return"—physical contact with places and objects with which they have had no previous tangible connection—promise those, like us, in the second or subsequent generations?

We've already noted that for the two of us, traveling to Chernivtsi for the first time with Lotte and Carl in 1998, the sharp edges of ambivalence and ambiguity were dulled by a deeper need to make contact with the daily world of their *before*—with what we posited as a safer world of home in which the Holocaust had not yet intruded. In the summer of 2000, however, we made a second journey to Chernivtsi in the company of two other second-generation visitors—Florence Heymann from France and Israel, and David Kessler from Israel and the United States. They traveled there to find material traces of their family's past in the place itself—documents, grave markers, addresses—and they were especially eager to identify and enter the very houses and apartments where their parents and grandparents had lived. By entering these dwellings, they were seeking to anchor the free-floating postmemories that had shaped their conception of that *before* through concrete, physical touch. And yet street names had changed, houses had been renumbered, and multiple entrances to apartment buildings confused easy access.

In the absence of parental guides to usher them through the city and verify sites, they (as well as we) became engaged in a kind of detective work using flimsy clues. Here again objects, specifically tile stoves, came to play a powerful mediating role—but this time in a postmemorial

dimension. For the descendants of refugees and emigrants who had been able to bring only very few objects along with them to their new homes, the discovery of solid, deeply resonant, and long-enduring objects such as tile stoves in the very places where they presumed their families to have lived had potentially tremendous reparative value.

In her journal from this trip, Florence Heymann writes:

I remember a photo taken from a window in the apartment from which the house across the street is visible. I think I recognize it. The Residenzgasse and [it] is now the University Street. . . . I feel that I have discovered the right house. I have a curious feeling of familiarity. A very strange impression for a place that is totally phantasmal to me. . . . The second floor has three apartments. . . . We ring on the right and a young Ukrainian woman in a pajama top answers the door. . . . "Of course, come in."

The apartment, if it is the right one, probably does not have a great deal in common with the one where my father spent his childhood. In one room, the green tile gas stove is probably of recent vintage. . . . But, in the other room, another white ceramic one is older. . . . In the garden, the walnut tree that Martha Blum (a cousin who grew up in the same house) describes in her novel *The Walnut Tree*. From that I deduce that I am in our familial home. . . . Later I will see that other very similar gardens are adjacent to many other houses, and that the city is full of walnut trees.

The Ukrainian furnishings do not stop me from imagining another apartment, another stairwell. . . . I imagine my father as a child in these rooms, coming home from school and going up the stairs two by two or four by four, his brother Leopold going down to meet his friends on the square in front of the temple or in one of the cafés on the Herrengasse. . . .

I feel myself both excited and at peace. The children play hoola hoop in the yard and wonder why this stranger is filming and photographing their house. (2003, 374, 5)

Florence's account demonstrates that her desire to find the actual place was so strong that it circumvented contraindications and present-day appearances. She could screen out the furnishings and the sounds

and smells of the present, the changes and doubts. She zeroed in on the older of the tile stoves. As the only object likely to have survived the ravages of time, it offered the most direct palpable connection to the familial past; further, it functioned, once again, as a synecdoche of home. It could effect what she most wanted: her reanimation of this alien place with the spirits of long ago—her grandmother, her father as a child, her uncle as a young man. Her "feeling" of being "at home," however, could only barely submerge her nagging doubts. How did she allay them? It is here that we note how photography and video serve as prosthetic devices substantiating a tenuous postmemorial intuition. For second-generation "returnees" encountering places and objects associated with the past, still and video cameras are vehicles of choice for knowledge, documentation, and memorial transmission. "I film and I photograph," Florence Heymann writes. She filmed and had herself photographed in front of and inside the apartment that she believed to have been the one in which her family had lived. David, our second travel companion, was equally eager to have his picture taken in what, on fairly thin clues, he deduced to have been his parents' first apartment and his grandparents' home. Triumphantly, he too posed in front of impressive tile stoves.

The impulse to frame a scene through the viewfinder and to freeze such a moment of encounter in a photograph can certainly be understood, especially since photographs can easily be transported home. Even in miniaturized, two-dimensional form, these photos, like other souvenir images, could serve as a proof of the visit and the quest ("I was there" and "It was there"). But given the uncertainty about what they depict, the photos' content demands confirmation that "it was *it*." For most descendants, such an imprimatur of authenticity is not available. And yet, highly *symbolic* and thus interchangeable, objects such as tile stoves might still be able to generate the evocation of mythic worlds of origin even without particularized authentication or, in Susan Stewart's terms, a "proper name" (1993, 138).

But once an object (or a place) has been photographically transformed into a simulacrum and is stripped of its materiality in the process of analog or digital reproduction, is it not also purged of its testimonial value and thus of its capacity to elicit particularized embodied memory? If photos of such objects as those discussed here are no more than memorial prostheses, what value other than the abstract and symbolic do they

ultimately have for those who bring them back, and for others who may simply view them in family albums or archives? If indeed such objects and the images of them are interchangeable, why show them, distribute them, digitize them, and post them on the Web, as so many second-generation returnees tend to do? (For example, see "Czernowitz-L Discussion Group Website" n.d.). What kinds of narratives do they spur? Stewart suggests that the "narrative of origins is not a narrative about the object; it is the narrative of the possessor" (1993, 136). In this case, it is the narrative of the returnee's own interiority and nostalgia, spurred by an image that can merely allude to the loss and the longing for a mythic "home."

In our past work on testimony, we have argued that the study of what we termed "testimonial objects"—personal and familial remnants from the past, carried materially or in memory across space and time—calls for an expanded understanding of testimony as a genre (Hirsch and Spitzer 2006). Such remnants carry memory traces from the past, we have said, but they also *embody* the very process of its transmission. At a moment now in Holocaust studies when, with the passing of the first generation, we increasingly have to rely on the testimonies and representations of members of the second and third generations, we will have to scrutinize the "acts of transfer," as Paul Connerton has termed them, by which memory is transmitted (1989). In such acts of transfer Connerton would include narrative accounts, commemorative ceremonies, and bodily practices—but we have also added the bequest of personal possessions, and the transmission and reception of their meaning, to his categories of analysis. Indeed, for anyone willing to subject them to informed and probing readings, material remnants can serve as testimonial objects enabling us to focus crucial questions both about the past itself and about how the past comes down to us in the present.

Massive stationary objects that refugees and exiles leave behind, such as the tile stove, cannot be bequeathed by their owners to descendants. The moment of transmission occurs through the testimonial encounter such as the one we experienced in 1998 or through encounters whose indexicality and authenticity are much more tenuous, such as our "return" visit of 2000. For second- and subsequent-generation members, the "touch" of the objects or the spaces cannot, of course, spark the habit memory of incorporated practices. And yet intergenerational testimonial transmission becomes evident: in the site of return and the touch of

the material object, Florence and David came to discover the quality of "home" that their parents had brought along with them and had, through narrative, affect, or behavior, transmitted to them as they were growing up. In the most profound sense, it is that quality that each of us set out to find as we opened the little doors of the tile stoves in Chernivtsi, Ukraine.

MARIANNE HIRSCH is a professor of English and comparative literature at Columbia University and director of the Institute for Research on Women and Gender. Her recent publications include *Family Frames: Photography, Narrative, and Postmemory* (1997, Harvard University Press/UPNE); *The Familial Gaze* (1999); a special issue of *Signs*, "Gender and Cultural Memory" (2002); and *Teaching the Representation of the Holocaust* (2004, Modern Language Association). She has also published numerous articles on cultural memory, visuality, and gender, particularly on the representation of World War II and the Holocaust in literature, testimony, and photography. *Ghosts of Home: The Afterlife of Czernowitz in Jewish Memory*, coauthored with Leo Spitzer, is forthcoming.

LEO SPITZER is the Kathe Tappe Vernon Professor of History Emeritus at Dartmouth College and visiting professor of history at Columbia University. His recent books include *Hotel Bolivia: The Culture of Memory in a Refuge from Nazism* (Hill & Wang, 1998), *Lives in Between: Assimilation and Marginality in Austria, Brazil, and West Africa* (Cambridge, 1990; Hill & Wang, 1999) and the coedited *Acts of Memory: Cultural Recall in the Present* (UPNE, 1999). He has also written numerous articles on Holocaust and Jewish refugee memory and its generational transmission. A new book, *Ghosts of Home: The Afterlife of Czernowitz in Jewish Memory*, coauthored with Marianne Hirsch, is forthcoming.

WORKS CITED

"A History of Traditional Tile Stoves: 600 Years of Kachelofen Tradition." n.d. http://www.ceramicstoday.com/articles/kachelofen.htm.

Connerton, Paul. 1989. *How Societies Remember*. Cambridge: Cambridge University Press.

"Czernowitz-L Discussion Group Website." n.d. http://czernowitz.ehpes.com.

Gold, Ruth Glasberg. 1996. *Ruth's Journey: A Survivor's Memoir*. Gainesville: University of Florida Press.

Heymann, Florence. 2003. *Le crépuscule des lieux: Identités juives de Czernowitz*. Paris: Stock.

Hirsch, Marianne, and Leo Spitzer. 2006. "Testimonial Objects: Memory, Gender, Transmission." *Poetics Today* 27(2):353–84. Reprinted in *Diaspora and Memory*, edited by M. Baronian, S. Besser, and Y. Janssen. Amsterdam: Thamyris.

Stewart, Susan. 1993. *On Longing: Narratives of the Miniature, the Gigantic, the Souvenir, the Collection*. Durham: Duke University Press.

EMMETT TILL'S RING

VALERIE SMITH

On July 13, 1945, Mamie Till received a telegram at her home in Argo, Illinois, notifying her that her estranged husband, Private Louis Till, had been killed in Italy.[1] The Department of Defense subsequently sent her his personal effects, including a silver ring he had bought in Casablanca, engraved with his initials and a date, May 25, 1943. During the following ten years, their son, Emmett Till, would occasionally try on his father's ring. Since Emmett was only four when Louis Till was killed, the ring was always too large for him. But in mid-August 1955, as he packed for what was to have been a two-week visit with relatives in Money, Mississippi, he tried the ring on again. Still too big for his ring finger, it now fit the middle finger perfectly. Emmett and his mother agreed that he could wear the ring on his trip to show his cousins and his friends.

In her memoir, *Death of Innocence: The Story of the Hate Crime that Changed America*, written with Christopher Benson, Mamie Till-Mobley recalls that during the conversation about the ring, Emmett asked her about his father:

> We had talked about the fact that his father was a soldier in World War II and that he had been killed overseas. The only thing I could tell him at that point was the only thing I was told by the army. The cause of death, I explained to Emmett, was "willful misconduct." I didn't know what that meant, and when I tried to find out, I never got a satisfactory answer from the army. A lawyer and friend, Joseph Tobias, had tried to help in 1948. But he was told by the Department of the Army there would be no benefits for me due to the willful misconduct. (Till-Mobley and Benson 2003, 103)

This incident occurs at the point in the narrative when Emmett's mother has begun to realize that her little boy is becoming an adult. In

[*WSQ: Women's Studies Quarterly* 36: 1 & 2 (Spring/Summer 2008)]

the preceding pages, she describes his heightened sense of responsibility, his first date, his impromptu driving lessons, his insistence on vacationing with his cousins instead of traveling with her, her hopes for his future. By giving Emmett his father's ring, she thus acknowledges his growing independence and maturity. Furthermore, she binds him symbolically to his paternity and his patrimony, despite the fact that irreconcilable differences had torn his parents' marriage apart.

As he boarded the train called the City of New Orleans on Saturday, August 20, at Central Station, Chicago, Emmett kissed his mother goodbye and gave her his wristwatch to keep, telling her he wouldn't need it in Mississippi. Although he removed his watch, he decided to wear the ring.

Eleven days later, on Wednesday, August 31, Robert Hodges, a seventeen-year-old white fisher, discovered Emmett's mutilated body floating in the Tallahatchie River, even though his murderers—J.W. Milam and Roy Bryant—had tied a cotton gin fan around his neck in hopes of weighing him down.[2] For allegedly whistling at—or saying something inappropriate to—Bryant's wife, Carolyn, in their store, Emmett had been killed. According to his mother's description, his tongue had been choked out of his mouth and left hanging onto his chin. His right eyeball was resting on his cheek. Only two of his teeth remained in his mouth, and the bridge of his nose had been broken. His right ear had been cut almost in half and one of his murderers had taken a hatchet and cut through the top of his head from ear to ear. He had also been shot through the head (Till-Mobley and Benson 2003, 135–36).

Given its condition, it is thus little wonder that Tallahatchie County sheriff H.C. Strider scrambled to get Emmett's body buried in Mississippi as quickly as possible. He and other local law enforcement officials wanted to try to minimize the impact of a heinous crime that had already captured national attention. Once Emmett's mother, then known as Mamie Bradley, learned that plans were being made to bury her son in Mississippi, however, she insisted that he be returned to Chicago. Authorities released his body on the condition that the coffin remain sealed. But Mamie Bradley was determined that she be allowed to identify the body of her only child. And famously, once she saw the body, she told the mortician that she wanted an open-casket funeral so the world could see what she had seen.

Law enforcement officials in Mississippi did not want her (or anyone else) to view Emmett's body for fear of the firestorm of public opinion it

might ignite. A.A. Rayner, the prominent black Chicago-based morti-
cian who handled the arrangements for Emmett's funeral (including
transporting his body from Mississippi) consented in writing to keeping
the casket closed and tried to prevent Mamie Bradley from opening it.
But as Bradley asserted, she had made no such agreement, and she dared
anyone to prevent her from examining her own child's body.

During the early days of his visit to Mississippi, she had often imag-
ined greeting Emmett at Central Station upon his return; she had never
dreamed that she would be meeting his body there instead. Her father,
her fiancé, and several relatives and clergymen accompanied her to the
station, and she nearly collapsed as the crate bearing her son's body
moved past her in the terminal.[3] But when she entered the room at the
funeral parlor where she would view his mutilated corpse, she insisted
that she be allowed to stand unassisted. Her account seems to suggest that
the touch of another person at that moment would have sapped the little
remaining strength she could muster. As she puts it, had anyone inter-
fered with her as she identified her son's body, she might not have been
able to go through with it:

> I was getting closer to discovering, to confirming, that this body
> had once been my son. And I couldn't let anyone in the room
> know what I was feeling right then. I didn't want them to think
> even for a moment that I was not up to this. They might try to
> take this moment away from me. I couldn't let them stop me
> from going through with it. If I was stopped one more time, I
> don't know what I would have done. I'm not sure that I could
> have worked myself back up to it again. (Till-Mobley and Ben-
> son 2003, 134)

Mamie Bradley needed to confront the body visually to confirm that
it was, indeed, Emmett's and to see for herself what had been done to
him. In describing the scene, she recreates the air of scientific objectivity
that she had needed to control her emotions. At first glance, the body—
mutilated, bloated, and deteriorated—seemed inhuman. To identify it,
she needed to examine it "like a forensic doctor," not, of course, to pro-
duce scientific measurements, but to match the physical evidence before
her to the body she had come to know by heart, the one she had known
through its similarities to and differences from her own. Segment by seg-

ment, she worked her way up the body, beginning with the feet. Each segment had a story: the ankles were slender and well tapered, unlike her own, which she considered to be fat in the back. His legs were strong, despite the fact that he had been diagnosed with polio as a young child. His knees—nice, fat, round, and rather flat—were like hers. Rumor had it that he had been castrated, but his mother looked at his genital area long enough to see that that was not the case. Her gaze moved quickly over this segment of the body because she knew how much Emmett valued his privacy.

Below the neck, Emmett's body was bloated but not scarred. But his face and head told a different story. One eye was missing altogether; the other hung out of its socket. His mother knew it belonged to her son because it was the light hazel brown color everyone had admired. Alive, Emmett had had a perfect set of teeth; now, only two remained, but Mamie Bradley recognized them as her son's. Emmett had a distinctive right earlobe; his mother was unable to match the one before her to the one she remembered because the right ear had been cut almost in half.

Because he allegedly spoke to or acted inappropriately toward a white woman, Milam and Bryant broke Emmett's spirit by mutilating his body. But Mamie Bradley refused to allow their punishment to be the final chapter in her son's life. When she insisted on seeing his body, she bore witness to the crime they had committed and to the final brutal minutes of Emmett's life. By looking at his body, and telling and retelling the story of that heartbreaking examination, she took the first step toward ensuring that her son would live on in collective memory long after his body had been buried. Furthermore, she figuratively reconstituted the brutalized corpse and crafted a perpetual epilogue, by imaginatively suturing its parts to her memories of each limb and feature, plane and surface. Her account connects the mutilated corpse with the life of the son she lost:

> I couldn't help but think of the first time I laid eyes on my son. I remembered my reaction to his distorted little face and how I made him cry. I would have given anything to take that back. That face seemed so adorable now. My first look and my last look at Emmett would forever be fused in my mind.
>
> I kept looking at him on the table and I thought about what it must have been like for him that night. I studied every detail of

what those monsters had done to destroy his beautiful young life. I thought about how afraid he must have been, how at some point that early Sunday morning, he must have known he was going to die. I thought about how all alone he must have felt, and I found myself hoping only that he had died quickly. (Till-Mobley and Benson 2003, 137)

Mamie Bradley was the second family member to identify Emmett. His great-uncle Mose Wright, from whose house he had been abducted, had been called to the river bank to identify the body once it was found. According to his testimony, he only knew for sure that he was looking at his nephew's remains because he recognized the ring that Emmett had inherited from his father.

Mamie Carthan Till Bradley Mobley has become an iconic figure in American culture for her courage, grace, and tenacity in the face of profound loss and unyielding injustice.[4] She honored her son's life and his suffering when she refused to protect herself from the ocular proof of the brutality he endured. When she insisted on the open-casket funeral, she invited the many thousands of African Americans who marched past his casket and the many thousands more who gazed in horror at the photographs that were published in the black press, to join her in an act of public witness to the irrefutable evidence of white racist depravity. To the extent that it inspired widespread demands for justice as well as a heightened sense of outrage and race consciousness, Emmett's death assumed a meaning that transcended the significance of his individual life. As Jacqueline Goldsby puts it, because she succeeded "in [mobilizing the resources of the *Chicago Tribune*], the *Chicago Defender*, *Jet*, and *Ebony* magazines, to publicize across the nation and around the world the court case arising out of her son's lynching" (2006, 296), the photographic images both of Emmett's mangled face, as well as his mother's own beautifully open and expressive one, are imprinted indelibly in the cultural imagination. While claims that his murder launched the modern civil rights movement may be excessive, without question the story and the image of Emmett Till profoundly shaped African American political consciousness in its own time and in subsequent generations.[6]

At the trial of Milam and Bryant, Bradley was called upon to witness yet again. In testifying at the trial of her son's murderers in the Tallahatchie

County courthouse in Sumner, Mamie Bradley ensured that her son would not be just another victim of lynching known only within his circle of intimates. The defense attorney tried to argue that the body that had been found was so badly decomposed that it would have been impossible to identify. Indeed, he even suggested that Emmett Till was alive and home in Chicago and that activists had thrown the body of an unidentified black man into the river and persuaded Bradley to say it was Emmett to generate national attention. Her earlier meticulous examination of her son's body thus served a dual purpose: it both confirmed her son's death for her and it substantiated her claim in court that the body that had been delivered to her in Chicago was Emmett's.

The ring Emmett inherited from his father served double duty as well. It allowed his great-uncle, Mose Wright to identify his nephew's mutilated remains. During the trial, when the prosecutor showed Bradley a picture of the ring retrieved from the body, she said that she recognized it because she had given it to him.

In the black press and the mainstream media alike, Mamie Till Bradley emerged as a woman doubly bereft—widowed by the war and rendered childless by virulent white racists. The *Cleveland Call and Post*, for example, reported that Till's father died in the service of his country, while his son "was sacrificed on the cross of ignorance" (Metress 2002, 146). And in his 1955 poem "The Money, Mississippi, Blues," Langston Hughes wrote:

> His father died for democracy
> fighting in the army over the sea.
> His father died for the U. S. A.
> Why did they treat his son this a-way?
> in Money, Money, Mississippi,
> Money, Mississippi. (Metress 2002, 97)

Within a few weeks after the end of the trial, however, a more complicated version of the death of Louis Till emerged, one that cast new light on his son's murder. Mamie Bradley, accompanied by a group of her friends and family members, traveled to Washington, D.C., to try to launch a federal investigation into Emmett's murder, when news broke that Louis Till had died ignominiously. Years earlier, Mamie Bradley had tried to find out the nature of the "willful misconduct" of which he was

guilty and why she had stopped receiving her estranged husband's bene-
fits when he died. At the time, she and her attorney had received no
response from the Department of Defense. But when Mississippi senator
James O. Eastland launched his investigation into Private Till's death, he
learned the full story and released it to the media.[7] As it turned out, Louis
Till had been court-martialed and found guilty of murdering one Italian
woman and raping two others. He was hanged and buried in a numbered
yet otherwise unmarked grave in Plot E of the Oise-Aisne American
Cemetery and Memorial, in France (Kaplan 2005, 175).

The negative publicity around this revelation fed stereotypes about
predatory black men and their lust for white women and contaminated
Emmett's story. It even prompted some to speculate that if Emmett's
father had been executed for violence against white women, then per-
haps his son was capable, if not guilty, of inappropriate behavior toward
Carolyn Bryant. And if there was any doubt about Emmett's innocence,
then perhaps he and his mother did not merit the outpouring of sympathy
they had received. Indeed, Mamie Bradley believed that the revelation
about Louis Till's story contributed to the breach in her relationship with
the NAACP; apparently, Roy Wilkins, executive secretary of the orga-
nization, had planned to refer to Louis Till's military service in a speech.
When he learned that the elder Till had been executed and was not a mil-
itary hero, he, too, rushed to judgment and expressed his relief that he
"hadn't gotten caught in the 'Louis Till trap'" (Till-Mobley and Benson
2003, 203).

There is, however, no reason to assume the accuracy of the Depart-
ment of Defense story. According to Louis Till's friends in the military,
black soldiers were executed for even the hint of fraternizing with white
women. Indeed, several of his friends doubted that he was guilty of the
charges for which he was hanged. No one will ever know the circum-
stances surrounding Louis Till's execution. But his fellow soldiers' asser-
tions are consistent with the evidence concerning the treatment of black
soldiers in Europe during the world wars. African American soldiers in
the segregated armed forces were executed at a much higher rate than
were their white counterparts for the same or lesser offenses (Kaplan
2005, 173). This differential helped to reinforce a policy of exporting
domestic Jim Crow practices through the enforcement of American mil-
itary protocols.

Just as we will never know the circumstances that led to Louis Till's

execution, we find that a similar curtain of doubt hangs over the events that took place in Bryant's Grocery and Meat Market in August 1955. We cannot be certain what Emmett said or did in the store. His mother died believing in her son's innocence: she was convinced that she had trained him never to speak inappropriately to any woman, let alone a white woman. The Reverend Wheeler Parker, Emmett's cousin and then close friend, who was in the store at the time, maintains that Emmett never said or did anything objectionable in the store. Other cousins who were there tell a different story, suggesting that Emmett, like his father, may have been guilty of "willful misconduct." Emmett might have whistled; or said, "Bye, baby"; or grabbed Carolyn Bryant's hand. Who is to say what a fourteen-year-old boy will do on a dare? What we can say, however, is that nothing that Emmett Till might have said to Carolyn Bryant merited the loss of his life.

There is a community of people I call Emmett Till junkies—people who are obsessed with the details of the case. They can tell you who is responsible for the different accounts of the story and they have practically memorized the court transcripts. They can tell you what happened to every person who was even remotely connected with the incident, and they will endlessly debate the different versions of what transpired both at the store and on the night when Emmett was abducted. While there is surely a place for the pursuit of accuracy and that level of devotion to the facts, at the end of the day we must settle for three facts above all others. First and most important, there is an enigma at the heart of this cold case, which we must accept. Fifty-two years after this chance encounter, with memories dulled by the passage of time and shaped by the violent history of race and sex in U.S. culture, not even those who were there can say for sure what actually happened in Bryant's grocery. Second, perhaps because it engages so many issues and themes that are deeply embedded in American life—migration, class mobility, tensions between rural and urban, and so on—the murder of Emmett Till has had a profound impact upon the American cultural imaginary, and that impact shows no signs of abating. And third, what really happened is always already infected by the phantom memory of the history of race, gender, and sexuality in the American context. The ring—a circle surrounding an absence—is thus a perfect symbol for the mystery at the center of the case. It points to the unknowable facts that cost Emmett and Louis Till their lives. Its material presence symbolizes

the very real effects of the history of racial violence that each generation bequeaths to the next.

In the end, we must judge and analyze the punishment to which Emmett and Louis Till were subjected independent of the question of their respective guilt or innocence. When Mamie Till passed Louis's ring to Emmett, acknowledging his claim to adult black manhood, unintentionally she acknowledged as well the threats that construct(ed) black masculinity under lynch law. As she put it in her memoir: "Louis died before he could see what would happen to his son. Bo died before he could learn about what had happened to his father. Yet they were connected in ways that ran as deep as their heritage, as long as their bloodline" (Till-Mobley and Benson 2003, 204). When Emmett—or Bo, as she called him—gave her his watch at the train, she removed her own and wore his. She writes that on the morning of his funeral, she could practically feel it ticking: "My pulse timed to Emmett's. Two hearts in sync. For all time" (141). When Emmett gave up his watch, unknowingly he also gave up his place in a linear narrative of racial progress. The ring he kept was an apt symbol of the cycle of gendered racial violence that caught him and cost him his life.

ACKNOWLEDGMENTS

I wish to thank Daphne Brooks, Elyse Graham, Marianne Hirsch, Nancy K. Miller, and Clarence E. Walker, Jr. for their assistance with this essay.

VALERIE SMITH is the Woodrow Wilson Professor of Literature and director of the Center for African American Studies at Princeton University. The author of many essays and articles on African American literature and film and black feminism, as well as two books, *Self-Discovery and Authority in Afro-American Narrative* (Harvard University Press, 1991) and *Not Just Race, Not Just Gender: Black Feminist Readings* (Routledge, 1998), she has also edited *New Essays on Song of Solomon* (Cambridge University Press, 1994), *Representing Blackness: Issues in Film and Video* (Rutgers University Press, 1997), and *African American Writers* (Maxwell Macmillan International, 1991). At present she is completing a book on the civil rights movement in American cultural memory.

NOTES

1. Throughout this essay I refer to Emmett Till's mother variously as Mamie Till, Mamie Till Bradley, and Mamie Till-Mobley, depending on the name by which she was known during the period in question. Born Mamie Elizabeth Carthan in 1921, she married Louis Till in 1940, Lemorris "Pink" Bradley in 1951, and Gennie "Gene" Mobley Jr. in 1957. She came to public attention as Mrs. Mamie Bradley after Emmett's murder in 1955 and was known as Mamie Till-Mobley after her third marriage.

2. After a trial that lasted from Monday, September 19, until Friday, September 23, 1955, an all-white jury acquitted Milam and Bryant of the charges of kidnapping and murdering Emmett Till.

3. A famous photograph taken at the station shows a distraught Mamie Bradley being supported by Bishop Isaiah Roberts, Gene Mobley, and Bishop Lewis Ford.

4. For an insightful discussion of the way both Mamie Bradley and Carolyn Bryant were constructed in the aftermath of the Till murder, see Feldstein 1994.

5. In the final chapter of *A Spectacular Secret: Lynching in American Life and Literature*, Jacqueline Goldsby (2006) brilliantly reads Till's murder and Bradley's response to it in order to explore the power of poetry and photography to "serve as archives of lynching history."

6. Activists who came of age during the 1950s and 1960s frequently identify the murder of Emmett Till as a pivotal moment in their consciousness. See, for example, Hunter-Gault 1992; Lewis with d'Orso 1999; Moody 1968; and Sellers 1973. Numerous artists—African American and white alike—have been inspired to imaginatively reconstruct the Till story, among them Bob Dylan ("The Death of Emmett Till") and Gwendolyn Brooks ("A Bronzeville Mother Loiters in Mississippi. Meanwhile, a Mississippi Mother Burns Bacon" and "The Last Quatrain of the Ballad of Emmett Till"). See also Baldwin 1964; Campbell 1992; Crowe 2002, 2003; Nelson 2005; and Nordan 2003. Major books about the case, in addition to *Death of Innocence* (Till-Mobley and Benson 2003), include Metress 2002; Hudson-Weems 1994; and Whitfield 1988. Recent documentary films about the case include Beauchamp 2004 and Nelson 2004.

7. A Democrat from Mississippi, Eastland was a virulent opponent of the civil rights struggle and a staunch segregationist. He served in the U.S. Senate briefly in 1941, and then again from 1943 to 1978.

WORKS CITED

Baldwin, James. 1964. *Blues for Mister Charlie*. New York: Random House.

Beauchamp, Keith A., dir. 2004. *The Untold Story of Emmett Louis Till*.

Brooks, Gwendolyn. 1960. *The Bean Eaters*. New York: Harper.

Campbell, Bebe Moore. 1992. *Your Blues Ain't Like Mine*. New York: G. P. Putnam's Sons.

Crowe, Chris. 1955/2002. *Mississippi Trial*. New York: Dial Books.

———. 2003. *Getting Away With Murder: The True Story of the Emmett Till Case*. New York: Dial Books.

Feldstein, Ruth. 1994. "'I Wanted the Whole World to See:' Race, Gender, and Constructions of Motherhood in the Death of Emmett Till." In *Not June Cleaver:*

Women and Gender in Postwar America, 1945–1960, edited by Joanne Meyerowitz. Philadelphia: Temple University Press.

Goldsby, Jacqueline. 2006. *A Spectacular Secret: Lynching in American Life and Literature.* Chicago: University of Chicago Press.

Hudson-Weems, Clenora. 1994. *Emmett Till: The Sacrificial Lamb of the Civil Rights Movement.* Troy, Mich.: Bedford.

Hunter-Gault. 1992. *In My Place.* New York: Farrar, Straus and Giroux.

Kaplan, Alice. 2005. *The Interpreter.* New York: Simon and Schuster

Lewis, John, with Michael d'Orso. 1999. *Walking with the Wind: A Memoir of the Movement.* New York: Harvest.

Metress, Christopher, ed., 2002. *The Lynching of Emmett Till: A Documentary Narrative.* Charlottesville: University of Virginia Press.

Moody, Anne. 1968. *Coming of Age in Mississippi.* New York: Dial Books.

Nelson, Marilyn. 2005. *A Wreath for Emmett Till.* Boston: Houghton Mifflin.

Nelson, Stanley, dir. 2004. *The Murder of Emmett Till.*

Nordan, Lewis. 2003. *Wolf Whistle.* Chapel Hill, N.C.: Algonquin Books.

Sellers, Cleveland. 1973. *The River of No Return: The Autobiography of a Black Militant and the Life and Death of SNCC.* New York: Morrow.

Till-Mobley, Mamie, and Christopher Benson. 2003. *Death of Innocence: The Story of the Hate Crime That Changed America.* New York: Random House.

Whitfield, Stephen J. 1988. *A Death in the Delta: The Story of Emmett Till.* New York: Free Press.

FAMILY HAIR LOOMS

NANCY K. MILLER

heirloom—2. something having special monetary or sentimental value or significance that is handed on either by or apart from formal inheritance from one generation to another.—Webster's Third International Dictionary

In the last years of his life, my father's rent-controlled apartment on the Upper West Side became the repository of what had been his lawyer's office in the glamorous Woolworth Building in Lower Manhattan. The office itself was small and chaotic, though my father claimed that he knew where everything was. My father's attachment to his office and the papers that filled it was intense, but at some point in the 1980s, the combination of his worsening Parkinson's disease and the economic demands of the law firm from whom he rented his space forced him to give up his name on the door. The Redwelds, the distinctive rust-colored containers of legal files, moved uptown.

When I inherited my father's possessions after his death, I found, tucked away in his dresser drawers and in the Redwelds that I thought contained the history of his legal career, the unsorted memorabilia of our family: random items from past and forgotten lives—cemetery receipts for the upkeep of graves, report cards, loose photographs of unidentified subjects, magazines, newspaper articles, telegrams, letters in Yiddish, and the mysterious locks of hair that I allude to in my title.

What was the point of my keeping what, on the face of it, was precious neither to me nor to anyone else—unless, through another kind of editorial decision, I could figure out whether there was something I could learn from what, as an academic, I called my archive, my material. Material for what? For a narrative I would some day construct about a family that had vanished without a trace. Or maybe just the opposite. This family, over generations, had left traces—in objects, in documents, and finally in me. What was missing was a story that would make sense of the silence that surrounded the scraps of information I had gathered, a

[*WSQ: Women's Studies Quarterly* 36: 1 & 2 (Spring/Summer 2008)]

story that would bear witness in the place of the absent voices.

If I haven't already done so in a gesture of efficiency, at my death someone will toss this entire legacy into a black trash bag and it will all vanish down the garbage chute of history, completing the disappearance already in progress. But perhaps if I convert these objects into words, I can counter the vanishing act. I can share my objects and reinsert them into the wider history to which they belong. This is because my story branches into a network of narratives both characterized by their incompleteness and their interrelatedness. The story I'm trying to tell is both individual and collective. For example, if you click onto the web site jewishgen.org you can see, through criss-crossing tracks of virtual connection, the attempts of many other third-generation descendants of an Eastern European world, shattered at the end of the nineteenth century into the shards and scraps of diaspora, to make sense of a fractured past. The objects—in particular, the locks of hair—photographs, and documents in my personal safekeeping for which I am seeking an interpretive framework take on meaning in relation to a world to which I have no direct access beyond their limited material dimensions. My objects bear witness, as it were, to the existence of a community to which I belong only remotely, but that I can invoke when I insert them into this historical context.

The hair was stored in a once-elegant cardboard box.

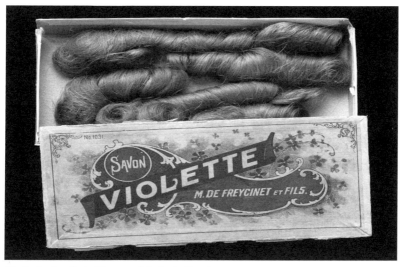

Fig. 1.: Locks of hair. Photograph by Lorie Novak.

I believe that after my grandmother's death in 1954, my father kept
the locks previously saved by my grandmother, without necessarily
knowing their origin. While I can safely guess that this hair belongs to
my father's side of the family (on my mother's side everyone had bone-
straight black hair), what does it mean to inherit something when you
don't know for sure to whom it belonged? In this case, since the hair is
unassigned—and, we might say, unlike a letter, unsigned—what is the
status of possession of hair? Is this hair an heirloom? The box was not
"handed on" to me, which is a condition for the category of heirloom. I
took the hair into my possession after my father's death. But does uncer-
tainty of origin and transmission disqualify an object from bearing wit-
ness to a meaningful prior existence? For me, the locks are family hair
that looms, that beckons mysteriously from the borderlands of my quest.
The hair is a link in a chain that ties me, binds me tightly, to the past,
even if I can't fully decipher either hair or past. Still, in these circum-
stances, is it ethical for me to make up a story about the locks, to place
them in a narrative I deliberately construct with the imagination, in part,
of fiction? My answer is yes, provided that the story is plausible, given
the history of these people, Eastern European immigrants who left Rus-
sia in 1906 for America.

Saving locks of hair was a commonplace practice during the Victo-
rian period. Hair was often included in scrapbooks and memory albums,
as a recent exhibition demonstrated: "Because it does not disintegrate
over time if it is properly protected, hair has been a symbol both of abid-
ing love and deeply felt loss for thousands of years. Mothers kept locks of
their children's hair, women often gave their suitors locks of their hair as
tokens of their affections, and locks of the sitter's hair were often added
to miniature portraits" (Moonan 2007). This gesture, a way of bearing
witness to love and loss, points almost by definition to the importance of
gender in the act of memorialization: mothers save the hair of their chil-
dren, women offer locks of hair to their suitors.[1] But what happens when
we cross gender with ethnicity, in particular that of Eastern European
Jews, in a slightly later period?[2]

When I first saw the box of curls in my father's dresser drawer after
his death, I felt almost viscerally certain that I was looking at the side-
locks (*payess*) worn by ultra-Orthodox and Hassidic Jewish men, and I
thought that the severed locks might have belonged to my grandfather.
But when it came to writing about the locks that both fascinated and dis-

turbed me, I realized that I didn't know what I could legitimately say about what they might represent in a tradition from which I had taken my distance. I wrote to Susannah Heschel, a well-known scholar of Jewish studies, to ask her what she thought (on the basis of the photograph above) of the payess hypothesis. "To cut off payess," she responded, "is an old sign of rejection of Jewish law," although "hair," she continued, by custom usually would be "burned, not preserved." But then she went on to speculate about the affect behind the gesture. She wondered rhetorically "who saved the payess": "Presumably his wife, perhaps as a nostalgic remembrance of the old ways together, the commitment to Orthodoxy, perhaps the wedding of two young people from religious homes, now repudiated—though not without some sadness" (e-mail communication, October 22, 2006). This interpretation made sense to me, given what I knew about my family's origins.

My grandfather Rafael was born in Bratslav, Russia, a tiny town in what is now Ukraine, a town known in Jewish history for a famous Hassid and storyteller, Nachman of Bratslav, as he is called, who taught and wrote there in the early nineteenth century. Perhaps Rafael left home and rebelled against his father by cutting off the signs of his youthful religious observance. Since my grandfather, according to the photographs, first trimmed his beard and then shaved it, while his father, my great-grandfather (in photographs), maintained his long beard, full and untrimmed, this tale has a certain intergenerational logic. I like the idea of inheriting a rebellion against orthodoxy, but if I continue in the direction of the wedding ceremony and ritual in Orthodox families, another, equally suggestive scenario emerges—that of the bride.

The locks are a bride's hair, twirled into ringlets that were sacrificed before the girl put on a wig as a married woman. Maybe this is the story of a woman who wants to remember her past as a girl, once proud of her hair. This is the view of Barbara Kirshenblatt-Gimblett, who after looking at the actual hair object, forwarded the following account of a bridal hair cutting that she found on an Internet site:

The next morning after the *khupah* [ceremony], when the *sheitl* [wig] had already been sent to the bride at home, the regal *siddur* [prayer book] in the golden cloth with a lock, a *shkot* (a mirror in a [wooden] frame), etc, according to one's financial ability, the groom's mother, often with all of the relatives went to see the

nakhas [proud enjoyment], that is, if the *mitzvah* was done in the true Jewish way, and the bride was lifted from the bed. After undressing her, her hair was cut, during which the young, often 14 or 15 year old bride heartbreakingly would cry over her beautiful cut locks and braids. After the cutting, the bride would be veiled. (Lerer n.d.)

Kirshenblatt-Gimblet reflected on this possibility in an e-mail conversation (April 15, 2007), citing her own family as possible evidence: "Who knows? Longing for the shorn locks? Especially in later periods when girls may have not wanted to go along with this anyway (my father's mother, for example)."

A third, alternative narrative suggested to me was that the locks of hair belonged to a son, whose hair, according to ultra-Orthodox Jewish tradition, would have been cut for the first time at age three in a formal ceremony. (This is a ceremony for boys only.) In this version, the act of saving might indicate a desire to recognize and memorialize the religious male development plot. On the other hand, since my grandmother may have lost children between the births of her two sons, the locks might simply be the hair of dead daughters. In either case, these curls would be an overabundance of hair for a three-year-old child (just as it would be for sidelocks).

Even DNA analysis, I have learned, cannot resolve the conundrum, since without a follicle, without a root, the gender of hair cannot be determined. At stake, however, is not necessarily a belief in the root—a verifiable truth of origin—but rather a narrative about uprooting, the departure that loomed large on the horizon of hundreds of thousands on the eve of the twentieth century. If this is a story not about a child, but rather of a man or a woman, the locks as preserved, whichever their gendered origin, seem to point to a break with tradition, a break probably consolidated, and perhaps inspired, by immigration. As such, my family hair would bear witness to a collective narrative, that of Eastern European Jews emigrating to the New World in the early years of the twentieth century, and shedding the marks of their foreignness.

But maybe not. Maybe in the absence of a specific story I am substituting a familiar, even overly familiar, narrative, by now a template about a certain aspiration to the modern and a compromise with Orthodoxy common to this generation of emigrants. What if my grandmother,

a woman fond of fashion, one day simply decided to abandon her golden locks, in favor of a new style? What if, when her husband suddenly died and she was newly widowed, my famously vain grandmother decided that the curls no longer suited her, mourned her loss through the cut, and saved the hair in remembrance of their bond?

Despite the proliferation of seductive narratives, my heirloom cannot stand alone in a meaningful way, except as a marker and bearer of memory itself: the locks of hair perform an act of remembrance. Someone, probably a woman, in view of the fancy French soap box, wanted to remember a boy or a man dear to her—or wanted to remember her own beautiful locks. Somebody else, probably my father, understood what was being remembered enough to preserve it (not that my father was capable of throwing anything away). A third person—a third-generation descendant—a daughter, saved the hair again to make a story in which her history might be continued. As an object, naturally, the hair cannot of itself testify to the experience it accompanied. But as the keeper of the locks, I can bring them into language, into the world of lost stories of which they so eloquently speak.

ACKNOWLEDGMENTS

I'd like to thank Deena Aronoff for her suggestions about the possible symbolic meanings of hair within the varieties of modern Jewish practices. I am grateful to Lorie Novak for taking and editing the photograph of the hair.

NANCY K. MILLER is a Distinguished Professor of English and Comparative Literature at The Graduate Center, City University of New York. Her most recent books are *But Enough About Me: Why We Read Other People's Lives* (Columbia University Press, 2002) and the coedited volume, *Extremities: Trauma, Testimony, and Community* (University of Illinois, 2002).

NOTES

1. In *Forget Me Not*, his study of photography and acts of remembrance, Geoffrey Batchen notes the intimate association of women with the construction of mourning objects that add hair to jewelry: "By the mid-nineteenth century, American women especially were being charged with new social roles as keepers of memory, as mourners, and as home-based teachers of religious belief" (2004, 68).

2. On the importance of gender to interpreting objects like these, see Hirsch and Spitzer 2006.

WORKS CITED

Batchen, Geoffrey. 2004. *Forget Me Not: Photography and Remembrance.* New York: Princeton Architectural Press.

Hirsch, Marianne, and Leo Spitzer. 2006. "Testimonial Objects: Memory, Gender, and Transmission." *Poetics Today* Summer 27(2):353–83.

Lerer, Moshe. n.d. "A Jewish Wedding in Chelm in the Old Days." Translated by Gloria Berkenstat Freund. http://www.jewishgen.org/Yizkor/chelm/che295 .html. Originally published in *Jewish Philology* (Culture League, Warsaw; edited by Max Weinreich, Noakh Prilucki and Zalman Reizen) (n.d.), 1(1249):n.p.

Moonan, Wendy. 2007. "Relics of the 19th Century, in a Sentimental Mood." *New York Times*, Feb. 9.

TRANSMISSIONS

PATRICIA DAILEY

Over the past seven years, during the life or half-life and death of my
father (he passed away in June 2004), I inherited a car, a 1907 Mitchell,
from my father. Well, this isn't exactly true; I wasn't its recipient, as
stated in his will, for my father had visions of its being part of an automo-
tive museum with a plaque bearing his name (he was a traditionalist at
heart, preferring those more monumental forms of tribute). The museum
confessed it would only sell the car to raise funds, which gave me reason
to hesitate. How best to align will, testament, desire of the deceased,
with the living? How to be the translator of intention and honor the
memory of my father through this odd creature of a car? To whom or to
what is a daughter faithful? Was I only a host to a will, to his intention?
Witness to and inscriber of a word's material form? Something else,
something less biblical, I felt, was being asked of me.

They strangely resembled one another, I began to think: the car was
no Rolls; it was a simple twenty-horsepower vehicle that, like my father,
was born in Minneapolis in 1919, was from the Midwest and seemed to
emblematize a kind of clear-intentioned absence of frills. Both the car, in
its lack of any panache that accompanied its ambition, and my father,
having been a veteran of The War, betrayed an almost noble humility
that I associate with the singularity of their time. Yet the car had, in its
current state, a tragic flaw: it was missing its engine. We were clearly
dysfunctional. When I was enrolled in grammar school, at the French
Lycée, I remember my father stating (when I was six) that he would
drive me to school in it as soon as he had the engine repaired. The idea of
being driven fifteen miles down the Santa Monica Freeway in a twenty-
horsepower-engine car with no doors and windows still haunts me
today—but it never happened, nor did my father ever drive me to school.
It was a vision. The engine needed repair; it needed parts: so began the
saga of the engine.

When I was in junior high school (no longer the Lycée, but an all-

[*WSQ: Women's Studies Quarterly* 36: 1 & 2 (Spring/Summer 2008)]

girls school on the west side of Los Angeles), the engine left the house to have its envisioned glory restored. Someone came to pick it up. And for the life of him, my father could never remember who that someone was.

In the course of the past twenty-five years, my father had forgotten to whom the work was entrusted, he could not remember the name of the repair person, and had no written trace. Organization was never his forte. There was no paper trail to follow, no witness to its whereabouts. When he began to suffer from dementia following a stroke in May 2000, he could provide one sole clue to the location of the engine (a clue he could not remember previous to his dementia): Sun Valley (California). He still could remember that, and something or someone in him, the person in him who once wanted to repair it, was able to attest to it in the form of those two words. This clue, by now almost a postmemory, came like an oracle, bridging time past with the promise of a future, from a father already no longer fully present, yet present in ways not even imaginable in life. As is the case with many stroke victims, my father changed after his stroke: not only could he remember the Latin names of orchids and the Czech language he had once learned at age eleven when living in Prague, but his own relation to himself and his relations to others had altered. Ipseity, or self-sameness, was clearly not a metaphysical concept, I thought: the cogito was as vulnerable as flesh, inscribed into it, part of its material association, traversing the body to remember itself. Our relation to ourselves is punctuated by the exposure of the body, this gaping hiatus that we are, as Jean Luc Nancy once wrote to me. In my father's case, the body's archive had reassembled itself, making the affective past far more present, and in doing so actually made him a nicer man than he was in life, permitting a reconciliation on other father-daughter fronts, which were almost hallucinatory in their irreality. His "state" was itself somewhat of a vision, as it provided a Dante-esque meeting ground for the impossible. We actually got along, and in the medium of a lucid madness, in which other things were forgotten and silenced, something real, it seemed, transpired. Sun Valley shared in this Paradiso of luminosity. I was not sure what of our illumination could be translated into the vernacular of the everyday, the record of the living. I did not know what I was being called on to bear witness to, to bring out from the depths of a past I barely recalled. I did not know who or what in me, in him, was being asked to be found.

I went to Los Angeles to reckon with the car in the fall of 2005, a

year after my father's death. I had to get an idea of its worth to decide what to do with it. Calling upon my skills as a researcher, I looked into the Los Angeles chapter of the American Horseless Carriage Society and pestered as many people as I could (most the age of my father) to come to see the hollow vessel of a car. None would budge. It was not worth much without the engine. No future, no vision, nobody. One person, called Peter Eastwood, whose name bore a vague hint of justice on the Western front, did come—his father had been in the old-car world too and had transmitted his passion to his son, who had been bitten by the bug of remembering these vessels. At our home, he found parts of a clutch (which I had dismissed as a useless piece of oddly shaped firewood), gave me an idea of the dollar value of the car in its present state, and as he was leaving said the strange and promising words, "I think I might be able to find your engine. The world of antique cars is not so vast." I shared with him what appeared to me the shibboleth to enter into its realm: two words, "Sun Valley."

Two months after he came to our family home to see the car, still no word. I called him to mention that I was leaving in a week, politely hoping to invoke the promised miracle, and the following day I received a call from him. "Tricia?" "Yes?" "You won't believe it." "No, no way." "Yes." Yes, he had found the engine. But how? He told me he had called a friend in Michigan, who remembered that, in fact, more than ten years ago, in around 1995, when Peter and his friend were at a man's home in Sun Valley to look at a Model D Ford, this man, a Mr. Bell, let them peek at an engine in his garage, an old Mitchell engine he was restoring. The man had since died, but his widow, whose name was (incredibly) Racine, was still living in the same house. The phone number had not changed, and the engine was still waiting to be worked on in the same timeless crypt as our Mitchell. Our Mitchell. The car had outlived its subjects, but the memory of the car in the eyes of its subjects was literally remembering it. It had left an impression, a fleeting yet lasting one, and the sense of something in an "us" was strangely recast by returning its gaze, catching us all off guard.

Who were we in relation to this vehicle? Who was I to Hecuba, for that matter? I felt as though I was barely an actor, not even a shade, on the stage of time, were this scene represented as a slowly exposed photograph taken through a lens that had remained fixed on the engine and the car for twenty or thirty years, revealing only that which persisted in the

dominant yet silent rhythm of the world. It was, to me, as though the memory of generations (of familial bonds, paternal passions, their inscription into people's affective lives and into geographical places), the memory of what was transmitted through generations—that which Freud so persistently had set out to render audible, that which silently masters us and is transmitted from parent to child, upsetting mastery in our own house—was for a minute almost visible, comprehensible, caught in its secret operation. I was its witness. The car, the outer vessel of memory, its material vehicle, had made manifest the site of its dislocated core. I still have not laid hands on the engine. It is still sitting in the late Mr. Bell's garage. I am waiting for his son, Don Bell, now the father of a young woman, to come from Ohio so that with his aid, Peter Eastwood, and I can retrieve the engine and pick up the remaining tab.

When I spoke to Don by phone, he said that he remembered me as an eleven-year-old. He remembered coming to our big white house on the hill, and he remembered that I had a brother. He said that his father had amused himself by thinking that maybe my father was waiting for my graduation to pick up the engine. In our shared inheritance, Don and I authenticated each other's memories, my legitimacy in the guardianship, and our place in its shifting line of command. His memory of the house, our family, and our almost insignificant interaction almost thirty years ago haunts me, precisely because of its impersonal nature. He did not know our faces, or if we spoke. The third-person nature of an encounter was articulating itself in the postscriptum of this transmission. Lives had unknowingly brushed up against something: was it an absence? Did the engine bear witness to the timeless mobility of an incalculable insignificance, or to our seeing ourselves from the position of the unthinkable, our own passing?

Many questions still remain for me: If, as philosophers assert, objects look at us, they contribute to our own sense of ourselves, of our bodies, of our way of being, what then of objects, such as this vehicle, and this engine, that did not inhabit the time of life, the life "under the sun," but of something deeper, Augustine's "true life" perhaps, something even more unknown and unknowable, some hypobiographical reality—as Jean-François Lyotard wrote of Malraux—that passes under the phenomenological skin of perception? How do these vehicles of memory operate? Something else seems to me to be gleamed in the way in which this disfigured promise of movement operates, outside intention, will, or

consciousness. What seems to appear—in this experience of testimony, not only of what I write now, but in its link with this testament of my father, the words of Don Bell, the memory of his father, the collective memory of Peter Eastwood and his Michigan friend, the viral transmission of paternal passions, my brother's and my glee in my having located the survival of an intangible desire—is not a Proustian patina of human change in time, but the silent testimony of something in us, and outside us, perceived yet unknowable, programmatic and haphazard, unchanging. The engine was keeping something of us, of our past, and of our future with it: some part of us that we can never know, a nonidentifiable share in "us," attesting to a secret in transmission. Like a constellation of times, peoples, and trajectories that marked the blind spot of a world we presumably lived in, the engine held the code to a memory that emerged in an epochal fashion to expose unidentifiable parts in us, to give a shape to something that eludes our field of vision. This memory is a witness of what we are subject to, but never subject of. This is the memory to which I—to which we all—will return.

PATRICIA DAILEY teaches at Columbia University and specializes in medieval literature and critical theory. Her articles have appeared in *New Medieval Literatures* (vol. 8, 2006), *Le secret: Motif et moteur de la littera-ture*, the *PMLA*'s special issue on Derrida; and the Cambridge *Companion to Christian Mysticism* (forthcoming). She is the translator of Giorgio Agamben's *The Time That Remains* (Stanford, 2005) and is currently working on her manuscript *Promised Bodies*, which focuses on temporality, embodiment, and inscription in medieval women's visionary texts and Anglo-Saxon poetry.

THE KNITTING LESSON

SONALI THAKKAR

Recently, I decided that I wanted to learn to knit. The emergence of this wish coincided with a planned visit home for spring break, where I shortly found myself in possession of a little booklet—an instructional manual—called *Learning to Knit*. This booklet was put in my hands by my mother, whom I asked to teach me while I was at home.

My mother, raised in India, was educated at a convent school, where learning about what she likes to term "the domestic arts" was an ongoing part of the curriculum. At our home outside Toronto she still has with her some needlework projects she made as a young woman, as well as exercise books in which are glued small samplers of an array of needle-crafts: smocking, embroidery stitches, preternaturally neat seams, and crochet work. Searching for what she needed to get me started, she pulled these treasured objects out of the far reaches of her closet, delighted that—twenty years later—I was finally interested in the skills I had refused to learn as a child, despite her profound desire to teach me.

However, these projects of hers were not just school projects. She had carefully saved them because they were also family projects and mementos. In addition to learning from the nuns, my mother was schooled by her mother and aunt and practiced with her cousins, all of whom were skilled in these arts and shared their knowledge and labor. Among this collection, in a bag of its own, was the knitting booklet, which she now retrieved for me. Unlike the other objects, however, this booklet had only come into her possession in Canada, purchased by her sometime shortly after she immigrated in the late 1970s, and had been in a plastic bag all this time, untouched since its purchase.

In the days that followed my mother taught me the basics of knit-ting. When I returned to New York, she gave me the booklet to consoli-date what she had taught me and to prevent me from forgetting this newly and precariously learned skill.

Yet there is a mystery about this book that preoccupies me. Why

[*WSQ: Women's Studies Quarterly* 36: 1 & 2 (Spring/Summer 2008)]

would my mother, who knew perfectly well how to knit, buy the most basic beginner's guide to knitting? I have several theories, by no means mutually exclusive, to try to explain this seeming incongruity. Perhaps, for my mother, who came to Canada alone to be with my father and whose family stayed behind, the little booklet was an attempt to reaffirm the world she left—something purchased in Canada but evocative of home. Perhaps it was an attempt to shore up her knowledge against a possible forgetting; the women who had taught her these skills were now far away. But as the book appears to come from the early 1980s, which would have been shortly after my birth, I also like to think that, for my mother, the purchase of this beginner's guide to knitting pointed to a possible future in which what she knew would be taught and transmitted to me. For my mother, the acquisition of the knitting booklet, purchased prospectively, would have borne witness to an implied promise to (and for) the future and expressed a commitment to transmission. Today, having been passed to me, the booklet appears ultimately to have served this purpose, if a couple of decades later than expected.

As the speculative nature of my theories suggests, however, the significance of the booklet to my mother cannot be so readily fixed, or her intentions so transparently accessed. My belated receipt of the booklet suggests not just a delay but a disruption in transmission—transmission of the booklet itself, of the art that it teaches, and of the entire complex of practices and life-ways that it represents for my mother. With transmission thus disrupted, does the object mean the same thing to my mother and me? Can it possibly bear witness to her—to the dislocations of a diasporic life, and to her hopes or fears for her life in Canada—in the way I imagine it does? Most important, what does this disruption in transmission suggest about my own ability to bear witness to my mother's life and stories? The challenge these considerations pose to the wishful neatness of my preliminary account is deepened by the way I am using the object here: how do I transform the object and alter its ability to bear witness to a particular lived history when, by writing about it, I further alienate it from its original function and turn it into an object of study?

It is neither possible nor advisable to draw firm categorical distinctions between objects that are generally accepted to be part of the public archive and those that are considered "merely" familial or sentimental objects. However, the collecting practices of many of our traditional insti-

tutions of memory still retrace a distinction between objects readily branded with the imprimatur of history and others that are treated as the memorabilia or even detritus of unhistorical lives. There are, in turn, gender dimensions to this question of history-bearing objects, for while histories and genealogies of formal inheritance—of land, property, wealth, and so on—have historically been transmitted through a patriarchal order (fathers passing on and dividing up wealth among sons), the transmission of certain kinds of private objects, which may often have little monetary or evident historical value in the conventional sense, has traditionally been understood as a feminized practice of sentimental and affectual connection. Such a notion is paired with the perception of the feminine or the maternal figure as the archivist of the family, charged with the task of bearing witness to familial memory and transmitting its intergenerational mnemonic objects. Thus, when a private object "goes public," as is the case here, its migration is also marked by gender. What does it mean for me, as my mother's daughter, entrusted with her book, to take an object that to her is marked with familial and personal associations and that evokes for her an art tied to her relations with the women in her family, and send it out into the world reframed as an object of scholarly study? In so doing, am I enriching the life of the object and the range of experiences to which it bears witness? Or does my reuse of the object not as an instructional manual but rather as an object of study simply highlight the break in transmission between my mother and me to which I have gestured, and underscore the limitations of my ability to bear witness to and transmit onward my mother's stories and familial and emotional investments?

In articulating this dominant concern, I am immediately beset by a host of others that cause me to question my presuppositions and reflexive tendencies. By worrying at the legitimacy of my treatment of the object here, and by framing the transformation between my mother's use of the object and my own in terms of a disjuncture between the personal and familial on the one hand, and the scholarly on the other, am I not simply reiterating problematic categories that yoke together the domestic/familial/personal/feminine, in contrast to the public/published/scholarly/masculine? Does my account romanticize a feminized transmission of the domestic arts from one generation of women to another and thus engage in nostalgia for the (lost) possibility of uninterrupted transmission? Is the fantasy that my mother bought the booklet with the expecta-

tion of someday teaching me to knit a self-indulgent one, in which I forcefully try to reinscribe myself into the narrative of transmission at the same time that I mark my difference from and rupture with it? And, most disturbing: are my speculations about the significance of the object to my mother not simply impoverished substitutions of my own stories about her for ones I could have known but implicitly rejected?

The continuing story of the object after it has come into my possession perhaps goes some way toward answering these questions. Since bringing the booklet home with me to New York, I have not used it. That's not to say I have lost interest in knitting—quite the opposite. However, for practical purposes I have quickly moved on from the booklet, with its opaque descriptions and puzzling pen-and-ink diagrams, to the clear instructions and snappy tone of books with titles like *Stitch 'n Bitch* and *Dominknitrix: Whip Your Knitting into Shape*—books that spring from the current explosion of interest in knitting, particularly on the part of young twenty- and thirty-something women and, increasingly, young men. Contemporary knitting culture is marked by a generational break, for while in my mother's life knitting was something one learned in school, a necessary skill upon which one could rely, for women of my age, at least in a certain class, knitting signifies pleasure, leisure, and disposable income. Its practitioners and enthusiasts discuss and celebrate the art in sometimes arch tones, frequently through the frame of feminist reclamation.[1]

Indeed, it's at precisely the nature of knitting as excess in my life that my mother now looks askance. When I tell her that sometimes I have dreams about knitting she looks alarmed: "Shouldn't you be dreaming about your dissertation?" Her concern is only assuaged, in fact, when I tell her that I'm working on a piece about knitting for this *WSQ* issue. Thus, my mother appears to feel at ease with my burgeoning interest in the craft when she can see it incorporated into my life in a way that she judges congruous and appropriate. My point, then, is that both the booklet and knitting mean very different things in our lives. I cannot adopt the practice or use the book in a way that allows me to witness her life in some unmediated fashion. The transmission of both the object and the art is disrupted by my belatedness, but it is also transformed by the way the object relates to both of us, but to both of us differently.

What we do have in common is that the book is something we do not

need but would never throw away. Thus, in this case, the object is most important for the way it may have permitted us to generate stories and imaginings about each other. For my mother, the purchase and safekeeping of the manual may have provided the opportunity to imagine her child and her future relation to it; for me, the booklet is a privileged object for speculating on my mother's relationship to her past. As my choice of words indicates, however, we are both, my mother and I, operating in the realm of conjecture. In work on memory, objects figure frequently and often poignantly. They are regularly spoken of as "witnesses" in which history and memory inhere in the form of powerful affectual traces and resonances. Yet what I am suggesting here, and what may apply to other objects besides my own, is that the value of the booklet lies primarily in its ability to trigger and incite narratives and imaginings, even fantasies, rather than in the object itself.

Furthermore, the significance of the booklet lies in the practices it transmits, which are vastly more important than the material booklet. It is highly appropriate that the object in question is an instructional manual, for it thus deflects attention away from itself as an *object* belonging to the archive and instead exposes itself as an index for a *practice* belonging to a repertoire, to use Diana Taylor's helpful terms (2003). It is this pliancy that allows the object to be available to two different kinds of practices of knitting (my mother's and my own), and that renders it legitimately accessible to different uses, from that of an instructional book for knitting to that of a theoretical prism. Indeed, recognizing that the object can belong to these multiple spheres highlights the ways in which the book served various and complex purposes long before I began to consider it an object of study: for my mother, who didn't need instruction in knitting but bought it anyway, it was a token, a talisman, and a promise; for me, it is a valued memento of my mom, but it wasn't an instructional manual, even before I turned it into a theoretical object. It is through these complex migrations that our object has gained its significance, rather than via a persistent unity of meaning or affectual wholeness. While I cherish the booklet, if it hadn't been a part of my experience of learning to knit with my mom, perhaps there would have been something else that equally could have come to serve as a privileged object of projection for fantasies about the relation between us and the practice that she was transmitting to me. The demonstrated complexity of these transformations, in turn, defuses my anxiety about the possibility that I alienate the object from

itself and the lived reality of my mother's life. The question I posed earlier about how my use of the object in this piece perhaps deforms its personal and familial significance depends, I realize, upon a distinction between public and private that the object now reveals as too facile. Such a distinction may not only reify problematic binarics, but also unwittingly impoverish the object's multifariousness.

What my mother and I also share in our relation vis-à-vis the booklet is a concern with its status as an object with which to teach. For my mother, the booklet is the means by which she can teach me an art, and for me, it becomes a teaching tool when I use it in this piece to generate and transmit a series of reflections. The object thus stands metonymically for the transmission of not just one practice—knitting—but for the practice of teaching itself, and it is here too that the object is made meaningful to both of us, albeit again differently.

Thus, this tiny knitting booklet is able to trigger and carry a series of different associations and projections, bearing witness to no one specific story. It consistently redirects our attention away from its actual objecthood toward the relations and imaginings that coalesce around it and the practices it transmits. Indeed, if we accept my theory that my mother bought a beginner's guide to knitting with the expectation that she would teach me one day, this spawns a mystery of its own: why buy a book to teach me something that she could teach me herself unassisted? I like to think that the book, which is portable and which she was able to send with me, signifies the migration and portability of what she had to teach me, making the book not just an object of memory for her or an object of study for me, but an object lesson for us both.

ACKNOWLEDGMENTS
I am grateful to one of the anonymous reviewers of this piece for his or her helpful comments on the public/private distinction and for encouraging me to clarify my thoughts on this issue.

SONALI THAKKAR is a doctoral student in English and comparative literature at Columbia University. She works on cultural memory, human rights, and transitional justice. Her research is supported by the Pierre Elliott Trudeau Foundation and the Social Sciences and Humanities Research Council of Canada.

NOTE

1. For more on this shift and an example of it, see the introduction to *Stitch 'n Bitch* by Debbie Stoller (2004), not coincidentally the editor of feminist magazine BUST.

WORKS CITED

Stoller, Debbie. 2004. *Stitch 'n Bitch: The Knitter's Handbook.* New York: Workman.

Taylor, Diana. 2003. *The Archive and the Repertoire: Performing Cultural Memory in the Americas.* Durham: Duke University Press.

FAULT LINES

KATE STANLEY

As long as I can recall, my mother's den has housed a large antique armoire—an old, monumental piece of pine furniture stained a distinctive turquoise green. While I was home in Vancouver for a visit over the holidays, my mother moved to a house with a narrow staircase. To maneuver the armoire up the stairs, she sawed off its top half, leaving a long, rough cut along its midline. When my father, long separated from my mother, happened to stop by the new house, she breezily pointed the cut out to him. The juxtaposition of my mother's cavalier pronouncement with my father's pained response prompted me to ask about the significance of this emotionally charged object. The armoire had once been part of a large collection of Canadiana antiques that my parents had amassed together—a collection that was dismantled and split between them at the time of their divorce. Now, twenty-five years later, the schism that divided the armoire in two seemed somehow to belatedly bear witness to the fissuring of my family and its collection.

Since most objects acquire a protracted familiarity through habits of use, I had previously taken little notice of the armoire past a vague sense of its functional place in the various interiors that housed it while I was growing up. Through each move that my mother and I made following the divorce, it remained part of the hazy backdrop of my home life, barely registering in my consciousness. It was only with this final move of my mother's, made almost a decade after I had left home, that the armoire and its place in my family's history came into the foreground for the first time. A toddler during the divorce, I was too young at the time to apprehend the implications of the split beyond my own bewilderment. The cut down the middle of the armoire made me newly cognizant of an enduring emotional legacy left behind by the fragmentation of my family. The fractured armoire both incarnated and bequeathed this painful familial inheritance. At the same time, it was a testamentary fragment of the collection that it once had been a part of, and to which I was also an heir.

[*WSQ: Women's Studies Quarterly* 36: 1 & 2 (Spring/Summer 2008)]

The vast collection of Canadiana antiques that my parents accumulated had filled my early childhood home and spilled over into a small antique store that they ran together in Vancouver. Most of the country furniture and folk art came from Ontario, Quebec, and the Maritimes, where early French and British pioneers were settling in the 1800s. Along with "primitive" pine furniture such as the armoire, their collection included antique decoys, quilts, hooked rugs, and folk art. After a less-than-amicable divorce my parents had remained at an irresolvable impasse. As a source of livelihood, the antiques in the store could be assigned a monetary value and divided according to the terms of a business transaction. But as an assemblage of art and artifacts that also formed the basis of a home life, their private collection had an order and an integrity that transcended any value assigned to the individual parts that comprised the whole. How, I now asked for the first time, was this home collection divided when they split up? While a biweekly schedule of joint custody allotted my time between the two new households, the furniture and art could not be easily shared. Finally, my mother recounted, she rented a U-Haul when my father was at work and loaded half the contents of the house into the van; the armoire was the largest piece that she took. In this way, the collection was unceremoniously dissolved. The objects that had once seemed to constitute a cohesive unit, with our family as its unifying reference point, were now atomized into individually charged sites of contention, but also poignant reminders of an earlier intimacy. My father describes the loss of half the collection as being as excruciating as the divorce itself, a sentiment that can perhaps be better understood if one considers Jean Baudrillard's claim that the collection and, in particular, the antique, represent the desire to restore objects to their earlier status as "spatial incarnations of the emotional bonds and the permanence of the family group" (2005, 14). If the organization of furnishings and the arrangement of interiors personify familial structures, then the two splits are inseparable and bear the same emotional burden.

But as the marked disparity between my mother's and father's attitudes toward the armoire makes clear, the collector's potential nostalgia for these dissipated "emotional bonds" is entirely contingent on how he or she perceives and values the implicit heteronormative structures underlying the assumed "permanence of the family group." In his 1968 work, *Le système des objets*, Baudrillard influentially characterized collecting as a process of overwriting the object's singular qualities—its

specific histories of use, production, and circulation—with a narrative that consolidates the interiority of the individual subject, that of the collector. According to Baudrillard's paradigm, this identificatory gesture hearkens back to a prelapsarian past, when objects anthropomorphized an ideal, unobstructed union between people and things. Collecting, for Baudrillard, particularly of antiques, attempts to recover this bygone "world of 'natural' harmony between movements of the emotions and the presence of things" (Baudrillard 2005, 23). Significantly, what is elsewhere described as a romanticized state of reciprocity with objects is concretely exemplified by what Baudrillard describes as the "traditional environment"—now lost to the "impoverished" functionality of the "modern interior"—but which once embodied the "moral unity" of the traditional nuclear family (13, 15, 13). It follows that the contemporary collector's efforts to recuperate an idealized realm of "natural" and "authentic" essences is coextensive with an implicit longing to rehabilitate an "original" family order.

In the case of my family, there was clearly no formerly intact state of wholeness to be even imaginatively returned to. While I dispute Baudrillard's suggestion that such an ideally integrated familial structure did in fact once exist, the notion that objects mark and are marked by a nostalgic longing for even so illusory a symbolic order resonates with my father's agonized response to the initial loss of the armoire and the final cut made down its midline. For my mother, the armoire was marked and experienced very differently. Throughout their marriage, my father was the collector, while she was the self-described facilitator of the collection. Her initial laying claim to the armoire rejected the sanctity of an exclusive relationship between collector and collection, possessor and possessed, which would have precluded any alternative affiliation with the objects outside that closed identificatory circuit. By dividing the collection and cutting the armoire in half, my mother disavowed a patriarchal conception of ownership and property hinging on the presumption of monolithic wholeness and integrity. Here I recognized how my mother's disruption of a patrilineal trajectory of inheritance also had implications for me, as the potential heir to the family collection. I had inherited, in place of the legacy of "a total order," my mother's strident disavowal of such an endowment, but also the fragmentary remains of my father's and perhaps my own residual investment in a lineage of unbroken transmission (Baudrillard 2005, 26).

Thirty years after they had found the armoire on a collecting trip together, my mother stripped it of any significance apart from its functionality and use value, effectively annulling its collectibility. The cut down its middle constituted a refusal of any intimate, interiorized association with the object at the same time as it represented a decisive break from the joint scene of its acquisition. My mother aimed to sever the armoire's connection with the family history, as well as with the gendered kinship structures that underpinned its history as a collected and collectible object. While my father was also intent on purging the armoire of any shared personal associations, he remained invested in a projected scene of its pristine, authentic heritage. For him, the cut severed the link that the antique had provided to an idyllic vision of Canada's pioneering past, where objects, their makers, and users enjoyed a fullness of harmonious relation. The loss, he claimed, was not of personal but of national and cultural significance: there was now one less piece of its kind left in Canada. And yet any nostalgic investment in this mythologized originary scene pivots on the naturalization of a traditional structure of kinship rooted in a patriarchal family order—one that was decisively rejected by my mother and melancholically mourned by my father. The armoire bears witness to the competing claims that had shaped my family history not by way of any testamentary capacity intrinsic to the object, but instead by making these fraught negotiations perceptible to me for the first time and, in turn, by spurring a recognition of my own position as witness.

My recent reencounter with the armoire has prompted a reconsideration of a more literary object—Henry James's central and titular "golden bowl"—whose fissure similarly emblematizes and bears witness to the conflicted history of a divided family and collection. While *The Golden Bowl* (1904) has been read as registering the collection's shift from the nineteenth-century bourgeois interior to its institutional reconstitution in the context of the "birth of the museum," little consideration has been given to the dispersal of the Verver family objects, which accompany and indeed instantiate this shift. Like the armoire, the bowl exemplifies how certain objects accrete and congeal a surplus of significance that exceeds and fractures the limits of the once self-contained collection. In neither case, however, do the objects work to consolidate narratives of familial unity or the coherence of the collection. They are instead emblematic bearers of the rifts, fragments, and fault lines of witness.

Both the armoire and the golden bowl are the vessels of memory insofar as they are inscribed with the complex histories of their affectively charged investments, identifications, and associations. Accordingly, *The Golden Bowl* is less about how people collect objects than it is about how those objects collect and re-collect meanings (Brown 2003, 171).

The novel ends with collector figure Adam Verver's move from London to American City, where his extensive private collection of European antiquities will be consolidated and installed in what he describes as his "life's work": the creation of a "museum of museums" that will demonstrate "positively civilization condensed, concrete, consummate" (James 1992, 142–43). But the establishment of this museum collection also constitutes the dismantling of his private collection; half of it will remain housed with his daughter Maggie at Fawns, their country manor in Kent. The move that will place a divide between father and daughter, as well as the American and European, public and private halves of the Verver collection is prompted by the unspoken motive to place a continental divide between the Ververs' respective spouses, who have been carrying on an adulterous affair with each other. Consequently, both splits are charged with the loss of what is retrospectively figured as an idyllic intimacy previously shared between father and daughter and the precious objects with which they surrounded themselves. It is significant, however, that even prior to its division, the collection is never associated with a conventional family unit, but instead with an unorthodox father-daughter relationship rife with incestuous undercurrents. In their final scenes together at Fawns, Maggie and Adam Verver's estrangement is manifest in an equally alienated relationship with the objects assembled in a home that no longer feels like one. The close proximity afforded by an interiorizing sense of possession is replaced by the defamiliarizing distance of the tourist gaze when Maggie imagines that she and her father are anonymous visitors to a gallery, without any relationship to each other or to the objects before them: "So it was that in the house itself, where more of his waiting treasures than ever were provisionally ranged, [Maggie] sometimes only looked at [her father]—from end to end of the great gallery, the pride of the house, for instance—as if, in one of the halls of a museum, she had been an earnest young woman with a Baedeker and he a vague gentleman to whom even Baedekers were unknown" (James 1992, 507).

As half the collection is gathered to be shipped away to the actual

museum that will house it in the United States, the stray objects left behind assume the status of redolent, melancholy souvenirs or mementos that remember, mourn, and bear the traces of two mythologized scenes of origin: their "authentic" antiquarian past and what Walter Benjamin has described as the "magical" scene of acquisition. Benjamin characterizes the latter as the moment of the object's rebirth as a proxy of the collector and the renewal of the imagined "old world" whence it came (James 1985, 64). Both the bowl and the armoire are initially imbued with the romanticized ambience that suffused the sites of their discovery. However, both James's jumbled junk shop of hidden treasures and the bucolic rural farmhouse that my parents visited on their last collecting trip together are refigured as scenes of profound disenchantment following the rupture of each relationship. At the same time that they nostalgically evoke these mythic narratives of their origin and rebirth, the objects are also testaments to the death of the collection and the illusive family order it promised.

The golden bowl itself is cracked from the beginning, but like the cut in the armoire, the invisible fissure only becomes discernible as an externalized fracture at the moment that the object is violently broken in half. As it literally and metaphorically circulates throughout the narrative, the bowl accrues referential significance that transforms it from "an enviable ornament, a possession really desirable," into "proof," a "document," an "incriminating piece" that finally "turns witness" to the adulterers' betrayal, as well as to the breach in the exceptional intimacy that father and daughter had once shared (James 1992, 422–24). The crack becomes a symbolic condensation of the internal and external pressures that ultimately fracture the collection and the filial bond around which it was founded. The already fractured bowl is finally broken in an attempt to efface any knowledge of infidelity and thus to reinstate the family order. By contrast, the Canadian armoire is cut in half to erase its familial affiliations. In both cases, however, these efforts to forget constitute forms of remembrance, as the fragments of the objects are erected as memorials to fragmented collections and fraught family histories, the traces of which they bear. For the fragments to function in this way, however, I have to put myself as reader of the fault lines and writer of this essay back into the equation by noting the passives in the preceding sentences and admitting their agents. Ultimately, these objects do not bear witness as the passive recipients of memory's affective inscriptions.

Instead, we can understand the object as witness to the extent that it incites the active processes of witnessing in those who remember, retrace, and narrate—as I have sought to do here—the fraught mutual implications of family and object relations.

ACKNOWLEDGMENTS

I am very grateful to Irene Kacandes, Kathryn Abrams, Marianne Hirsch, and Anjuli Raza Kolb for their careful readings and invaluable advice.

KATE STANLEY is a doctoral student of English literature at Columbia University. She is studying transatlantic modernist literature and object relations theory, with a particular interest in the status of objects in processes of memory, perception, and identification. Her research is supported by the Social Sciences and Humanities Research Council of Canada.

WORKS CITED

Baudrillard, Jean. 2005. *The System of Objects*. Translated by J. Benedict. New York: Verso.

Benjamin, Walter. 1985. "Unpacking My Library: A Talk About Book Collecting." In *Illuminations*, edited by Hannah Arendt. Translated by H. Zohn. New York: Schoken Books.

Brown, Bill. 2003. *A Sense of Things: The Object Matter of American Literature*. Chicago: University of Chicago Press.

James, Henry. 1992. *The Golden Bowl*. New York: Everyman's Library.

EVERYDAY ATROCITIES AND ORDINARY MIRACLES, OR WHY I (STILL) BEAR WITNESS TO SEXUAL VIOLENCE (BUT NOT TOO OFTEN)

SUSAN J. BRISON

Seventeen years after having been jumped from behind, beaten, raped, strangled into unconsciousness, and left for dead at the bottom of a ravine in a rural area in the south of France, I still—as I just did—occasionally bear witness to the assault. Why do I continue to tell this story? It certainly isn't because I enjoy doing so: at this point, telling the story is neither therapeutic nor retraumatizing. Frankly, after telling this story hundreds of times, to perhaps a million people (if one counts the readers of the *Sunday New York Times*), I'm bored by it. [1] But I continue to tell it, albeit with decreasing frequency, because doing so is bearing witness to something much larger, and much worse, than what happened to me personally: namely, the atrocity of widespread and ongoing gender-based violence against women around the world. I also mention it, somewhat paradoxically, to reassure other victims of sexual violence that I've moved beyond it and don't feel the need to talk about it regularly anymore.

Looking back on the several years before I was attacked, I see now that I was living a charmed life. I was newly married and had a full-time job I loved, teaching philosophy at Dartmouth, and enough energy and drive to teach additional courses at both New York University and Princeton, while sitting in on law school classes at NYU, taking tap dancing lessons in SoHo and musical theater classes in Greenwich Village, and singing jazz occasionally with friends in piano bars in the city. One term I managed to teach five days a week at Dartmouth and still spend every weekend in New York City with my partner going to cabarets and jazz concerts and Sunday night swing dancing at the Cat Club. And, then, wham! I lost it all, just that suddenly, and for a very long time, but—I can now report—not forever. In spite of my having

[*WSQ: Women's Studies Quarterly* 36: 1 & 2 (Spring/Summer 2008)]

written, years ago, that I died in that ravine, I now have more in common with my preassault self than with the person I became for more than a decade afterward.

Although I originally described my preassault life as a quite sunny one that suddenly went dark, I stopped thinking about it in that way after someone pointed out what he saw as the "gothic novel" structure of the tale I was telling. I became quite suspicious of the "reverse-conversion" narrative I found in many rape stories (including my own) and made a point of downplaying any contrast between my preassault happiness and my postassault misery. But now that I have emerged from the latter, I think I *was* genuinely blessed with joie de vivre and fortunate circumstances before that fateful day.

There are many different reasons to tell a trauma narrative, and I'm guessing that, over the years, I've told mine for just about all of them. The very first time, I told it (mentally) to myself, as it was happening: "What *is* this? This is a nightmare. No, this is a rape. No, this is a murder." The purpose of that narrative was to keep me alive, and by sheer luck, it did the trick. After my assailant had dragged my body to the bottom of a creek bed and choked me one last time, I played dead until he left, which enabled me to scramble up the ravine to a roadside, where I was rescued by a man in a tractor who took me to his nearby farmhouse.

My next attempt to bear witness to my attack was met with incredulity, as the people who gathered around me decided initially that I must have been hit by a car, even though I kept saying that I had been attacked by a man. After I repeated my story to the police and the doctor who had been summoned and my account started to gain plausibility, someone said, to general agreement, "It couldn't have been anyone from around here." As it turned out, my assailant was a young man who lived right across the road. But whatever I said fulfilled the function of the narrative at the time, since it brought the personnel necessary for my survival, including EMS volunteers with an ambulance, who took me on the forty-five minute ride to the Grenoble hospital where I spent the next eleven days.

My determination to speak publicly about my assault first arose while I was being transported by ambulance to the hospital. I vowed that, if I survived, I would dedicate myself to doing something (I didn't know what, but *something*) to help other women who had been beaten. At the very least, I would bear witness to sexual violence against women—

speaking out not only about my own assault but also about the countless other gender-based crimes that occur daily around the world.

Before I could bear witness in any politically significant way, I needed to tell doctors and law enforcement officers the story of what had happened to me. It came as a huge relief when I was able to do so. For the first thirty hours in intensive care, however, while doctors and nurses waited to see whether surgery would be necessary, I was not allowed to eat, drink, or sleep, and, to breathe, I was dependent on an oxygen mask that included an anti-inflammatory drug to reduce the swelling of my fractured trachea. So I was silenced, not for political reasons, but of physical necessity.

When my life was no longer in danger, a steady stream of visitors came to my hospital room to ask me about what had happened: first, the doctors—that was relatively easy and straightforward—and then the police who came to take what turned out to be an eight-hour-long bed-side deposition. They apologized repeatedly for putting me through the ordeal of recalling the brutal assault I had so recently endured, and I repeatedly replied, "No, you don't understand. I feel so much better when I'm *talking* about what happened." At that point, I had two options (well, three, if you include sleep, which, blessedly, came, finally, when chemically induced): lie awake in bed being bombarded with sensory images of the assault—in effect, being forced to relive the trauma—or narrate it, out loud, to a present listener, which, at least temporarily, gave me some small feeling of agency and control, since I was the one deciding what to tell and how to tell it.

That was the first time I recognized the healing potential of bearing witness, although I was not, at the time, doing it for that purpose. Talking to others about what had happened gave me a reprieve from the onslaught of passively experienced, and largely somatic, traumatic memories. In the next day or so, I also had the opportunity to tell the story to a psychiatrist, who stayed by my bedside listening to me for two and a half hours. This, not surprisingly, was the most therapeutic of my early narrations.

I was extraordinarily lucky for a victim of such a crime, not only because I somehow survived, in spite of a fractured trachea and multiple head traumas, but also because my subsequent recountings of the assault were believed. There was ample physical evidence that I had been attacked in the ways that I described, and the perpetrator, who was

apprehended not long afterward, confessed to the assault. At the trial, two and a half years later, even the defense lawyer accepted my version of the facts of what happened, and he congratulated me on my strength and courage as he tried to get my assailant off on an (ultimately unsuccessful) insanity defense.

Although my account of the physical facts of my assault was believed, my intention to bear witness to sexual violence—that is, to an ongoing group-based phenomenon of gender-motivated violence—has been continually thwarted. There were, for example, a few distressing moments as I gave my deposition to the police. When I mentioned the fact that, as I was thinking, "Why bother to struggle to stay alive?" I had a vivid image of my partner finding my dead body, which galvanized me to do what I could to stay alive, the officer taking my deposition said that it was a good thing I mentioned my husband, since my assailant had claimed, in a statement to the police, that I had provoked the attack. Under the circumstances, this was too ludicrous for anyone to believe. But had the circumstances been different—in any number of ways—my assailant's claim might have been credible, to some people, anyway. I guess the police officer was at least somewhat concerned that a jury might find his claim plausible, had I not evinced some concern for my husband. One can only imagine what a jury might have considered plausible had I not been married, thirty-five years old, dressed in baggy jeans and a sweatshirt, and walking in broad daylight in a "safe" place. [2]

Although my purpose in telling my story to the police officers was to help to apprehend, indict, and ultimately convict and put behind bars the man who raped and nearly murdered me, I very quickly realized that my bearing witness to my assault would also serve an educational purpose, that of raising awareness of at least some of the causes and effects of sexual violence. Whereas most people around me were determined to see what had happened to me as an inexplicable, random, isolated incident (firmly entrenched in the past and now best forgotten), I—still hearing my assailant's vile antifemale epithets and still seeing, feeling, and even smelling the sexual degradation he subjected me to—viewed myself as having been very nearly murdered by misogyny.

While I was still in the hospital, my own lawyer (whom I'd retained to help me through the legal morass of my assailant's prosecution and trial—and who had been recommended as the best lawyer in the area for sexual assault victims) said to me, "Don't think of your assailant as a

man, a human being. Think of him as a lion, a wild beast." But I couldn't help but think of him as a man, a man who harbored enough rage against all women to want to rape, torture, and kill me. Two years later, before my assailant's trial, the attorney general with whom I met about the case admonished me, "When the trial is over, you must forget that this ever happened." As if I were the only woman who had ever been—or would ever be—the victim of gender-based violence. This sealed my conviction that I must tell the world about sexual violence—not because it happened to me, but because it happens to so many other women.

It is hard for most people to see rape or sexual murder as group-based gender-motivated violence against women: people tend to think of victims' rape testimonies as individual stories of either interpersonal violence (and thus, completely explained by the particular relationship between the victim and perpetrator) or random violence (and thus totally inexplicable). We do not, generally, use the words "testimony" or "witnessing" in discussing rape narratives (unless we are speaking of courtroom scenarios). Holocaust survivors give their testimonies. Political prisoners bear witness to the torture they endured. Rape survivors tell their stories.[3]

The very prevalence of sexual violence can, paradoxically, render it invisible. It is unlike those phenomena that prompt moral outrage—relatively discrete geographic and historical events, such as the Armenian genocide and the Holocaust—in that it is diffused: it is inflicted on victims spatially and temporally distant from one another. This can make different instances of gender-motivated violence appear to be unrelated to one another and to the gendered roles of men and women.

We can find an example of this in the campuswide reaction to the kidnapping, sexual assault, and murder of a female student at Colby College in October 2003. (The woman had been abducted in the parking lot outside her dorm while getting into her car at 7:30 in the morning.) The discovery of her body in the woods a couple of miles away sparked widespread alarm; an appropriately high level of concern on the part of the administration; and at least one oddly inappropriate, though well-intentioned, campus response, which was that the football team started up a service escorting women around campus at night. A week after the body was discovered, the assailant was apprehended and confessed to the crime. (There was also sufficient physical evidence that the police—and the rest of the community—were confident that the perpetrator had

been caught.) Subsequent memos stressed that the perpetrator was not a Colby student and that this was a "random act of violence." The escort service provided by the football team stopped and, for many students, things quickly returned to "normal." But many, if not most, women on campus had had their earlier sense of security shattered. Some of them told me that their male friends quickly became exasperated with them for still being afraid after the perpetrator was caught: "What's the matter? They found the guy! It was just an isolated incident. It's not going to happen again." That it was clearly a gender-based sex crime against a woman—part of a larger pattern of such crimes—was a terrifyingly obvious truth to some and a faintly ridiculous proposition to others.

Furthermore, unless she has a feminist consciousness, even the victim of sexual violence may view what happened to her as a "private" trauma, rather than an instance of group-based victimization. It can make a survivor of sexual violence feel less isolated and less crazy to realize that she is not alone, not the only one to have had her life shattered in this way. ("It didn't just happen to me.") It can motivate her to speak out, to take action. However, that same realization can, especially when she is faced with others' lack of concern, make her feel even crazier, more overwhelmed by the enormity of the problem. ("It didn't just happen to *me*!") It can lead to paralyzing demoralization.

Attempts to bear witness to sexual violence can also be frustrated by the fact that society seems to hold, simultaneously, two contradictory views about this kind of crime. On the one hand, many people seem to believe there is no such thing as gender-based violence. Yet on the other, at some intuitive level they regard sexual violence against women as something that is to be expected, that is only natural, that makes sense. These contradictory effects may be fostered by a culture in which violence is sexualized and sex is increasingly bound up with the degradation, humiliation, and brutalization of women. The sex-violence link is now being touted by some scientists as a phenomenon grounded in evolution, a genetically hardwired feature of human nature. Whether or not there is a biological basis for this link (which I'm inclined to think is largely culturally forged), it is reinforced (and trivialized) by pornography, prostitution, and other forms of the commodification of women's bodies.

I saw the effects of this pervasive socialization when I returned to the United States and began to tell friends and family members about the

assault. When I told them that I had been nearly murdered, and when they asked, "Why?" they were satisfied with the "explanation" that the attack began as a sexual assault. A young man jumping a woman from behind on a country road, beating and strangling her and leaving her for dead makes no sense. Add that the woman was sexually assaulted and, suddenly, it all makes sense! How the addition of a further criminal act (the rape) helps to explain the murder attempt remains a mystery to me, even more so because the further act was, physically, the same as the act we refer to as "making love." But the fact that a-man-raping-and-then-attempting-to-murder-a-woman *makes sense* to people reveals that we do, as a society, grasp the concept of gender-motivated male violence against women, even as we manage to deny that such a group-based phenomenon really exists.

Characterizing sexual violence against women as gender-based violence can help us to confront many of these misconceptions. It can also help to facilitate redress on behalf of victims. As we comprehend more fully the harm to the victims of such crimes and the groups to which they belong, and as we understand whatever common cause(s) there may be of these seemingly "isolated incidents," we can better craft strategies to prevent them and legal remedies to redress them when they occur.

Bearing public witness to violence against women is central to this recharacterization. As depressing as it can be to talk about violence against women, I find it, ultimately, encouraging to conceptualize it as culturally induced, gender-based violence, because doing so enables us to work toward eliminating it. If it is not a fact of nature, hardwired into our genes or coming from out of nowhere like a natural disaster; it is something we can—and should—do something about.

Finally, I still tell my story to show other survivors that it is possible to thrive even after being subjected to such extreme abuse and humiliation. I recall the woman in the support group I attended who had been raped twelve years earlier and who asked, "Does it ever stop hurting?" My answer at the time, six months after my assault, was "I don't know." My answer in 1992, when I wrote chapter one of *Aftermath*, was "Yes, it does stop hurting, at least for longer periods of time. A year after my assault, I was pleased to discover that I could go for fifteen minutes without thinking about it. Now I can go for hours at a stretch without a flashback. That's on a good day. On a bad day, I may still take to my bed with

lead in my veins, unable to find one good reason to go on" (Brison 2002, 20). My answer now is "Yes, it does stop." I don't want to sound obnoxious. I hated the Pollyannaish comments I got shortly after my assault—from people who had no idea what I was going through, but were certain that the experience would make me stronger. (One aunt actually called the whole ordeal "a real blessing from above, for sure.") But I have some credibility now, having lived through the assault and its aftermath. And I want to help others get through this, as other survivors helped me by telling their stories.

I really am over my assault. Other things distress me much more now, and rightly so: the war in Iraq, the torture our government is inflicting with apparent impunity, devastating and inexcusably unjust global inequalities. This is not to say that my assault has left no traces. I still have lingering symptoms of posttraumatic stress disorder. I have fractured speech and a disordered brain in stressful situations. I have claustrophobia (which I never had before) that prevents me from taking elevators unless absolutely necessary. I still take antidepressants and sleeping pills (which I'd never taken before), and I won't go for walks in the woods by myself (which used to be one of my favorite activities). But these things are pretty trivial. I *have* regained my lost self.

I wrote in *Aftermath* about the distinction between "living to tell" (staying alive to bear witness at a trial or, in some other way, to see that justice is done) and "telling to live" (constructing a narrative about a traumatic assault that enables one to project oneself into the future with some degree of hope and optimism) (2002, 106–117). I've now moved beyond both of those, to not needing to tell the story any longer. I lived to tell what I needed to tell to get my assailant convicted and put behind bars for ten years. And over the years, the story I have told about my assault in order to live has got shorter and less central to my life's narrative, until I now no longer need to tell it at all. I can make new friends without having to inform them of my long-ago ordeal. Sometimes they find out about it anyway, which is also no big deal. A musician I met at a "jazz camp" this summer read about *Aftermath* and e-mailed, half-jokingly, "Man, you got a right to sing the blues!" The assault, or, rather, the depression I suffered for years afterward, may well have added a depth to my singing that wasn't there before—and this is how the assault feels most salient to me personally right now. But I have to disagree with his assessment of my musical entitlement: one can't *really* sing

the blues while having the level of well-being and security I now enjoy.

My regained equilibrium sometimes induces affective dissonance in audience members when I give talks about my experience with sexual violence, or read from *Aftermath*, with what is, for them, a somewhat unsettling sangfroid. I'm reminded of the comment a therapist made to me shortly after my assault about detachment: "You talk about this incident as if it had happened to somebody else." Had I remained unable to integrate affect into my narrative, it would have been unhealthy and hindered my recovery. (I was not, at that early stage, beyond feeling, but, rather, was so overwhelmed by feeling that I could not cope with even small doses of it. And I was only marginally functional in other aspects of my life.) Now, because I have worked through the trauma, whatever narrative repetition I engage in is consciously chosen. It is far removed from the early compulsion I felt to say at least *something* about the assault to everyone I knew—and even to people I'd just met—before I could carry on a conversation about anything else. My narrations these days are aimed primarily at testifying to the pervasive character of sexual violence against women and supporting other survivors, something I am better able to do because of the overall trajectory of my life to the present.

The attack I endured no longer defines who I am. Being a singer does, and I want people to know about that. Telling the story of my assault is not, at this point, therapeutic. Singing is. And I like to think my music making gives others pleasure, too. Music, for me, is life, and making music is the ordinary miracle I hold up against the everyday atrocity of sexual violence.[4]

I now question Jean Améry's assertion that "Whoever was tortured, stays tortured" (1995, 131). It's possible that I'm able to embrace life so wholeheartedly now, in some sense, *because of* my assault. *I'm not supposed to be alive.* When my lawyer informed me of that fact, while I was still hospitalized, I resented the implication that I was to henceforth rejoice in my good fortune. But I now have to agree that there is something liberating—exhilarating even—in that realization. The day will come (and it could come at any time) when I will feel no luckier than the average person muddling along in life. Or worse. No one should covet my (current) good fortune. As the woman in Grace Paley's poem "Luck" says to an envious friend with a hard life, "Take it easy / there's time for me to be totally wrecked" (2000, 171).

I'm doing what I can to ward off that day, though. I'm trying to do

good work, treasuring the time I have to spend with my family, surrounding myself with life-affirming friends, and listening to and singing and playing as much music as I possibly can. From time to time, I still bear witness to the brutal sexual assault I survived, but no more often than I feel I have to, to help raise people's awareness of gender-based violence. I'm bearing witness at this point to show other, perhaps recent and still struggling, victims of such crimes that it really is possible not only to carry on afterward, but also to take so much pleasure in life that at times you almost can't stand it. I'm bearing witness to what's happening to others as I speak, or write, so that they might find aid and comfort. I'm bearing witness to what will happen to others if we don't speak out now and try to prevent it. But I'm no longer in the story. I've walked right out of the picture, and I'm sitting at my piano, with a few good friends, making a joyful noise.

ACKNOWLEDGMENTS
Kathryn Abrams and Irene Kacandes went way beyond the call of editorial duty in providing invaluable advice and support. An external reviewer, Naomi Scheman, also provided extremely helpful comments. My deepest gratitude to them all.

SUSAN J. BRISON teaches philosophy and women's and gender studies at Dartmouth College and is the author of *Aftermath: Violence and the Remaking of a Self* (Princeton University Press, 2002).

NOTES
1. I published my story first in Brison 1993 and, most recently, in Brison 2002.

2. It also helped that I was white, middle class, and well educated, although it did not help that I was a foreigner. The French colleagues my husband and I had been staying with pointed out that nothing like this had ever happened around there before I arrived (although the local paper reported a similar-sounding rape that same day in the next valley over). When they wrote to us a couple of months later and mentioned that another American woman had visited them, they said they made sure to keep her "on a short leash," as if I had been a bad dog, causing trouble where I didn't belong.

3. In making reference to the Holocaust, I am not suggesting that what I experienced and what victims of the Holocaust suffered were in any way commensurable. They were not.

4. I thank Naomi Scheman for helping me to formulate this insight in this way.

WORKS CITED

Améry, Jean. 1995. "Torture." In *Art from the Ashes: A Holocaust Anthology*, edited by Lawrence Langer. New York: Oxford University Press.

Baudrillard, Jean. 1986. *Le système des objets*. Paris: Denoël-Gonthier.

Brison, Susan J. 1993. "Survival Course." *New York Times Magazine*, March 21.

———. 2002. *Aftermath: Violence and the Remaking of a Self*. Princeton: Princeton University Press; Paris: Editions Chambon, 2003; Munich: C. H. Beck Verlag, 2004.

Paley, Grace. 2000. *Begin Again: Collected Poems*. New York: Farrar, Straus and Giroux.

"FROM THE MOUTH OF THE RAPED WOMAN RIVKA SCHIFF," KISHINEV, 1903

MIKHAL DEKEL

When the swine broke into the attic through the roof, a few of them jumped on the Zichec daughter first. They slapped her and formed a circle around her. She fell on the floor from the blow. They raised her dress, turned her face downward and her behind upward and began slapping her on her behind with their hands. Then they turned her around again, parted her legs, covered her eyes and her mouth so she wouldn't scream; one climbs on top of her and the others kneel down around her and wait for their turn. They all did what they did in front of all the people in the attic. A few jumped on top of me and my husband. He wanted to escape and I'm behind him. They attacked him: Give money! Miti Karsilechic wanted to taunt me, and asked me for money. I asked for pity: Don't touch me, Miti, you have known me and have been acquainted with me for many years. I don't have money. Several of them ripped my dress from behind, and one slapped my cheek and said: If you don't have money, we'll enjoy you in another way. I fell to the floor and Miti is on top of me doing me. And the rest of the gang around me, waiting. My husband and the rest of the Jews in the attic saw Miti on me. My husband gave them the silver watch and a necklace. They thought the necklace to be gold and until they finished examining it, my husband jumped to the ground [level]. There they beat him. The rest of the Jews also jumped. Only I and Simi Zichec remained. They mocked and taunted me: "It seems you never in your life slept with a goy—now you will know the taste of a goy" I don't know how many were with me, certainly no less than five and possibly seven. When they finished doing—they went down one by one. One goy came up—Bubichec—and said: Hide in the corner because soon other thugs will come up. In a moment I'll come with my wife and bring you down. I sat in the corner in my underclothes, and at that moment Simi Zichec came and sat with me. We are both sitting silent and mute. Immediately one came up and began calling his friends. He saw that there is no one and left. Later approximately four more came up. One kneeled above me as if he was feeling sorry for me. He saw the earrings and ripped them off my ears and wanted to torment me again. At that moment the honest goy Bubichec came up and in

[*WSQ: Women's Studies Quarterly* 36: 1 & 2 (Spring/Summer 2008)]

front of his eyes Simi and I were had, each by two. The goy tried to
cunningly stop them and said: "But you are Christians and daughters of
Israel are forbidden to you." But they wanted to beat him as well and he was
afraid and attempted to only save lives: "Do what you want with them, just
don't kill them." The four finished and the goy helped me cover myself with
a shawl and Simi held my hand and that's how we descended the attic, and
the swine behind us. Accompanied by the goy, Sima and I went to my
mother's house in the Vagazal—Tabakari—(Sima also has an aunt there)
and found that there everything was destroyed as well. I returned to ask
for my husband. I did not know where he is, dead or alive? Crushed and
shattered, a receptacle of shame and filth, I returned to the courtyard in my
home, perhaps I will find him—and saw a woman running away from there
and ran after her. "Where is my Bube" asked the woman (Bube also lay in
the attic). I consoled her that no one was killed. We came to the yard of the
ritual bath—the woman had some relatives there and had previously lived
there—where I fell, fainting. My husband and Bube were also there.
There we slept and on Tuesday morning my husband and I escaped naked
and barefoot to Kolresh and on Wednesday we returned to Kishinev. All the
merchandise in our store was taken and we were left without anything.
—Testimony of Rivka Schiff as written down by H.N. Bialik

On April 6, the last day of Passover and the first day of Easter 1903, a wave of attacks against the Jews of Kishinev, capital of Bessarabia, began. For two, and in some areas three, days, homes and businesses were destroyed and looted; men, women, and children were beaten, mutilated, and murdered; women were gang-raped. The perpetrators, as in Schiff's ordeal, were often young male neighbors, students and business partners of the victims. They operated uninterrupted while Russian policemen stood by, local government officials ignored pleas for help, and the postal service refused to deliver the telegrams containing desperate calls for the intervention of the central government (Goren 1991, 9).

By 1903, Russian Jews had already lived through pogroms, anti-Jewish legislation, and forced expulsion; later pogroms of the late 1910s and early 1920s would claim tens of thousands more victims in Kishinev: it is estimated that in those years 1,326 pogroms took place in the Ukraine alone, in which between thirty thousand and seventy thousand Jews were massacred (Kadish 1992, 87); still, Kishinev, with "only" forty-nine dead, became, at least until the Holocaust, a code word for the brutalization

and vulnerability of Jews, the most traumatic event in modern Jewish memory.

The level of brutality at Kishinev, or more accurately, the ways in which this brutality was represented, reported, and disseminated worldwide, was unprecedented. For a nominally local occurrence, Kishinev elicited numerous articles, letters, and photos in major newspapers across the globe, including the *New York Times* and the *London Times*; it drew a significant political response in Russia, England, and the United States and made it into the larger cultural sphere—into plays, songs, poems, and essays—some of which are recited even today.[1] Kishinev was also the first pogrom to be extensively photographed, the first visually documented horror of the twentieth century, to be followed a decade later by the images of bloody battlefields and mutilated soldiers of the World War I. It coincided with and perhaps signaled the beginning of "new media"—sensationalist, image-seeking, violence-obsessed, globally oriented news coverage that feeds on blood and gore; photos of contorted dead bodies, including those of babies, and of homes turned to rubble appeared in papers and books everywhere (Gluzman, Hever, and Miron 2005, 71–154).

Over the course of the following century, however, what brought Kishinev to the consciousness of generations of Jews was not photos or history books, and certainly not testimonies such as Schiff's, but a poem, "Be-ir ha-hariga" ("In the City of Killing"), written in the wake of the pogrom by the prominent Hebrew poet Hayyim Nahman Bialik. At least in Israel, where I grew up, this poem is an integral part of the school curriculum; I do not remember when I first read or studied it, but the words "Kishinev" and "pogrom" seem to have been part of my vocabulary for a long, long time.

"In the City of Killing," was published in 1904. The thirty-one-year-old Bialik had by then already achieved legendary status in the world of Modern Hebrew letters. He had also already published a poem on Kishinev titled "On the Slaughter"—a moving, anguished elegy that was favorably received. In May 1903, a month after the pogrom, he was sent to Kishinev, not to write another poem about it, but to gather survivor testimonies and publish them in a book. He was commissioned by the Jewish Historical Committee in Odessa, a small yet influential political entity headed by the Zionist editor and essayist Ahad Ha'am (Asher Ginzburg). In 1903, the Zionist movement was not yet a full-fledged ter-

ritory-seeking national movement, yet it viewed itself as a political entity representing the Jews and sought to document and publicize the atrocities as widely as possible.[2]

Bialik, it should be noted, actively sought the task. A lawyer, not a poet, would perhaps have been a more obvious choice. But the poet insisted on going to Kishinev himself. He reportedly wanted to see the violence from up close, to become a direct eyewitness to the brutalization of his people.

While in Kishinev, Bialik and his associates took great pains to ensure the truthfulness and accuracy of testimonies. Eyewitness accounts were compiled, with the help of locals, over the course of two months (May–June 1903). All interviewees were presented with the same questionnaire, and their answers were jotted down in several notebooks by order of appearance. With varying degrees of detail and length, each witness relayed the events in chronological order, from the time he or she heard about the anticipated attacks to the point at which they had subsided. Testimonies were organized in clusters, divided by neighborhoods and courtyards, so that the events that took place in each locale could be corroborated by several witnesses—neighbors or members of the same family. Often, an estimated monetary figure for the damages incurred by the witness appeared at the end of a testimony (Goren 1991, 48–49).

Approximately 150 testimonies were collected, ranging in length from a short paragraph to eight pages. Bialik then set out to the remote estate of his father-in-law to edit and organize the testimonies. In his final version, each testimony is prefaced with a short blurb about the witness's address, age, occupation, financial standing, place of origin, and familial status. Schiff's testimony is prefaced as follows:

House no. 11 Nickolai Street
From the mouth of the raped woman Rivka Schiff, wife of Shabtai Schiff (now living in 36 Bandersky Street and during the pogrom in 11 Nickolai Street), 24 y/o, 4 years after her marriage (she had a son who died). Born in Yassi and in early childhood (3 y/o) came to Kishinev (her father was a butcher in Romania, left for America, where he was not accepted, and settled here). (Goren 1991, 80)

Schiff's testimony is followed by those of her husband and others who were in the same courtyard. The second woman who was raped in the attic of 11 Nickolai Street—Sima Zichec—does not give testimony, or her testimony has not survived. In his testimony, Schiff's husband, Shabtai Schiff, mentions Sima Zichec's rape (though he implies that he only heard about it, not that he actually saw it). He does not mention his wife in any way. The rape is mentioned at the end of his testimony, following his account of what took place after he and the others jumped down from the attic (he was beaten; an old woman, Bube, was stabbed with a knife):

> In the attic, according to one eyewitness, one virgin was raped, 19-year-old Rachel Darnizki, and because of the shame she left town. People also testify that the raped young woman Sima Zichec is deteriorating and since the day of the catastrophe has become extremely thin. (81)

After devoting months to organizing and editing the testimonies into a publishable book, Bialik decided to abandon the project entirely, for reasons that he never publicly disclosed. He buried the testimonies deep in his archives and refused to release them in his lifetime, even after he immigrated to Palestine. Instead, he embarked on composing "In the City of Killing"—the monumental epic poem that would shock the Jewish world immediately upon its publication, energize and politicize not only Zionists but Jews at large, and engrave the Pogrom in the biography of post-Holocaust-born Jews like me.

Bialik's poem is centered on witnessing: male witnessing. It begins with God's command to the male poet/messenger to "rise and go to the town of killing," to see with his own eyes and feel with his own hand "the congealed blood and hardened brains of the dead."[3] It then continues through a series of shocking synecdoche: a "disemboweled chest filled with feathers," "a case of nostrils and nine inch nails," "a baby found by the side of his stabbed mother / still dozing with her cold nipple in his sucking mouth." The second stanza, in which God commands the poet to witness the rape of Jewish women is loosely based on Rivka Schiff's testimony:

Go down . . . and come to the dark cellars
Where the pure daughters of your race were defiled among the pots
 and pans
Woman by woman under seven after seven uncircumcized,
Daughter in front of mother and mother in front of daughter,
Before killing, during killing, and after killing;
And with your hands feel the filthy pillowcase and blushing pillow,
Den of wild boars and raping paddock of centaurs
With the axe's blood dripping and steaming from their hand.
And see, oh see: in the shade of the same corner
Under this bench and behind that barrel
Lay husbands, fiancés, brothers, peeping out of holes
At the flutter of holy bodies under the flesh of donkeys
Choking in their corruption and gagging on their own throats'
 blood
As like slices of meat loathsome gentile spread their flesh—
They lay in their shame and saw—and didn't move and didn't
 budge. (Hadari 2000, 2)

The stanza, surely one of the strongest in the poem, made tremendous waves when the poem was first published. Its harsh and unrelenting critique of Jewish male passivity was generally accepted as true, legitimate, and well deserved; in its wake, Jewish self-defense groups were formed all over Russia and the Ukraine (Goren 1991, 40–44) and the Zionist ethos of self-reliance gained fresh and urgent momentum. In subsequent years, however, and particularly since the complete publication of the Kishinev testimonies in 1991, the same stanza has been subject to intense critical reevaluation. In a 2004 conference held at the Jewish Theological Seminary in New York to mark the hundredth anniversary of the poem's publication, and in "Kishinev in the Twentieth Century" a subsequent special issue of *Prooftexts* (Mintz and Roskies 2005), many of the papers treated Bialik's misrepresentation of survivors' accounts. We now know that there were in fact attempts at self-defense in Kishinev by both individuals and groups. We also know that such attempts were thwarted by the police and, in most cases, ineffective. There were no peeping husbands in the Kishinev story except, metaphorically speaking, the poet himself, whose imagistic, slightly pornographic language both draws the reader into the rape scene and removes her or him from its reality.

The reasons why Bialik traded Schiff's clear-headed, highly subjective, detailed, and angered testimony for the generic, unspecified rape of "pure daughters" by a "den of wild boars" have also been discussed by several scholars. Beyond the most obvious reason—that images of pure Jewish maidens attacked by a "raping paddock of centaurs" would serve the poem's Zionist underpinnings far better than that of an ordinary woman raped by her business acquaintance and his drunken friends—several others have been suggested. In a recent article, Michael Gluzman argues that a reactivation of an early sexual trauma had triggered in Bialik both a strong identification and a real terror of women's victimization in Kishinev (Gluzman, Hever, and Miron 2005, 13–36). Dan Miron has suggested that Bialik suffered from posttraumatic stress symptoms experienced by the "exposed to the exposed"—those doctors, clerks, and journalists who come into contact with survivors of mass trauma and whose terrors were originally documented and catalogued by Robert Jay Lifton in his 1967 *Death in Life: Survivors of Hiroshima* (Gluzman, Hever, and Miron 2005, 71–154). Bialik, according to this explanation, became numb, apathetic, and even fascinated by the horror and perversity of Kishinev's violence, and the poem is a testimony to the symptoms of a reluctant witness more than to the actual survivor tales of Kishinev.

Undoubtedly, in choosing to publish "In the City of Killing" over the original Kishinev testimonies, Bialik had shifted readers' focus from survivor testimony to the indirect testimony of the poet/witness. It is this witness—his observations, his moods, his anger and muted tears, his wrath at victims' helplessness—that is the true subject of the poem. And it is with this figure or subject-position of the ambivalent witness, affected by the horrors yet situated well outside them, that readers identify. Yes, Bialik's judgment was obscured by his Zionist underpinnings, by his childhood trauma, by secondary posttraumatic stress disorder symptoms, but these do not explain why almost no one who read the poem upon its publication noted the ethical fault of blaming the victims, why almost no one questioned the truthfulness of Bialik's account, and why no one made sure that the actual testimonies were published; these reasons do not explain the poem's unprecedented popularity, then and now, and its immediate appeal to almost any reader's sensibility.[4] Indeed, it is its exact narration of suffering through the poet's mediated gaze, its exact treatment of the impossibility of witnessing suffering directly that makes the poem work for many.

There is, I think, a reluctance to engage with actual testimonies to the kind of victimization that you yourself might have endured had circumstances been slightly different. So Bialik creates a mediating figure—that of the male poet/messenger who sees and feels for the Jewish sufferers, and particularly for women, but who distinctly marks them as Others. This was a normative Zionist response: to anchor its claim to legitimacy in Jewish suffering and yet strive for the creation of a universal subject who is untouched by that same suffering and victimization. Zionism created a new person who is affected by Jewish history but at the same time cut off from it. I am that person. And because I am that person, discovering and translating Schiff's testimony feels nothing less than liberating. In its simplicity, in the precision of each of its details, in its slow-paced chronology, the contingency of every moment of that horrific time comes alive for me. Kishinev was a horror. That does not change when one reads the testimonies and discovers that Bialik misrepresented, magnified, or belittled some of its details. Yet reading Schiff's testimony across the bar of Bialik's timeless monumental poem, history, however painful, is made palpable and real in a new way. It is a clearing of the field of vision.

MIKHAL DEKEL is an assistant professor of English and comparative literature at the City College of New York. She received her doctorate from Columbia University in 2005, has published several articles, and is currently completing her manuscript *Modernity, Masculinity, and the Making of a Jewish National Subject*.

NOTES

The epigraph to this text is quoted in Goren 1991, 80–81.

1. Several inquiry committees were set up, including one by the czar's interior minister, resulting in the dismissal of the head of local government. These measures, however, were later viewed as cynical and ineffectual, as the central government itself has arguably been implicated in allowing, if not instigating, the attacks. See Goren 1991, 9–35; Roskies 1989, 145–68.

2. The First Zionist Congress met in Vienna in 1897; Theodore Herzl, founder of political Zionism, had already began his attempts at bargaining over parts of Palestine with the Ottoman Empire, and when that failed, at exploring other territorial options for Jewish resettlement. Yet the bulk of early Zionist discourse at this stage did not focus on territorial nationalism but rather on the creation and dissemination of what perhaps can best be termed as national feeling. It was mostly a literary-polit-

ical movement with nominal administrative institutions, several journals, sporadic publishers, and a small but growing readership.

3. These and all subsequent quotations from "In the City of Killing" are taken from Atar Hadari's translation (2000, 1–9).

4. One exception to this general applause was the reaction of Yiddish writer S.Y. Abramovich, who bitterly and publicly attacked of Bialik for his cruelty to the victims. See Gluzman, Hever, and Miron 2005, 71.

WORKS CITED

Gluzman, Michael, Hannan Hever, and Dan Miron. 2005. *Be-ir Hahariga: Bikur Meuchar (In the City of Slaughter—A Visit at Twilight: Bialik's Poem a Century After)*. Tel-Aviv: Resling Press.

Goren, Jacob, ed. 1991. *Eduyot Nifgaei Kishinev, 1903* [Testimony of Victims of the 1903 Kishinev Pogrom]. Tel-Aviv: Hakibutz Hameuchad and Yad Tabenkin.

Hadari, Atar, trans. and ed. 2000. *Songs from Bialik*. Syracuse: Syracuse University Press.

Kadish, Sharman. 1992. *Bolsheviks and British Jews: The Anglo-Jewish Community, Britain, and the Russian Revolution*. London: Routledge.

Lifton, Robert Jay. 1967. *Death in Life: Survivors of Hiroshima*. New York: Random House.

Mintz, Alan, and David G. Roskies, eds. 2005. "Kishinev in the Twentieth Century." Special issue, *Prooftexts* 25(1&2).

Roskies, David G., ed. 1989. *The Literature of Destruction: Jewish Responses to Catastrophe*. Philadelphia: Jewish Publication Society.

HENYA PEKELMAN: AN INJURED WITNESS OF SOCIALIST ZIONIST SETTLEMENT IN MANDATORY PALESTINE

TAMAR S. HESS

Henya Pekelman was born in about 1903 in Markuleshty (Mǎrculeşti) Bessarabia (then part of the Russian Empire and now in Moldova) and emigrated to the British Mandate of Palestine in 1922. Her memoir, *Hayey Po'elet Ba-aretz* (The Life of a Worker in Her Homeland or, more accurately, The Life of a Woman Worker in the Homeland) self-published in Hebrew in 1935, follows the events of her life until about 1925. Recently reprinted, it had been ignored over the years.[1] The title indicates that Pekelman wished to place her story within the national context of Zionist socialism and to offer it as representative of the collective experience. The work's epigraph, "Let your fellow's honor be as dear to you as your own," is taken from the midrashic tractate Pirkey Avot (Ethics of the Fathers). As she tells her story it will emerge that Pekelman reads "honor" in a gender-specific denotation that diverges from that of her source: she seeks "revenge against all those who abuse woman's honor" (2007, 173). Although the Hebrew term for "woman's honor" itself stems from a patriarchal value system in which to abuse a woman's honor would mean either hurting a man's right to ownership or, correlatively, damage to a woman's possibility of winning protection from a man by exchange of ownership, Pekelman gives the term a different meaning: "a woman's honor" denotes her own ownership of her body and life.

Pekelman declares at the outset that she is following an inner obligation to defend her honor and feels compelled to break accepted codes in order to do so. "I cannot surrender to the demands of my surroundings and their taste," she writes (9). Her story stems from a violent affront to her honor: she was raped, became pregnant, and gave birth, and when the child died a month later, she was suspected of murder and finally was left to mourn alone.

Socialist Zionist circles in Palestine of the 1920s propagated a strict

[*WSQ: Women's Studies Quarterly* 36: 1 & 2 (Spring/Summer 2008)]

sexual code (Biale 1997). Manifestos from the period call for abstinence until the national project might attain a secure foundation. When Pekelman's pregnancy was discovered, she was ostracized by her peers for breaking sexual codes. Until her pregnancy came to term, she wandered, seeking odd jobs under a false name. Her intention in her narrative is to clear her name.

The book begins with a poem in which Pekelman compares the exposure of the hidden corner of her heart to the lifting of the curtain (*parokhet*) that covers the Torah scrolls in the ark in a synagogue.[2] Thus, Pekelman introduces her testimony as a challenge to male ownership of the truth (in the image of the ark). She insists that her narrative is a straightforward and exact testimony: "I have not omitted from the shadow, nor embellished on the light. Without paint or brush, I have only written about my life" (10). Pekelman describes her narrative as "innocent" and devoid of artifice. At first reading it may seem as such: a narrative written by a woman with a minimal education (her official education was complete when she was eleven).

Beginning with her early childhood, Pekelman depicts herself, whether at school, home, or work, as an innocent victim of cruelty, manipulation, and insult. Her description of her immediate and her extended family reveals violence and emotional abuse, in an exposure rare within the conventions of Hebrew Zionist settlers' memoirs. As she grows up, she highlights her lack of awareness of sexuality and slight grasp of social norms and codes. She does not understand what the sailor aboard the ship to Palestine wants of her when he approaches her at night on the deck, but her screams awake the other travelers, and he leaves her alone.

Our faith as readers is stretched to its extreme when this portrait of the asexual chaste woman adopts a recognizable cultural pattern: that of a virgin birth that takes place in the Galilee, the Virgin Mary's home province and the cradle of early Christianity. When Pekelman gives birth to the baby, the doctor and nurses whisper to one another that it is "a wonder" (185). She later finds out what they were amazed by, when the head nurse (who assumes that Pekelman is married) asks her how she had lived with her husband and remained a virgin.

Singular though her story may be, Pekelman invests every rhetorical effort into framing it as collectively emblematic. This position serves her self-defense. If all women are alike, they are all at risk of being

raped, and nothing she had said or done could have brought the rape on her, since any woman might have been in her place (see also Brison 2002, 18). She consistently treats her personal pains and tribulations as collectively representative first of Jewish life in the shtetl and later of Socialist Zionist circles in post–World War I Eastern Europe and Palestine. When her mother is upset that she cannot provide or her daughter's needs, Pekelman tells her: "I am not alone, mother. I belong to a class, I belong to people that have rules and regulations, the workers circle, the proletariats" (47). Watching a tipsy young woman being ridiculed, she comments: "I felt this young woman's insult was my own, the insult of all young women" (36). To support her case, Pekelman frequently blurs the ethnic, age, and class marks that can differentiate Jewish women, a unifying universal vision being necessary to her all-encompassing claim. Thus, for example, in the hospital, after meeting a woman who has just miscarried her seventeenth child, she comments, "Woman herself, not man, is responsible for her suffering, for she is not independent, and does not live for herself, but for the man, always trying to find favor in his eyes" (186). The forty-six-year-old woman, who was born in Tsfat and had raised sixteen girls, is aligned with young women immigrants immersed in socialist Zionist ideology, who in Pekelman's eyes are identically subject to masculine dominance (194).

Pekelman was raped in the fall of 1924, while on a visit to Tel-Aviv, by Yeruham Mirkin, a former business partner. Pekelman describes meeting Mirkin by chance, after their partnership had ended badly, and his begging her to come to his room so that he could show her family photos that he had just received from his relatives in Europe. Reluctantly she followed him, but as soon as they entered his room he locked the door, saying that his landlady did not allow female visitors. Pekelman began to struggle but Mirkin knocked her down and she lost consciousness. The rape itself appears in the text as two blank lines. Pekelman next remembers herself walking on the beach "like a madwoman" (163). When she found she was pregnant, she at first thought she could cause a miscarriage with a hot bath; it didn't work.

> Words cannot describe what I felt. I decided to go immediately to the beach and commit suicide. . . . I walked up to the roaring sea and decided to throw myself into it. But it was as if a transcendent power suddenly seized me, pulling me by my hair and

crying: In thy sufferings live! The will to live overcame me. And life seemed more beautiful than ever. A terrible war raged within me. I heard a voice calling me to die and another calling me to live. The first voice was shouting: "You have no right to live, you have strayed from the right path, you have violated your own honor, a woman's honor. You are about to bear a child against the law of Moses and Israel." And the other voice was comforting me and saying: "You have not wronged anyone, how can you murder a living soul within you? Who knows if your child will not be more useful in its life than a child born within the laws of Moses and Israel? You are still young and cannot take your own life. Whom have you wronged? Why should you kill yourself? Because a contemptible man abused you? Your death will place the blame on you, but if you live—you can still take revenge on him. You need to go on living for revenge."

These two voices raced within me, threatening my sanity, and the idea of my mother's pain over my situation haunted me as well. . . . Depressed and helpless, I stood on the roaring shoreline until it was dark. Then I went to sleep at my friend's without thinking about anything else. It was as if I was dumbfounded, and my mind was no longer capable of any thought (166–67).

The words "in thy sufferings live!" connote a widely quoted phrase from Ezekiel 16:6, "In thy blood live." The prophet addresses the people of Israel, who are cast in the image of an abandoned girl baby whose mother's blood has not been rinsed off her. God walks by the deserted infant and orders her to live, but he does not reach out to her or adopt her until she approaches puberty, when he recognizes her sexual potential and then weds her. The prophet's words connect the blood to the child, but it is her mother's blood, not her own, that the baby is covered in. Thus, Ezekiel's narrative breaks the tie between mother and child, and God replaces the mother as husband and Lord. Pekelman's narrative enables a return of the mother that the biblical text has erased. In tying the potential child within her to her own mother, Pekelman creates a lineage of women that stems from the biblical text—in its choice of words—but rejects its values and allows for the baby and mother to live. Paradoxically, the baby later becomes Pekelman's bodily proof and evi-

dence of Mirkin's guilt, as she grows and her resemblance to him becomes apparent. Pekelman publicly insists on her right to love the baby as well as to document in detail her own and other women's conditions of life in Palestine. The rape leaves her "dumbfounded"; she feels she has become an automaton (191), but bent on revenge, as she terms her act of witnessing (192), she documents her exchanges with Mirkin, as he denies his connection to the child.

Pekelman named the daughter born in the spring of 1925 Tikva (hope), but at one month old, the child died. Pekelman was arrested on suspicion of poisoning, but was soon released. Her narrative ends at this point. In 1927 she married and had a second daughter. The memoir does not reach these events, but the subtitle, *Book One*, suggests that the author meant to continue her story. The chilling last sentence, describing her feelings after she was released from jail, may explain why she was unable to pursue her undertaking: "On the day I was set free my emotional tragedy began" (194). In 1940, while working as an usher at a cinema in Tel-Aviv, she threw herself off the building's balcony.

Pekelman's testimony is a contemporary revelation of the extreme discrepancies between what individual women hoped for in immigrating to Palestine and the actual conditions that they faced. Other women underwent similar ordeals and later wrote of them, but Pekelman was the only one to bear witness to rape. Her shattering experience put her fellow Socialist Zionist settlers to a test, which they failed. Their circles could not embrace her as an injured witness; they denied her the belonging, support, and approval that she desperately needed. Telling her individual story as a representative and universal one, Pekelman can rewrite herself into the collective that rejected her. In writing her desolate narrative she is therefore motivated by not only the desire to set the facts straight and to clear her name, but also, no less, to analyze and expose the conditions that permitted her story to take place. The fact that her book was ignored attests to its failure to reach its intended addressees, but does not diminish the heroism and significance of her attempt.

ACKNOWLEDGMENTS
I am grateful to Nancy K. Miller for encouraging me to submit this essay, to Scott Ury for helping me locate and historically contextualize Mărculeşti, to Lisa Katz for help in translating the quotations, and to Mira Frankel Reich for her careful editing.

TAMAR S. HESS is assistant professor of Hebrew literature at the Hebrew University of Jerusalem, Israel. She is coeditor with Shirley Kaufman and Galit Hasan-Rokem of *The Defiant Muse: Hebrew Feminist Poems from Antiquity to the Present* (The Feminist Press, 1999). Her book *Memory's Maternal Embrace: Women, Autobiography, and the Second Aliya*, in Hebrew, is in press (Yehuda, Israel and Heksherim Institute, Ben Gurion University of the Negev, Beer Sheva, Israel).

NOTES

1. Deborah Bernstein was the first to note Pekelman's memoir (Bernstein 1987, 44–46). However, this reference relates to the sexually discriminating working conditions that Pekelman describes, of importance in themselves and not to her personal story. The recent Hebrew edition of Pekelman's book includes two essays, one by labor historians Talia Pfefferman and David De-Vries, and the other by myself. The limitations of the present essay do not allow a presentation of the full intricacies of the historical context of Pekelman's writing.

2. In a Jewish synagogue, the Pentateuch (Torah), written on scrolls, is kept in a closet at the fore of the hall and taken out at the peak of the prayer service for the ritual reading. This closet, called the ark, is traditionally draped by decorated curtains, often lavishly embroidered. The ark is a symbolic remnant of the Holy of Holies in the Temple. In Jewish collective memory an intruder raising the curtain that protects the ark is an image loaded with connotations of violation and rape, as epitomized in the story about Titus, the Roman conqueror and destroyer of the Second Temple, who marched into the Holy of Holies, ripped the curtain with his sword, spread it on the altar, and raped two women on it (Talmud Bavli, Gitin, 56b). Pekelman's employment of this image is therefore suggestive of unsettling gendered arrangements of meaning and interpretation.

WORKS CITED

Bernstein, Deborah. 1987. *The Struggle for Equality: Urban Women Workers in Pre-state Israeli Society*. New York: Praeger.

Biale, David. 1997. *Eros and the Jews: From Biblical Israel to Contemporary America*. Berkeley and Los Angeles: University of California Press.

Brison, Susan J. 2002. *Aftermath: Violence and the Remaking of a Self*. Princeton: Princeton University Press, 2002.

Pekelman, Henya. 2007. *Hayey Po'elet Ba-aretz*. Or Yehuda and Beer-Sheva, Israel: Kinneret, Zmora-Bitan, Dvir.

CAPTURING CRESWELL

RACHEL KRANZ

For the past five years, I've been living with Elihu Creswell. I've listened
to his rough, uncertain voice, belligerent, tender, defensive. I've looked
at the clothes he wears, the mud-spattered trousers, the heavy shoes, the
one good shirt—white, of course, with soft, white underthings beneath.
You'd never know, the way he dresses, how much money the man has,
but that's often what happens when someone works his way up from
nothing and still can't believe what a rich man he is, never mind that it
almost never makes sense to dress up for the job he does. I've seen him
doing that work, standing in the hot sun, ignoring the one patch of shade
in the bare, steamy yard, so that the people he's giving orders to won't
think he's soft, will respect, indeed, fear him. I've watched him eat and
drink and get ready for bed. I've even seen him in bed, witnessed what I
assumed were his most private moments. Maybe I haven't learned all his
intimate secrets, but haven't I discovered some? I thought I knew him. I
thought I had made him mine.

Elihu Creswell was a slave trader. He bought people at the cheapest
prices he could find and sold them for as much as the market would bear.
I first encountered him in October 2002 as I worked my way through the
state supreme court transcripts archived at the University of New
Orleans. Most of these cases involved someone suing a slave dealer for
selling defective merchandise: slaves who later became sick, died, or ran
away.

I was beginning to write a novel about slavery, and Creswell's story
immediately seized my imagination. He had sold a thirty-two-year-old
enslaved woman named Clarissa in her ninth month of pregnancy, so
pregnant that "the milk was coming out of her breasts." While Louisiana
law did not allow Clarissa to be sold away from her children, it did allow
her to be separated from them, so Creswell first saw her at the New
Orleans jail, where she was confined with her eighteen-month-old
daughter; her three-year-old son remained with her owners. Clarissa

[*WSQ: Women's Studies Quarterly* 36: 1 & 2 (Spring/Summer 2008)]

had been sent there on account of having "too much Jaw": she was "saucy" and talked back to her owners, known for her complaining. This was a key point for the defendant, since the plaintiff would later charge that she'd had *angina pectoris*, "dependent upon a diseased heart." Yet if Clarissa had indeed suffered from heart disease, why had she never spoken of pains, palpitations, or anxiety? Her only complaint, according to her former mistress's brother, was that her feet were swollen from her pregnancy, making it difficult to go freely about her work.

Creswell took Clarissa from the slave jail to his own depot on Common Street, where he sold her to David R. Coulter, a farmer from Union County, Arkansas. Coulter transported her by steamboat to the landing at Alexandria, from which he bundled her into a wagon and drove her "over the rough roads of Arkansas." A few days later, she died.

Coulter quickly claimed he'd been sold defective merchandise and demanded a refund on the money he'd paid for Clarissa. To prove she had been defective, he had three separate autopsies performed on her still-warm body. Every time I read them, I began to cry:

> The woman Clarissa (a mulatto or copper colored) about 35 or 40 years of age, was in the advanced state of pregnancy: her body was lying with a slight inclination to the right side, eyes closed, inferior extremities extended, cold & rigid, left forearm flexed and the hand lying on the chest, near the region of the heart; and the right hand was applied to the epigastric region. The abdomen and thorax were warm. Her appearance was that of a person in a natural sleep; not the slightest indication of pain or convulsions were discoverable. The examination was commenced by making an incision from the ensiforone cartilage to the os pubis, by another from the right to the left lumbar region dividing the umbilical. The angles being raised, the gravid uterus and bowels were brought into view. . . . All in view now appeared healthy; but on raising the womb, on the posterior superior part of the fundus, a greenish spot, about the size of a dollar, was discovered, enclosed in a dark red circle. . . . The left ovary was greatly enlarged, half the size of a healthy kidney. . . . On opening the pericardium, the apex of the heart presented a considerable covering of fat. . . . There was attached to the inside of the left ventricle a *fleshy growth*, extending into the aorta about

five eighths of an inch across its base. . . . From the natural appearance of the body, the absence of the usual signs of convulsions or pain in the last moments of life, the position of the hands, and from the obstruction offered to the circulation arising from the diseased condition of the heart . . . and also, from the suddenness of the death of the girl Clarissa, I believe she died of "Angina Pectoris" dependent on a disease of the heart.

I don't know why the medical account of Clarissa's body should have overcome me so. I suppose it was something about the image of this woman's body cut open, so that not even her own nakedness was left to her. Something about the way this outspoken, "jawing" woman had been reduced to an object, her body penetrated to find answers that ought to have been visible before she died. "It is very difficult to tell the age of a slave," testified another doctor who had once observed her in passing at the home of her former owner in New Orleans. "They generally appear older than they really are." But he was not there to treat Clarissa, nor did she receive much treatment during her final illness; although a physician did attend her briefly upon the steamboat, the only medical attention she received in Coulter's household was those autopsies.

"Why was not a physician sent for, there being two near his door?" Creswell demanded, but I thought that was only his way of defending himself against the claim. He also wanted to know how Coulter could have been so heartless as to have transported Clarissa over "the rough roads of Arkansas," adding, "He should have had more humanity."

I was so struck by those words when I first read them that I found a way to work them into my novel. In fact, I took the whole story— Clarissa, Creswell, the two young children, the slave dealer's assistant— and did what I wanted with it, changing names, ages, personal histories to suit my novel's needs. And every time I began to write, I heard Creswell's reproach to the planter ringing in my ears: *He should have had more humanity.*

Clearly, the only way to understand those words was as hypocrisy. But as I write them now, I feel a shock of wonder. Should they have been my first clue?

I had started writing this novel to prove a point: that even though my impoverished Jewish family had emigrated from Eastern Europe in the

1910s and 1920s, somehow, I, too, was implicated in America's history of slavery; that as a white American living in New York, I too had inadvertently benefited from that legacy. Inadvertently suffered from it, too, of course. On the one hand, there was the enormous wealth generated by two hundred years of forced labor—slaves had built the wall that became Wall Street; they had harvested the Georgia rice that financed the American Revolution; they had chopped the cotton that gave the United States its first national industry and turned the Port of New York into one of the world's major centers of capital. Slave money had helped establish banks, shipyards, and insurance companies. Slave labor made the United States rich.

On the other hand, what price did a person pay for using another person as an object, for treating a soul as a commodity? What was the cost to living in a world full of barbaric strangers whose servile grins masked a cunning hatred, so that you always had to wonder whether they might stir poison into your food or slit your throat as you slept? What price for pretending, as virtually every Northern state did, that slavery had never existed *here*, to erase your own history, your own memory, to insist that those who had lived among you for generations were nonetheless aliens, intruders? If I was a real American—despite my sometimes Yiddish-speaking parents, my own sense of strangeness—that history had to belong to me as well.

So I constructed a plot in which a contemporary white New Yorker is haunted by images of slavery, shadowed by the third child I'd invented for Clarissa and by the slave dealer whose life I had taken from Elihu Creswell. I traced the legacy of slavery through the mercantile wealth of New England, through the Yankee traders who'd carried Africans to the Caribbean and sold West Indian slave owners timber from Maine, wheat from New York, horses from Connecticut. I followed the cotton money from Southern fields to New England mills and on to New York brokers and banks and finance companies. I looked, too, at the many ways we try to own the ones we love, children, lovers, spouses, friends; at the ways we treat our own bodies as objects, our own souls as commodities to buy and sell and turn to profit.

As I wrote, I continued to read. One day, I was working my way through historian Steven Deyle's *Carry Me Back: The Domestic Slave Trade in American Life* (2006), and to my surprise, I stumbled once again upon Elihu Creswell. Encountering him in this volume of history was discon-

certing, the way you might feel if you stumbled upon an account of your high school prom or your first love affair, your story taken by someone you'd never met. I knew Elihu Creswell—by this time, I had known him intimately—and so it was odd to discover that this historian knew him too.

Still, these new facts were interesting. I read that at the time of his death, Elihu Creswell had owned fifty-one slaves, then valued at the equivalent of what today would be $6.6 million, part of a total estate worth, in today's currency, about $13 million. That money was his share of the $4 billion worth of human property that until 1861 constituted far and away the most significant source of U.S. wealth. (All figures in today's currency.) Compare that $4 billion worth of slaves with, say, the $1.07 billion then invested in livestock or the $1.16 billion in railroads, or the $1.05 billion in manufacturing, not to mention the paltry $421 million then invested in banks. Four billion dollars worth of slaves cost even more than the land they worked—valued at about $2.41 billion in the slaveholding states. Only $442 million worth of currency was then in circulation, which means that if all the slaves in the United States had gone on sale at once, there wouldn't have been enough cash to buy them.

But it was Elihu Creswell's story that unnerved me most, because I still couldn't quite grasp that he really didn't belong to me—he'd had his own life, there in New Orleans, and this historian whom I'd never met was free to write about his own version of that life. The real shock came on page 241, where Creswell is mentioned almost in passing:

> Having no heirs, he left his entire estate to his mother in South Carolina, with two important exceptions: first, he manumitted his personal servant, Gabriel, whom he had inherited from his father, and provided this man with $50 for his "long and faithful services"; and second, he freed all of his other slaves (a total of fifty-one) and provided them with money for their transportation to the free states. Despite some legal challenges from his mother, in the end, virtually all of his former slaves made it to the free states. (2006)

Who was this man I thought I knew? Many slaveholders freed a faithful servant, but Elihu Creswell freed his entire stock. A handful of slaveholders freed their slaves after death—George Washington was

famous for it—but how many had provided them with money, too, to leave the South and find their freedom? What could possibly have moved this man—the one who had sold Clarissa, the one who'd disclaimed all responsibility for her death—to dissolve his estate, abolish his legacy, free the people whom he had held not as part of a family, but simply to profit from their sale?

I felt that my character had escaped me. I could see him finishing his life alone, with only a faithful servant for companion. I could see him isolated, bereft, no heirs for his lonely fortune except his mother. I could even, I suppose, see him wishing to divest himself of his human property—after all, slave trading was a dirty, dangerous business and most retired traders were glad to be done with it.

But freeing his slaves? Giving them money to depart for the free states? Turning them from property into people, from commodities into men and women, becoming able to see who they were and what they might have wanted? Was it a sudden conversion or a growing distaste? Did one particular slave appeal to him—Gabriel, perhaps?—or was it a gradual process, so that one day he realized, perhaps already sick, already dying, that all of them were human? Did he congratulate himself on his generosity or reconsider his entire life? Had he expected his mother to understand? (She didn't; we only know about Creswell's extraordinary action because his mother contested the will.) Was he moved by an abolitionist, or by the then copious abolitionist literature on the horrors of the trade? Or had he always somehow known that what he was doing was wrong? *He should have had more humanity.* Was that the hypocritical quibbling I had always assumed it to be? Or was it, actually, the beginning of something?

I don't expect my questions ever to be answered, though maybe the answers exist somewhere—a letter in someone's attic, a remark in someone's diary, a tale passed down in some family history. Or perhaps his action lives on in some other way. Those fifty-one freed slaves must now have hundreds, maybe thousands, of descendants—maybe I've even met one or two, without any of us knowing the story, without any of us even being able to imagine it, even after knowing the facts: *Elihu Creswell was a slave dealer. And at the end of his life, he freed his slaves.* I thought I knew him. I thought I had made him mine.

ACKNOWLEDGMENTS

The revelation about Elihu Creswell came, of course, in Deyle 2006. My initial acquaintance with Creswell was inspired by the brilliant work by Johnson (1999) and then by the extraordinary research librarian (now retired) Marie Windell of the University of New Orleans, who pulled that and many other useful trial transcripts for me. The transcripts that concern Clarissa are of *D.R. Coulter v. Elihu Creswell* (1851) and *D.R. Coulter v. Elihu Creswell* (1853). The transcript concerning Creswell's will is "Succession of Creswell" (1853). Many thanks also to historian Ariela Gross for doing so much to deepen my understanding of slavery and race in the United States.

RACHEL KRANZ is a novelist, playwright, and freelance writer whose work includes *Leaps of Faith*, a novel published by Farrar, Straus, & Giroux in 2000. Her researches into slavery have inspired a sequel, *Healing Hands*, currently in progress, as well as a play, *Playing Alexina*.

WORKS CITED

Deyle, Steven. 2006. *Carry Me Back: The Domestic Slave Trade in American Life*. New York: Oxford University Press.

D.R. Coulter v. Elihu Creswell. 1851. No. 4372, Second District Court of New Orleans.

———. 1853. No. 2784, State Supreme Court of Louisiana.

Johnson, Walter. 1999. *Soul by Soul: Life Inside the Antebellum Slave Market*. Cambridge: Harvard University Press.

Succession of Creswell. 1853. No. 2423, 8 La. Ann. 122.

BEARING WITNESS TO BIRTH

BYLLYE AVERY

Spring comes early in Gainesville, and 1979 was no exception. The city was awash with a riot of brightly colored azaleas, redbud, and dogwood trees. The ligustrum hedges around many homes filled the air with the fragrance of spring. It was a beautiful day: perfect Florida weather. As I pulled into the parking lot at Birthplace, I thought about how time flies. It was just five months ago that we opened a birthing center.

Soon after the civil rights movement ended, the women's movement and the women's health movement began. The rejection of second-class citizenship by blacks made white women aware of their position in society and they started examining their lives through the lens of feminism, questioning authority, and making decisions about their lives. The women's health movement was fueled by women's demands to control their reproduction and by an inability to secure safe abortions or explore childbirth options. Women wanted to learn about their bodies, and after the passage of *Roe v. Wade* in 1973 led to the opening of health clinics and birth centers, the success of civil rights activism gave hope to women and set in motion a sea change that transformed society and health care delivery.

In May 1974, a group of us opened the Gainesville Women's Health Center (GWHC), providing first-trimester abortions and well-woman gynecological services. It was the beginning of the women's health movement, when women opened clinics providing reproductive health services, including abortions, for well women. Judy, a real smart child psychologist, who was fearless when it came to revolutionary change, led our efforts to open the center. Margaret, whose razor-sharp mind retains almost everything she has ever read, served on the board working on legal issues, fund-raising, and anything else that was needed. I was interested in educational services and workshops on birth control, menstruation, and sexuality. I was committed to making sure our services met the needs and were known to African American women; I did not

[*WSQ: Women's Studies Quarterly* 36: 1 & 2 (Spring/Summer 2008)]

want the center to be seen as a place *just* for white women. Early on we met Betsy Randall-David, who was getting a master's degree from the University of Florida's School of Nursing. All kinds of people identified positively with the center and were grateful that we were there.

We noticed that women were raising concerns about their pregnancy and birthing experiences. They were dissatisfied with the attitudes and practices of most obstetricians-gynecologists. One woman was told by a physician that "her pregnancy was none of her business, it was his business." Women wanted to be an active participant in their care, to know what was happening to their bodies, to have access to their medical records, and to participate in medical decision making. As a result of their dissatisfaction they started having their babies at home, with the services of midwives, birth attendants, or both. And if they or their babies needed health care, they came to us at GWHC. We knew we had to do something.

On a hot August evening in 1978, GWHC called a meeting, by word of mouth, of people interested in establishing a birthing center. We were overwhelmed by the numbers of people whose cars lined both sides of the duck pond in northeast Gainesville. They let us know that they wanted a birth center and would support our efforts. We went to work immediately, Randi came up with the name Birthplace, I started thinking about services, and others looked for the perfect house. A beautiful two-story brick Georgian mansion that previously served as a Methodist parsonage became Birthplace. It stood, stately, on Northeast First Street among large live oak trees with moss trailing unevenly from their branches. We immediately checked with Dr. Mahan, a supportive obstetrician, to determine if the building's location would allow us to make a timely emergency transfer to Shands Teaching Hospital, if needed. We went to work raising money; hiring staff; furnishing the house; and, oh, yes, developing medical protocols. Judy led our efforts, relishing the idea of confronting the medical community, as she had done previously. Margaret, who did not work at GWHC, quit her job at Shands to work as our business manager. I got busy creating an environment that would make birthplace a unique experience, planned the orientation program for expectant families, and started publicizing Birthplace. The fact is, we all worked on everything. The first person we hired was Nancy, a talented nurse-midwife from south Florida who had worked with an OB-GYN for several years and had delivered more than a thousand babies. More

than 75 percent of the women selected her for their deliveries. They loved her and had confidence in her. And we did too.

After a well-attended open house, the old mansion came alive in a new way. People loved the decor, with the large living room full of books on childbirth and feminism, soft chairs and large pillows on the floor. In the large front room, photographs of a natural childbirth, pregnant women, and fathers with babies created feelings of being at home. Other rooms downstairs included a playroom and a fully equipped kitchen. The two upstairs birthing suites were furnished with antiques and handmade quilts, which added a warm touch to the brass bed and four-poster walnut bed. We placed large, soft chairs by the windows in each room, and medical equipment was stored in the bedroom closets. Nancy saw families in a warm, friendly examination room with rocking chairs in addition to the necessary medical equipment. Her rolltop desk added a touch of familiarity that was comforting. Our environment said, Yes!

Women came to the center filled with excitement and a resolve to have a natural childbirth, in a different way. Women complained about being overmedicated and "out of it" for their births, being afraid, being left to labor alone in drab surroundings, and being told not to make so much noise. They wanted a choice in medical decisions, to know what was going on with their bodies, and to have their families present. They not only wanted it, they demanded it, and the medical profession was forced to listen and change its practices. Once doctors got over feeling threatened by women's demands they accepted that knowledgeable patients practice better self-care and have more positive health outcomes.

We hired two highly skilled obstetric nurses. Samantha worked in the delivery room at Shands Teaching Hospital, and her presence at Birthplace lent validation to our work. Mary Jo was an ex-nun whose gentle and calming spirit was reassuring. We were full of excitement and expectation.

Linda, our receptionist, greeted families as they came to register for services, ran the office, and kept us laughing. On Tuesday nights I led an orientation for perspective patients and took great pride in the fact that nearly all of them signed up for prenatal care that night. Much to my dismay we had only a few African American births; health insurances only covered hospital births, despite hospital charges three times higher than the $1,300 we charged for prenatal care and delivery. The Medicaid reimbursement rate for midwives was $250.

We watched excitement replace fear as couples anticipated their birthing experience. Empowerment and education were an integral part of our mission. Women had access to their medical records; enjoyed the monthly half-hour visits with Nancy; and were often accompanied by their husbands or partners, who were encouraged to ask questions and talk about their experience of being part of the pregnancy. Couples wanted to talk about not only the pregnancy but also their relationships. They had many questions: How would they know what to do at the time of birth? Was delivery and birth very bloody? What about breastfeeding in public? If it was a boy, did they want the baby circumcised? What would it be like to have their children at the birth? Many hours were spent with women sitting on the porch or in the living room talking about their pregnancies and their lives. So many women said they were excited when it was their day to come to Birthplace. What a feeling!

One day, as I was arriving at the center, Margaret, one of our founders, pulled her car next to mine and was out of it in a flash with her camera and a big smile, as though she knew something was going to happen. Once inside, I immediately headed upstairs without thinking and found myself making sure all the medical supplies were in place, the pillows fluffed, diapers and baby blankets in the sauna.

"I bet we'll have our first baby today!" Nancy's singsong voice snapped me out of my busy work.

"How do you know?" I asked, stunned that she'd read my mind.

"You're nesting," she said, with a crooked smile.

"I am." I returned her smile, knowingly.

I'd never seen a birth and was barely present for the birth of either of my two children. From the moment I discovered that I was pregnant, I was so fearful I wanted to have the baby the next day, just to get it over with. My pregnancy was so-so; I did have a lot of morning sickness. I wanted to read about what was happening. There were not many childbirth books available to prospective mothers in the early 1960s, so my friend Theola lent me her nursing textbook, which was filled with reports of birth complications. I wanted to be knocked out cold for my labor, and I asked my doctor whether, if he were not there, other doctors who would be treating me would know how to knock me out. However, instead of being knocked out, I was in a fog, until I heard Wesley's first cry and my world changed forever. I was less anxious during my second pregnancy. My friend Delores and I were pregnant together. I was

crushed when she gave birth two days before I did. We visited her on the second day following the birth, and as I was leaving the hospital I went into labor and Sonja was born six hours later.

The doorbell rang. Linda opened it and announced with a slight laugh, "Our baby is coming!" As Pamela and John walked through the front door it was obvious that Pamela was having contractions. They headed upstairs to the examination room, where Nancy determined that Pamela was in active labor. They chose the brass bedroom. We proceeded to create the atmosphere the couple desired: lowered lights, classical music, and candles. We gave Pamela backrubs, fed her ice chips, and whispered encouraging words of power between contractions. Three hours after their arrival, Nancy announced that the baby was crowning. Pamela got a burst of new energy when she saw the baby's head in the mirror and felt its soft hair. The baby's face became visible with the next contraction, and the next one delivered the beautiful, screaming baby girl into Nancy's waiting hands. She lifted the baby and placed it on Pamela's stomach. Pamela looked at her daughter and said, "Hello, Alicia." The baby was covered with a cheesy coating that smelled like Baby Magic. After excited moments of cooing and congratulations, John cut the cord and weighed the baby, and Nancy placed her at her mother's breast. The Pachelbel Canon played quietly in the background while the midwife and birth attendants delivered the afterbirth. We took pictures, feeling giddy and proud. We had been part of the miracle of birth, of women having true birth options, and of the revival of midwifery. I thought about what my own birth must have been like with my mother, at home with her mother; her sisters; and her midwife, my cousin Ella. Birth is a time to rejoice; it is a joyous social event.

While we stood around watching a tired, elated mother nurse her newborn, John brought in a bottle of champagne, and a toast was offered to the new parents and their beautiful baby. They shared with us their decision to give the baby a name beginning with an A to signal Birthplace's first baby.

I emerged from the birthing room, which had become a womb of energy cradling me as I witnessed the awesome power of women and childbirth. When I stepped outside the building, the darkness caught me by surprise. Evening had fallen—five hours had passed. I felt the cool air on my face and thought of midwife Ina May Gaskin's words: "A midwife's work means something. It prepares the woman to go through

childbirth in a way that's transformative and empowering. The empowerment and self-respect she learns in labor is passed on to the child in a loving relationship. When we as a society begin to value mothers as the givers of life then we will see social change in ways that matter."

Over the years the Birthplace concept has been able to survive, despite its changing management and location. It is now called the Birth Center and is part of the Florida School of Traditional Midwifery, housed in a beautiful renovated Victorian mansion in northeast Gainesville. Samantha, now called Selma, and Mary Jo are still there providing exquisite care to laboring women. The rest of us have moved on. Judy died of breast cancer in 1987 and a local chapter of the National Organization for Women has been named in her honor. Margaret still lives in Gainesville and works with a group of lawyers on political campaigns. Nancy no longer catches babies; she has earned a graduate degree in medical anthropology. I moved on to organize the National Black Women's Health Project (now known as Black Women's Health Imperative), now twenty-five years old. It's hard to believe that Alicia will be twenty-eight this year.

Time passes quickly. I wish I had been aware, back then, of how special the 1970s were. It was a privilege to be involved with the birth of ideas that changed our health care system in so many fundamental ways. We created a way for women's health to become a specialty, for women to become active participants in their health care and to be treated with respect.

Some things we witness only once in a lifetime.

BYLLYE Y. AVERY, founder of the Black Women's Health Imperative and the Avery Institute for Social Change, has been a health care activist for more than twenty-five years, focusing on women's reproductive health. She is currently working on universal health care access and lives in Boston and Provincetown, Massachusetts.

THE DAY WE EXIST AGAIN

MICHELLE MAISTO

I'm standing in front of a gated garden of wildflowers in New York City, beside the old water-pumping station at 119th Street and Amsterdam, where I told my father to meet me. It's my street, but I didn't tell him it's my street. My mother tries to keep each new address a secret from him, and my instinct, however flustered I was by his call, was to follow her lead. It wasn't until I hung up that I realized how very not-covert a meeting place I'd chosen, and I kicked myself for not thinking of the cathedral on 112th instead.

It's September, but the weather hasn't cooled much yet, and my cell phone has grown slippery at my cheek. My boyfriend, Rich, is on a business trip, and I should probably let him go, but I'm clinging to the phone as if he could make this easier somehow, and I'm wishing he were here and I were holding on to him instead of this hot silver rectangle; except that would mean that he, too, would have to deal with my father, and that would be too much, too embarrassing. So then I'm glad it's only me.

"This is like some gross, incestuous date," I say. "I feel so weird." I can't decide where, or how exactly, to stand. "Why am I doing this?"

"So don't do it, then," Rich says. "He makes you miserable—forget about him. You don't need him."

"He's my *father*," I retort, more from reflex than conviction. "I can't just *forget* about him." In our two years of dating Rich has barely heard a redeeming word about this man, and still it stings to hear him say this.

I take a deep breath and exhale it slowly. "OK, I can do this," I say. "And I am *not* going to cry." Privately, I also decide that I am not going to sweat, that I will be cool. "He's always on time. He likes to look around, or talk to people. Where *is* he?" Then I spot him across the street, talking to a Columbia University security guard in a glass booth beside a service entrance.

"Oh my gosh, he's so . . . *old*." His black hair is sprinkled through with far more gray than the last time I saw him, making me feel as

[*WSQ: Women's Studies Quarterly* 36: 1 & 2 (Spring/Summer 2008)]

though ten years have passed, not three. My parents divorced when I was fourteen, and more or less since then he'd been skipping alimony payments, threatening my mother, and stealing or vandalizing her property. Eventually, whenever something bad happened—car trouble, a flat tire—we were left to wonder whether it was bad luck, road construction, or him. Just after I finished college, his threats escalated to the point that I became afraid for my mother, and finally I told him that he could talk all he wanted about how this wasn't my business, but until he started acting like a decent human being I wasn't listening anymore. I hadn't expected him to stop talking.

My mother and my two sisters and I are all close, and while I did feel his absence, the four of us were fine together. Well-intentioned relatives would try to pursue conversations about how difficult divorces were on teenagers, wanting us to talk about our feelings. What they didn't realize was that it wasn't the divorce that was so upsetting—their marriage had been a bad one, and each of us was relieved to have it end. What hurt was the realization that our father wasn't the kind of father that as young girls we imagined we had. The greater disappointment was that, instead of setting the mark we held all other men up to, our father had become the most dangerous man we knew.

I walk to the corner and wait, hoping he doesn't see me before the light changes; I don't want to have to maintain eye contact from this distance. Rich has changed his support tactic and is now saying things like, "You're going to be fine. You can do this." I decide to appear so engrossed in conversation that I haven't noticed my father across the street, though now I can't think of anything to say.

Even with four wide lanes of traffic between us, I can see how tan he is. He has always been tan from working outside, fixing generators for a local utility company, but now he's retired and it's a more golden tan from golfing in Florida. He and his buddies retired early, after it was discovered that their lungs were speckled with asbestos. They were mostly guys from Brooklyn who had been with the company since they were eighteen or nineteen years old. They used to take naps on the soft pink insulation packages during their lunch breaks. They'd handled the asbestos with their bare hands for nearly twenty years before anyone suggested it might be dangerous. After the settlement, he and his new wife moved to Florida.

The light changes, Rich tells me he loves me, and we hang up.

My father glances at me for a second as I step up onto the curb, not realizing it's me. But then he does, and he tries to contain a little look of surprise and an awkwardness about the weird date quality of our meeting. He has brought me flowers.

"Whoa," he says, chuckling a little and looking me over. "You cut your hair." I did. It's three inches at its longest point. It occurs to me that he is the only one who doesn't know my Shirley Temple curls straightened two years ago when I turned twenty-three. After a lifetime of ringlets, they just straightened—three months and they were gone.

"You look so *skinny*," he says. He means it as a compliment, but hanging between us it sounds more like "scrawny," and I realize he still thinks of me as the plump junior high kid he used to visit on weekends, back when the divorce was going through. Those outings, too—lunch and a movie—were awkward, and soon my younger sister, Maria, was opting out, and gradually, quietly, each of us let the amounts of time between those afternoons extend.

He smiles and shifts his weight, and through his tan he blushes a little. His skin has the bronze glow of roasted poultry, and his round, brown eyes are deeper set than I remember. He's freshly shaven and showered, and instead of his usual white sneakers he's wearing beige summer dress shoes, and suddenly I want to laugh, realizing that for all the time we've spent pretending not to know each other, pretending the other does not exist out there in the world somewhere, I'd bet anything that I could accurately describe the moments that led to our standing here: the expression he wore driving over; the station his car radio was tuned to; that he didn't shave in that shirt—that he laid it out on the bed with his pants and socks and rolled belt, shaved in the bathroom with a towel around his waist, combed back his short wet hair with a small black comb, and then dressed and applied his cologne. It has been a long time, but I know this man.

He hands me the flowers, a mixed bouquet, and leans in toward me in a confidential way. "I kind of feel like I'm on a weird date," he says quietly, so the security guard doesn't hear. I give a half-laugh response and don't tell him that I ran home from class to fix my lipstick, that I changed my clothes twice.

He says, "Take care," to the guard, and we head south down the sidewalk. "Why couldn't you just wait where I told you to?" I ask. "Why were you talking to that guy?"

"I was just asking him how safe the neighborhood is," he says breezily, ignoring the irritation in my voice. "You live around here, right?"

"Yeah," I say. I don't mention that we were standing across from my building. We walk down Amsterdam for a few quiet seconds, pretending to take in the area. He's been holding a plastic bag this whole time, a drugstore bag with a heavy, lumpy bottom, and now he remembers it and hands it to me. "Oh, this is for you," he says. Inside are every little shampoo, conditioner, body wash, mini soap, mini dental floss, and sealed bag of cotton balls that has been left on the counter of every hotel he has stayed at in, it would seem, years. He has always done this—taken things because they're free, because they're there—and it has always bothered me.

"You're like one of those prisoners of war who was starving and now can't leave a table without eating every last bit of food," I tell him. "You *can't not* take things." He laughs and shrugs, but there's a little defensiveness in his voice now.

"I didn't have a lot growing up," he says. "I can't help it." There's a story from his childhood that my sisters and I know well. Some neighborhood boy had a bicycle that my father wanted to ride because he didn't have one of his own. Presumably, the boy's parents had told him not to lend it out, but the only explanation he would offer was, "I can't. I can't. . . ." Maybe they didn't have enough language in common—my father had just emigrated from Italy and spoke hardly any English. Regardless, the experience frustrated him so completely that when my sisters and I were growing up, we weren't allowed to repeat what he thought was a ridiculous phrase. When the words would accidentally slip out, the anger so immediately flushed his face, it was as though he were being denied this childhood rite of passage all over again.

We turn onto the Columbia campus at 116th Street and walk west toward Broadway. Passing through the tall iron gates I feel proud, and I want him to know that I'm here because of my *mother's* hard work. That she read to me every night when I was a kid. That *she* took out the loans to support me through my undergraduate years. But then I'm quickly also embarrassed, leading him across the obsessively manicured grounds. He never went to college—neither of my parents did—and here I am earning a master's, at Columbia.

HOMER, HERODOTUS, SOPHOCLES, PLATO. By the time we're halfway

across campus, with Butler Library's brocade of scholars to our left and
the lead gray dome of Low Library to our right, I've careened from
embarrassed to guilty. I feel responsible for how discriminating this
place is, as though he is being judged just by standing in contrast to it.
Judged by me, I suppose, and this makes my stomach curl. No matter
how hurtful he has ever been, I can never muster enough anger to hurt
him back. My sympathy for him is immediate and absolving. The hurt is
a messy ordeal, but the anger just dissolves, floats away—even when I
wish I could hold on to it, pack it into a tight, hard ball I could lob at
him. No matter what this man does, behind the booming voice, the short
temper, the very De Niro demeanor, is a vulnerable boy I can't help but
always see.

He makes small talk while we walk—asks how I like New York,
how school is—as though everything is fine and we are normal people
and there isn't so much to say. Neither of us mentions that the last time
we spoke was when he uninvited me to his wedding, after I called his
wife-to-be. I had wanted to somehow shake her head clear. He has so
many faces, I told myself; she couldn't possibly know what she was get-
ting into. It took me weeks to work up the nerve, and when I finally did
call, I couldn't bring myself to name specifics, to present a laundry list of
his crimes. Recounting them aloud suddenly seemed immature, as
though I was tattling about something long over and done with, which is
just how he would have dismissed it. I had wanted her to infer it all—to
save me from blurting out things like: "He tells my mom he'll slit her
throat. He stole our car." But all I did was stammer vague warnings
while she listened quietly and then politely thanked me for calling. A
few days later he called me back. "What did you say to her!" he barked.
I could hear how red his face was through the phone. "She thinks
I molested you or some shit. What did you tell her?" The thing was, I
hadn't told her anything.

We're walking and talking and I'm trying not to give him too many
personal details, protectively not telling him too much about Maria,
feeling that our lives must still be very separate and he shouldn't know
too much. Though he probably knows the answers already. My older
sister, Bridget, still talks to him. She has kids and wants them to have a
grandfather. It was from her that he got my phone number. Whether he
knows the answers already or not, his questions—simple questions:
What's Maria doing? Where is she working?—are jarring and difficult,

because I can't bring myself to say that I don't want to tell him. I'm even shaking a little, clutching my purse and the flowers and the bag of shampoos, and silently running a monologue through the back of my mind of all the things I want to say to address everything between us—a mountain of obstacles like a cartoon junkyard pile, all fish bones and car tires and muck. I have been practicing this speech for years, practicing it so that when the time comes I can deliver it without crying.

I lead him to a restaurant, and the waiter seats us outside, close to the sidewalk. What if one of my new school friends walks by? I've been blocking him out of my mind for years; if I have to introduce him and say "my father" I know I'll cry. Please God, I pray, please don't let me see anyone I know.

My mind keeps flashing to a scene. It's the one I was thinking about when I called his fiancée, the scene I can't seem to come to terms with, though it's only one in a series of similar incidents. In it, I'm sixteen years old, and a few days from beginning my senior year of high school at a new school; after the divorce my mother couldn't afford the house in New Jersey, so we moved. It's nearly midnight and I'm standing at the kitchen island pouring a glass of juice. I have the refrigerator door propped open with my foot, and the interior light spills onto me. Aside from the TV, it's the only light. The juice is red, there is ice in my glass, and I'm wearing my thinnest summer pajamas, a little pale blue camisole with baby doll bottoms. It is August in the South, and at midnight the unbearable heat has only slightly let up. My mother and I are watching TV in a little living area in the kitchen; Maria is upstairs; Bridget is married and lives in Los Angeles with her husband. It's a new house, and because we haven't been there very long, and because there is a thick ring of trees between us and the house behind us, we haven't yet put up blinds or curtains on the long windows or the French door to the back patio. I am pouring the juice, my mother is flipping through the channels, and then there is the loud sound of static. "Hey . . . it's not working," she says. She's only a few feet from the set, but she's still pointing the remote and pushing the buttons very deliberately. I'm impatient with her, assume she's hit too high a number, and without looking at it I say, "Come on, it's late. Let's go to bed."

The next morning we discovered that the TV wasn't working because the cable wire had been cut. Someone had also thrown bright yellow paint at our burgundy front door. It was pooled on the porch; and

on the new red brick front steps; and running down our steep, white concrete driveway for all our new neighbors to see. My mother called the utility company in New York, where my father still worked, but they said he wasn't there—that he'd taken the week off to visit his brother in Georgia. My first thought had been that he'd paid someone to do it; I guess I couldn't imagine that he could do it himself. Either way, what bothered me most was the thought that I had stood in the bright refrigerator light in those thin pajamas, and that the long windows were bare, and that someone had been out in the darkness of the trees, watching.

The waiter hands us menus and pours us water. The air is that dancing yellow color of dusk, and there's a breeze that still smells of summer. It's all so normal, as though this is not the tremendous moment I have been waiting for, and I want to scream. Why is no one reacting to the ridiculousness of my sitting here with him? Sitting with this man who called, as though calling me was no big deal, and said, *Do you want to have dinner this week?* This man who threatened my mother for years over money he said she still owed him from their nearly decade-old divorce. This man who made himself a looming threat in our lives, repeated to my mother that he'd kill her, while saying it had nothing to do with us girls. When he called I had almost asked, *Who is this?* I hadn't recognized my father's voice.

He asks if I want to split a salad, and I say sure. "How about Caesar?" he asks. I tell him that's fine, and I make a mental note that my father likes Caesar salad. It's not the Italian choice—not what he would have chosen years ago—and this fact, or maybe the fact that there are things I still don't know about him, or that he's changing even in the smallest ways, surprises me.

He's in town to wrap up the last details of the utility company settlement. He says he saw some of his buddies—Fat Louie, Vinny, Nicky, Vito—when he signed the papers and that everyone's doing OK, that some have it worse than others. I know these men, or their names and faces, anyway. They played a Friday-night poker game for almost thirty years. I can still feel the excitement of standing in the dark with Maria on the second-floor landing of our staircase—five or six years old, the two of us in nightgowns patterned with rosebuds, faces washed, teeth brushed—watching our father open the heavy front door to these men, whose shouting and laughter would rush in like a wave. The next morning we'd tiptoe to the basement to pick through the bowls of stale cheese

puffs and chips. The gray odor of cigars would still be heavy in the air, packs of opened playing cards fanned on the tabletop, and piles of red, blue, and white playing chips pushed toward the chip holder: all of it confirmation that something thrilling had happened while we were sleeping overhead.

Looking over the menu, he says he joined an Italian American club in Florida, that he plays cards with the members now, and that they have big spaghetti dinners down at the hall, though his wife doesn't really like going. "She thinks they're . . ." he searches for the word, looks up from his menu, and says in a lowered voice, "You know, not so classy." He laughs at this a little and rolls his eyes good-naturedly, knowing she's right. Then he's telling me more stories about his wife, about her new job, about Florida, and I'm trying not to look at him too much. I don't want to pay him too much attention, but I can't help it. The last time I saw him was at Maria's college graduation, a year after mine. It occurs to me that the last time I spent an ordinary week with this man I was fourteen, and the last time when we were a family without all the arguing, I was a kid. It's as though my childhood is sitting in front of me, and I can't stop myself from staring. This is my *father*, who ran up and down the street with his hand on the back of my bicycle seat, steadying me; who taught me how to swim, how to play bocce and horseshoes and poker; how to mound the soil in a garden into hills and valleys; who played round after round of indoor tag with us after dinner; and who worked that job for practically his entire life so that my mother could stay home with us. He is neither all good nor all bad, but he presses closer to the extremes than I've ever been able to deal with.

The bread comes, and then the wine. We touch glasses and say "*Salute.*" The waiter has barely walked away with our order and it hits me: This is it. All or nothing. My father, or no father. He is sitting in front me, attending to his bread, and I realize that I can either take this very flawed man and forgive him again and again, forgive him the grudges I hold out of respect for my mother, out of respect for myself, and I can put down the load I've been bearing—or I can have nothing. And I realize that I would prefer him, that I am too exhausted by the hurt to carry it around any longer.

I don't say this to him, though. Just as he will not say what he ought to; there will be no speeches tonight. He will simply let enough time pass and then invite me to dinner, eat and drink with me as though no

time has passed and no wounds exist, neither open nor healing.

The salad arrives and he takes up the serving spoons, dividing it between our plates and giving me a too-generous share of the croutons and anchovies. I take a deep breath and lean back, letting it all fall off me. I feel as though twenty suitcases are unlatched from each shoulder. The freedom is immediate and exhilarating, like a shot into my bloodstream, and I decide to enjoy the evening and the meal.

We have two glasses of wine each, and then dessert, and when the check finally arrives the wine is flushing my cheeks and I'm aware of having talked more than I'd meant to. I waited for him to ask about Rich, though he didn't. Which was a relief—less personal information to disclose—but also a disappointment.

It's a soft, pretty night, and we decide to take a walk, heading north. Then I remember that he said he parked south of the restaurant, so I suggest we go south so I can walk him to his car. Then he says why doesn't he drive me home, and then it's all over in a matter of minutes. Too quickly we're at my corner, and I open the car door, lean to give him a quick kiss, and get out. He says, "I love you, be good." I say it back and close the door, and then he's driving away, and I'm crying before I make it to the elevator.

MICHELLE MAISTO received an MFA in nonfiction writing from Columbia University. Her first full-length work, *Eating Together*, is forthcoming from Random House in spring 2009.

MARIE BURGESS

When I was about five years old, I used to watch movies with my father in our basement. I would sit on his lap while he smoked a cigar and we would watch John Wayne or some other manly person. I still believe that cigar smoke carries the most comforting smell in the world. We would talk through the movies, but for years, I could not remember a single word that passed between us on those nights. I was convinced my father had told me something that proved to be foundational, that helped form the person that I am. I never asked my father because I was afraid he would tell me that I made it all up. This is not a scene that I am willing to sacrifice. I will not risk having to cut it from the movie reel of my memory.

I believe that the scenes that constitute my reality are transgenerational. When I think of those moments that I know have a central and permanent place in my memory, those moments that seem most real to me, those moments that I use to tell me who I am, I see that they are family mythologies, scenes that come through from the past. The memories that make me Christine Anne Taylor are not necessarily my own in the strict sense, but rather memories inherited, or maybe stolen, from family members who died long before I was born. If you asked me to narrate the events of last Monday, we would be in for a snooze. I would look at my date book and read, "Drop off book for L before 6:00." I can tell you I probably went to the library, read some books, made some photocopies, drank four cups of tea, and smoked three cigarettes. We choose the days we want to remember, the days we want to see as foundational, by narrating them. Memory and narrative are one. Narrative is communication. Thus, memory can be communicated, passed between generations, and I can begin at the beginning.

It is just after one o'clock in the morning on January 31, 1981, in St. Paul,

[*WSQ: Women's Studies Quarterly* 36: 1 & 2 (Spring/Summer 2008)]

Minnesota. I am hurtling down Interstate 35E with my parents in a Pontiac Bonneville. My father, in the front seat, has vomit on his sweater, and my mother, in the backseat, is hoping that I will please not come out of her birth canal just yet. She has been in labor for hours, but only realized it twenty minutes ago, when her water broke. Her sister Susan likes to tell this story to emphasize how spacey my mom is. I prefer to think it makes her look tough. Dad thanks Mom for her confusion to this day, as it allowed him to stay at the bar until last call. To Dad's credit, when Dwayne the bartender picked up the phone behind the counter and relayed the message, he didn't stay to finish that last drink. No, he jumped right in the Bonneville, zipped up Dale Street, and grabbed my mom, who promptly puked on him. Knowing how finicky he was about his clothes, she apologized. They then sped down Larpenteur Avenue and onto 35E, where we first saw them.

By this point, my mom is pretty sure that my head is actually coming out. She doesn't want to have a baby in a Bonneville. In fact, she isn't sure if she wants to have a baby at all. Six days ago, she packed up a suitcase, drove to Hudson, Wisconsin, and checked into a Motel 6. But she came back two hours later. She is twenty-three years old and she is married to a man who is twenty years her senior. She is having a baby in a car with velour seats, and she is a little freaked out. However, she is not as freaked out as the sixteen-year-old girl who gets pulled out of a birthing room to make way for the two of us when we finally arrive at the hospital. The nurses think the girl has more time than my mom, but they are wrong: she ends up having her baby in the hallway like some kind of twentieth-century Mary, Mother of God. My dad is standing around in a ripped operating gown, because the largest available size does not fit across his shoulders. The medical resident who delivers me calls him the Incredible Hulk. I have arrived.

Two months later, just before my first Easter, we three find ourselves back at Ramsey County Hospital. My mother's appendix is about to burst. As various doctors and nurses poke and prod her, behind a plate-glass window I start wailing in my father's arms. Terrified, he does what he always does when I start crying—he rushes into the other room and drops me on my mother's chest. Chaos. Milk starts leaking from my mother's breasts, the vein the nurse is using to get a blood sample collapses, the doctors start yelling, and somebody shoves me back into my

father's unwilling arms. He calls my grandmother from the pay phone to tell her that her daughter is in the hospital and somebody has to come and take care of the baby. I don't know what my grandmother says on the other end. Unlike the rest of my mother's family, she gets along with my father. Maybe because they are almost the same age. I suppose they talk about the 1950s. Although I think that for Grandma, the 1950s are a blur of pregnancies and babies. Anyway, they both like whiskey and fruitcake. But still, I imagine that she sighs when she realizes that here is one more incompetent man in a long life of incompetent men who either can't do anything for themselves, or die and leave you alone with five children at age twenty-seven, or leave you for your best friend, and so on, until you decide that Irish Setters are the best companions. No matter what she says, she is on her way. But what to do in the five hours it will take her to drive up from Madison? In a move that, for decades, he will maintain is crafty and bold, my father finds the premature-baby ward and pays the nurse one hundred dollars to watch me. When my grandmother arrives, she finds what she will later call "a giant baby snoozing among the preemies."

In 1959, when my mother was two years old, her father died of a stroke at age twenty-nine, while carrying in groceries from the car. My grandmother looked out the window to see her five young children jumping on Elliot's prone body in the driveway, thinking he was playing a game. My aunts remember this; my uncle and my mother do not. In fact, my mother does not have a single memory of Elliot. He is no more real to her than he is to me. His death is the great event of our family history. I can see it happening slow-mo, my grandmother running outside in one of those belted, short-sleeved 1950s dresses I like so much, although if I'm honest with myself, pants would be more in keeping with her character. But when I try to force the young Grandma of my imagination into a slim pair of 1950s pants, my mind rebels and the whole scene slips away. No, 1959 Grandma will just have to suffer the dress I choose for her. Sometimes it has polka dots. She would kill me if she could see inside my head. But never mind, for there she is, dashing out the door in suburban California, scooping up my grinning mother, wailing and warbling as first Patty and then the others realize that something is very wrong. A neighbor, who wears the same dress but in a different color, runs over and quickly returns to her own house to call 911. This is where my mind starts

to wander. Did they have 911 in 1958? Is that a ridiculous question? Of course they had 911. I am reminded of the time I asked my father if they had Jell-O when he was a kid, and he answered that he was not, in fact, 170 years old. But maybe in 1958 you could still pick up the phone and breathlessly say, "Operator? I have an emergency." This is where the fantasy ends. Elliot is dead; they pack up and move back to Missouri. We are almost at the limit of my Elliot knowledge. I could sum up the rest in a few sentences. He was an engineer. He was from Kansas City. He had four brothers and sisters, whom I knew as distant relatives. In 1983, his senile mother fed my dad a whole batch of raw cookie dough and threw a piece of toast at my mom. He thought it was funny to drive around until the car ran out of gas and see where he ended up. But for this story, he might as well be my great-great-grandfather, some name in the family Bible with no real memory attached to it.

My father met my mother when she was twenty-one years old, a waitress working in his friend's restaurant, wearing a ridiculous "traditional" German dress. He was nineteen years and eight months older than she was, and he had just broken up with his girlfriend of ten years, a kleptomaniac who had pampered him just like every girlfriend he'd had since he left Boston and the pampering of his mother and grandmother. It is entirely possible that he never did a load of laundry in his life until he was fifty-two and he moved into his postdivorce bachelor pad. All this I know from my mother, not from him. What the hell did she see in him? Her explanation is that he pestered and got all her waitress friends to pester in his stead until she caved. I have never asked her if she thinks it has anything to do with Elliot's death or her fatherless childhood. Really, one shouldn't try to perform amateur psychoanalysis with one's own mother. Think of all the awkward places it could lead.

I am nine years old and I am at my dad's apartment watching *Rescue Rangers* in my Catholic-school jumper. Next year I will be in fourth grade and instead of a jumper I'll get to wear a skirt. The older girls don't wear jumpers because they have boobs. Little do I know, I won't have boobs until the eighth grade. But by then I'll be in public school and I'll get to wear whatever I want. I am sitting on the carpet, eating half a cantaloupe, my slimy retainer staring at me from atop a napkin. I am trying very hard to scrape the last of the cantaloupe meat off the skin, even

though by now all I am getting is the pale, tasteless stuff I usually leave. I can see the horizontal lines where the spoon carved the flesh from the rind, and I concentrate on smoothing out those lines. When I am done with the cantaloupe, I'll have to get up and throw away the remains, and when I stand up, I'll be able to see out the window. I don't want to do this, because I can already hear what's happening out there and I don't like it. Finally, I have shaved the cantaloupe so thin the spoon pokes through. I can't wait any longer. And of course, right when I stand up and look out the window, I see my dad pick up his foot and slam it on the hood of my mom's white Honda. I'm mad at her because she has made him mad, and soon he will come inside and start telling me she is impossible or stupid or crazy. I know my father did not want to separate and that divorce is wrong and shameful. I know this because my teacher is always pointing out that Tom, the one kid in my class with divorced parents, has nothing to be ashamed of. I remember all this, but I do not remember what happened when he came back in. Later, I will find out that my dad was angry because he found out that my mom was planning to take me and move in with her brother's family in Madison. That summer, as he drives me up to my mom's house in the suburbs, he says, "I know what they were planning a few months ago. And you can tell them nobody is going to take my daughter away from me. You don't want them to take you away from me, do you?" Of course I have to say no. And I don't want them to, because the thought of what he will do if they piss him off is pretty unpleasant. But I make the huge mistake of saying, "Even if we did move, I could still see you on the weekends." Screaming. Weekends, it seems, are not acceptable.

It has been more than ten years since I've seen my father lose his temper in the screaming manner of old. I have to give him most of the credit for this. I do believe he took Michael Jackson's advice and had a look at the man in the mirror. Maybe he realized he was hurting me. Maybe he realized it was useless. Maybe anger fades. But I think part of the credit must go to my program of lies. One of my mother's boyfriends lived with us for two years and my dad never knew. I also managed to convince him that my college boyfriend was a Catholic. Dad is of the old school and he assures me that I am meant to stick to my own kind. He thinks I go to church every weekend.

It never occurred to me until I had been left myself that my father's

rage might have been an expression of humiliation or fear. But thirteen years after my parents' separation, when I found myself alone in an apartment meant for two, sleeping on a futon while Jonathan fucked his new girlfriend in our bed, which he had taken with him to Washington, I started to understand. I, however, did not go to Seattle and stomp on Jonathan's car. Anyway, on the bright side, I could breathe easily, knowing I would never know what Dad would say if he found out Jonathan was a Presbyterian.

I am flying down 35E with my parents once again, but this time we pass Ramsey County Hospital and continue to the airport. I am leaving home for college. By this time, Mom and Dad can see each other without yelling and swearing and stomping of cars. In the past year, I have noticed an odd development. They have starting joking around like old pals. Inside my Volvo, I look at them with squinty, suspicious eyes. I'm thinking that the closest thing I saw to joking around when they were still married was the time Mom punched Dad and he laughed like it was hilarious. They are having a loud round of *remember the time*. All their *remember the times* are from the days before I had memory. *Remember that time in Florida when Bob was so drunk he thought some girl at the bar was Cheryl Tiegs and bought her drinks all night? That was so funny!* I was six months old. *Remember that Christmas down at the lake when it was so cold we had to take shifts through the night and start up all the cars every hour? Twenty people squeezed into that house!* I was two. *Ooh, remember when my brother shoved you into the river in your wedding tuxedo? Everybody laughed for hours!* I was a fetus. I realize that at some point, my parents got on like a house on fire. Just not at any point in the history of my conscious memory until right now, when I am about to move across the goddamn country. If I chimed in, they would hear, *Remember the time Dad kicked the wall and broke his toe?* I am weaving in and out of traffic, taking my last crack behind the wheel for months. There will be no driving in D.C. As I repeatedly twist my head to check traffic and swerve into the next lane, giving a half-second flick of the blinker if I am feeling generous, I see my mom's face hovering just behind me. She's in the middle of the backseat, leaning forward and grinning. I know it is a grin and not just a smile when I can see the gap between her fourth and fifth teeth. I think my parents are totally oblivious to my agitation.

If, six years later, I look at the scene from my very mature and

understanding present vantage point, I realize they were just trying to talk over my nervousness and their own sadness so nobody had to hear a painful silence. Logically, I can appreciate their game of *remember the time* as fodder for my transgenerational life's narrative. And then I feel a great tenderness for my parents as they were on that day. For about ten seconds. More than a decade of screaming at each other and shouting at me, "Your mother has no idea what she's about," and, "You think your Dad is so great? I'm the one who has to put up with everything," and suddenly they are best buds? Come on.

Back in the year 1999, we get to the airport, and my suitcase weighs ninety-seven pounds. The smiling check-in attendant tells me I will have to take out twenty-two pounds or pay seventy-five dollars. My dad starts saying we should go over by the chairs and repack my bag, but before he is halfway through his sentence, I cut in with a tone that can, unfortunately, only be described as hysterical and say, "Just give her the damn money." This is the first time in my life that I have ever sworn in front of my dad. Like him, I have a filthy mouth. "Fuck" is my filler. Not too classy. But I am dumbfounded to have let slip this tamest of profanities in front of my dad. It isn't even a real swear; it's on network TV. Thing is, he doesn't even notice the swear, because he is so shocked that I have given him an order, like I am the queen of the Lindbergh Terminal. He immediately forks out the seventy-five dollars, without saying a word to me. My mom pulls him about ten feet away from me and I hear them arguing: "Well, what the hell did I do?" "Nothing, she's just upset because she's leaving home." "But why does she have to lose her temper?"

Why indeed? To this day, my father thinks I have a bad temper because of this single incident, the only time he has seen me snap since I was a small child. Save for this eruption at the airport, my patience in his presence has been worthy of a biblical heroine, Ruth or Naomi or Hephzibah, whichever one of those was patient; I don't remember, but I bet at least one of them was. Nevertheless, from time to time he will chide me about my bad temper, like I am the silliest of creatures. The best part is, I am ill tempered. I am a screamer and a door slammer and, like my dad, a kicker of walls. But never with him. When I am with him I keep my goddamn mouth shut.

On the airplane, I cry for two hours while a nice lady from Maryland tells me I'm going to be just fine. She's right. I settle into my dorm room, pop into place the eyebrow rings that I have kept hidden from my

father, and set to work taping my Björk and *London Calling* posters to the wall. I am advertising my coolness. It works. The girl who will become my best friend in college and roommate of six years wanders in to ask if it is my Björk poster. She is wearing a *Star Trek* shirt and her name is Esther. She is either the biggest dork ever or the hippest girl at Georgetown. The Clash poster attracts guys, including my first college boyfriend. I'm having a great time until my dad calls. At first the conversation is jovial. I tell him I'm meeting new people; he says, "Goddamn it, I'm going to miss you, kid!" in a goofy voice. But then I realize it's not goofy. He's about to cry. I have never heard my father's voice shake. I panic and say, "Listen, I have to go, but I'll call you tonight. I love you." Then I hang up and run out for a pack of cigarettes.

Dad struggles with my absence, although he is proud of my choice of careers. He sees it as proof that our family is an American success story. Every upwardly mobile family needs a lawyer. When I went away to college, he told me to remember that I am one generation away from a slum. But he is lonely without me. I know. He never remarried, and for reasons he won't explain, he rarely sees any of his family in Boston. If I have been gone for more than a month and have no solid plans to return in the coming weeks, he starts to pout. I can't help but think of him, alone in his apartment, feeling isolated and scared. I think of his father, Jack, who couldn't adjust to being alone. First, his wife died of heart failure. Four months later, his mother, with whom he had lived his entire life, died of old age. At the funeral in Boston, my uncle told my dad, "The old man's in bad shape," and my dad answered, "He'll be dead in six months." He was right, like he usually is. Grandpa drank himself to death, which is probably not hard when you've been a drinker your whole life and are already damaged. That's my father's word. "Drinker." The old man wasn't a drunk, but he was a drinker. Dad is a drinker, too. The amount of alcohol he can drink without getting drunk is astonishing. If I drink two bottles of wine, the result is bad enough to make me believe that sin does exist and God punishes it with his righteous pain. But Dad just gets a headache. It can't be good for the old liver.

I was an accident. I discovered this one day when I was ten and snooping through my mother's file cabinet. I found their divorce papers, and of

course I had to read them. Date of marriage: October 20, 1980. Wait a minute. Do the math on my fingers. I was an accident! And I thought my mom's wedding dress was big and flowing because that was the *style*. But after the initial shock, it didn't bother me so much. Frankly, the thought of one's parents sitting down and planning to make a baby is discomfiting. And it's not as if they can sit down and plan specifically to make *you*. Nobody knows which sperm will win, or which egg is bumping down the fallopian tube just then. Even if my parents had planned me, they wouldn't have been planning *me*. They couldn't have chosen all the little things I inherited, like Dad's height and Dad's eyes and Dad's oily skin and Dad's memory and Mom's . . . well, whatever genes I got from Mom must be doing something invisible, because I certainly do not look like her. Except once in a while, a mutant red hair grows out of my head as if to say, "Heeeeeey, yoooou . . . whatcha doin'?" like my mom when she calls just to say hello. I like the idea that my whole existence is a crazy matter of chance. By the time I started peeping out in the Bonneville, I'd already won my life's most important game of roulette. My mom didn't admit my near miss with illegitimacy to me until I was twenty-three. But even if I hadn't snooped through the file cabinet, I think I would have guessed long before then. Mom is not subtle in her preoccupations. Whenever I call her and say I have news, she asks, "Are you pregnant?" I never am. But she always continues, "It would be OK if you were. I would support you. Well, emotionally."

Growing up, I would occasionally spend an entire weekend with my father. At Dad's apartment, we would sit at the dining room table and read after dinner. What he read stayed the same: fat books about the Civil War and Irish monks and the Roman Empire and Winston Churchill. Meanwhile, I went from Judy Blume to Tom Clancy to John Steinbeck to William Faulkner. Every so often, Dad would glance at what I was reading, like *The Catcher in the Rye* or *East of Eden*, and recognize it from a million years ago. He could still remember characters' names and plot details. He remembers phone numbers from thirty years ago and all sorts of other useless information. I have inherited my own particular form of this extraordinary memory—I have an obnoxious habit of recalling conversations nearly verbatim, sometimes for many months. It makes people nervous.

Lately, Dad's memory hasn't been so sharp. He might forget what

time my flight is coming in on Thursday or leave his laundry in the dryer for hours. Most people do this kind of thing their whole lives. But not my father. It reminds me that he is about to turn seventy years old, my career path does not lead back to Minnesota, and there is nobody there to take care of him. His whole family still lives in Boston, and he's far too stuck in his ways to go back and live with his sister or the one brother with whom he is still on good terms. He doesn't mention this. He says he'll live to be one hundred. And maybe he will. But in the meantime, septuagenarians and octogenarians and nonagenarians sometimes need help. And he's noticed the change, too. His rate of crossword puzzle consumption has increased dramatically. Apparently it staves off the Alzheimer's. And really, as long as he can still do the Saturday *Times* puzzle, I shouldn't worry. But I am buzzing with nerves.

My father often says there is a lot he wants to tell me about his life, one day. But what if he starts forgetting? What if his car spins out on 35E and hurtles off the Mendota Bridge and into the Minnesota River? His friend Al lost his sister in that river in 1938. At this moment, Al is in a rest home yelling at nurses who he thinks are the waitresses at his old diner. But I already know the story of Al's sister. What about all my dad's stories? Who will remember them when he forgets, or dies?

When my great-grandfather Joe Hannon died, his sisters went to his wife, my great-grandmother Annie, and asked what to do for his funeral. She said to stick a hambone in his ass and drag him to the river. I'm pretty sure that is not what they actually did. The story is almost too good to be true. And seeing as Annie and I have two generations and death between us, I'll never know if it is. Thing is, it doesn't matter. This story has shaped the woman's character in my mind, where she looms over the vast majority of my memories. I have lived with this image of my great-grandmother for years. It is part of my history, my reality, my narrative DNA.

When my grandmother Rose was young, Annie told her that old Joe was out of their lives, that he was no longer part of the family. One day, at the school playground, he came around and motioned her over. She didn't go—she later told my father that she always regretted it. I wonder what she imagined he would have said. I wonder what vast family history she felt she was missing. The story haunts me, because just as Rose refused to listen to her father, my father refuses to tell.

I feel close to this grandmother who died seven years before my birth. Her whole life, she knew she wouldn't see sixty-five. Rheumatic fever damaged her heart when she was still a child. What must it have felt like to know your expiration date? I suppose there is a chance I'll die tomorrow as I cross the West Side Highway to pick up milk and tampons at Gristedes, but I'm convinced I'll live at least a century, despite much smoking and bad behavior. They'll give me a pig lung or something. The future is now. Medicine and progress and so forth. Rose didn't get to think like that. It must have been some fever, not only to kill my grandmother after fifty years of waiting, but also to deny me the seven years I needed. I think about her all the time, about the questions I would like to ask her, questions my dad can't answer. I wonder if having six children in fifty-six months drove her out of her goddamn mind. I wonder if the "lady troubles" she developed after her second set of twins is code for telling my grandfather never to put that thing inside of her again. I wonder if living with her wacky, lemon-wearing mother-in-law until her dying day was fun in the manner of an ethnic comedy film.

My father never goes to Boston, but I do whenever I can. I miss Boston. It is a place where I have never lived, but going there is going home. Boston is my old country, my Ireland, my Italy. Boston is something that Kansas City will never be, because my mother and her mother would answer all the questions I have about Kansas City, if I had any. But Boston is a silence from my father, except during those moments on the St. Paul freeway when he screams, "If people drove like this in Boston nobody would ever get home!" I wish my father would go to Boston with me and show me around, but he always comes up with some excuse. His whole family is there, but I haven't met most of his relatives and know the others only vaguely. I wouldn't feel comfortable looking any of them up. In Boston, I walk around wishing I knew the street names, the neighborhoods, the bars, the stores. But I only know these things in cities where I have to make my own history, and there is no longing in that. I know Barcelona. I know D.C. and New York. But these streets have nothing to do with me. My family came here before Ellis Island existed, straight to Boston. The only one to come after the 1850s was the Italian great-grandmother, and as the story goes, she always said, "I came through Everett, Massachusetts, thank you very much." Great-Grandma was too cool for New York. She believed in *malocchio* and bad omens. She

disliked redheads and thought lemons could suck a headache out of your head. This, too, is almost too good to be true.

These are the kinds of things my father will tell me, over and over, the same tidbits. But ask him why I've never met two of my uncles and I get no answers. Ask him why he hasn't been back to Boston in more than twenty years and I get nothing. The last time I was in there, I asked him where his parents' graves were. He wouldn't tell me. He just said it is a dangerous neighborhood now. I didn't have the guts to say, This isn't 1983; it's probably gentrified and full of fancy baby strollers today. It is becoming obvious that Dad will never share all his past with me. So I'll have to make something out of our shared quarter century, create my own portrait of the man.

I spent half my childhood at my father's Italian restaurant in St. Paul, begging Shirley Temples off the bartenders and people watching from the coat checkroom. All my childhood friends are the children of people who work in restaurants and bars. Growing up around countless bartenders, waiters, and cooks, I figured out quickly that my father is one of those local figures whom everybody loves. Every time I go into a bar in St. Paul, I hear, "Shit, it's Joe's daughter!" and see a smiling face that I don't remember coming over to shake my hand. When I see my dad, it is always in a restaurant or bar. I'm sure that to those who don't know us, we seem an odd pair: a seventy-year-old man and a twenty-six-year-old woman knocking back cocktails and cackling with the bartenders until closing time. I wonder what we look like to everybody else, but I'm not even sure what we look like to me. How do I capture my father in words? How do I communicate his mannerisms, his presence? How do I reveal his rather touching crush on Catherine Zeta-Jones without making him seem an idiot?

Now that my parents have been divorced for over fifteen years, the rest of my mom's family has made their peace with my dad. Sometimes Parnell family remember-the-time sessions include memories of Joe. Last Christmas Dad featured heavily in the family reminiscences. *Remember the time Joe took Uncle Phil out for drinks and lost him in Minneapolis the night before David's wedding?* That's a favorite. *Remember how everybody would fight over who got to be Joe's Trivial Pursuit partner?* My dad is a master of Trivial Pursuit, especially the sports category. When he gets to talking about

sports he's like a foreigner who gets a chance to speak in his native language; the sudden fluidity is surprising to everybody in the room. During the World Cup, I introduced him to soccer. At first he thought it was "more boring than darts," but by the quarter finals he was calling me up in the middle of games to scream, "Did you see that?! My grandmother could have stopped that shot in her nightgown!" or "Maybe if Ronaldo's ass wasn't wider than two axe handles he could score a goal. Jesus Christ on the Cross." And for the first time in my life, I could join the sports talk: "Hello, Dad? Are you watching? Still think Gianluigi Buffon is overrated? He's a jumping-jack God!" After the final game, we loudly discussed Zinedine Zidane's head-butt on Marco Materazzi and my dad said, "Well, they say that Zidane is a real shit kicker." Suddenly, I was five years old, climbing on to Dad's lap while he smoked a cigar and looking up at a man on the television with a gun. "Who's that?" "That's Dirty Harry. He's a real shit kicker."

Recently, I saw *Dirty Harry* for the first time in years and realized it was unquestionably inappropriate for a child of five. Somehow, this knowledge rendered the memory all the sweeter.

MARIE BURGESS grew up in St. Paul, Minnesota. She now lives in New York City, where she is pursuing a Ph.D. in English literature. This is her first published fiction.

MAXINE CHERNOFF

> *My traditional Christ-image was somehow inadequate.*
> —C. G. Jung

Grateful for bread
Grateful for toast
grateful for deployment
to a bridge under a freeway

Under the sway of winter
wars command the world
satellites in space
and praise is underdone

Pleasant as an ache
Remembered for its lie
First it was a place
Now it's come to this

Underneath the sky
Glaciers sink and fall
A thousand and more men
Die before they know

Grateful for wars
Generals make their case
We need this you know
To comfort and seduce

[*WSQ: Women's Studies Quarterly* 36: 1 & 2 (Spring/Summer 2008)]

So they die for you
with summer in the air
breathless with belief
we understand your loss

Grateful for lambs
whitewashed on snow
grateful for delusions
and a thousand flying geese

MAXINE CHERNOFF is the author of six books of fiction and eight books of poetry. She is chair of creative writing at San Francisco State University and edits *New American Writing*. In 2008 her new book of poems, *The Turning*, will be published by Apogee Press, and her translations of Hölderlin (with Paul Hoover) will be published by Omnidawn Press.

DE *SEPTIEMBRE*, CAPÍTULO 3
FROM *SEPTEMBER*, CHAPTER 3

DOLORES DORANTES
Translated by Jen Hofer

Otra orilla

la orilla donde zarpas
en la sangre
de todos los cuerpos

(en tu navío
de sangre)

Con fuerza
cruza
a mi cielo de sal

la luz
de tu marea

Other Edge

the edge where you sail away
in the blood
of all the bodies

(in your blood
ship)

With force
crosses
to my salt sky

the light
of your tide

[*WSQ: Women's Studies Quarterly* 36: 1 & 2 (Spring/Summer 2008)]

•

Falta poco
para que timbren los trenes
y bajen de los vagones
tus soldados

El ejército
contralbura
ondeando su sedosa
bandera

(*No volveremos a nuestro interior*

mientras
en las miradas
carguemos la moneda
reluciente
del beso)

•

Not much longer
until the trains whistle
and your soldiers
come down from the boxcars

The army
contrafog
their silky
flag undulating

(*We will not return to our interior*

while
in gazes
we carry the coin
gleaming
of a kiss)

● ●

Quién	Who
con la fuerza	with the force
de qué mano cerrada	of what closed hand
cubrió tu corazón	covered your heart

¿tú?	you?
No	No

sino el recuerdo	rather the memory
del color en los ojos:	of color in the eyes:

Aún mujer	woman still
con el sol cantando	with the sun singing
de su boca	from her mouth
era	it was

y no en el pecho ésta	and not the chest this
tu ceniza	your ash

latente	latent

ACKNOWLEDGMENTS

This excerpt is from chapter 3 of *Septiembre*, originally published in *sexoP-URosexoVELOZ* and Septiembre, a bilingual edition of books two and three of *Dolores Dorantes* by Dolores Dorantes (Counterpath and Kenning Editions, 2008).

DOLORES DORANTES was born in Veracruz in 1973 and has lived most of her life in Ciudad Juárez, where socioeconomic violence and politically charged daily brutalities have informed her radically humane and beautifully incisive work as a poet, journalist, and cultural worker. Dorantes is a rare presence in Mexican literary communities, in that she takes a

wide-ranging international stance toward poetry and poetics while refusing to accept state support from a government she cannot respect. She has published four book-length works of poetry in Mexico and is a founding member of the border arts collective Compañía Frugal (Frugal Company), which counts among its activities publication of the monthly poetry broadside series *Hoja Frugal*, printed in editions of four thousand and distributed free throughout Mexico.

JEN HOFER'S translations of Dorantes's work have appeared in the anthologies *Sin puertas visibles: An Anthology of Contemporary Poetry by Mexican Women* which she edited and translated,and *War and Peace 2* as well as in the literary journals *1913*; *Achiote*; *Action, Yes*; *Aufgabe*; *Counterpath Online*; *Kenning*; and *Tampa Review*, and as a Seeing Eye chapbook. In early 2008, Counterpath Press and Kenning Editions copublished *sexoPUROsexoVELOZ* and *Septiembre*, a bilingual edition of books two and three of *Dolores Dorantes* by Dolores Dorantes.

DEBRIS

NICOLE COOLEY

Wooden pilings from a shotgun house pink insulation loose and threaded
a blonde-haired doll a toilet stucco crumbled to sand a football helmet
the face of a metal fan a sign: *Demolition Alert* a mattress spiking metal
a front door a stove a beach chair a crushed pickup truck a soup ket-
tle yellow bedsheet twisted in a tree a rocking horse a refrigerator
with school snapshots taped to the door sandbags a stop sign a baby
bottle an armoire shredded window screens a sign: *Do Not Destroy*
dented fender of a school bus a leather couch a claw-foot bathtub a
cyclone fence pleated like a fan on poster board: *405 Paris Avenue* a
ketchup bottle a wheelchair a refrigerator spray-painted *Help Me Jesus*
slab of wallboard spilled with mildew door like a blank eyehole a sign:
For Sale by Owner a sign: *No Demo* a sign: *Keep Out* a torn Blue Roof
unspooled yellow caution tape sheetrock black rot a sign: *We're
Coming Home*

NICOLE COOLEY grew up in New Orleans and is the author of two books of
poetry and a novel. She is working on a collection of poems, "Breach,"
about Hurricane Katrina, and she directs the new MFA program at
Queens College, City University of New York.

[*WSQ: Women's Studies Quarterly* 36: 1 & 2 (Spring/Summer 2008)]

ANNE BABSON

No one believes me, and yet the tape played,
However murkily, corroborates.

I called the FBI. They put me in
Voice mail, never to return the phone call.

I told my pastor. He quoted a verse.
He asked me how my husband was doing.

I have the fingerprints. I have samples.
The police made me fill out a long form.

I called my oldest girlfriend. She whispered,
"Why haven't you let this go yet, honey?"

I am writing this note and posting it
On this pole. The number is my mobile.

If you read this and saw it, too, just call.
I don't have answers, but I won't hang up.

ANNE BABSON is proud to be included in the British anthology of American writers, *Seeds of Fire: Contemporary Poetry from the Other USA* (Smokestack Books, 2008). In her most recent chapbook, *Counterterrorist Poems* (Pudding House, 2002), she explores the painful relationship between women and religion wherever extremism exists. She is the only Caucasian on a new hip-hop CD, *The Cornerstone* (Newlewmusic.com, 2007), where her poetry meets the cadence of the street and finds reasons to get up and dance. She wrote the libretto for the new opera *Upbringing*, about Chinese women's lives, with world-renowned Chinese American composer Su Lian-Tan; the work will be performed by the celebrated brass

[*WSQ: Women's Studies Quarterly* 36: 1 & 2 (Spring/Summer 2008)]

chamber orchestra Meridian Arts Ensemble. Babson's work has appeared in more than eighty literary journals over the past several years. She teaches writing and literature in New York.

HOW DO QUILTS BECOME MISSING?

JEN TYNES

Stolen from a vehicle (car, van, U–Haul, etc.).

Large green swags on the border.

Stolen from home (or nursing home, storage space, etc.).

Blue Skies over a Parched Land in their Caravan.

Lost/dropped in a public area (hotel, restaurant, airport, park, zoo, etc.).

Her husband packed up precious possessions accumulated during forty years of marriage and stored them in a utility trailer.

Stolen from a public area (airport, park, etc.).

Tragically, the suitcase never arrived.

Hand appliquéd and called "World Without End."

Lost by someone else (friend, dry cleaner, etc.).

The face of Christ was hand painted and his hair was embroidered.

She used some of his favorite T-shirts that he had outgrown.

Missing from relative's estate (the heads of Washington, Lincoln, Roosevelt, and Evelyn).

[*WSQ: Women's Studies Quarterly* 36: 1 & 2 (Spring/Summer 2008)]

The maker embroidered the names and dates of different red school-
houses that she found as she and Barbara's grandfather took Sunday
drives in the country.

Manner of Missing Unknown.

Last seen during May 2004 in a 1996 Buick Century.

Manner of missing unknown (Marie specifically remembers this in the
hot pink sashing).

Missing from a round-robin exchange (She was a very private person
and cautious about what she revealed to people).

Thrown or given away (very bright colors and hot pink tips).

Lost in Tornado (At that time she began having daily help with meal
preparation and housekeeping).

Quantity and How Lost.

In a fit of anger at an ex-girlfriend, her son gave the quilt away to a
stranger.

The label said something like this.

Dawn is looking for a crib quilt that her youngest child threw in the
trash without her knowledge. (Her other son is crushed.)

How do quilts become missing.

Nancie's ex-husband gave away all of her belongings including this
quilt.

How do quilts become missing.

Apparently she lost the storage unit in fall 2005.

How do quilts become missing.

Cheri's ex-husband threw it away in a dumpster behind the Century 21 office.

How do quilts become missing.

I don't use my real name on the web, but would reveal it to someone who knows about the quilt.

JEN TYNES lives in Denver, Colorado, and is an editor of horse less press. She is the author of the following books, chapbooks, and collaborations: *Found in Nature* (horse less press, 2004); *The End of Rude Handles* (Red Morning Press, 2005); *The Ohio System*, with Erika Howsare (Octopus Books, 2006); *See Also Electric Light* (Dancing Girl Press, 2007); and *Heron/Girlfriend* (forthcoming, Coconut Books, 2008).

"THE BOOK OF HOURS" AND "THE WAYS THEY SILENCE WOMEN"

ANGELA VERONICA WONG

THE BOOK OF HOURS

January

It begins,
suspended
bustles
and thighs
that don't touch
spread
like a mass
grave
uncovered.

February

Is this you
hovering?
Face,
curving
letters
and exclamations,
mouth-tough
and glistening
a threat.

[*WSQ: Women's Studies Quarterly* 36: 1 & 2 (Spring/Summer 2008)]

March

Your body—
white shark.

April

squeeze together
bleed into
and out of
pretense
discontinue
promise

May

Moss weather
and yellow
identity.

June

Crablike I creak
gold and pearl.

July

i itch you
peel my skin off
like a tarp

August

memory suicide

September

my mythology punishes.

October

In my
dream, I
moved your
hand onto my
belt. You
parted my
lips. We
were not far
apart then. You
did not speak You
were welcome
intrusion You
were list
less lost last lust I
forget.

November

cold like jade
I self-heal
expand like a clot
I am chemical
I am blood in the toilet

cliffs shrinking
wet cornhusk
three colors haunting
each other
hunted
unsettled
discard
I am purposeful bride

December

like sleep,
falls lightly.

THE WAYS THEY SILENCE WOMEN

the ways they silence women:
 roll of paper or piece of wood stuffed
 these are days when living as a woman is acknowledging you are
a rape waiting to happen no matter how many lemons you scrub on
your skin
 to stop smelling of yourself

ACKNOWLEDGMENTS
The calendar poems are a series of short poems under the title "The Book of Hours." "June" was previously published in *Foursquare* (edited and published by Jessica Smith, 2007; reprinted by permission of the author).

ANGELA VERONICA WONG recently named a kitten Galliano and even more recently painted her bathroom hot pink. She lives and dances in New York City. Her poems appear or are forthcoming in *Barrow Street*, *Womb*, and *Court Green*.

LOOKING BACK/LOOKING FORWARD

LEIGH GILMORE

For many feminist academics working outside the clinical study and treatment of trauma in the early 1990s, Judith Herman's *Trauma and Recovery* offered us an absorbing, detailed, and profoundly useful analysis of past and current clinical practice, as well as unparalleled insights into the relationship between traumatic experience and the path to recovery. Her analysis of trauma emphasized how gender bias had constrained the field's earliest practitioners, thereby bequeathing a legacy of misogyny that the discipline would labor to reveal and expunge. This feminist historicization clarified a network of political, historical, cultural, and personal relations that had previously gone unremarked. Herman maneuvered contemporary trauma theory and treatment out of range of the field's limitations so that it could benefit from feminist insights into gender developed since the 1970s. She used historical critique to chart the political transformations that enabled this reconceptualization of trauma theory and treatment: "The study of war trauma becomes legitimate only in a context that challenges the sacrifice of young men in war. The study of trauma in sexual and domestic life becomes legitimate only in a context that challenges the subordination of women and children. Advances in the field occur only when they are supported by a political movement powerful enough to legitimate an alliance between investigators and patients and to counteract the ordinary social processes of silencing and denial" (1992, 9).

As important as Herman's work was to feminists outside her field, it was rooted in a feminist transformation of psychology, psychoanalysis, and trauma studies. The interplay across this disciplinary boundary and between disciplinary critique and institutional transformation, as well, was, by 1992, an established achievement and method of feminism. Building on this base, Herman brought trauma studies and feminism together to shift the known and knowable about human suffering, violence, and healing. Central to this was the feminist reconceptualization

[*WSQ: Women's Studies Quarterly* 36: 1 & 2 (Spring/Summer 2008)]

of power, victimization, harm, and redress. When the study of trauma borrowed its understanding of victims from legal and cultural notions of status, it took women and children as the subordinate subjects that the law had turned them into and wrote these unequal relations of power into notions of the human. Violence against women and children, when unaddressed, both creates and confirms their subordination. For example, the rape of a woman by her spouse was not a crime until the state considered it as such. Status, rather than injury, defined a legitimate victim. Feminism clarified this wrong. Once women could seek redress and support from structures that were created to offer it, the harm and trauma of rape within marriage could move out from under the cover of family norms and the legal and cultural constructs that subtend them. Feminist revisions of victimization claimed women as legitimate victims and, at the same time, refused to see women as perpetually victimized and vulnerable. Herman rejected the dominant construction of women's victimization as natural, unavoidable, and minor and, instead, politicizedvictimization. Feminism constructed a different understanding of "victim" that refused the violent assertion that victimhood was an inherent identity and looked instead at the persons and policies that inflicted and permitted violence. Trauma sufferers fall victim to organized state violence as well as forms of violence that are disorganized and endemic to daily life, and feminists clarified how women are vulnerable to both. Herman's work shifted who counts as a victim and through what forms of suffering, to whom one should turn for help and how, and how therapists should best manage the treatment of trauma survivors. In Herman's analysis, men and women veterans, abused children, incest survivors, battered women, and bystanders caught up in multiple forms of violence stand together in the specificity and urgency of their differing need.

Herman's work exemplifies the turning of second-wave feminism toward the twin goals of disciplinary critique and institutional transformation. It is perhaps this focus on engagement that makes *Trauma and Recovery* such a galvanizing and steadying read. In a world awash in violence, and in myriad situations that feel out of balance in profound ways, it is possible to feel that trauma has no boundaries, that we are irredeemably in it, and that it cannot end. This would not be an adequate gloss of Herman's view. While she is rigorous in clarifying what constitutes trauma, and does not shrink from either its ubiquitous or its overwhelming qualities, the book's title links trauma *and* recovery. Her

threading of recovery through the project rewrites harm into the context of healing. When Herman documents the early failure of trauma studies to connect the shell shock men suffered in World War I and the sexual abuse women suffered within the very relations of family and care on behalf of which men were mobilized to fight, she presents the parallel paths that research and treatment subsequently followed as a missed opportunity in the development of the field. However, as nonjudgmental as she is in crediting the early insights of Freud, Janet, and others, Herman will not permit her contemporaries to repeat their failures, as when she discusses the entry of terms for trauma into the American Psychiatric Association's *Diagnostic and Statistical Manual*.

Herman is acutely alive to how formations of sexism (historical and disciplinary) intrude into contemporary practice. Given the dynamics of silencing and denial (as Herman names them) that arise within cultural formations of sexism, it is no wonder that trauma survivors must first get out of hurting range and then find both the words to say and the witness to hear what has happened to them. We can understand this move in the context of her historicization of the field, but it also connects to her therapeutic claim that trauma requires a witness. One becomes a witness to one's own experience by finding a testimonial form; in other words, a language and a listener. Yet even more specifically, the survivor finds a narrative and an interlocutor who will listen with moral identification to the process but without reaction or judgment about the morality of the survivor. In the field of autobiography studies (which includes the study of testimony, first-person narration, and witness narratives), the survivor's tale represents a rich site of analysis. Herman's work offers insights into the production of such narratives as well as the hermeneutics that would unlock their knowledge.

A final thought: *Trauma and Recovery* predates the research into brain scans and other data gathered from the body that constitute an important focus in current studies of trauma. In some ways, this focus on the body in the research into trauma might seem orthogonal to Herman's focus on narrative and the relation of patient and clinician. Yet I see a link here. Herman's reading of the somatic aftermath of trauma (flashbacks, nightmares, hypervigilance) relates bodily response to the psyche's integrity because it suggests that clues to how the body and mind are connected are revealed when mind and body become deranged from each other in response to trauma. These same disconnections offer insight into how the

body and mind might be reknit in recovery. By paying close attention to how trauma makes the mind and body fall apart from each other, Herman offers potent insight into how they are one. Psychosomatic symptoms argue for a link between mind and body, but we cannot easily read this connection in trauma. Current work on mindfulness meditation and yoga as therapies suggests that trauma survivors are being seen in the more holistic and feminist ways that Herman called for.

LEIGH GILMORE is the Backstrand Chair of Gender and Women's Studies at Scripps College. She is the author of *The Limits of Autobiography: Trauma and Testimony* (Cornell University Press, 2001); *Autobiographics: A Feminist Theory of Women's Self-Representation* (University of Tulsa Press, 1995); and numerous articles on autobiographical practices and feminist theory and is a coeditor of *Autobiography and Postmodernism* (Duke University Press, 1995).

WORK CITED

Herman, Judith. 1992. *Trauma and Recovery*. New York: Basic Books.

REVISITING *TRAUMA AND RECOVERY*

ELIZABETH M. SCHNEIDER

I am grateful for the opportunity to contribute to this discussion of Judith Herman's important book *Trauma and Recovery* and its relevance today. In this volume, published in 1992, Herman developed many crucial dimensions of battering that continue to be essential to work on violence against women. In these brief comments, I want to highlight two of these dimensions.

The first is the link between battering, trauma, and larger political and social violence—what I would call the operation of gender violence on a *macro* level. I remember reading the book for the first time after I had already been doing work on legal representation of battered women for many years. I was amazed by the very first chapters, in which Herman makes the connection between political violence and battering. I realized that my own understanding of violence against women had been limited by my sense of it as being within the context of a relationship between two people. Yes, I had seen it as political, as a part of a larger context of patriarchy and gender subordination, but I had not consistently made the link between larger political violence and violence against women. Herman saw that battering was "terrorism in the home" and made those links explicit (see Marcus 1994).

Aspects of Herman's analogies have been integrated into sociological and psychological accounts of battering, such as the use of the phrase "hostage." But the past fifteen years has seen the development and expansion of these insights, particularly in the context of a global women's international human rights movement (see Schneider 2000). This movement has explicitly linked sexual violence and political violence. We now understand gender violence as a form of torture and recognize that violence against women occurs in wartime and as a weapon of national and international conflict (Copelon 2003). Even the United Nations secretary general's *In-Depth Study on All Forms of Violence Against Women*, submitted to the General Assembly in fall 2006 (and

[*WSQ: Women's Studies Quarterly* 36: 1 & 2 (Spring/Summer 2008)]

on which I worked as a consultant), recognized gender violence as a human rights violation and as a vehicle of war (United Nations General Assembly 2006). The law school casebook on battering that I coauthored includes a chapter on international human rights and emphasizes that international human rights frameworks expand our understanding of battering as linked to larger political and social violence (see Dalton, Schneider 2001; Schneider, Hanna, Greenberg, and Dalton 2008). It also emphasizes links between battering and dowry deaths, female genital mutilation, women's economic development, AIDS, forced and early marriage, "honor" killings, and many other aspects of gender subordination.

What is also remarkable about Herman's work is that it is so detailed in describing the way in which the trauma of violence is experienced on a personal level. In an intensely moving and powerful manner, she explains the terror, disconnection, and sense of captivity that is endemic to the experience of battering. This is what I would call the *micro* level of battering. And for many of us who work with battered women, or help train others to do so, the book offers profound insights into the trauma that helpers also experience. In the final chapter of our casebook, "Doing the Work," we include excerpts from *Trauma and Recovery* that discuss this "secondary trauma." For lawyers who will be working with battered women, these insights are crucial.

I celebrate Judith Herman and *Trauma and Recovery*. It is a pathbreaking book that has become only more important with time.

ELIZABETH M. SCHNEIDER is the Rose L. Hoffer Professor of Law at Brooklyn Law School.

WORKS CITED

Copelon, Rhonda. 2003. "International Human Rights Dimensions of Intimate Violence: Another Strand in the Dialectic of Feminist Law Making."11 Am U.J. of *Gender Law and Soc. Policy Law* 865.

Dalton, Clare, and Elizabeth E. Schreider. 2001. *Battered Women and the Law*. New York: Foundation Press.

Marcus, Isabel. 1994. "Reframing 'Domestic Violence': Terrorism in the Home." In *The Public Nature of Private Violence*, edited by Martha L. Fineman and Roxanne L. Mykitiuk. New York: Routledge, 11.

Schneider, Elizabeth M. 2000. *Battered Women and Feminist Lawmaking*. New Haven: Yale University Press.

Schneider, Elizabeth M., Cheryl Hanna, Judith G. Greenberg, and Clare Dalton. 2008. *Domestic Violence and the Law: Theory and Practice*, 2nd Edition. New York: Foundation Press.

United Nations General Assembly. 2006. *In-Depth Study on All Forms of Violence Against Women: Report of the Secretary General*. www.un.org/womenwatch/daw/vaw.

TRAUMA AND RESEARCH: BEARING RESPONSIBILITY AND WITNESS

JENNA APPELBAUM

More than fifteen years after its initial publication, Judith Herman's *Trauma and Recovery* remains the standard reference point of trauma studies, providing a common language for endeavors as varied as psychiatric analyses of traumatized individuals, critical examinations of literary representations of trauma, and sociological studies of shared traumatic experiences. Herman clearly stresses the importance of disinterest and neutrality in her work with trauma survivors, describing "disinterest" as "abstain[ing] from using [one's] personal power over the patient to gratify her personal needs" and "neutrality" as "'not taking sides' in the patient's inner conflicts or try[ing] to direct the patient's life decisions" (1992, 135). Note that these definitions say nothing about the need for *emotional* disinterest or *moral* neutrality. Rather, they require that a distinction be carefully made between emotionally and morally laden interactions, that is, those related to inner conflicts and life decisions, and emotionally and morally driven actions, such as gratifying personal needs, taking sides, or directing decisions.

In fact, Herman emphasizes the importance of emotional and ethical *engagement*—a sense of empathy and a "committed moral stance"—insisting that "it is not enough for the therapist to be 'neutral' or 'nonjudgmental.'. . . The therapist's role is . . . to affirm a position of moral solidarity with the survivor" (178). And yet Herman is also acutely aware of how uneasily such sentiments sit in certain scientific circles: "Early investigators often felt strong personal bonds and political solidarity with trauma survivors, regarding them less as objects of dispassionate curiosity than as collaborators in a shared cause. This kind of closeness and mutuality may be difficult to sustain in a scientific culture where unbiased observation is often thought to require a distant and impersonal stance" (240). Indeed, investigators who emotionally and ethically engage with their research—interviewers who experience and express

[*WSQ: Women's Studies Quarterly* 36: 1 & 2 (Spring/Summer 2008)]

"strong personal bonds and political solidarity" with their subjects—will likely often be seen as veering dangerously close to the boundary between social science and social work.

Thinking about this tension while reflecting upon early research encounters of my own of which I am particularly not proud, I cannot help but question the appropriateness of "unbiased observation" in trauma research. Two brief examples come immediately to mind. The first involves a young boy who repeatedly beat his head against the seat of the couch as I asked him, repeatedly, about past victimization by his parents. Although I knew that the upsetting nature of my interview was directly implicated in this boy's distress, I neither stopped the interview nor stepped outside the role of the interviewer. When the interview's results later showed suicide ideation, my supervisor expressed deep concern for the research project, not the research subject—"If the kid offs himself, we'll lose the data!"

The second example involves a rape crisis counselor who spoke extensively of her own history of sexual violence and then suddenly said, "OK, welcome to the Rebecca[1]-shares-too-much section," and divulged her plans to engage in sex work the following night. Although I knew that the intimate nature of my interview was directly implicated in this disclosure, again, I neither stopped the interview nor stepped outside the role of the interviewer. When Rebecca called me late the next night from a hospital emergency room—"Things didn't end well"—I found myself immediately back in interviewer mode; my field notes read: "I'm detached, impartial, 'clinical' on the phone. Typing on laptop at first, but soon began to write instead by hand—worried she might hear the keys. Imagine if she knew I was taking notes. . . ."

When I am honest with myself now, I admit that these were times when I hid behind the scientifically sanctioned borders of emotional and ethical disengagement. I took refuge in the role of the researcher and prioritized the research results over the research subjects themselves. But in protecting the research methods and the projects' data, I also put the individual victims at greater risk.

Interviewed in 1996 about the danger of retraumatization through testimony, Herman maintained, "Anyone showing interest and providing an opportunity for someone to tell their story can have a therapeutic effect. Some victims may be ready to take advantage of the slightest opportunity in a positive way. For others, it opens them up and leaves

them with nowhere to go" (Hayner 2001, 141). But unlike other sites of testimony, social science is not intended as "an opportunity for someone to tell their story" and research interviews are far from the ideal place for trauma victims to reap the benefits of what Herman calls "the universality of testimony as a ritual of healing" (1992, 181). Investigators always have research agendas and rarely do they include the provision of "therapeutic effect[s]" or "healing" to project participants, as the University Committee on Activities Involving Human Subjects (UCAIHS) makes perfectly clear in their warning: "Take care not to exaggerate potential benefits; research studies rarely provide direct benefits to subjects.")[2]

Still, investigators must anticipate that trauma survivors might "take advantage of the slightest opportunity" to venture beyond the borders of the research interview—*welcome to the Rebecca-shares-too-much section*—and they must always be prepared for the possibility of messy moral and emotional terrain. Although UCAIHS prohibits investigations that involve harm or risk "greater than that of everyday life" (see UCAIHS n.d.), I would argue that trauma research, through its exploration of that which exists "outside the range of usual human experience" (as the DSM-III and the DSM-III-R's definition of trauma would have it),[3] *always* involves harm or risk "beyond that of everyday life" (see UCAIHS n.d.). Thus, to foreground this unfortunate truth and draw attention to its potentially tragic consequences, I propose the need for a new model of qualitative trauma research: one that reframes interviews with trauma survivors as both empirical evidence collection processes and potential places of testimony. According to Herman, "the best way the therapist can fulfill her responsibility to the patient is by faithfully bearing witness to her story" (1992, 192). I suggest that the best way the researcher can fulfill her responsibility to the research subject is by taking on the role of both interviewer and witness. Faithfully bearing witnesses to the stories of trauma survivors in a research setting necessarily involves recognizing and wrestling with the risks that result from "the telling, [as] the trauma story becomes a testimony" (181). In shirking this responsibility, investigators are merely serving as silent bystanders, opening subjects up and then "leaving them with nowhere to go" (Heyner 2001, 141). In order to examine that which exists "outside the range of usual human experience," interviewers of trauma must reformulate usual understandings of what should remain inside the realm of research.

JENNA APPELBAUM is a doctoral candidate in the Department of Sociology at New York University.

NOTES

1. Name has been changed in order to protect the identity of the research subject.

2. See the application for the University Committee on Activities Involving Human Subjects (UCAIHS) at New York University, available at: http://www.nyu.edu/ucaihs/. All research involving human subjects must be reviewed and approved by the Principal Investigator's University's Institutional Review Board before being carried out.

3. The DSM-III is the *Diagnostic and Statistical Manual of Mental Disorders, Third Edition*, published by the American Psychiatric Association in 1980. The DSM-III-R is the revised third edition, published in 1987. The DSM-IV-TR (2000, 467) later broadened the definition of a traumatic event and included two criteria, both of which must be present: "(1) the person experienced, witnessed, or was confronted with an event or events that involved actual or threatened death or serious injury, or a threat to the physical integrity of self or others; (2) the person's response involved intense fear, helplessness, or horror."

WORKS CITED

American Psychiatric Association. 1980. *Diagnostic and Statistical Manual of Mental Disorders, Third Edition* (DSM-III). Washington, D.C.: American Psychiatric Association.

———. 1987. *Diagnostic and Statistical Manual of Mental Disorders, Third Edition, Revised* (DSM-III-R). Washington, D.C.: American Psychiatric Association.

———. 2000. *Diagnostic and Statistical Manual of Mental Disorders, Fourth Edition, Text Revision* (DSM-IV-TR). Washington, D.C.: American Psychiatric Association.

Hayner, Priscilla B. 2001. *Unspeakable Truths: Confronting State Terror and Atrocity*. New York: Routledge.

Herman, Judith. 1992. *Trauma and Recovery*. New York: Basic Books.

University Committee on Activities Involving Human Subjects. n.d. http://www.nyu.edu/ucaihs/.

JUDITH HERMAN AND CONTEMPORARY TRAUMA THEORY

SUSAN RUBIN SULEIMAN

Trauma studies constitutes a huge field today, keeping whole armies of theorists—philosophers, literary scholars, and historians as well as clinicians—very busy. There are many reasons for this, starting with the enormous and still growing interest in the Holocaust and other collective historical traumas (the diagnosis of posttraumatic stress disorder, which first entered the American Psychiatric Association's diagnostic manual in 1980, was based largely on symptoms of Vietnam War veterans), and extending to the increased clinical awareness of sexual abuse as a phenomenon of "everyday life" for both adults and children.

There exists today both a wide consensus among theorists on a certain definition of trauma, and a strong and sometimes violent debate about specific aspects of trauma, notably as regards its relation to memory. The importance of Judith Herman's work is that she is one of the pioneering clinicians in the field as well as a major player in the theoretical debate.

What is the consensus about trauma? Everyone seems to agree that a traumatic event "overwhelm[s] the ordinary human adaptations to life," as Herman puts it. "Unlike commonplace misfortunes," she writes, "traumatic events generally involve threats to life or bodily integrity, or a close personal encounter with violence and death" (Herman 1992, 33). A more neurologically based definition would be that a traumatic event—or "traumatic stressor"—produces an excess of external stimuli and a corresponding excess of excitation in the brain. When attacked in this way, the brain is not able to fully assimilate or "process" the event, and responds through various mechanisms such as psychological numbing, or shutting down of normal emotional responses. Some theorists also claim that in situations of extreme stress, a dissociation takes place: the subject "splits" off part of itself from the experience, producing "multiple personalities" in the process. The diagnosis of MPD (multiple personality disorder) was once very rare, but became quite common for a while

[*WSQ: Women's Studies Quarterly* 36: 1 & 2 (Spring/Summer 2008)]
© 2008 by Susan Rubin Suleiman. All rights reserved.

in the 1980s and 1990s. Symptoms of MPD, according to clinicians who diagnose it, always indicate earlier trauma, even if—or especially if—the trauma is not remembered by the patient.

This is where we enter the contested territory of trauma theory. The most important subject of debate concerns the relation of trauma to memory and came about as a result of a number of legal cases in the 1980s involving recovered memory of sexual abuse. There are two very hostile camps here, as far as I can see, and both of them are linked in interesting ways to Freud. Members of the first camp, which includes clinicians such as Judith Herman as well as researchers, among them Bessel van der Kolk, believe firmly in the theory of dissociation, which is related to (though not identical with) the concept of repressed memory, or traumatic amnesia. According to this view, the more horrific and prolonged the trauma, the more the subject has a tendency to dissociate and therefore have no conscious memory of the traumatic event. Thus, a child or even an adolescent who is subjected to repeated sexual abuse by a family member may very well not remember it until he or she (the overwhelming majority being girls) enters into therapy as an adult; at that point, the patient may recover memories in a gradual process, sometimes with the help of hypnosis. Only by finally remembering the repressed trauma can the patient move on to recovery, that is, to "mastery" and healing.

Judith Herman writes:

> The patient may not have full recall of the traumatic history and may initially deny such a history, even with careful, direct questioning. . . . If the therapist believes the patient is suffering from a traumatic syndrome, she should share this information fully with the patient. Knowledge is power. The traumatized person is often relieved simply to learn the true name of her condition. By ascertaining her diagnosis, she begins the process of mastery. . . . She discovers that she is not alone; others have suffered in similar ways. . . . A conceptual framework that relates the patient's problems with identity and relationships to the trauma history provides a useful basis for formation of a therapeutic alliance. This framework both recognizes the harmful nature of the abuse and *provides a reasonable explanation for the patient's persistent difficulties*. (1992–1997, 157–58; my emphasis)

I have to admit that I am uncomfortable with these formulations, for several reasons. First, there is the disturbing possibility that the therapist is imposing an interpretive framework on the patient ("if the therapist believes"). While this may provide a kind of relief, since the patient's problems are given a causal explanation and bring the patient into relation with others who have suffered in similar ways ("she is not alone"), it can also wreak havoc in real life, as family members are suddenly viewed as perpetrators of horrific abuse. Judith Herman herself manifests a certain vacillation in the preceding passage, between proposing the trauma diagnosis as a heuristic paradigm, a "framework that provides a reasonable explanation" for what ails the patient, and assuming that the explanatory framework describes an actual state of events—"the traumatic history." But it seems to me crucial to maintain the difference between those two views. If a patient can find relief by constructing a story of childhood trauma that she does not actually recall, or that she recalls only after much "direct questioning" by the therapist, that is one thing; if the patient then goes on to claim, whether in a court of law or merely in a family circle, that the construction corresponds to historical fact *in the absence of any other evidence*, that is a very different thing. (I emphasize "in the absence of other evidence," because obviously there are many cases of abuse that are documented at the time they occur, or are corroborated by family members even if the patient has forgotten, or else were never forgotten in the first place; those cases are not in question here.)

Interestingly, Herman's theory is derived from Freud in some respects and is extremely critical of him in others. The idea of repressed memories, which is dependent on the concept of the unconscious, is definitely Freudian, and Freud never abandoned it; what he did abandon was the idea that such memories always correspond to actual events, rather than representing the patient's desires and fantasies. As is well known, in the late 1890s he abandoned the "seduction theory" that he had advanced in several essays published a few years earlier, which carried with it the concept of unconscious memories of childhood trauma. Judith Herman and others part company with him there, blaming him for abandoning the seduction theory and not believing his patients.

At this point, we encounter the second camp of trauma theory, which has proceeded along two paths—in both, what is contested is the concept of repressed memory. First, some theorists have gone back to

Freud's original papers from the 1890s (in particular his 1893 paper "The Aetiology of Hysteria") that deal with the seduction theory; they discovered that he too tended to impose his own constructions on his patients—in other words, they say, it was not that he gave up believing his patients' memories of childhood abuse, but that he stopped trying to force his own theory of "repressed" sexual abuse in childhood down his patients' throats. Instead, say these theorists, Freud started forcing a new theory on his patients, centered on the Oedipus complex. Mikel Borch-Jacobsen and Ian Hacking (both are philosophers, not psychologists) are among the leaders of this branch of the "anti-Freud" camp. They not only blame Freud for imposing his own unjustified constructions on his early hysteric patients, but also then blame him for wanting to "cover up" his "crime" and inventing the Oedipus complex in the process! Borch-Jacobsen has written a number of quite violent books against Freud and has also edited a collective volume titled *Le livre noir de la psychanalyse*, whose title echoes those of earlier "black books" detailing the crimes of Nazism and communism. However, even if Freud was indeed often guilty of imposing his own constructions on his patients, that does not mean that all his theories about the human psyche are wrong—much less, criminal.

The other branch of the "anti–repressed memory" camp is represented by clinicians and psychological researchers, foremost among them Elizabeth Loftus and Richard McNally. The theorists in this group could be called hard-nosed empiricists: to test the hypothesis of repressed traumatic memory and recovered memory, they rely on thousands of empirical experiments that have been done on both animals and live subjects. Loftus has shown that many people are prone to having false memories "implanted" in them—though not false memories of trauma, because it would be unethical to try to prove that empirically; as McNally points out, you cannot persuade people that they were traumatized as children for the sake of an experiment. But people who vividly "remember" being abducted by aliens are a good nonexperimental example of delusion functioning as firmly held memory.

McNally makes some very strong arguments, based on his exhaustive review of the literature as well as on his own research. Memories of trauma, he claims, cannot be dissociated or repressed—on the contrary, the more violent the trauma, the more subjects are likely to remember it, indeed to never forget it even if they want to. McNally does not reject the reality of such traumas as childhood sexual abuse, but he argues that

such abuse is always remembered if it occurred after the age of two (before that age, no one generally remembers anything, traumatic or not). It's true, he says, that subjects may not think about such traumatic events for many years and then suddenly remember them because some event triggers the memory, but McNally wants to distinguish this kind of forgetting from repressed memory or dissociated memory, because they imply an *inability* to remember, whereas forgetting events in one's life is a function of ordinary memory and its lapses.

I find many of McNally's arguments persuasive and also support his insistence on the need to look for corroborating archival evidence whenever possible in cases of reported trauma. People often fabricate memories of horrific experiences that never happened (some Vietnam veterans who claim to have been in battle were in fact never deployed), especially in a cultural and legal environment where being a victim "pays"—which doesn't mean that all those claiming to suffer from post-traumatic stress disorder are faking it or are victims of suggestion by bad therapists, but simply that wherever possible, it is a good idea to supplement the personal memories of trauma victims with historical research. One thing I find less than satisfying in the "hard-nosed" approach represented by McNally is its strong animus against Freud and psychoanalysis. Even when Freud was wrong, his work is worthy of respect and often illuminating. This view may be my own prejudice, but I don't mind admitting it.

Whatever camp one is in, finally, I think it is important to understand that trauma is not only a drama of a past event, but also, even primarily, a drama of survival. This is emphasized in Robert Jay Lifton's works on survivors of Hiroshima, Vietnam, and the Holocaust. The survivor, Lifton writes, is "one who has encountered death but remained alive," and it is this remaining alive that leads to "psychological themes" that he associates with survival: the inability to move beyond indelible images of death, guilt about having survived while others died, psychic numbing, lack of trust in the world, and struggle for meaning. Lifton points out that all these themes can have positive or negative consequences for the individual: guilt can be paralyzing or else a "powerful impetus for responsibility," while recurrent images of death can be paralyzing as well as a source of creative energy (Lifton 1980, 119). What has been called "the era of the witness" (Wieviorka 2006) is no doubt proof of that.

SUSAN RUBIN SULEIMAN is the C. Douglas Dillon Professor of the Civilization of France and professor of comparative literature at Harvard. Her latest book is *Crises of Memory and the Second World* (Harvard University Press, 2006). Other books include *Authoritarian Fictions: The Ideological Novel as a Literary Genre* (Columbia University Press, 1983); *Subversive Intent: Gender, Politics, and the Avant-Garde* (Harvard University Press, 1990); *Risking Who One Is: Encounters with Contemporary Art and Literature* (Harvard University Press, 1994); and the memoir *Budapest Diary: In Search of the Motherbook* (University of Nebraska Press, 1996).

WORKS CITED

Herman, Judith. 1992–1997. *Trauma and Recovery*. With a new afterword. New York: Basic Books.

Lifton, Robert Jay. 1980. "The Concept of the Survivor." In *Survivors, Victims, Perpetrators: Essays on the Nazi Holocaust*, edited by Joel Dinsdale. Washington: Hemisphere Publishing Corp.

Wieviorka, Annette. 2006. *The Era of Witness*. Trans. Jared Stark. Ithaca: Cornell University Press.

CLASSICS REVISITED, COMMENTARY

JUDITH HERMAN

I wrote *Trauma and Recovery* in the hope that it would reach a wide audience: activists and academics, trauma survivors and those who care for them. This hope has been realized in ways I could not have imagined. In the fifteen years since the book was first published, it has touched readers in many walks of life and many parts of the world (it has been translated into sixteen languages). I am grateful to *WSQ* for choosing *Trauma and Recovery* (*T&R*) as a "classic," and to the colleagues who have offered their thoughtful critique and appreciation.

In the early days of the second wave, a little pamphlet circulated called *Women: The Longest Revolution*. Juliet Mitchell's (1966) long-term historical perspective offered some comfort to those of us who felt continually frustrated by the intransigence of patriarchal institutions and the slow pace of change. I tried to incorporate that historical perspective into the writing of *T&R*. As Leigh Gilmore points out, a historical critique is central to the book's feminist project. When I was delving into the past of what would now be called the trauma field, one of the biggest puzzles was to figure out why, in the late nineteenth century, "hysteria" became the focus of so much public attention. Why did eminent men of science suddenly find it interesting to pay attention to women patients who previously, if they were noticed at all, had been the object of general scorn? I remember the excitement I felt when it all fell into place: the study of hysteria was part of a political movement! Jean-Martin Charcot, founding father of the scientific study of hysteria, was also a founding father of the Third Republic in France. His Tuesday Lectures, in which patients with hysteria were displayed to an enthralled Parisian audience, were political theater, the purpose of which was to demonstrate the triumph of scientific rationalism over religious superstition. A fierce anticlericalism and a sincere faith in the tenets of the Enlightenment fueled this political movement.

By the early twentieth century, once secular democracy was

[*WSQ: Women's Studies Quarterly* 36: 1 & 2 (Spring/Summer 2008)]

securely established in France, the study of hysteria disappeared from the public stage as quickly as it had appeared. There was no longer any compelling reason to listen to women with hysteria, especially since as soon as anyone paid them the slightest attention they began to talk about things like incest and rape. Soon these patients once again became the object of general scorn—until the women's movement of the late twentieth century.

Elizabeth Schneider also calls attention to what she calls the "macro" level of analysis in *T&R*. She speaks of her own moment of excitement when she saw the link between violence against women and other forms of political violence. Suddenly the women's movement could speak in the language of human rights. This fundamental insight has been a creative source in Schneider's own work and in the work of activists around the world.

Jenna Appelbaum proposes to revive the kind of scientific inquiry that was practiced in the early days of the women's liberation movement. She argues that a disinterested stance of open curiosity does not preclude moral engagement and empathy with one's subjects. She calls for a new model of qualitative trauma research that would allow investigators to recognize and embrace their role as witnesses to the trauma story. I would add that there is no reason why quantitative research cannot fulfill this mandate equally well. At the Victims of Violence Program, where I work, we study treatment outcome using both qualitative (interview) and quantitative measures.

Finally, there are many ways in which I could take issue with Susan Suleiman's portrayal of contemporary controversies in the trauma field. I will limit myself to two comments. First, despite Suleiman's assertions to the contrary, there is no serious scientific dispute about the fact that trauma can have a profound effect on memory. Traumatic memory disturbances are widely recognized in both clinical and research literature. In fact, the *DSM-IV* lists "inability to recall an important aspect of the trauma" (American Psychiatric Association 1994, 428) as one of the diagnostic criteria for posttraumatic stress disorder. For an exhaustive review of the relevant literature, interested readers may consult an authoritative work on the subject: *Memory, Trauma Treatment and the Law* (Brown, Scheflin, and Hammond 1998).

Second, I would call attention to the sexual politics implicit in Suleiman's critique. On the one hand, she depicts "hard-nosed [*read mas-*

culine] empiricists" who have done "thousands of experiments" and who make some "very strong arguments." On the other, she refers to myself and colleagues as individuals who "believe firmly" in the "theory of dissociation," as if this were a matter of faith or theory rather than empirical observation. Patients who recover traumatic memories after a period of amnesia are presumed to be either overly suggestible (*read feminine*) or frankly malingering, "especially," Suleiman writes, "in a cultural and legal environment where being a victim 'pays.'" The cynicism and scorn implicit in this last comment take us all the way back to the bad old days. I would challenge Suleiman to spend a day in our psychiatric clinic, where our patients suffer from the same traumatic syndromes that Charcot observed so carefully more than a century ago, or a day with the battered women in Elizabeth Schneider's law clinic, or a day talking to Jenna Appelbaum's trauma research subjects. I would assure her, being a victim never "pays."

JUDITH LEWIS HERMAN, M.D., is clinical professor of psychiatry at Harvard Medical School. She is also training director of the Victims of Violence Program in the Department of Psychiatry at the Cambridge Health Alliance.

WORKS CITED

American Psychiatric Association. 1994. *Diagnostic and Statistical Manual of Mental Disorders, Fourth Edition (DSM-IV)*. Washington, D.C.: American Psychiatric Association.

Brown D., A. W. Scheflin, and D. C. Hammond. 1998. *Memory, Trauma, Treatment, and the Law*. New York: Norton.

Herman, Judith. 1992–1997. *Trauma and Recovery*. With a new afterword. New York: Basic Books.

Mitchell, Juliet. 1966. "Women: The Longest Revolution." *New Left Review* 1(40).

SUSAN SULEIMAN RESPONDS TO JUDITH HERMAN

SUSAN RUBIN SULEIMAN

Judith Herman's comments made me realize that I had expressed myself clumsily in places, and I am glad to have this chance at clarification. My aim in my essay was to try to understand the stakes in a major contemporary debate, not to take sides. As concerns the question of memory and the definition of trauma, the conflicted issue is not memory disturbance, but total obliteration of the traumatic event in consciousness. I'm afraid there *is* disagreement on this issue among theorists, and the *DSM-IV*'s listing of "inability to recall an important aspect of the trauma" does not resolve it; it is one thing to be unable to recall an important aspect of a traumatic event, and another not to remember that the event occurred at all.

It was clumsy of me to say, without apparent qualification—and Judith Herman is right to reproach me for it—that we live in a "cultural and legal environment where being a victim 'pays.'" Yet I am not the first to point out that contemporary society, especially in the United States, has a tendency to wallow in stories of victimization—which does not mean that victims don't suffer and often lead sad and miserable lives, as I think I acknowledge in my essay. Judith Herman herself was a bit hasty in attributing to me the "presumption" that "all patients who recover traumatic memories after a period of amnesia are . . . either overly suggestible (*read feminine*) or frankly malingering" (284). The link between suggestibility and femininity is not one that I make, nor do I imply it. I am careful to point out that even Richard McNally, who rejects theories of repression and dissociation, recognizes that people may forget an event for many years, and then remember it if there is a "trigger" for remembrance. I explicitly say, in my own name, that the existence of some false claims of posttraumatic stress disorder does not invalidate the many true claims. Finally, I stand by my statement that "wherever possible, it is a good idea to supplement the personal memories of trauma victims with historical research." On September 27, 2007, the *New York Times* ran a long article about a woman named Tania Head,

[*WSQ: Women's Studies Quarterly* 36: 1 & 2 (Spring/Summer 2008)]

who for the past six years has told a heart-rending story of survival and loss in the World Trade Center to avid audiences. Head was for a time president of the World Trade Center Survivors' Network and often told the story of how her fiancé died in the North Tower while she herself was on the seventy-eighth floor of the South Tower when the second plane hit. The *Times*'s careful investigation revealed that every piece of information Head provided about her work, her education, and her involvement with the man she said was her fiancé has turned out to be false. This fact does not discredit or cast "scorn" on all the traumatized survivors of September 11; it does confirm the need for extreme caution in treading on the delicate grounds of memory, imagination, and trauma.

For a short biography of SUSAN RUBIN SULEIMAN, see page 281 of this volume.

REVIEW

ANNETTE WIEVIORKA'S *THE ERA OF THE WITNESS*, TRANSLATED BY JARED STARK, ITHACA: CORNELL UNIVERSITY PRESS, 2006 (ORIGINALLY PARIS: PLON, 1998, IN FRENCH)

JUDITH GREENBERG

At a moment when increasing attention to testimony, witnessing, trauma, and oral history seem to be expanding and enabling dialogue among scholars and professionals in diverse fields, Annette Wieviorka's book, *The Era of the Witness*, sends up some cautionary flares for the historian of the Holocaust. Published in 1998 as *L'ère du témoin* and beautifully translated in 2006 by Jared Stark, Wieviorka's book recalls an earlier conception of the historian's role, conceiving of a detached, objective, and analytic history along the lines of Hannah Arendt and Raul Hilberg. While careful in her conclusion not to position the historian in a battle "against memory and against the witness" (149) and respectful of the need for survivors to be heard, Wieviorka argues that an "explosion of testimony" (140) has displaced the scholarly historian and puts us in the "era of the witness." Her view of history prizes analysis over emotion and personal opinion, abstraction over individual stories, and intellectual rigor over sentiment and sentimentality. Stark's eloquent and clear translation makes accessible to English readers this critique that stands, if not in opposition to, than in spirited debate with work on witnessing currently embraced by scholars in diverse fields in this country. While I suspect that it will prove controversial for those of us who find value in the interweaving of individual memory, emotion, storytelling, and history, Wieviorka's intelligent and deeply learned perspective serves as a sobering check to possible scholarly lapses in the name of empathy and sensitivity.

The stakes are particularly significant because how historians write about the Holocaust has become the "definitive model for memory construction" in general, according to Wieviorka. That is, in her view, the

[*WSQ: Women's Studies Quarterly* 36: 1 & 2 (Spring/Summer 2008)]

centrality of the position of testimony that now pervades the understanding of the Holocaust affects the ways in which we conceive of other historical phenomena and current events such as the genocides in Bosnia and Rwanda. The replacement of the historian with the witness/survivor as the scribe of events threatens the very transmission of the past to the future. The truth of individual memory now overshadows or even contradicts historical narrative. "How can the historian incite reflection, thought, and rigor when feelings and emotions invade the public sphere?" Wieviorka asks (144).

The volume builds chronologically as it leads us through changes in the role of the Holocaust witness. Wieviorka traces the function of survivors' testimony as it has moved through three phases—from virtual erasure to preservation, as seen in the current amassing of archives of thousands of stories: "survivors have gone from being dispossessed to exploited and reified" (129). The first phase of testimonies she considers in the first of three chapters, "Witnesses to a Drowning World," includes the voices from "beyond the grave" found in ghetto archives, diaries, and *Yizker-bikher*, or memorial books, that assembled survivors' words. In this early phase, while such testimonies served as a form of resistance and immortality, they were often dismissed when recovered. One factor in their isolation lies in their being written in Yiddish, the language of the executed, which virtually disappeared or died with the Jews who spoke it. She considers how even Eli Weisel originally wrote *Un di Velt hot geshvign* in Yiddish but translated and adapted it into the French *La nuit* to transmit his message to a wider audience. Such acts of translation or rewriting that occur in literary texts, Wieviorka warns, also permeate memory and thus can change testimonies over time.

The trial of Adolf Eichmann transformed the role of the witness, Wieviorka argues, taking survivors' stories from within the family sphere to the public. Gideon Hausner, the principal organizer of the trial in Jerusalem, understood the need to tell stories for future generations and "placed testimonies at center stage." The trial inaugurated a second phase of witnessing, a listening to *survivors'* stories and feelings, in which survivors "acquired the social identity of survivors because society now recognized them as such" (88). Wieviorka locates the "advent of the witness" at a specific moment in the trial that is often overlooked: the testimony of Ada Lichtman, the first witness from Poland. In contrast to the previous witnesses, Lichtman spoke in Yiddish, the language of the dead,

and shifted the focus away from "the man behind the glass" and to memories of the dead. Wieviorka questions a legal proceeding that sought to rewrite history "based solely on testimonies" (86) and finds that it was just a step from casting the spotlight on the victims to a change in the writing of history. Hausner's agenda—to move away from a clinical approach to the facts—set the path for Daniel Goldhagen's eventual publication of *Hitler's Willing Executioners*, a book that broke the rule of keeping the professional historian out of the role of judge or prosecutor and instead presented history as "the juxtaposition of horror stories" (92). For Wieviorka, "Daniel Goldhagen's work pulverized the universally established criteria for the academic writing of history" (90).

Wieviorka saves her strongest critiques for our current phase, the "era of the witness." In the 1970s and 1980s the "craze" for "life stories" and the post-1968 political attention to the "man in the street" fostered a culture in which "the individual alone became the public embodiment of history" (97). In addition, a number of films and video projects contributed to an "Americanization of the Holocaust" that not only prioritizes the individual story over history but also promotes a vision of optimism, equality, goodness, and innocence. Video and film brought survivor stories to the fore, from the late 1970s televised miniseries *Holocaust*, which offended survivors around the world, to the Yale Video Archive for Holocaust Testimonies, whose model has spawned interview projects at memorials and museums internationally. While Wieviorka respects the sensitivity and merit of listening engendered by the Yale project, she considers Steven Spielberg's Survivors of the Shoah Visual History Foundation perhaps the greatest culprit in the usurpation of history. Spielberg and Michael Berenbaum, the foundation's president, aim to tell the history of the Holocaust by amassing enormous archives of video testimonies, editing them according to their guidelines and structure, and presenting history as the sheer volume of individual stories. "Their goal, then, is quite simply to replace teachers with witnesses, who are supposed to be bearers of a knowledge that, sadly enough, they possess no more than anyone else" (133). In the end, for Wieviorka, the explosion of testimony and the focus on the individual appeals to the heart but fails to construct a historical narrative. Spielberg and Berenbaum stand at the extreme end of a chain of commandeers of history that began with Hausner, was pulverized by Goldhagen, and was reduced and misconstrued through the miniseries *Holocaust*.

Wieviorka's book merits attention, if not only for the intelligence of her approach and the thoroughness of her knowledge of the field, then also for the awareness of the dangers and excesses of an unchecked claim to "know" the Holocaust by amassing individual stories. But what does her position for keeping emotion and testimony out of history say for feminism? The call for papers for this journal proposed that "feminism was born of acts of witness." If so, the "other" child born of acts of witness—feminism's sibling, so to speak—might be the kind of testimonial-based history that Wieviorka portrays in her book. Both feminism and the "era of the witness" share an attention to how emotion and individual stories recast traditional models of understanding. Yet it's difficult to categorize Wieviorka's position as antifeminist. She concentrates on the testimonies of two *women* as fundamental to the central moments in major Holocaust trials: that of Ada Lichtman in the Eichmann trial and that of Esther Fogiel in the trial of Maurice Papon. She considers Fogiel, a woman who spoke in a "little girl's voice" and told stories of being raped, isolated, and forced into harsh labor by a foster family with whom her parents left her, to provide the most gripping testimony in the Papon trial, capturing sentiments, if extreme, of many children who grew up during the war years (145). These women emerge as the source of powerful, compelling voices to which Wieviorka devotes considerable attention. Thus while Wieviorka may consider their testimony to have distorted the course of the writing of history, she feels a need to listen to, and *retell*, their stories. She may be more compelled by and pulled into the stories of these women than she cares to acknowledge, reproducing them at the heart of her book.

In the end, Wieviorka finds the profession of history to be at a crisis. "The repercussions of an event inform us about the power of an event but do not account for what the event was" (149). Here, she establishes a dichotomy between an event and its aftermath. Despite her vast knowledge of the field, Wieviorka seems to have missed one of the central insights from trauma studies. Her idea of history posits a straightforward temporal structure. But, as Cathy Caruth has written, trauma refuses historical boundaries. Characterized by its temporal *delay*—by the belated return of the event that could not be known or possessed and that, instead, possesses—trauma forces us to reconceive the very phenomenon of an "event" and to consider how the after-effects of a traumatic event are tied up in the very nature of that event itself. In the

words of Caruth: "For history to be a history of trauma means that it is referential precisely to the extent that it is not fully perceived as it occurs; or to put it somewhat differently, that a history can be grasped only in the very inaccessibility of its occurrence" (1995, 8). In her fight against the fracturing of her historical model, Wieviorka may have reason to critique certain misuses of testimony but may be shattered nevertheless by the voices of witnesses and the power and inaccessibility of trauma.

JUDITH GREENBERG is an adjunct professor at the Gallatin School for Individualized Study at New York University. She is the editor of *Trauma at Home: After 9/11* (University of Nebraska Press, 2003) and publishes on trauma and literature.

WORK CITED

Caruth, Cathy, ed. 1995. *Trauma: Explorations in Memory*. Baltimore: Johns Hopkins University Press.

REVIEW

SUSAN RUBIN SULEIMAN'S *CRISES OF MEMORY AND THE SECOND WORLD WAR,*
CAMBRIDGE: HARVARD UNIVERSITY PRESS, 2006

PHILIPPE CARRARD

In this book Susan Rubin Suleiman gathers and expands texts that she rehearsed in article form between 2000 and 2004, adding a theoretical introduction as well as two completely new essays. By "crisis of memory," Suleiman means a "moment of choice, and sometimes of predicament or conflict, about remembrance of the past, whether by individuals or by groups" (1). The crises that Suleiman analyzes in this study are mostly related to the memory of World War II in France and Central Europe, a memory that Suleiman regards as transcending national boundaries because of the "global nature" of the war and the "global presence" of the Holocaust (2). Chapter 1 is devoted to Sartre's writings about the period of the German Occupation in France; chapter 2, to the case of Raymond and Lucie Aubrac, a French couple who were involved in the Resistance and later published memoirs; chapter 3, to the ceremony that marked the transfer of Resistance leader Jean Moulin's remains to the Pantheon, as well as to the narrative of that ceremony in Malraux's *Antimémoires*; chapter 4, to *Hotel Terminus*, Ophuls's documentary film about the Gestapo head in Lyons, Klaus Barbie; chapter 5, to *Sunshine*, Szabo's epic movie following the destiny of a Jewish family in Hungary; chapter 6, to the different texts in which Semprun evokes his stay in the concentration camp at Buchenwald; chapter 7, to Wilkomirski's hoax, *Fragments*, and to some variants among the successive editions of Wiesel's Holocaust memoirs; chapter 8, to the experimental writings of Perec and Federman; and chapter 9, to the topics of forgiving and forgetting, as they obviously are related to memory.

Suleiman's book touches on several issues that directly concern the subject of "witnessing." With most contemporary theorists, Suleiman first underscores the necessarily constructed nature of any testimony.

[*WSQ: Women's Studies Quarterly* 36: 1 & 2 (Spring/Summer 2008)]

Witnesses, however sincere they might be, must always select among the events they have observed or experienced and then organize those events along the lines of a coherent narrative. Construction as selection, Suleiman shows, is particularly obvious in the case of the articles that Sartre published in 1944–45 about the Occupation and the liberation of France. Endorsing the myth that de Gaulle was seeking to accredit at the time, Sartre maintains that all French did in fact resist (though perhaps only in their hearts) and that the collaborators constituted little more than a social and psychological margin. In doing so, Suleiman explains, Sartre picks out some facts while excluding others: an avowed fascist such as Brasillach was not a marginal, as he had attended the same prestigious schools as Sartre himself and had become a well-known writer; collaborators such as Papon and Bousquet were able to reconcile their socioprofessional status "with a routinized collaboration that would later qualify as crimes against humanity" (29); and several collaborators acted not out of neurosis or social exclusion but for specific "ideological" motives, such as rejection of democracy and anti-Semitism (29). Similarly, Suleiman surmises that Lucie Aubrac might have "arranged" (54) some details in the narrative of her husband's imprisonment and escape because of "narrative desire," that is, to abide by the requirements of "coherence" (61). In other words, according to Suleiman, Lucie Aubrac probably assumed that recounting the events "as they actually occurred" could pose problems of credibility for the readers. She thus (consciously? unconsciously?) altered her narrative, at the risk of being taken to task by historians—as she and her husband were in scholarly studies and at a roundtable whose transcripts Suleiman analyzes at length.

While Suleiman emphasizes the constructed nature of all testimonies, she is careful to distinguish "construction" from "forgery." The accuracy of some details in Lucie Aubrac's narrative might be questioned. Aubrac, however, undoubtedly "was there," her memoirs meeting in this respect the most fundamental condition of a genuine, "authentic" testimony. Wilkomirski, by contrast, never witnessed the events that he claims he went through as a child and reports in *Fragments*. As journalists' investigations have revealed, he didn't spend the war in Poland but in Switzerland, with the family that had adopted him. Whether Wilkomirski is deluded or deliberately wrote a false memoir, therefore, does not really matter; in both cases *Fragments* is disqualified as a testimony, because its author was not where he asserts that he was. For

Suleiman, such disrespect for the basic contract between text and reader must be set apart from the inconsistencies in Aubrac's testimony, as well as from the occasional transgressions of that contract committed by writers such as Semprun and Wiesel. Semprun's testimonial works about Buchenwald thus include some "liberties" that the author has acknowledged in interviews or in the works themselves, such as the use of false names, the invention of characters, and the telescoping of two characters into one because that shortcut was "more effective than simple reality" (137). Similarly, the successive Yiddish, French, and English editions of Wiesel's Holocaust memoirs reveal discrepancies, for instance, between the different versions of the train journey that took Wiesel and his family to Auschwitz. Yet those discrepancies, according to Suleiman, do not undermine Wiesel's enterprise as a whole more than do Semprun's "liberties." Indeed, Wiesel does not make false claims, as Wilkomirski does; he merely strives for more accuracy, returning again and again to the same passage to make his account agree more closely with his experience. In this respect, Suleiman concludes, Wiesel's revisions are "emblematic" of the process of writing a memoir; they show that if the past can never be reconstructed "as it was," the way around the problem is not to give up, but to "keep writing and rewriting" (177).

Describing her approach in her introduction, Suleiman qualifies it as "textual" (9). Her goal is to elaborate a "poetics" of memory, that is, to answer the question "*How* is memory enacted or put to public use?" (8). Suleiman's interest in the formal aspects of texts is especially noticeable in her analysis of difficult works such as Perec's and Federman's. Focusing on *W, or the Memory of Childhood* and *Double or Nothing*, she scrutinizes such "textual" features as the suspension points that separate parts 1 and 2 in Perec's text (188–89), as well as the graphic layout through which Federman inscribes the "bredouillement" (stammering, sputtering) that characterizes the main character's attempt to reconstruct his identity (204–5). But Suleiman is equally attentive to the means that filmmakers employ in order to make sense of past historical events. Discussing *Hotel Terminus*, she thus explores the use of still photographs (83–84) and German music (85–86), and she devotes a whole section of her analysis to the "expressionist moments" during which Ophuls, questioning the supposed objectivity of the documentary as genre, stages himself as an inquirer (90–100). Similarly, she looks at the way *Sunshine* refers intertextually to Szabo's early work, specifically, at the way that movie lifts the "repres-

sion" of the characters' Jewishness in *Father* (122–24), making the Son-nenschein family story into that of a Jewish family in Hungary, not of any family asking, "Who are we?"

If Suleiman, as a literary critic, is attentive to the formal aspects of historical and fictional testimonies, she is also concerned with the moral implications of the features on which she focuses; her "poetics" is also an "ethics" (8). Moral concerns permeate the whole study; for instance, the passage in which she explains that Ophuls's moments of self-representation are also moments "when questions of moral judg-ment are posed in the most acute and compelling way," insofar as they pertain both to the "difficult subject of guilt and responsibility in the Holocaust" and to the "role of documentary filmmaking in representing those very questions" (100). Suleiman devotes her last chapter entirely to ethical issues. Considering the relations between forgiving and forget-ting, she argues that such measures as the successive amnesties granted to the French who collaborated with the Germans during World War II did not "close" the chapter they were intended to close, namely, the Occupa-tion (220). They caused violent protests, and a law adopted in 1964 declared some crimes "imprescriptibles" (indefeasible) because they were "against humanity" (225). The ideal, Suleiman suggests, would be "forgetting without amnesia, forgiving without effacing the debt that one owes to the dead" (232). But these are, she acknowledges, "uncom-fortable positions to struggle with for both individual and societies that have experienced . . . acts of collective violence and hatred" (232). Indeed, no response is fully "adequate" in the face of such acts, and silence is equally "unacceptable" (232).

Engaged in a rich conversation with fellow theorists (Adorno, Arendt, Cohn, Freud, Kofman, LaCapra, Laub, Mannoni, and Ricoeur), Suleiman also relies with profit on old-fashioned historical and philolog-ical scholarship. Her knowledge of the French context thus enables her to clarify several points, for instance, to identity the "Brigitte" in Malraux's *Antimémoires* as Brigitte Friang, a "Gaulliste résistante and journalist" who worked with Malraux both after the war and in 1958, when the writer became minister of culture (75). Similarly, her profi-ciency in Hungarian allows her to provide a comprehensive account of the reception of *Sunshine* in the Hungarian press, whether liberal, Jewish, or nationalist and anti-Semitic. Suleiman's theoretical arguments, more-over, however sophisticated, always develop with the utmost clarity,

and they are couched in a language that constantly remains accessible. In short, Suleiman is among those theorists who give theory a good name. *Crises of Memory and the Second World War*, therefore, can be strongly recommended to all scholars concerned with the subject of "witnessing," whatever their academic specialty and theoretical orientation might be.

PHILIPPE CARRARD is a professor emeritus of French at the University of Vermont and a visiting scholar in the Program of Comparative Literature at Dartmouth College. He is the author of *Malraux ou le récit hybride* (Lettres modernes, 1976) and *Poetics of the New History: French Historical Discourse from Braudel to Chartier* (Johns Hopkins University Press, 1995; French version, Payot, 1998) and several essays on the rhetoric of factual, nonfictional discourse. He is currently at work on a study of the memoirs written by some of the Frenchmen who volunteered to fight alongside the Germans during World War II.

REVIEW

BRETT ASHLEY KAPLAN'S *UNWANTED BEAUTY: AESTHETIC PLEASURE IN HOLOCAUST REPRESENTATION*, URBANA: UNIVERSITY OF ILLINOIS PRESS, 2007

ERIC KLIGERMAN

In her rich comparative study *Unwanted Beauty: Aesthetic Pleasure in Holocaust Representation*, Brett Ashley Kaplan probes the import of aesthetic pleasure in shifting modes of Holocaust representation ranging from French and German literature and the visual arts to architectural sites in North America and Germany. Rather than contributing to an ethical rupture, Kaplan argues, "beautiful representations can enhance Holocaust remembrance" (2). Contrary to Hal Foster's demonization of beauty, Kaplan joins other scholars who see a resurgence of aesthetic pleasure in literature and art. However, Kaplan goes one step further by reading beauty alongside Holocaust representations. *Unwanted Beauty* complements other recent works that investigate various aesthetic strategies of witnessing the Shoah in relation to questions of affect. But counter to Weissman's *Fantasies of Witnessing* and Landsberg's concept of prosthetic memory, where each scholar examines how the nonwitness desires to feel the horrors of the Holocaust, Kaplan asserts that art does not need to terrorize in order to deepen our understanding of trauma. Instead, "'illicit' aesthetic pleasure of unwanted beauty" (3) helps in the construction of Holocaust memory and "deepen[s] [the] search for Holocaust understanding" (20).

Kaplan tracks the development of aesthetic pleasure from its use as a survival tool in the literature of primary witnesses to a device that catalyzes memory of the nonwitness. Following her theoretical discussion of the beautiful and sublime, she probes in chapter 1 how aesthetic pleasure in the works of Celan and Delbo assists in their survival; chapter 2 continues with an exploration of how the transformative powers of beauty in Semprun's novels help him come to terms with his traumatic memory; chapter 3 shows how Jabès's aesthetic allusions to the Holo-

[*WSQ: Women's Studies Quarterly* 36: 1 & 2 (Spring/Summer 2008)]

caust shift the task of witnessing to the reader, who is compelled to uncover poetry's traumatic residue; chapter 4 examines the function of visual pleasure in Kiefer and Boltanski and the degrees to which they aestheticize mourning. *Unwanted Beauty* concludes with an analysis of the tensions between aesthetic pleasure and architecture as Kaplan rejects critics' tendencies to read monumental aesthetics as fascistic.

Kaplan's introduction presents the ethical implications of rendering the Holocaust into beautiful forms, and she repudiates the three interdictions against beauty most often invoked by critics: Adorno's critique that poetry after Auschwitz is barbaric, the position that the uniqueness of the Holocaust requires a new mode of representation to confront its horrors, and the assumption that beauty is indicative of a particular fascist aesthetics. While scholars such as Lyotard link the Holocaust to the crisis of representation by invoking Kant's sublime and exalting the disruption of the artwork, Kaplan denies the premise that beautiful art is a disservice to traumatic memory. Although her theoretical model would benefit from a closer analysis of what in particular constitutes beauty and sensual pleasure, her incisive, close readings of literary and visual texts help illuminate some of these distinct features of aesthetic pleasure.

Chapter 1 begins by returning to the oft-discussed polemic between Adorno's critique of poetry after Auschwitz and Celan's signature poem, "Death Fugue." But what makes this chapter so compelling are Kaplan's provocative readings of Delbo and Proust. Moving away from Freud's model of traumatic memory, Kaplan foregrounds instead the intricacies of Proust's figure of memory and its associations with sensual pleasure. The invocation of how pleasure evokes memory in *Remembrance of Things Past*—the nostalgia induced by a madeleine soaked in tea—functions as the template to how unwanted beauty influences Holocaust memory. Providing a fascinating study of memory in her reading of Delbo's discussion of "thirst" and "skin of memory" alongside Proust's depictions of voluntary and involuntary memory, Kaplan delineates the complicated interplay between aesthetic pleasure and how the past is recollected. But within the context of Holocaust memory for both the witness and nonwitness, Kaplan shows how Proust's focus on a lost past transforms into a past that ceaselessly haunts the present.

These Proustian inflections continue to unfold in Kaplan's intriguing analysis of Semprun, where Proust's poetics become integral to Semprun's survival strategies during his deportation to Buchenwald. The

traumatic event is disrupted, albeit momentarily, by pleasure invoked through his recollections of the past. Yet this moment of what Kaplan calls "imaginative escape" (76) dissipates, as the nostalgia induced through the reminiscence of the prewar era that removes Semprun from the train slips back into the horrors of deportation. While such moments of pleasure are essential for Delbo's and Semprun's survival in the camps, Kaplan shows how the tension between the sensual pleasures evocative of a Proust-like mode of recollection and the horrors of the Holocaust signifies both the potential transposition of memory from the text to the reader and the movement toward secondary acts of witnessing. The contradictions that Kaplan highlights throughout each of her chapters—pain/pleasure, forgetting/memory, and nostalgia/horror—signify the moment when the discussion of aesthetics shifts to a potential witnessing of catastrophic history. Even though she may argue that beauty becomes constitutive of "see[ing] the Nazi genocide" (147), it appears to me that the moment of witnessing has less to do with the specular and more with what Kaplan describes as the "uneasy, complicated and difficult" (168) effects induced in the reader/spectator by the irresolvable poles of the artworks.

It is in the second half of her book where the question of witnessing becomes most salient. Exploring how the work of memory is transferred to the nonwitness, chapters 3, 4, and 5 illustrate the representational shifts that unfold in secondary acts of witnessing. The following line from Jabès denotes what is at stake not only for those artists who engage with the Holocaust, but also for Holocaust scholars: "One must write from now on about this caesura, about this wound that ceaselessly reopens" (99). Despite her original critique of a crisis of representation linked to Adorno, Kaplan investigates how unwanted beauty arises in relation to a postmodern aesthetic associated with ellipses, missing words, and traces. Building from Hirsch's concept of "post-memory" (80) and van Alphen's "Holocaust-effect" (144), Kaplan reveals how the responsibility of witnessing now shifts to the reader/spectator to "find the Holocaust" (79) in the oblique representational strategies of Jabès, Kiefer, and Boltanksi. The metonymic import of Jabès's language consisting of ash and burning books is reflected visually in Kiefer and Boltanski's "allusions to loss, nostalgia, mourning or melancholia" (105). They convey traumatic loss by inserting Holocaust tropes—ash, hair, and articles of clothing—within their respective artworks.

Similar to Celan's own poetic trajectory, where "Death Fugue's" sensual images give way to his call for a "terrifying silence" in his later poetry, the movement of *Unwanted Beauty* edges toward a disruption of representation in the projects of Eisenman, Freed, and the Gerzes; aesthetic pleasure coalesces with the visceral horror of mute stone, as the relation between affect and witnessing moves away from sensual pleasure and toward the uneasiness associated with the prosthetic memory sites of museums and memorials. The abstract and nonnarrative structure of Eisenman's memorial in Berlin, which aims to produce "fear in the visitor" (159), is echoed in Freed's museum in Washington, D.C., a space composed of "beauty and danger" (163). Although Kaplan describes a "dialectic between beauty and the worst" (105), her analyses reveal that there is no resolution to the manifold binaries throughout her study. Despite her use of such therapeutic terms as "work of mourning," "coming to terms with the past," and "healing wounds" to depict the artworks throughout her project, Jabès's figure of the open wound gestures toward the very melancholia—of a past that neither can be completely witnessed nor remembered—that haunts this book and the Holocaust's aftermath. The "bittersweet melancholic energy" (20) of Celan moves to the "melancholic beauty" (55) of Semprun and the "melancholy pleasure" (104) of Kiefer and Boltanski and concludes in the cenotaphic spaces of Eisenman's and the Gerzes' countermemorials.

Although at the onset of *Unwanted Beauty* Kaplan distances herself from the sublime and its link to a crisis of representation, by the second half of her study the artworks she foregrounds have indeed succumbed to mimetic disruption. As she observes, the representation of the Shoah "occurs almost through its absence" (108). Aware that the sublime "silently haunts" her investigation (9), she concedes that the beautiful and sublime "perpetually slip into" and "blur" with one another (7–8). Recognizing that her concept of "unwanted beauty" gestures toward a "neologism that combines the two terms" (8), Kaplan points to a hybrid form of Holocaust representation in which beauty coalesces with terror and the work of mourning becomes melancholic. Unwanted beauty in "the worst" does not disperse the horror, but "allows us to fully *realize* (in the largest sense of that word) the ways in which the Holocaust lives with us, in our language, in our emotions, always there even if in trace form" (102).

Kaplan's stance that the work of memory is enriched by aesthetic

pleasure offers a fresh perspective in a field that conversely emphasizes how second-generation witnesses are drawn by the desire to feel the Holocaust's horror in order to sustain its legacy. Her astute readings of the relation between memory, mourning, and witnessing the Holocaust also provide keen insights into the intersection between trauma and the aesthetic complexities of the artwork. *Unwanted Beauty* is a significant contribution not only for scholars of the Holocaust, but also for those interested in the interplay between aesthetics, witnessing, and historical violence.

ERIC KLIGERMAN is an assistant professor of German and Slavic studies at the University of Florida. His book *Sites of the Uncanny: Paul Celan, Specularity and the Visual Arts* was published by the Walter de Gruyter Press in fall 2007.

REVIEW

DANIEL MENDELSOHN'S *THE LOST: A SEARCH FOR SIX OF SIX MILLION*, NEW YORK:
HARPERCOLLINS, 2006

MARTA BLADEK

At the center of the front cover of Daniel Mendelsohn's prizewinning memoir, *The Lost: A Search for Six of Six Million*, a space customarily reserved for the prominent display of a book's title and author, there is, instead, a blank. The dazzling whiteness of the overexposed image, whose content is impossible to make out, seeps into and blurs the edges of the surrounding sepia photographs. As a result, it is not so much the readable images as the glaring absence of the central photograph that piques our attention by its refusal to reveal that which it so conspicuously obscures.

It was such an intriguing and "irritating lacuna" (42) that led Mendelsohn to undertake and embark on a systematic and extensive search for the unknown truth about the fate of his maternal great-uncle Schmiel's family who perished in the Holocaust. Culminating in a climactic discovery about his ancestors, Mendelsohn's highly complex and intensely engaging memoir chronicles the author's worldwide quest for any information that would cast light on the lives and deaths of Schmiel Yaeger's family. A gripping and moving account of Mendelsohn's determined pursuit of his family's history, *The Lost* is also an eloquent meditation on storytelling, remembering, and bearing witness to a past that we have not experienced.

Having grown up under the spell of his maternal grandfather's stories about life in the small town of Bolechow, a home to generations of the Yaeger family, Mendelsohn had spent his youth trying to untangle and order the confounding family history that would clarify his connection to the elderly Yiddish-speaking relatives, some of whom would begin to cry every time he entered a room. Yet even after years of meticulous research, Mendelsohn, now a classicist in his forties, still confronts

[*WSQ: Women's Studies Quarterly* 36: 1 & 2 (Spring/Summer 2008)]

the tantalizing gap that had first motivated his relentless pursuit of his family's complicated past: no one knows what had happened to the family of Schmiel, the lost Yaeger brother whom the young Daniel so uncannily resembles. Just when Mendelsohn contemplates abandoning his search, "a small number of strange coincidences, odd reminders of Bolechow, or Schmiel, or [his] family's specific past" (43) make him consider "the possibility that the dead were not so much lost as waiting" (43).

Wryly observing that "the return to the ancestral shtetl was by now . . . cliché" (109), Mendelsohn self-consciously positions his project within, as Eva Hoffman terms it, "the growing genre of what might be called second-generation quests—attempts by children of immigrants or Holocaust survivors, to track down and apprehend a remote and often traumatic ancestral history" (2007). What distinguishes *The Lost* from these texts, however, is not only the generational difference—Mendelsohn belongs to the generation of grandchildren of Holocaust survivors—but also his relationship to the people whose story he sets out to reconstruct. Whereas the second-generation memoirists quest for their parents' life stories, Mendelsohn searches for the unknown truth about Schmiel Yaeger's family, distant relatives whom he has never personally known.

The extraordinary structural intricacy of *The Lost* inscribes it into the classical Greek tradition embraced by storytellers who, like Mendelsohn's beloved grandfather, resisted the obvious narrative strategy that would seamlessly progress from beginning to end. Accordingly, Mendelsohn organizes his narrative into "vast circling loops, so that each incident, each character . . . ha[s] its own mini-story, a story within a story, a narrative inside a narrative" (32). Playing on the exceptional narrative dexterity such an approach requires, Mendelsohn adds yet another layer of complexity to his text by framing each section with commentaries of individual parashot from the Book of Genesis that carefully explicate and relate key stories from the Torah to the events Mendelsohn narrates. Providing an evocative interpretative framework, these ruminative sections also map the trajectory of Mendelsohn's deepening understanding of the Hebrew religious tradition, an understanding that challenges him to readjust what he thinks he can know about his family's past. Still in other passages Mendelsohn directly reconsiders and revises the assumptions that shape his narrative strategy. In the course of the memoir, his initial preoccupation with finding out how his uncle's

family died gives way to a fervent wish to learn as much as possible about the way they had lived. It is when, inspired by his brother Matthew, the photographer who accompanies him on his travels and whose uncaptioned photographs are interspersed throughout the text, Mendelsohn replaces the question "What happened?" with "How did it happen?" that he confronts the disjunction between history and memory that has long been central to the scholarly discussion of the Holocaust.

"I'm not asking you to witness it," Mendelsohn assures Meg Grossbard, a Bolechower he meets in Sydney, when she refuses to share with him any unconfirmed information about Frydka, one of Schmiel's four daughters (193). Even when acts of witness do not accurately present historical facts, they convey the truth about how the past continues to affect survivors in the present. When, on his subsequent visit, Meg still insists that he write facts only, Mendelsohn justifies his simultaneous interest in stories that, unlike facts, cannot be proved: "[E]ven if these stories weren't true, they were interesting because of what they revealed about the people who told them. What they revealed about the people who told them, I said, was also part of the facts, the historical record" (411).

As Mendelsohn's critical reevaluation of what constitutes history, *The Lost* not only argues for the inclusion of individuals and their stories of the past, but also recognizes that transmission, the process through which past events are passed down to the present, is inseparable from history itself. Hence, for Mendelsohn, the surviving Bolechowers' life narratives from which the story of Schmiel's family gradually emerges are no less important than the historical facts they corroborate. Because of these individual testimonies Schmiel and his family are no longer "lost to narrative" (241); at the same time, however, the affective intensity of the survivors' searing memories exposes the limits of narrative reconstruction as a reparative act.

Convinced at the outset of his quest that a story, any story about the lost members of his family, "was better than the alternative, which was no narrative at all" (149), at the end of his journeys, Mendelsohn accepts that the only story he can tell is "a story about the problems of proximity and distance" (433) that confront the one who sets out to reanimate the past. Concluding that "proximity brings you closer to what happened . . . but distance is what makes possible the story of what happened" (437), Mendelsohn articulates what Marianne Hirsch and Leo Sprtzer refer to as "the aporia of Holocaust testimony—the necessity and the

impossibility of bearing witness" (forthcoming). Never completely revealed, but not lost either, like the glaringly overexposed central photograph on the cover of Mendelsohn's intricate memoir, the unknown and unknowable traumatic pasts of victims and survivors do not so much fade away as fade into others' lives and the stories they, too, eventually become.

MARTA BLADEK is a doctoral candidate in English at The Graduate Center, City University of New York. Her dissertation explores how location, memory, and narrative work together in contemporary autobiographical texts whose authors reflect on returning to places from their past.

WORKS CITED

Hirsch, Marianne, and Leo Spitzer. Forthcoming. "Holocaust Studies/Memory Studies: The Witness in the Archive." In *Mapping Memory*, edited by Susannah Radstone and Bill Schwartz. New York: Fordham University Press.

Hoffman, Eva. 2007. "Family Secrets." Review of *The Visible World*, by Mark Slouka. *New York Times Book Review*, April 29.

REVIEW

ERIC STOVER'S *THE WITNESSES: WAR CRIMES AND THE PROMISE OF JUSTICE IN THE HAGUE*, PHILADELPHIA: UNIVERSITY OF PHILADELPHIA PRESS, 2005

RICHARD MOLLICA

Eric Stover tells a good human rights story. In this book he gives us an in-depth analysis of the mission and functioning of the International Criminal Tribunal for the Prosecution of Persons Responsible for Serious Violations of International Humanitarian Law Committed in the Territory of Former Yugoslavia (ICTY). This court is one of the great new modern experiments in bringing war criminals to justice. By the end of its term it will have brought approximately one hundred cases to trial at a total cost of 1.5 billion dollars. As Eric Stover states, "Little, if anything, is known about the experiences of victims and witnesses who have testified before international war tribunals." So he has chosen and interviewed eighty-seven witnesses who had testified at the ICTY to help us understand the experience, thoughts, and feelings of witnesses as they passed through the judicial process.

In his introduction he states three objectives for his research and book (1) to probe the "meaning" the witnesses of war crimes derive from testifying before an international tribunal; (2) to provide judges, lawyers, and other staff members at the Hague tribunal with insights into the process of "bearing witness before a tribunal"; and (3) to shift the debate away from the theoretical benefits of ICTY-style justice to the real-life benefits of justice as experienced directly by witnesses after their testimony at The Hague.

Eric Stover's narrative evidence provides a very damning account of the way witnesses were treated every step of the way, from pretrial preparation; to testimony and support during the trial; to follow-up after their return home, including protection from local harassment resulting from their testimony in The Hague. The failure of the ICTY to protect witnesses is dramatically illustrated in the case of a forty-six-year-old

[*WSQ: Women's Studies Quarterly* 36: 1 & 2 (Spring/Summer 2008)]

Croatian officer who was killed when a hand grenade exploded in a car he was repairing in his hometown. Two years earlier he had been a witness at the ICTY. The ICTY had promised him that the Croatian government would protect him; this promise was never fulfilled. The witness accounts in this book are filled with examples of insensitive treatment during the trial, feelings of abandonment once the witnesses returned home, prosecution lawyers failing to get close to or support witnesses in order to avoid the appearance of witness tampering, and an almost total lack of regard for the well-being of the witnesses once their duties were fulfilled and they left The Hague.

In spite of these perceived court failures, most of the witnesses interviewed by Stover were still adamant that all suspected war criminals in the former Yugoslavia, regardless of their ethnicity, should be arrested and tried for their alleged crimes. Witnesses in general felt that "the truth had to come out," and that a forum should exist where their suffering could be heard or acknowledged. Some witnesses felt that trials provided the benefit of removing war criminals from their communities; many believed that convictions and arrests had the potential of deterring criminals from continuing their illegal actions. Some witnesses also hoped that the trials would educate the following generation about the rules of law and prevent further human rights violations and atrocities.

The Witnesses reveals the enormous gap between the expectations and experiences of witnesses in regard to the concept of justice, and the understandings of those in The Hague legally seeking the pursuit of justice. How can this divide between the two sides be adequately explained? Is it primarily the result of a young and naive international justice system stumbling along on best intentions, making many mistakes with witnesses along the way? Certainly, it is inconceivable that a legal system that will spend $1.5 billion on a hundred cases—or approximately 15 million dollars a case—does not have enough resources to adequately address the witness issues raised in this book.

Eric Stover missed the opportunity to conduct a scientific study of the concept of justice within the witness community, and the relationship of this concept to the witness experience, including the related attitudes and behaviors of the legal professionals, and the proceedings at The Hague. The research approach (including the hypotheses or important issues to be studied) and the quality of interview questions (including the accuracy of the translation of his survey instrument and the adherence to

standard research protocol in conducting witness interviews) are nowhere addressed. From the published book, it cannot be known whether Stover believed that he was conducting oral histories or collecting data using a semistructured interview schedule. This failure to ask critical questions as well as give an assessment of the accuracy of interview responses limits the generalizability of his findings. The reported research of witness reactions and beliefs is anecdotal and seems to follow a journalistic model of data collection. In addition, only one side of the witness-prosecutor relationship is recorded. It would have been fascinating to survey the experience of defendant witnesses and their lawyers. There is an implicit assumption in Stover's model that the court should only focus on the well-being of "victim" witnesses.

These methodological issues have important consequences for readers of Stover's book. From a scientific perspective, the readers have no idea how the survey sample was selected; basic demographic information, including ethnicity, gender, age, level of education, and levels and types of trauma, are not presented. Certainly, the sexual violation of women of all ages in the former Yugoslavia, the killing of children, and the disappearance of family members create such deep and long-term suffering that these witnesses may not have been able to benefit from the ICTY experience. The degree of religiosity as well as the extent of social disadvantage (lack of shelter, income, and family reunification) was hinted at as playing an important role in witness disappointment with the judicial process. But readers lack information about other crucial questions. Were any of the witnesses physically or mentally damaged by their human rights violations? Are any witnesses currently suffering from posttraumatic stress disorder, depression, and other trauma-related health problems or disabilities? An analysis of all these factors would have important implications for Stover's findings and recommendations.

A scientific framework for witness evaluation pre- and post-ICTY testimony would also have allowed for a more sophisticated assessment of the importance of the trauma story within the legal and the healing experience (Mollica 2006). The trauma story has a number of elements, and if only the "facts" of the story are solicited—usually generating high emotions in the witness—the negative impact on the well-being of the storyteller can be severe. Stover actually arrives at this reality by recognizing that the witnesses were frustrated with the "facts only" approach. Prosecutors and the legal system must accept that their soliciting of

"toxic" trauma stories can psychologically damage witnesses. As a result, all witnesses in cases of extreme violence must be assigned to a counselor before, during, and after a trial. Stover's suggestion that the ICTY does not have enough money to do this is not acceptable as far as witness safety is concerned.

As Stover suggests in this book, testifying in a trial of an alleged war criminal is not the same things as achieving justice and social healing and may have no relationship at all to personal healing. The ICTY trial and its important results are together only one component of a nexus of recovery for the witness that requires additional elements that address the social and psychological needs of those damaged by extreme violence. The ultimate question is, Who is accountable for achieving this therapeutic agenda?

RICHARD F. MOLLICA, MD, is director of the Harvard Program in Refugee Trauma and professor of psychiatry at Harvard Medical School. Over the past twenty-five years, Dr. Mollica has helped pioneer advances in the health and mental health care of survivors of mass violence and torture worldwide.

WORK CITED

Mollica, Richard F. 2006. *Healing Invisible Wounds: Paths to Hope and Recovery in a Violent World.* New York: Harcourt Press.

REVIEW

SUSAN GUBAR'S *ROOMS OF OUR OWN*, UNIVERSITY OF ILLINOIS PRESS, 2006

AMY HUNGERFORD

If there is a young scholar, somewhere, who does not know Susan Gubar's work, or the history of feminist thought, *Rooms of Our Own* would make an excellent gift. Indeed, the book itself reads as a kind of gift: a gift to feminist scholars, to university communities, and to the reader rooted among either of these. Which is to say, this book is a gift to the people and institutions its author has lived among with such brilliance and wit for the past four decades as one of our most influential feminist literary critics.

Those three words—"feminist," "literary," "critic"—are as reductive as they are appropriate when applied to Susan Gubar, and *Rooms of Our Own* demonstrates, and also reflects upon, why this is so. Susan Gubar is a scholar of astonishing range. She has been a fearless voice in the evolution of feminism—a founder of "second-wave" feminist criticism—and yet, today, a provocateur who is leading the way into what she has called the "fourth stage," calling feminism to account for its divisions, conflicts, and sometimes alienating rhetoric. Two of her more recent books, *Racechanges: White Skin, Black Face* and *Critical Condition: Feminism at the Turn of the Century*, took up race and gender in a way that sought to reconcile emerging theories in these areas with the work that had already been done in feminist literary studies. *Rooms of Our Own* continues that effort in a different register.

As the title announces, Gubar has crafted a meditation on the situation of the woman scholar today using the model of Virginia Woolf's famous essay. This is not a passing allusion, but an engagement with Woolf's work in the truest sense. The book is a fictional first-person narrative, spoken in the voice of "Mary Beton," a scholar of literature working at a state university in the middle of the United States. (While many of the details about Mary Beton match up with the biography of

[*WSQ: Women's Studies Quarterly* 36: 1 & 2 (Spring/Summer 2008)]

Susan Gubar—a fact that Gubar wryly acknowledges—there are also
departures from that biography.) The chapters each center on an event
or day in Mary's life over the course of an academic year and take up
accompanying questions facing feminist work. Chapters revolve around
the sex/gender distinction, the role of "theory" in feminism's evolution,
the jostling between race and gender as intellectual (and material, and
political) concerns, the implications of a global point of view for femi-
nism, the stakes of institutionalizing women's studies, and the status of
family and reproduction in relation to all these concerns.

Mary Beton's interior monologues on these subjects have the dis-
tinctly interruptive quality of Woolf's prose and, like Woolf's prose,
interweave the abstract and the material in strands both gorgeous and
funny. Gubar uses Woolf's sentence form (the form Woolf had to invent
for herself in the absence of a women's tradition) to reflect the interrup-
tive challenges that contemporary life poses for the woman scholar who
has plenty of rooms to call her own. We see the stacks of grading from
ever-larger classes; we see the tenured boor, hater of feminism, harassing
graduate students during oral exams; we see the dog Mary takes care of
for a friend. And there is young Chloe, a friend of Mary's students, who
disappears, and is presumed dead, perhaps murdered by her abusive
boyfriend. As Mary moves through these experiences they call to mind
for her the questions that have defined feminism over the course of her
career and that, she worries, may threaten its future.

Mary Beton's voice waxes, by turns, grumpy or naive or profound
but it is always grounded in the moment. Perusing the Harlem Renais-
sance shelf in her friend Melissa's carrel she reflects on the intellectual
tradition it represents and simultaneously tries to remember the meaning
of instant-messaging abbreviations she and Melissa had learned from
their students: "But why, I could not help asking, as I ran my eyes over
the spines of these books, why were they, with very few exceptions,
composed by race men? . . . What were women of color doing to pro-
mote feminist issues among the Talented Tenth (did 'ww' denote 'where
are the women?' or 'what's wrong')?" (91). Her question walks through
to another after a page spent citing the historical case: "How could I fret
that there had been no female Booker T. Washington or W.E.B. DuBois,
given the Hottentot Venus and Tospy, *Gone with the Wind* and Aunt
Jemima, Sapphire and *Birth of a Nation*, *Imitation of Life* and *Blonde Venus?*
Better to have been imaginatively insignificant than the grotesque com-

posite that emerges of the maligned black woman" (92). She struggles, too, in the chapter titled "'Theory' Trouble," with what "feminists could possibly find useful in Professor de M.'s argument that women are only a figure of speech," and, moreover, how to understand what Professor de M. meant in the first place when his prose was "stymied by hideously abstract postulates going round and around . . . like agitated gerbils scrambling on an exercise wheel" (47). And she wonders how, after a semester of reading "the greatest books by the most renowned authors"—of both genders—"there seemed to be no common, coherent sentences ready for [her students'] use. Female as well as male student writers appeared to view the architectonics of language from the impassive vantage of a remote, soggy field" (113). As these examples suggest, Gubar is not so much presenting an argument as modeling the thinking that someone coming as a student to feminism, or reflecting on its past, might undertake.

Gubar's revision of Woolf is evident in the last example as it is throughout the book, but the most significant revision is flagged by Gubar's title, which reflects the plural worlds and communal goals of feminism after the end of Woolf's century. Gubar attempts to haul the "larger picture" of feminist inquiry into the light, to "map the contours of its shapes in a manner that rises above the fray of pitting this approach against that one" (217). I think she succeeds in doing so in this experimental book, which repays close reading the way poems do, so condensed is it with allusion and internal cross-reference. As the conclusion suggests (a few pages at the end where Gubar speaks "if not exactly in [her] own voice then certainly not in Mary Beton's" [217]), she is borrowing not just from Woolf but from the contemporary genres of narrative and autobiographical criticism. She is doing a scholarly service for students (both by delighting them as they see that larger picture and by providing a fine annotated list of readings in the notes) but is also using this genre in an attempt to shake the questions of feminism free of their existing formulations. "Perhaps," she writes, "narrative criticism arises . . . to bridge a widening gap between intellectual matters that might sound arcane . . . but that profoundly impinges on the everyday lives of ordinary people" (218).

And so this book is, appropriately, given the concerns of the present issue of *WSQ*, a mode of witness to the history of feminism in the academy. Through Mary Beton, Gubar not only distills the complexities of

feminism's pressing questions but also imagines how those questions bear on the daily rounds of a woman making her way as a scholar at a public university. Like all compelling witness, of the fictional or the autobiographical kind, it offers telling detail, a distinct voice, reflective and performative responses to the thing witnessed, a figure with whom a reader can identify or against whom she can push. Gubar's ear for poetry, her love of the well-tuned literary instrument, her faith in creative acts of all sorts (writing, singing, dressing, cooking, child rearing, thinking) meets her conviction that creative acts can both analyze and transform the realities they witness. Her most recent book, *Poetry After Auschwitz*, demonstrates these assumptions in another realm (it is one of the very few major books on how poetry as a genre responds to genocide). *Rooms of Our Own* does so in a less catastrophic key.

One of the most moving lines in the book, for this reader, is Mary Beton's late reflection, as she stands at a party among her women friends, colleagues, and students, celebrating her (single, older) friend's adoption of a baby girl from China. She feels "more firmly attached to all of them than colleagues ordinarily are—not in a personal sense, but in a more capacious, more porous and disinterested way," and she wonders, "Do we have the same pairs of eyes, only different spectacles, for I never stop thinking of them, what they might perceive differently through their lenses and how that might color the picture, or sharpen the focus, or change the frame of my own views" (213). I found this moving, despite the familiar visual metaphor, for its affirmation of intellectual flexibility but even more for that unequivocal cry, "I never stop thinking of them." This strikes me as a moment when Mary Beton's voice gives way to Gubar's, for surely Susan Gubar is the one who never stops thinking, and never stops thinking of those around her, near and far, intimate friends and women she hardly knows, fellow travelers to whom she wants to respond with encouragement or incisive question, usually both. As the eyes, and voice, of witness to the past half century of feminism, the fictional Mary Beton serves us with grace. Susan Gubar has brought to that task something much more—all of herself—and that is what I hear in this prose.

Pleasure reading for those who know or have helped to make the history Mary Beton reflects upon, a happy introduction to feminism for graduate or advanced undergraduate students, *Rooms of Our Own* seems, finally, to be a love letter to the women in Gubar's life: her mother; her

daughters; her godchildren; her friends; her students; and, of course, the muse whose sentences rise so beautifully to Gubar's hand, Virginia Woolf. It is this suffusion of the prose with warmth and light—and crankiness and wit and erudition and edge, too—that makes *Rooms of Our Own* a particular delight.

AMY HUNGERFORD is a professor of English at Yale University. Author of *The Holocaust of Texts: Genocide, Literature, and Personification* (Chicago, 2003) and, more recently, essays on Don DeLillo's Catholicism and Allen Ginsberg's use of chant. She now is completing a book titled *Postmodern Belief: American Literature and Religion Since 1960* (forthcoming from Princeton).

REVIEW

TRANSGENDER RIGHTS, EDITED BY PAISLEY CURRAH, RICHARD M. JUANG, AND SHANNON PRICE MINTER, MINNEAPOLIS: UNIVERSITY OF MINNESOTA PRESS, 2006

JULIA SERANO'S *WHIPPING GIRL: A TRANSSEXUAL WOMAN ON SEXISM AND THE SCAPEGOATING OF FEMININITY*, EMERYVILLE, CALIF.: SEAL PRESS, 2007

ANGELA P. HARRIS

What is the relationship between the transgender movement and the feminist movement: are they allies, rivals, opponents, or a complex mix of all three? The two books under review offer some answers to this question.

Transgender Rights (hereafter *TR*) is a magisterial collection of essays covering cutting-edge legal developments, movement histories, and political theory, written by some of the most celebrated names in both trans activism and scholarship. In addition to the three editors—all national figures in the transgender movement—contributors include some of the leading lights in gay and lesbian legal scholarship, such as Kendall Thomas and Ruthann Robson. The collection even includes an essay by Judith Butler, whose pioneering work using the practices of drag to understand gendering makes her both celebrated and controversial. The essays are all relatively short and accessible to a wide audience, yet they are also uniformly theoretically challenging and conceptually rich, suggesting heroic labor on the part of the editors. This is an indispensable collection.

Whipping Girl (hereafter *WG*) is a collection of personal narratives, political polemics, academic exegeses, and media critiques, thrown at you at top speed with dark wit and a dizzying number of neologisms. Unlike *TR*, which mostly speaks in the dispassionate third person, *WG* takes the passionate, sardonic voice of a pissed-off trans woman who doesn't intend to take it anymore. Like *TR*, however, *WG* moves with facility across a wide terrain, addressing academics, nonacademics, trans people and nontrans people (or "cissexuals" as Serano names people

[*WSQ: Women's Studies Quarterly* 36: 1 & 2 (Spring/Summer 2008)]

whose subconscious sex has always been identical with their ascribed sex). One moment, Serano is speculating about the biological origins of gender dysphoria; the next she is penning a furious diatribe against all those creepy straight men who want to tell her how turned on they are by the idea of a "she-male." *TR* engages with a number of identity movements, including the disability rights movement, the intersex movement, and the gay and lesbian movement. *WG* also interrogates the gay and lesbian movement, but is particularly concerned with feminism.

These books revealed for me three issues common to feminist and trans agendas: identity politics, the relationship between "nature" and "culture," and the value of the feminine. Regarding identity politics, the essays in *TR* make clear that at least some trans scholars and activists have internalized the lesson that many feminists had to learn the hard way: race, class, sexuality, and gender are not severable. Trans activists and scholars come by antiessentialism honestly. As nearly every book on trans identity begins by acknowledging, the term is an umbrella that attempts to shelter very different kinds of folks. Proliferating terms vividly illustrate the diversity: transvestite, cross-dresser, trannie, trans, genderfuck, genderqueer, FMT, MtM, trans men, boyz, bois, bigendered, third sex, nellie, queer, eonist, invert, androgyne, butch, femme, she-male, he-she, boy-dyke, girlfag are all identities that have been claimed by (and sometimes inscribed upon) people who in some way violate the rigid gender-norm system enforced by United States heteropatriarchy. The trans movement has lacked a stable and homogenous subject position from the get-go, and so by necessity has avoided some (not all) of the painful internal "authenticity" purges that African American, lesbian, and other communities have endured.

As the trans movement has learned from feminism's failures, so feminism can learn from the trans movement's successes. Both *TR* and *WG* show how it is possible to acknowledge the heterogeneity of identity while still challenging subordination in politically potent ways. The co-constitutive nature of subordination means that the most far-reaching political work in an identity movement is not done on behalf of the "but-for" people—the people who "but for" a single stigma would be able to realize the American Dream—but on behalf of the queerest, those who live furthest from the norm. Accordingly, Dean Spade places trans issues in the context of the contradictions of capitalism and the legacy of white supremacy. Spade argues that the trans fight must be not

for "non-discrimination"—which would leave race and class privilege intact—but for "gender self-determination," which necessitates, among other things, giving individuals the right to hormone and surgical therapies on demand. Gender self-determination thus requires class struggle.

A second intersection between feminism and the trans movement is the relationship between "nature" and "culture." Feminists, in their effort to counter the notion that "biology is destiny" (meaning, of course, that women do not make good mathematicians, physicists, artists, or orchestra conductors), have stressed the "social construction" of gender. This move tends to make "sex" a simple biological substrate with very little content and "gender" a complex cultural superstructure that does all the work. (There are also some who have attempted to understand "sex" itself as a product of gender politics, making it socially constructed turtles all the way down.) Serano, a biologist by training, wonderfully complicates this approach. She offers what she calls an "intrinsic inclination" model of sex/gender, under which subconscious sex, gender expression, and sexual orientation are separate "inclinations" that vary independently from one another. Each of these inclinations should, in her view, moreover be understood as "intrinsic"—that is, not the product of either conscious choice or social construction but rooted deep in the body, stubbornly resistant to attempts to purge, repress, or ignore them. Serano does not, however, turn to biological reductionism: for her, each of these inclinations is itself the product of a complicated interplay of genetic, hormonal, environmental, cultural, and psychological factors. Although at the scale of the population these inclinations correspond roughly with two types of genitalia, producing evidence for the view that there are two and only two "sexes" or "genders," at the level of the individual there are endless variations (*WG*, 99–100).

This model produces an elegant and thought-provoking way to understand sex and gender: not in terms of norms and deviations, "choice" versus "immutability," or "nature" versus "nurture," but as a complex interaction producing, as Serano puts it, "naturally occurring examples of human variation" (100). In support of this model, Serano provides a nuanced account of her own transition from male to female sexed body, during which she experienced a complex give-and-take between the physical and the psychic. Serano also talks about what it feels like to have one's subconscious sex diverge from one's ascribed sex. The striking word Serano uses to describe this is "sadness": "a chronic

and persistent grief over the fact that I felt so wrong in my body" (85). Serano portrays this grief as persistent, beyond the reach of either individual or social interventions, and eased only by her hormonal transition.

Feminists ought to be invested in the issue of how sex/gender arrives upon us, especially at this moment when genetic explanations for everything pervade scientific and popular culture. Serano makes a powerful case that some feminists have imposed their own version of "biology is destiny" upon trans women (as in the notorious exclusion of trans women from the Michigan Womyn's Festival), and that this position is foolish and destructive. At the same time, Serano does not embrace the idea to which Judith Butler's work is sometimes reduced: that gender is nothing but a set of cultural norms that can be thrown off with enough political will. To Serano gender is both given and chosen, persistent and plastic. Her model has much to offer feminist theorists.

A third intersection between the trans and feminist movements is the valuation of traditional femininity. Serano argues throughout her book that both male supremacists and feminists have spent a lot of time trashing femininity, and that much of what is usually thought of as "transphobia" directed at trans women is better described as pure misogyny. Here she distinguishes trans men from trans women, arguing that trans women come in for a unique stigmatization, sexualization, and denigration that has everything to do with our culture's devaluation of the feminine. As she puts it: "The idea that masculinity is strong, tough, and natural while femininity is weak, vulnerable, and artificial continues to proliferate even among people who believe that women and men are equals" (*WG*, 5). She calls upon us to find value in the "soft" qualities traditionally associated with femininity and to support those people who express those qualities in their daily lives, no matter in what kind of body or identity they find themselves—cissexual, trans, sissy, transsexual.

The essays in *TR* do not discuss femininity as such, but Kendall Thomas's brilliant and thought-provoking closing essay does articulate in its most attractive form a vision that Serano views as deeply problematic. Thomas wonders whether "human rights" is a capacious enough term to express the goals of the trans movement, given that some trans people claim identities that are beyond gender or outside gender. If in the dominant culture traditional gender is necessary for a recognizably human identity, trans people mark (trans-gress) the boundary between the human and the nonhuman. Thomas concludes, approvingly, that "the

denizens of trans-gender publics are experimenting with a new art of the self and fashioning an insolent political aesthetics of affirmative inhuman being" (*TR*, 323).

How radical, we can imagine Serano responding; and how radically chic. Serano argues that the desire to "shatter the gender binary," though described by some as the ultimate aim of trans activism, is not, in fact, universally shared. In her view, the portrayal of people who reject gender as more trans-gressive and thus more politically progressive than other trans people gives rise to a dangerous internal contest over who's the most "gender-radical" and contributes to the denigration of people who find themselves comfortable within traditional genders.

As I read them, Thomas and the other *TR* authors do not mean to reject traditional genders by affirming support for what Thomas calls "the right to indetermination." Paisley Currah, for example, sees transgender activism as moving toward the elimination of "any legally prescribed relationship between biological sex, gender identity, and gender expression" (*TR*, 23). This is a vision of autonomy, not re-regulation: Currah hopes for a world in which we can argue about gender without putting child custody, employment, or lives at stake. Serano, however, fears the creep of a moral hierarchy in which identifying as "beyond gender" is cooler than identifying with a gender, and a traditionally feminine gender is the uncoolest identification of all.

More conversation between trans and feminist thinkers is overdue. Now and then one of my friends asks me in a whisper appropriate to respect for the passed, "So, whatever happened to feminism?" From now on I intend to recommend these books to them, and tell them, "Transgender happened. Check it out." Check it out.

ANGELA P. HARRIS is a professor at the University of California–Berkeley School of Law (Boalt Hall). She writes widely on questions of gender, race, sexuality, and class inequalities in American legal theory.

REVIEW

KAMY WICOFF'S *I DO BUT I DON'T: WHY THE WAY WE MARRY MATTERS,*
CAMBRIDGE, MASS.: DA CAPO PRESS, 2006

IRENE KACANDES

This sassy, surprising book belongs to several genres: part memoir, part
advice book, part social analysis; its author aims high and imaginatively
to accomplish several goals. As I read it, Wicoff, a professional writer
and editor currently balancing those responsibilities with the duties of
raising two young children, shares quite a bit about her own engagement
and wedding in order to help other couples have a more positive experi-
ence of legally becoming wife and husband. She argues that the way we
marry matters and aims to help individuals set the most equitable, satis-
fying tone for their future life together. Toward those dual purposes,
Wicoff dissects the contemporary pattern of middle- to upper-middle-
class American weddings and offers proposals for how certain rituals
might be modified.

The book's chapters proceed from "The Proposal" to "The Ring,"
"The Dress," "The W.C. [Wedding Consumer]," "Beauty Day," and of
course "The Wedding," recounting in a humorous, sometimes even hilar-
ious, and almost always brutally honest fashion Wicoff's own march
from happily coupled woman to fiancée to bride. In addition to detailing
the author's emotions in various situations and things she wishes she had
and had not done along the way, Wicoff often anchors the anecdotes she
has gathered from women like herself with statistics about the frighten-
ing explosion of the "one-hundred-billion-dollar-a-year" (!) wedding
industry (xvi). She also reports about the proliferation of wedding advice
books, magazines, and web sites and their lists of things to do; at wed-
dingchannel.com, there are 124 items, for instance.

In response to the knowledge Wicoff acquires through her own expe-
rience and her research, she puts forth various concrete suggestions for
how individuals might make different choices, choices that the author

[*WSQ: Women's Studies Quarterly* 36: 1 & 2 (Spring/Summer 2008)]

implies would be more feminist or, more accurately, more postfeminist. One such concrete proposal arises out of Wicoff's embarrassment and indeed frustration that, after several years of cohabiting with her partner and feeling certain about her own and his desire to spend the rest of their lives together, she finds herself waiting, craving, pining, even whining for him to propose to her. "Feminism might have taught me that as a woman I didn't need marriage," but it never taught that marriage "was mine to bestow upon a man" (19). A new procedure should exist in a postfeminist world: "when a couple is ready to get married they agree on a month during which each will propose to the other. During Proposal Month, both partners have the chance to propose and be proposed to" (56).

At this point, I am assuming that many *WSQ* readers of this review are developing concerns, perhaps protests. Two that I'm anticipating and that I have space to address involve whether *I Do but I Don't* is a feminist book and what it has to do with the topic of this special issue, *Witness*. I feel more certain about this second question, so I'll take it up first.

In my view, this book effectively and poignantly witnesses to a contemporary U.S. American woman's participation in a ritual that for various reasons—many of which Wicoff includes in her analysis—has achieved an economic and social prominence in recent years that it simply did not have in decades prior, perhaps ever. The dimensions of this prominence in financial terms and in the psyches of a large swath of my co-citizens, especially co-citizens who might consider themselves feminists or postfeminists, were mainly unknown to me. While I found the general phenomenon of how "one" marries these days and many of its individual ritualistic steps shocking and often regrettable—does the author truly believe that "bachelorette" is an important sign of progress? (265)—I feel genuinely grateful to Wicoff for making me aware of them. For one thing, she's schooled me about topics I'll need to add to my Sex, Gender, and Society course.

Let me return to what I hypothesize is the first concern of *WSQ* readers by explaining the quotation marks around "one" in the previous paragraph. Having been made aware of *I Do but I Don't* by the *WSQ* staff, I had assumed that it was a feminist book. As I began to read, though, I became more and more agitated by generalization after generalization about how "one" marries today, since the forms of the rituals being described, as well as the very ability to marry legally, are not available to many and large groups of individuals in our society. While

the topic of gay marriage does eventually come up (272–73), and there are occasional admissions about the impingement of class on consumption, accompanied by explanations of how people with more restricted financial resources accommodate themselves to ring or dress buying, the assumptions sometimes made by the author about how "non" or "modified" participants feel while engaging and marrying—or not—often left me uncomfortable and not at all certain that the descriptions offered were accurate. Is being asked to show off one's ring finger when announcing one is engaged really a part of every engaged woman's experience today? And are certain individuals truly left feeling unvalued when the finger is unadorned or the ring there displayed is inexpensive (73)? Do we have enough? any? data about the engagement rituals of gay people marrying or entering into civil unions to know how they may differ? I'll be the first to announce myself ignorant of the answers to these questions, since I haven't been privy to an engagement or a ring thrusting in such a long time that I can't even remember when the last instance might have been. What I'll also announce is that I regret the absence of an explicit explanation of the limitations on the group to which the experiences described in this book might apply. Being aware of one's subject position, its privileges, and its disadvantages has always been an important part of feminist identity and behavior for me. While I have no reasons to doubt what Wicoff says about her own emotions—to the contrary, I have already saluted in all sincerity what I perceive as her honesty about what she was feeling—I'll also admit to becoming depressed by the idea that someone who grew up with many privileges that previous generations (and some contemporary groups) of American girls simply did not have—such as a mother who was college educated, Title IX, and safe birth control, to name just a few—was so incapable of curbing her need to conform, to compete with other women, to doubt her decisions about her earlier sexual life, to worry about the name she would use as a married woman, and to put so much energy and money into creating the perfect wedding.

Although Wicoff might not have been able to stifle such feelings while she was engaged, she was aware of her bridal role-playing, and she was often uncomfortable about it—that's her "I do but I don't." In fact, Wicoff felt so uncomfortable that she was driven to write this book, a book that she hoped might save some other individuals heartache, even if—this is my corrective now—her suggestions can only be taken up by

those individuals who share her privileged status.

Wicoff told me an anecdote that is not "in" the book, and yet signs of it can be seen in the book—at least in some copies of the book. Evidently Wicoff and her publisher had a tussle about the subtitle that the editor "won" for the hardback edition; it reads: *Walking down the Aisle Without Losing Your Mind*. This clearly puts *I Do but I Don't* in the "how-to" category of books that generally sell well, as it also puts the individual marrying at the center of the book's concern. Of course, the publisher's subtitle obviously fails to announce some of the other goals Wicoff had for her work and that I've tried to outline here. Wicoff didn't give up. She insisted that the subtitle be changed for the paperback edition. The press relented, and the paperback cover bears the subtitle, *Why the Way We Marry Matters*, a subtitle that to my mind expresses Wicoff's concern and desire to do something about what she experienced as an eyewitness to and a participant in twenty-first-century U.S. American marriage rituals of the prosperous. However, in a twist she could not control, the publisher evidently recycled unsold copies of the hardback by simply removing the old and adding a new cover, and thus these copies bear the new subtitle on the outside cover and the old subtitle on the first inside page. It is just such a copy of *I Do but I Don't* that I read. These traces of the struggle between an individual and the hyperconsumerist culture in which she and we are living expose a silver lining for me when I stare at the clouds in the postfeminist sky.

For a biography of IRENE KACANDES, please see the guest editor's introduction to this issue.

DESTINATIONS OF FEMINIST ART: PAST, PRESENT, AND FUTURE

SIONA WILSON

> *When women's movements challenge the forms and nature of political life, the contemporary play of powers and power relations, they are in fact working towards a modification of women's status. On the other hand, when these same movements aim simply for a change in the distribution of power, leaving intact the power structure itself, then they are subjecting themselves, deliberately or not, to a phallocratic order. This latter gesture must of course be denounced, and with determination, since it may constitute a more subtly concealed exploitation of women. Indeed, that gesture plays on a certain naiveté that suggests one need only be a woman in order to remain outside phallic powers.* —Luce Irigaray, *Speculum of the Other Woman*

Feminism's headline-grabbing conflicts with New York City's museums have usually been addressed to straightforward equal-opportunities issues. Damning statistics about the low numbers of women artists are accompanied by photo-friendly scenes of placard-waving women. This is a mission that the Guerrilla Girls art collective has combined even more effectively with the use of theatrical costume. In January 2007, wearing their signature gorilla masks to maintain anonymity, two Guerrilla Girls took the platform at the Museum of Modern Art's (MoMA's) first-ever feminist conference, "The Feminist Future: Theory and Practice in the Visual Arts." Among the list of eminent and emerging scholars and artists present were Marina Abramovic, Ute Meta Bauer, Beatriz Colomina, Coco Fusco, David Joselit, Geeta Kapur, Carrie Beatty Lambert, Lucy Lippard, Richard Meyer, Helen Molesworth, Wangechi Mutu, Linda Nochlin, Griselda Pollock, Martha Rosler, Ingrid Sischy, Anne Wagner, and Catherine de Zegher. "The Feminist Future" was the first in a yearlong round of feminist-centered events in the art world. These have included panels at the College Art Association conference in New York organized by the Feminist Art

[*WSQ: Women's Studies Quarterly* 36: 1 & 2 (Spring/Summer 2008)]

Project; the establishment of a center for feminist art at the Brooklyn Museum with the permanent installation of Judy Chicago's monumental work *The Dinner Party* (1974–79); and two major exhibitions, Global Feminisms: New Directions in Contemporary Art at the Brooklyn Museum, and WACK! Art and the Feminist Revolution at the Geffen Museum of Contemporary Art in Los Angeles (with further venues to follow, including MoMA's contemporary art venue, P.S.1).[1] Perhaps as an attempt to remedy the atrocious record on women artists in New York's museums, these two major exhibitions of feminist-engaged art were women-only affairs. Following Irigaray's warning, however, we must pay careful attention to the form that feminism takes as it enters the mainstream museum world. The complicities it ends up enduring in the name of "woman" may not in fact benefit that half of the sky.

Although the statistical approach is a necessary means of pressurizing museums to improve their policy on gender equality, it is a far less adequate format for presenting the more complicated issues of sexual difference and artistic representation. Before actually viewing these two ambitious exhibitions and attending MoMA's inaugurating conference, I had hoped that the nearly four decades of feminist art, art history, and theory taken up there would assert themselves with a degree of intensity and complexity that would knock me off my feet. Alas, they did not. Perhaps this is an overly tall order, considering the framing dates for the two exhibitions and MoMA's infancy in matters feminist. To be sure, certain occlusions and limitations became visible to me immediately.

With WACK! focused on 1965–80 and Global Feminisms addressed to art by a younger generation of women born after 1960 (with works made mostly after 1990), the 1980s seem to have dropped out of the picture. That decade saw feminism embarking upon its first serious period of self-examination. The celebration of universal sisterhood was complicated by differences, of power, geopolitics, sexuality, and so on, and psychoanalytic approaches such as Irigaray's asked difficult questions about the unconscious as well as women's complicity with masculinist structures of power. Although the MoMA conference included some excellent papers, it unfortunately ended up repeating some of the worst errors of feminism's past. A few speakers, Griselda Pollock, for example, attempted to remedy this. Pollock frequently stepped up to the microphone to redirect the proceedings, first stemming the rising tide of

anti-intellectualism—after audience members and speakers began to blindly condemn "theory," then offering valuable correctives to blatant ethnocentrism. Nevertheless, barefaced displays of sanctioned ignorance were on offer from speakers and audience responders alike. And it was disheartening to hear women of the global South continually cast in the monolithic role of "pre-civilized" victimage and to see the very few women of color present on the podium being asked to "explain" whole cultures in a sound bite.[2] This demonstrated that the inclusive ambition of Global Feminisms is certainly needed, but also that merely putting "difference" on a podium is not enough. WACK! too, ought to offer some solid foundations for a renewed critical engagement with feminism's past.

WACK! includes an enormous range of practices from the traditional fine arts, painting, sculpture, printmaking, and photography, to the non-traditional art forms, performance, installation art, and the massive area of experimental filmmaking. This last body of work is particularly interesting and is frequently ignored by art historians, but the exhibition's curator, Connie Butler, has drawn together many important works, including films that are rarely screened. For example, the Berwick Street Film Collective's experimental documentary *Night Cleaners* (1975) about the unionization campaign of women night cleaning workers in London is given a deservedly central place. Meanwhile, alongside expected works by widely known feminist figures such as Judy Chicago, Mary Kelly, Faith Ringgold, Martha Rosler, Marina Abramovic, and Louise Bourgeois are works by artists that are rarely if ever presented in museums in the United States. Examples include Rose English's peculiar, erotic, chorus girl–style group performances for English country fairs, Sanja Ivekovic's haunting photoconceptual works, and the exuberant consciousness-raising-inspired approach of the first Native American feminist theater group, Spiderwoman Theater.

The layout of WACK! doesn't make it easy to navigate, but as Carol Armstrong argues in her passionately enthusiastic review, its nonchronological and nonthematic arrangement captures something of the lived intensity of the period, "the thrilling (and exasperating) chaos of the moment, the all-over-the-place free-for-all that was those two decades" (Armstrong 2007, 362). Nevertheless, the antiteleological impulse also means that certain important and interesting historical conjunctions remain hidden. WACK!'s spirited mélange obscures the ways in which artists participated in generating new ethical, philosophical, and

political models through meaningful conflict, intellectual debate, and provocation, not to mention irreconcilable differences. For example, the first part of Mary Kelly's major installation *Post-partum Document* (1973–79) was exhibited at the Institute of Contemporary Art in London in 1976. This was the month before Cosey Fanni Tutti's participation in the Prostitution exhibition at the same cutting-edge London venue. (That Tutti's work was part of a mixed-gender collective called COUM Transmissions was unfortunately not foregrounded in WACK!). Kelly's work is an austere and theoretically sophisticated retreat from the iconic representation of the female body, while Tutti's speaks in the language of pornography with the artist center stage as porn model. Both works provoked a media furor. But their difference in approach indicates wildly diverse responses to the feminist debate about the representation of the female body and sexuality (in London alone, not to mention elsewhere), as well as feminism's relation to and distance from mass culture. Why Faith Ringgold's important early paintings that forge a relationship between feminism and civil rights in the United States were considered a better room companion for Tutti remains a puzzle. And what, I wondered, would an exhibition of this scope and ambition look like if the feminist revolution was not simply conceptualized as a matter for women?

Visiting Global Feminisms after viewing WACK! is bound to produce some initial disappointment. The two exhibitions are addressed to such different questions that a straightforward comparison is simply not fair. Indeed, there is a very real difficulty in being a daughter of "art and the feminist revolution" *without the revolution*. This troubling dilemma is addressed directly by Carey Young's video *I Am a Revolutionary*. A young, slight, English-accented white woman in a masculine business suit stands awkwardly in a sparse office space intoning the phrase "I am a revolutionary." She is accompanied by a middle-aged businessman who plays the part of a voice coach, training her to make this unlikely declaration. With each reiteration she is more and more unconvincing. These artists clearly do not feel they are living a "feminist revolution" like their predecessors in WACK! and as a result the works are much more circumspect. *I Am a Revolutionary* speaks most directly to this very real problem and to the difficult task faced by today's feminist-engaged artists.

The inclusive focus of Global Feminisms—with artists from all the inhabited continents of the world—does indeed seem both necessary and

welcome. But despite the aspiration to be global, the desire "to include all voices," as one of the curators put it, felt rather like a straightforward application of the Guerrilla Girls' statistical approach (Nochlin and Reilly 2007, 38). The curators, Linda Nochlin and Maura Reilly, argued that an aim of the exhibition was to incorporate the insights of the 1980s, when issues of race, class, gender, and sex had become central to feminism and were no longer marginal extras. Although this was an excellent ambition, Global Feminisms had something of a check-the-box bureaucratic feel compared with the vigor of WACK! As a result, the kinds of tensions and conflicts produced by the important critiques of the 1980s were paradoxically not evident. Instead, this version of globality tended toward the United Nations–style celebratory feel that the curators had hoped to avoid.

Perhaps a less-is-more approach may have produced a more effective exploration of the different "localized feminisms" that Nochlin and Reilly sought to present. At times, these intersections come across as banal thematic analogies with unfortunate trivializing effects. Nevertheless, the rather anodyne category "life cycles" includes two of the most provocative and interesting works in the exhibition. One example is the fifty-seven-minute DVD Fountain (2000), by Turkish artist Canan Senol. Displayed small scale on a monitor, the image is not immediately perceptible; a few moments elapse to allow it to cohere before the impact of its sparse corporeal minimalism takes effect. The fountain in question is the slow, amplified drip of a woman's lactating breasts. Senol's low-resolution, antispectacular image is all the more unrecognizable because it is set against a plain black background without a contextualizing body (of mother or child). This effect of defamiliarization erases all the erotic and sentimental allusions that are usually associated with the representation of this female body part. Instead, in Senol's video the breast is a part-object, operating within a temporal economy of production, excess, and waste. In contrast to this powerful work, Hiroko Okada's Future Plan #2 (2003), showing an overblown, crudely Photoshop-manipulated image of grinning pregnant men, just seems a flippant and very dated joke. Catherine Opie's Self-Portrait/Nursing (2004) is the proper iconic counterbalance to Senol's breast machine. Opie's is a powerful evocation of the roots of Western maternal sentimentality in the Christian imagery of Madonna and child. But the nursing infant at her breast is a little too old and the mother is much too

queer for the traditional maternal pose she strikes. The word "pervert" has been scratched directly into the flesh of her chest in large gothic letters. This work, by a widely known American photographer, is relativized by Global Feminisms and staged as locally specific to its U.S. context. As a result, Opie stands as a fitting daughter of "art and the feminist revolution," if this "revolution" can be reframed in light of its own inevitable parochialism.

Finally, it needs to be noted that Global Feminisms was organized to accompany the permanent display of Judy Chicago's *The Dinner Party* (1974–79) in the Elizabeth A. Sackler Center for Feminist Art. The exhibition serves as an appropriate framing device for this monumental work from feminism's past. While Chicago's installation is an important landmark from the 1970s, its presentation alongside Global Feminisms provokes some necessary critical reflection.

The Dinner Party is a large sculptural installation presented as an imaginary transhistorical dinner party for thirty-six named women. A three-sided table is laid with individual handcrafted and uniquely designed place settings for mythological and historical female figures (with the names of 999 further women inscribed in the floor). The sides of the table follow a chronological sequence: (1) "from prehistory to classical Rome," (2) "from the beginning of Christianity to the Reformation," and (3) "from the American revolution to the women's revolution." Thus *The Dinner Party* gives us the female version of the traditional Euro-U.S. model of teleological historical progress. This is American feminism as manifest destiny.

Chicago's installation certainly deserves to be on permanent display in a major U.S. museum. But as I have suggested, some of the political implications of this work require careful scrutiny. The decision to frame *The Dinner Party* with Global Feminisms perhaps unwittingly draws attention to the more unsettling ethnocentrism of Chicago's undertaking. Nevertheless, its position in the Elizabeth A. Sackler Center for Feminist Art—the first such institution in the country—rightfully acknowledges the significance of Chicago's achievement and the historical importance of this ambitious project.

WACK! can only effect a renewed interest in the feminist transformation of art making in the 1970s and its ongoing reverberations for artists of both sexes. Global Feminisms promises that there is much more to say about the ways in which contemporary artists have addressed this

legacy transnationally. It also demonstrates that we must learn to understand much more about global feminism. We are living in times unfriendly to feminism; reassuringly, both these exhibitions promise feminist futures to come.

SIONA WILSON is an assistant professor of art history at the College of Staten Island, City University of New York. She has recently published essays on the work of Mary Kelly, Jo Spence, and Sunil Gupta and is preparing a book manuscript on feminist art and film in 1970s Britain.

NOTES

1. For more on the Feminist Art Project, see http://feministartproject.rutgers.edu/. The other venues for WACK! are National Museum for Women in the Arts, Washington, D.C., September 21–December 16, 2007; P.S.1 Contemporary Art Center, Long Island City, New York, February–June 2008; and Vancouver Art Gallery, Vancouver, British Columbia, October 4, 2008–January 18, 2009.

2. Because of cancellations, Coco Fusco, Geeta Kapur, and Wangechi Mutu were the only women of color at the podium. After presenting a sophisticated paper, Geeta Kapur was asked by an audience member to speak about "feminist art" in general in India (an unthinkable question for a scholar of American feminist art), and the young expatriate Kenyan artist Wangechi Mutu was asked to justify her own invitation to the conference over and against other women artists of color.

WORKS CITED

Armstrong, Carol. 2007. "On WACK! Art and the Feminist Revolution and Global Feminisms." *Artforum* 45(9):360–62.

Irigaray, Luce. 1985. *Speculum of the Other Woman*. Translated by Gillian C. Gill. Ithaca: Cornell University Press.

Nochlin, Linda, and Maura Reilly. 2007. *Global Feminisms: New Directions in Contemporary Art*. New York: The Brooklyn Museum.

LAW AND THE EMOTIONS: A CONFERENCE REPORT

TUCKER CULBERTSON

What do witness and gender have to do with law and the emotions? Obvious associations include the fundamentality of witnessing in the procedures and paradigms of law; legal rules that alternately and discriminatorily banish or cherish certain witnesses' emotions as relevant legal facts; the binary gendering of raging, caring, and other emotions; laws' production and policing of gender and genders; and the opposed gendering of law and emotion as such.

However, there is a more fundamental and formal operation performed by witness, gender, law, and emotion: individually and in concert, these terms signify practices under, through, and against which humans' encounters with our world of appearances may be ordered, in any or all the meanings of that word. At a minimum, "order" is to command, categorize, or rank; and is a state of peace or community of faith.

Sexual harassment law in the United States reveals the work of witness, gender, law, and emotion in ordering our experiences of appearances. The movement to establish sexual harassment law was crucial in making women's labor livable. It forced judicial recognition of sexual coercion, degradation, and hazing as employment discrimination. This movement facilitated redress for individual women and acculturated various publics to a particular feminist account of gender, sexuality, and inequality. These endeavors depended entirely upon bearings of witness, on testimonies of feeling by women who were often left or kept literally silent about gendered and sexualizing exploitation, humiliation, and violence that was previously deemed legally unspeakable and socially invisible in hegemonies of heteropatriarchy and hierarchical capitalism.

However, the mere admission of women's witnessing could not secure individual, let alone systemic, redress. Such witnesses had to be judged reasonable. Courts asked whether a hypothetical reasonable person would have found what these witnesses witnessed to be discriminatory. Was she right to read gendered harm into what might have been

[*WSQ: Women's Studies Quarterly* 36: 1 & 2 (Spring/Summer 2008)]

just good fun? Had her emotions got the best of her reason? Was she lying? What was she wearing? Are we sure she didn't like it? Kathryn Abrams (a coeditor of this special issue of *WSQ* and a key figure in sexual harassment jurisprudence) persuasively argued that the "reasonable person" standard was gender biased because it was gender blind. The reasonableness of subjects' feelings of discrimination depends wholly upon their sex assignment and gendered experience in our heteropatriarchal culture of sexually exploitative male domination. Hence Abrams successfully suggested that courts ask whether a "reasonable woman" would find discriminatory the scenes to which sexual harassment plaintiffs bear witness.

However, Abrams noted too that legislatures' and courts' sexual harassment regimes—taken over by commercial interests, corporate doublespeak, and cottage industries—may proliferate unnuanced or obstructionist narratives about gender, sexuality, and inequality that conscript women's understanding of their experience in scripts as essentializing and disempowering as those enacted by sexual harassers.

The trajectory of sexual harassment law suggests the vexed hermeneutical function of witness, gender, law, and emotion. Rendering sexual harassment employment discrimination was in part a struggle to force legal institutions and the culture at large to witness women's emotions. Yet legal and other institutions may exploitatively or otherwise discipline women's emotions and experience as witnesses.

A recent conference richly engaged such conjunctions of witness, gender, law, and emotion. "Law and the Emotions: New Directions in Scholarship" took place in Berkeley, California, on February 8 and 9, 2007, with participants from throughout the United States, Canada, Switzerland, Japan, and Australia. The conference was organized by Kathryn Abrams (University of California, Berkeley, law), Susan Bandes (DePaul University, law), Hila Keren (Hebrew University of Jerusalem, law), and Terry Maroney (Vanderbilt University, law) and sponsored by the Gruter Institute for Law and Behavioral Research, Boalt Hall School of Law (University of California, Berkeley), the Center for the Study of Law and Society (University of California, Berkeley), Vanderbilt University Law School, and DePaul University College of Law.

"Law and the Emotions" represented diverse substantive and methodological investments from the fields of neuroscience, analytical

philosophy, film and television criticism, political theory, public law, evolutionary biology, sociology, and psychology. Such disciplinary variance led Rachel Moran (University of California, Berkeley, law) and Carol Sanger (Columbia University, law) in the opening and closing sessions to cogently question how and whether "Law and the Emotions" can and should constitute a coherent field of intellectual research or a compelling site for critical praxis. To my mind, such concerns are crucial, but they enriched and did not impair the conference, and may similarly beneficially vex and thus advance the field.

Some presenters at "Law and the Emotions" spoke directly to witness and gender, and to identity and testimony more broadly. Laurel Fletcher (University of California, Berkeley, law) offered a presentation concerning the role of states and statist legal processes in transitional justice systems, which presume that violent social crises are best redressed by criminal trials and public confessions, usually regarding violent conflict between ethnic, religious, or national classes. Such systems, Fletcher argued, tend to stifle local voices even as they presume that revealing personal trauma is necessary and sufficient for healing. More complex, critical, and reflective consideration of identity, testimony, injury, healing, and reparation might yield more effective and less imperial approaches to "transitional" justice, which might then become instead "transformative."

Devon Carbado (University of California, Los Angeles, law) discussed the complex and not always apparently discriminatory ways in which workers perform and have policed their racial and other identities within the workplace. Because many forms of race discrimination involve matters of dress, class, and accent, conventional definitions of discrimination can neither comprehend nor counteract the racial harms perpetrated in the scenes Carbado describes. A more explicitly emotional conception of discrimination might produce superior antidiscrimination policy, because it might better recognize and redress the emotional harm done to racialized workers who—systemically or spontaneously—may be made to feel that they are profiled, slow-tracked, or otherwise exceptionally pushed outside the fences of the chosen corporate fold.

Sharon Krause (Brown University, political science) considered the affective elements at work in the composition of democratic society. Krause focused on the importance of subjects' feelings of inclusion,

recognition, and participation. Krause argued that the "feeling of impartiality" matters for collective self-governance and filial citizenry, and as such advocated educational, electoral, legislative, and other processes in which groups, such as genders, might engage in processes, such as witnessing, in order to establish genuinely democratic orders.

Arlie Hochschild (University of California, Berkeley, sociology) delivered the conference's first keynote address, wherein she discussed two current trends in the United States: a trend of turning to markets generally to meet emotional needs and a trend toward ever larger explicitly emotional markets, including those represented by life coaches, personal assistants, dating coaches, party planners, and so on. Hochschild shared her research, conducted through interviews with primarily female witnesses, to these emotional economies, including both consumers and providers. Women, according to Hochschild, are the fulcrum of these new emotional economies. Not only gender, but also race and nationality, certainly figure powerfully in these emotional markets.

Hochschild thus asked whether, and what parts of, our lives differ from the shilling of goods and services. She noted, too, that the often-lamented detachment and dissociation of markets is precisely what is desired in emotional outsourcing. Hochschild then reminded us of Weber's contention that Protestantism—its ethic and orientation— spread well beyond the domains and doctrines of the church. So too, Hochschild argued, has Adam Smith's "invisible hand" reached outside the market to grab hold of our hearts.

Dacher Keltner (University of California, Berkeley, psychology) delivered the conference's second keynote address, drawn from his groundbreaking work on the social and relational causes and consequences of emotions. Keltner presented his research on numerous topics, including facial expressivity, the social relevance of inquiry into positive emotions such as pride and awe, and the capacity of touch to communicate and comprehend emotion. Keltner reported that among pairs of separated subjects, the emotional intention of one subject was quite often correctly interpreted by the second subject based solely upon light physical contact between the two. Consequently, Keltner's research suggests that emotionality is a more tangible physiological phenomenon than is often assumed and might be as reliable an apparatus for observation as ocular forms of witnessing. Keltner suggested too that sensory communication of emotion is gendered, reporting that men are disproportionately

unable to comprehend women's expressions of anger through touch, as are women less able to comprehend men's tactile communications of sympathy. Keltner's presentation generated productive conversations on the legal application of scientific research into the emotions, including the possible use of his research on touch in claims of sexual harassment, which hinge on the objective accuracy of plaintiffs' subjective interpretation of defendants' physical as well as verbal communications.

Several presenters sought to disrupt biological and economic oppositions between reason and emotion and proposed ways in which legal scholarship and governance might better engage with both. Oliver Goodenough (University of Vermont, law, and the Gruter Institute) engaged with the "dual processing" model of cognitive behavior, which constructs intuitive (emotional) and deliberate (rational) mental processes as independent and antonymous. Goodenough noted the ways in which emotions combine neurochemical, limbic, and cortical physiological systems and serve to direct attention, strengthen memory, promote learning, and yield cognitive diversity. In this way, Goodenough moved against oppositional cognitive models that imagine subjects as hyperrational and that are thus anatomically and jurisprudentially unreal.

Jeffrey J. Rachlinski (Cornell University, law) discussed the import of the "dual-process model" for understanding judges. Rachlinski proposed a theory of and test for judges' behaviors that imagines them as neither hyperrational nor wholly emotive. Rachlinski proposed an "intuitive-override" model of analysis, which maintained an opposition between rationality and emotionality, and suggested structured ways in which we might engage this opposition.

Regarding the work of emotions in economic behavior, Dan Kahan (Yale University, law) argued against conventional convictions that economic subjects are merely irrational when they allow emotions to outweigh classical cost-benefit analyses. Kahan shared a cultural constructivist account of emotional economics, suggesting that subjects' feelings might be normatively valued in legal evaluations of risk, reasonableness, and foresight.

Elizabeth Phelps (New York University, sociology) reviewed the mutual dependence of emotional and cognitive processing in the brain. Phelps', though, differed in important ways from the other cognitive, biological, and economic critiques of rational/emotional dualisms.

Rather than arguing that emotion aids, is as important as, or might be alternatively emphasized alongside rational faculties, Phelps suggested that the braided anatomical and chemical structures of reason and emotion urge that we perceive and practice knowledge not only of, or with, *but also through* our emotions. Phelps's project more powerfully deposed the dualism under siege by others, describing a genuinely deconstructive way of feeling/thinking that might advance our sense of social, institutional, and individual decision making.

Other presenters critiqued laws' attempts to order emotions from antifoundationalist standpoints regarding the relation between law and culture. Cheshire Calhoun (Colby College, philosophy) questioned hope, emphasizing that law's relation to hope is complex and productive in strange ways, far beyond mere enfranchisement or obstruction. Laws restricting migration or marriage, for example, may well foster hope precisely by producing exclusions that provoke desire, longing, and struggle. This observation—which in different iterations would return throughout the conference—poses a most troubling task for any critical engagement with law and the emotions. Given this productive relation between laws and emotions, how are we effectively to engage intentionally therewith? A similarly vexed question must be asked of this special issue's themes: how should we understand the role of witnessing in our interventions into gender difference and dominance, when such witness is simultaneously central to the production and policing of gender?

Hila Keren and Kathryn Abrams also asked after law and hope. They argued that hope and despair are inextricably bound, and thus law's engagement with hope need not—because it cannot—be conceived as granting subjects' hopes or as granting hope to subjects. Rather, by way of *Born into Brothels* (Zani Briski and Ross Kauffman's documentary of Briski's photography school for children of prostitutes in Sonagachi district, Calcutta) and the Head Start Program (founded by Sargent Shriver under President Lyndon B. Johnson in 1964 as a means to aid the entry of the children of disadvantaged and disenfranchised parents into public education), Keren and Abrams argued for an alchemical collaboration with subjects of hope through facilitative and solicitous practices that enfranchise subjects' acts of witness, reflection, and creation.

Elizabeth Spelman (Smith College, philosophy) queried whether and how we can ethically (as opposed to effectively) enfranchise desires

(such as hope) when desire always involves making colonial outposts of our others. Spelman focused on the church, the corporation, and the state as cultivators of colonizing desires, and she discussed the history of sumptuary law in the United States. Spelman argued that law in advanced capitalist states such as the United States is only ever a restraint upon capital in the interest of capital. As such, what may law's ends be in such contexts? Can law's imagined or imaginable moral functions do work in the midst of law's economic regime? Can we optimistically contemplate law's aiding emotion, when our laws, our emotions, and our laws' emotions are presently articulated and perhaps only articulable in substantively capitalist and structurally colonizing schemas?

Considering the conference as a whole, I would propose that the most vital questions—and perhaps conflicts—raised include: Should inquiries into law and the emotions be necessarily radical, and not merely reformist, given law's historical self-defined opposition to emotion? Or is it acceptable to integrate the study of emotions into standing bodies of law's evidentiary and institutional frameworks? Should the methodologies with which we engage "law and the emotions" be necessarily critical, given the field's immanent disruption of long-standing dogmas regarding objectivity, observation, and deduction in the production of knowledge as fact? Or may the dispassionate pretenses of analytical, positivist, and empirical methods be brought to bear on law and the emotions without untenable tension?

Although—as the conference made clear—the stark distinctions between rules/desires, reason/passion, and analysis/emotion found in certain legal mythologies, biological taxonomies, and economic fantasies are indefensible, they are not easily dispatched. In the same way that critical race feminism engages not only positive laws that disadvantage racialized gendered subjects, but, rather, also law's racial gendered forms, structures, and methods, inquiry into "law and the emotions" must involve systemic challenges to legal politics and epistemology. As Angela Harris (University of California, Berkeley, law) discussed in the conference's closing roundtable, "Law and the Emotions" is (or ought to be) inherently critical and radical, insofar as the pair of law and emotion itself has historically been a gendered opposition. This gendered opposition is always already racial as well, imagining law as a civilized manly order of rational forces, and emotion as a savage feminine disarray of passionate ephemera.

As such, it seems to me that when negotiating and intervening in orderings of our experiences of appearances—such as those deployed through witness, gender, law, and emotion—strictly reformist, integrationist, positivist, and empirical forms, structures, and methods can neither provide nor withstand the full content of their critique.

TUCKER CULBERTSON is from Gray Court, South Carolina. He is a J.D.-Ph.D. student at Boalt Hall School of Law and the Jurisprudence and Social Policy Program at the University of California, Berkeley; an adjunct professor of political science at San Francisco State University; and a Fellow at Columbia Law School's Center for the Study of Law and Culture.

ALERTS AND PROVOCATIONS
MOVING AMERICAN MORES: FROM WOMEN'S EDUCATION
TO TORTURE

JUDITH RESNIK

In the spring of 2006, I was asked to give the convocation address at Bryn Mawr College (BMC), from which I graduated in 1972. Upon accepting the honor, I did what I had been taught to do there—research.

The college provided me with the texts of more than one hundred speeches dating from 1889 when Paul Shorey, a professor of Greek and Latin, addressed the first group of twenty-four graduating students. He told them that BMC was no mere high school for girls but a potent force in the intellectual life of "America."[1] Speaking in 1919, Bryn Mawr's own president, M. Carey Thomas argued that the "inseparable corollaries" of "women's rights" were "women suffrage, equal educational opportunity and equal pay for equal work."

Not all speakers agreed. Senator George Hoar of Massachusetts advised the graduates of 1898 that "every American woman" had to understand that it was "not only her function to be the companion, helper, comfort and nurse of her husband and son and brother in misfortune and sickness and sorrow, but that it is her special function to be his stimulant to heroism and his shield against dishonor." Yet William Howard Taft, giving a commencement speech in 1910 when he was president of the United States, had a very different view. Taft told his audience that "actual experiment has shown the claim that there is any difference in favor of man in the quickness of learning, or the thoroughness of acquisition of knowledge, to be entirely unfounded. Indeed . . . the averages of women are higher than that of men." Moreover, as Virginia Woolf advised in her book, *A Room of One's Own*, President Taft stressed women's economic independence; he urged graduates to enter professions and the business world so that they could be financially independent.

Jump forward to 1979 to capture both the speed and the slowness of

[*WSQ: Women's Studies Quarterly* 36: 1 & 2 (Spring/Summer 2008)]

change. Jeannette Ridion Piccard, described on the roster of speakers as a "balloonist," titled her talk "Caution." Piccard had entered Bryn Mawr in 1914 and she reported that in 1920, when women got the vote, she expected many doors to open. But Piccard's own efforts to gain ordination as an Episcopal priest proved otherwise; she was not able to take her orders until the 1970s. Like Virginia Woolf, Piccard focused on doors, but for her, they were not a source of solace but a barrier. Piccard counseled that the only way to move forward was by "each door being cracked, forced, or unlocked and opened."

Issues of nationality, ethnicity, religion, and race enter the archive of speeches during World War II. The first speaker from abroad, coming in 1940, was the Chinese ambassador Dr. Hu Shih, who remarked on "Mr. Hitler" and his armies, as he told the students that they had to take moral responsibility for the consequences of the decisions they made.[2] In 1966, Martin Luther King Jr. joined President Robert Goheen of Princeton to speak at graduation and, in the decades thereafter, stellar women and men of all colors can be found as regulars in the ranks of invitees.

This set of historical materials provided a window both into changing attitudes and norms about women and race in the United States and into a particular literary genre—the convocation address. Such materials are in need of more scholarly attention as they are an under-mined source of women's histories. Some were wonderful to read and, as a lawyer and a person interested in, if not always loyal to, social customs, I also regarded them as precedents.

I wondered about whether—in light of the joy of the occasion—I should raise the subject of *torture*, intellectually apropos as it, like attitudes toward women, was an example of changing American mores. As justification for mentioning this awful subject when addressing a commencement audience, I could have cited previous speakers who had taken up the topics of war, terrorism, poverty, and hunger.

But that was not why I decided to talk about torture in the spring of 2006 or why I have done so on many other occasions since. Rather, I agree with the Chinese ambassador who told the BMC graduates of 1940 that we share moral responsibility for the consequences of our actions. I needed to speak of torture to impress upon those younger than I how profoundly bizarre it was and it is for torture to be an issue, let alone a practice, openly contested. Moreover, because the movement of law is transnational, and the United States is both an import and an export

nation, this shift has the potential to do grave harm beyond our shores.

Ariel Dorfman explains that the practice of torture is a crime not only against the body but also "against the imagination," for it requires dehumanizing people such that their pain is not ours (2004, 8). Torture is now tied to images of the Abu Ghraib prison, run by Americans in Iraq; to the detention facility on Guantánamo Bay, also run by Americans; and to a legal act called "extraordinary rendition," a term that is a euphemism for sending detainees to countries where they may be tortured.

In 2004, we learned that our government's lawyers had advised the Attorney General of the United States that inflicting intense physical and mental pressures was not really "torture." In memos sent in August 2002 (but not coming to public light until two years thereafter and eventually "withdrawn"), the Office of Legal Counsel within the U.S. Department of Justice offered a formal opinion that "torture is not the mere infliction of pain or suffering on another. . . . The victim must experience intense pain or suffering of the kind that is equivalent to the pain that would be associated with serious physical injury so severe that death, organ failure, or permanent damage resulting in a loss of significant body function will likely result" (Office of Legal Counsel, Memorandum for Alberto R. Gonzales, Counsel to the President 2002).

Our Justice Department lawyers further advised that, to be found guilty of torture required not that a person knew that "severe pain will result from his actions," but that a person had the "express purpose of inflicting" such severe pain and suffering (Memorandum 2002). Further, the Justice Department's memorandum argued that the president—when acting as commander in chief during a war—was not bound by various conventions to which we as a nation are a party and that the Constitution left him unconstrained by other of the country's laws.[3]

My horror about these propositions is profound. But my worry is not limited to the harms that these claims have done to persons who have fallen under the control of either Americans or others operating at their behest or with their knowledge. I am horrified by the way in which this memorandum—even though subsequently withdrawn—has had an enormous legal and conceptual impact, transforming the boundaries of permissible discourse and practice (Greenberg 2006).

A moment of personal biography is in order. I graduated from Bryn Mawr in 1972 and from New York University Law School in 1975. During my entire career as a student and then as a lawyer, I knew virtually

nothing about what is called the "law of torture." Further, up until just a few years ago, no lawyer, no law professor, and no member of the Department of Justice of whom I was aware openly proffered arguments that claims of torture were not to be considered by U.S. courts and that U.S. practices of sensory deprivation and intimidation were distinguishable from those banned by the Convention Against Torture and other Cruel, Inhuman, or Degrading Treatment or Punishment (which is one of the U.N. conventions that the United States ratified in 1988). Indeed, over the second half of the twentieth century, it has been the United States that has proudly led the way with a ban on coercive extraction of information. That is why movies and television programs all over the world show police giving "*Miranda* warnings"—named after a Supreme Court decision in the 1960s holding that detainees have rights to counsel and to be silent in order to protect them from police abuses (*Miranda v. Arizona* 1966).

Even before that decision, a federal appellate court in the mid-1950s derided the New York City police for holding a man "incommunicado" for twenty-seven hours; for "refusing to allow his lawyer, his family, and his friends to consult him"; and for questioning him continuously in a cell that made "sleep virtually impossible." Because that isolation and the psychological pressure were so abusive, the court threw out the man's confession. The decision explained that "all decent Americans soundly condemn satanic practices," which were methods used by "totalitarian regimes" (implicitly the Soviet Union) and which did not "comport with the barest minimums of civilized principles of justice" (*United States ex rel. Caminito v. Murphy* 1955).

Yet detainees at Guantánamo Bay—taken there in the wake of 9/11—have been held, in custody, incommunicado, and without access to lawyers and family, for a lot more than twenty-seven hours (Margulies 2006). Hundreds of individuals have been at that naval base for years, kept by our government, which has argued in our courts that, because these individuals are not on United States soil and are alleged not to be United States citizens, the Constitution does not regulate how Americans—how we—treat them.

In December 2003, a lawyer for the Department of Justice told a panel of three appellate judges that our government was free to imprison offshore, at Guantánamo Bay, anyone deemed appropriate and that no court had the power to oversee the detention. One of those judges posed what

sounded at the time like a "gotcha"—an irrefutable proposition posed as a question. He asked what the government's position would be, were detainees to allege that they had been tortured or that they could be "summarily execut[ed]." The judge's assumption was that the government lawyer would have to make the obvious admission that, of course, the U.S. Constitution gives such a person a right of access to court. But the Justice Department lawyer said otherwise, answering that no court could hear even claims of torture or of summary executions (*Gherebi v. Bush* 2003).

It was about a year later, in 2004, that we all learned that the rhetorical was real, that people held at Guantánamo and elsewhere in U.S. custody claim that they have been subjected to torture. Further, we can all read a set of 2002 Justice Department materials—now named the "Torture Memos." Sadly, new barriers to court have been erected. In December 2005, while condemning torture, our Congress passed legislation limiting access of aliens at Guantánamo to the U.S. courts and providing new defenses to those who are accused of torturing or imposing grave harms on individual detainees. After the Supreme Court proffered interpretations leaving a court's door open, the Congress responded in the fall of 2006 by imposing other limits on access and tried to give more immunity to alleged wrongdoers.[4] (Whether Congress can constitutionally do so is an issue pending in 2007–2008 before the Supreme Court.)[5]

The enactment of these "court-stripping" provisions made me realize that the Torture Memos had been written to provide alibis for individuals, were they ever pursued for the harms they imposed. In that respect, those awful memos were artifacts of a slightly better world, in which government lawyers thought that government employees or agents could be called to account. In contrast, the 2006 provisions sought to insulate wrongdoers from even having to provide any such defense (Resnik 2006).

The litany of horrors has not abated. In 2006, a federal judge in New York refused to hear the claims of a Canadian citizen (Maher Arar), detained by our government for thirteen days, incommunicado, at JFK airport in September 2002, and then shipped off to Syria, where he was subjected to torture and kept for almost a year in a grave-like cell (*Arar v. Ashcroft* 2006). Later that year, before a U.N. committee in Geneva, the State Department's senior lawyer made the statement that, while the United States would apply standards against torture, "as a purely legal matter, we think it is crystal clear in reading the terms of the [torture] Convention . . . that it does not apply to transfers that take place outside

the United States" ("U.S. Defends Treatment" 2006). In the spring of 2007, another appellate court dismissed a case brought by a German citizen alleging torture through American actions. Despite widespread reports of such events, the judges relied on the government's claim that it needed to keep "state secrets" (*El-Masri v. United States* 2007). In other words, it is the officially stated position of the government that, in some settings, while it will comply with prohibitions on torture, that compliance is on a voluntary basis. Further, as the references above to these lower court decisions make plain, some federal judges have adopted the proposition that individuals alleging torture can be denied access to courts.

My anxiety is not only about the underlying activities (gruesome as they are) but also about the corruption of American law. I am horrified that my current students might think that the discussions about the legality of torture are normal—as if, on a Monday, one studied the First Amendment and, on a Tuesday, one turned to the legal arguments about what forms of the infliction of pain were egregious enough to constitute torture.

Debating the legality of "waterboarding"— which is strapping people to boards and putting them under water to create the sensation that they are drowning—is obscene. Justifying such harms ought to be seen as comparable to trying to argue that the United States could keep slaves as long as they were held offshore, or by someone else, or not hurt too much. Such arguments should be understood as antithetical to, rather than plausible within, the fabric of American law. Yet in the fall of 2007, the Senate confirmed (53 to 40) Michael Mukasey to be the Attorney General of the United States even though he refused to say that waterboarding was torture.

I write as both a spectator and a participant, amazed at the array of changing mores. Some are to be celebrated, such as the dents made into women's subordination that a century's worth of speeches at Bryn Mawr College's convocation reveals. But as I watch the invasion of persons' bodies in the name of the protection of democracy, I see a breach in a dam that several decades of work by people in and outside the United States have built out of respect for the dignity of all humans.

Bryn Mawr first introduced me to William Butler Yeats, and his sorrowful words: "The blood-dimmed tide is loosed, and everywhere / The ceremony of innocence is drowned"—seem all too appropriate. Innocence is indeed lost. In another poem, "On Being Asked for a War

Poem," Yeats also wrote that poets "have no gift to set statesmen right" (Yeats 1920/1956).[6]

May he be wrong, especially if, alerted and provoked; we of all our varied métiers (balloonists included) seek to stem this tide.

ACKNOWLEDGMENTS

This essay is based on a convocation address that I gave at Bryn Mawr College in June 2006 and relates to my article "Law's Migration: American Exceptionalism, Silent Dialogues, and Federalism's Multiple Ports of Entry," 2006, *Yale Law Journal* 115(7):1564. My thanks to Kathyrn Abrams and Nancy Miller for their engagement with my ideas and their editorial advice, as well as to Joseph Frueh and Michelle Morin, Yale Law School, class of 2008, for thoughtful research assistance. Working with Nancy enables me also to continue connections first forged through Carolyn Heilbrun.

JUDITH RESNIK is the Arthur Liman Professor of Law at Yale Law School, where she teaches courses on Procedure, Federal Courts, and Citizenship, Equality and Sovereignty. Her recent work includes *Representing Justice: From Renaissance Iconography to Twenty-First Century Courts*, (June, 2007) published in the Proceedings of the American Philosophical Society 151: 139 (with Dennis E. Curtis), and *Whither and Whether Adjudication?* (2006) published in the Boston University Law Review 86: 1101. At Yale she is co-chair of the Women Faculty Forum and the founding Director of Liman Public Interest Program and Fund.

NOTES

1. Bryn Mawr College (BMC), Completion of the First Full Course of Study, News Clipping from the "Public Ledger" at 77 (1898). Sources were provided with the help of BMC's Nell Pointer and Donna Hecker and Yale's Camilla Tubbs. A few have been published in a magazine for graduates that has, over the century, had different names and formats. Because of the relative inaccessibility of the speeches, all quotations from those materials are neither footnoted nor listed as references but are on file at Bryn Mawr College.

2. Dr. Hu Shih advised that one had first "the duty to verify our facts and check our evidences; second, the humility to admit the possibility of error of our judgment and to guard against bias and dogmatism, and thirdly, a willingness to work out as thoroughly as we can the possible consequences that may follow the acceptance of our view or theory, and to hold ourselves morally responsible for the consequences."

Dr. Hu Shih, whose papers are at Cornell, was also the chancellor of the University of Beijing in 1946 and, in Taiwan, led its Academia Sinica.

3. After these memos were leaked to the press in 2004, the Office of Legal Counsel revised its position. But in the fall of 2007, revelations of subsequent memos appear to have softened that reversal.

4. See Military Commissions Act 2006.

5. See *Boumediene v. Bush* 2007.

6. The lines "The blood-dimmed tide is loosed, and everywhere / The ceremony of the innocence is drowned" are from the poem "The Second Coming," which was first published in 1920 in *The Dial*. The material quoted above can be found in the Yeats 1920/1956. Also in the 1956 edition is the second quote, from "On Being Asked for a War Poem," which was first published in 1919.

WORKS CITED

Arar v. Ashcroft. 2006. 414 F.Supp.2d 250 (E.D.N.Y.).

Boumediene v. Bush. 2007. 476 F.3d 981 (D.C. Cir.), *cert. granted*, 127 S. Ct. 3078 (U.S. June 29, 2007) (No. 06–1195).

Bryn Mawr Alumnae publications and archival materials.

Dorfman, Ariel. 2004. "The Tyranny of Torture: Is Torture Inevitable in Our Century and Beyond?" In *Torture: A Collection*, edited by Sanford Levinson. New York: Oxford University Press.

El-Masri v. United States. 2007. 479 F.3d 296 (4th Cir. 2007), *cert. denied*, 128 S. Ct. 373 (2007).

Gherebi v. Bush. 2003. 352 F.3d 1278 (9th Cir.), *cert. granted and judgment vacated in light of Padilla v. Rumsfeld, and of Rasul v. Bush*, 542 U.S. 952 (2004).

Greenberg, Karen J., ed. 2006. *The Torture Debate in America*. New York: Cambridge University Press .

Margulies, Joseph. 2006. *Guantánamo and the Abuse of Presidential Power*. New York: Simon & Schuster.

Memorandum from the Office of Legal Counsel, Department of Justice, to Alberto R. Gonzales, Counsel to the President, Standards of Conduct for Interrogation under 18 U.S.C. §§ 2340-2340A, August 1, 2002, available at http://www.washington post.com/wp-srv/nation/documents/dojinterrogationmemo20020801.pdf.

Military Commissions Act of 2006. 2006. Pub L. No. 109–366, 120 Stat. 2600 (codified at various sections of titles 18 and 28).

Miranda v. Arizona. 1966. 384 U.S. 436.

Resnik, Judith. 2006. "When the Justice Department Played Defense: Congress Gives the 2002 Torture Memos a Weird Upside." *Slate*, October 27. http://www.slate.com/id/2152211.

"U.S. Defends Treatment of Terror Suspects to UN Body." 2006. *New York Times*, May 5.

United States ex rel. Caminito v. Murphy. 1955. 222 F.2d 698, 701 (2d Cir.).

Yeats, William Butler. 1920/1956. *Collected Poems: Definitive Edition with the Author's Final Revisions*. New York: MacMillian.

Meridians

feminism, race, transnationalism

*Makes scholarship
by and about women
of color central to
contemporary
definitions of
feminism*

Edited by Paula J. Giddings

p - ISSN 1536-6936
e - ISSN 1547-8424

Meridians: feminism, race, transnationalism provides a
forum for the finest scholarship and creative work by and
about women of color in U.S. and international contexts.
Recognizing that feminism, race, transnationalism, and
women of color are contested terms, the journal engages
the complexity of these debates in a dialogue across ethnic
and national boundaries, as well as across traditional
disciplinary boundaries in the academy.

Institutions:
print $87.00
electronic $78.30
print & electronic $121.80

Individuals:
print $34.50
electronic $31.05
print & electronic $37.95

Now available
on...

e-publishing portal of IU Press

HTTP://INSCRIBE.IUPRESS.ORG
1.800.842.6796

INDIANA UNIVERSITY PRESS JOURNALS

FEMSPEC

an interdisciplinary journal committed to challenging
gender through speculative art, fiction, poetry, and criticism

Recently and Forthcoming in FEMSPEC

Gina Wisker, "New Blood" (Fiction)
Louise Moore, "Joan of Arc" (Poetry)
Pat Ortman, "Don't Tread on Me" (Art)
Linda Holland Toll, "What to Do When You are Stuck at Toxic U"
R. S. Fullerton, "Not 'Of Woman Born': Fairy Tale Mothers for Postmodern Literary Children"
Eric Drown, "Business Girls and Beset Men in Pulp Science Fiction"
D. B. Shaw, "Sex and the Single Starship Captain: Compulsory Heterosexuality and ST Voyager"
Marleen Barr, "Superfeminist, Or, A Hanukah Carol" (Fiction)
Candi Cruz, "The Goddess Rag" & "Avatar Blues" (Poetry)
Erin Smith, "Women Writing Pulp"
Marion Epstein, "Feminist Speculative Art" (Art)

Advisory Board	*Contributing Editors*
Suzy McKee Charnas	Paula Gunn Allen
Florence Howe	Marleen S. Barr
Joanna Russ	Samuel R. Delany
Pamela Sargent	Gloria Orenstein
	Darko Suvin

Submissions* and
Subscriptions to:
FEMSPEC
c/o Batya Weinbaum, editor
1610 Rydalmount Road
Cleveland Heights, OH 44118

Subscribe online at
www.femspec.org/subscriptions.html

Individuals $40 (2 issues).
Institutions $95 (2 issues)
[International subscribers, please add $10]

*Four blind copies, cover letter with contact information, and disk

[[·]] UNIVERSITY OF ILLINOIS PRESS

Feminist Teacher

*a journal of the practices, theories, and scholarship
of feminist teaching*

Subscription Rates:
 Individuals, $38
 ($58 Non-U.S.)
 Institutions, $85
 ($105 Non-U.S.)

Issued three times per year

ISSN 0882-4843

Includes access to the FT
online archive located at
http://ft.press.uiuc.edu

Since 1984, Feminist Teacher has been at the forefront of discussions about how to fight sexism, racism, homophobia, and other forms of oppression in our classrooms and in the institutions in which we work. A peer-reviewed journal, Feminist Teacher provides a forum for interrogations of cultural assumptions and discussions of such topics as multiculturalism, interdisciplinarity, and distance education within a feminist context. Feminist Teacher serves as a medium in which educators can describe strategies that have worked in their classrooms, institutions, or non-traditional settings; theorize about successes or failures; discuss the current place of feminist pedagogies and teachers in classrooms and institutions; and reveal the rich variety of feminist pedagogical approaches. The journal also remains committed to addressing issues that face educators today, including anti-feminism, anti-academic backlash, and sexual harassment.

www.press.uillinois.edu • 866-244-0626 • journals@uillinois.edu

TRANSFORMATIONS

THE JOURNAL OF INCLUSIVE SCHOLARSHIP AND PEDAGOGY

Transformations: The Journal of Inclusive Scholarship and Pedagogy is a peer-reviewed journal published semi-annually by New Jersey City University. It is an interdisciplinary forum for pedagogical scholarship exploring intersections of identities, power, and social justice. The journal features a range of approaches—from theoretical articles to creative and experimental accounts of pedagogical innovations—by teachers and scholars across all areas of education.

Please see our website at www.njcu.edu/assoc/transformations for submissions guidelines and information on future issues. Send mail to: TRANSFORMATIONS, New Jersey City University, Hepburn Hall, Room 309, 2039 Kennedy Boulevard, Jersey City, NJ 07305.

SUBSCRIPTIONS

Rates

INDIVIDUAL:	One year - $20	Two year - $35
INSTITUTION:	One year - $50	Two year - $85

International subscribers should add $10 per subscription for surface mail and $20 per subscription for air mail.

Name

Address

City State Zip

Telephone

Email

Make check or money order payable to: New Jersey City University
Mail this form to: TRANSFORMATIONS, New Jersey City University, Hepburn Hall, Room 309, 2039 Kennedy Boulevard, Jersey City, NJ 07305.

TRANSFORMATIONS *is published semi-annually by New Jersey City University*

The Feminist Press at The City University of New York
is a nonprofit institution dedicated to publishing literary and educational
works by and about women. We are the oldest continuing feminist
publisher in the world; our existence is grounded in the knowledge that
mainstream publishers seeking mass audiences often ignore important,
pathbreaking works by women from the United States and throughout
the world.

The Feminist Press was founded in 1970. In its early decades the Press
launched the contemporary rediscovery of "lost" American women
writers, and went on to diversify its list by publishing significant works
by American women writers of color. More recently, the Press has
added to its roster international women writers who are still far less
likely to be translated than male writers. We also seek out nonfiction
that explores contemporary issues affecting the lives of women around
the world.

The Feminist Press has initiated two important long-term projects.
Women Writing Africa is an unprecedented four-volume series that
documents women's writing in Africa over thousands of years. The
Women Writing Science project, funded by the National Science
Foundation, celebrates the achievements of women scientists while
frankly analyzing obstacles in their career paths. The Series also pro-
motes scientific literacy among the public at large, and encourages
young women to choose careers in science.

Founded in an activist spirit, The Feminist Press is currently under-
taking initiatives that will bring its books and educational resources to
underserved populations, including community colleges, public high
schools, literacy and ESL programs, and international libraries. As we
move forward into the twenty-first century, we continue to expand our
work to respond to women's silences wherever they are found.

For information about events and for a complete catalog of the Press's
more than 300 books, please refer to our website: www.feministpress.org
or call (212) 817-7915 to request a catalog with our entire list.